AEROFILMS
A History of
Britain From Above

TRADE MARK

AEROFILMS
COLINDALE AVENUE, HENDON, N.W.9.
LIMITED

AIR PHOTOS
of
TOWNS and PLACES
of INTEREST

James Crawford, Katy Whitaker and Allan Williams

AEROFILMS

A History of Britain From Above

ENGLISH HERITAGE

Royal
Commission on the
Ancient and
Historical
Monuments of
Scotland

100
CBHC
RCAHMW

Published in 2014 by English Heritage

Unless otherwise stated all images are
copyright English Heritage
Crown copyright © RCAHMS
Crown copyright © RCAHMW

Images reproduced from the
Medmenham collection are courtesy of
the Medmenham Collection trustees.

NCAP images are courtesy of
the National Collection of Aerial
Photography.

Registered charity
RCAHMS SC026749

British Library
Cataloguing-in-Publication Data.
A catalogue record for this book is
available from the British Library.

ISBN 9781848022485

Original design by Dalrymple
Layout by Oliver Brookes RCAHMS
Typesetting by Three (B)
Typeset in Garamond and Interstate
Printed in Poland by Ozgraf

FRONTISPIECE
Aerofilms advertising leaflet.
1929 ROYAL AERO CLUB COLLECTION, RAF MUSEUM

ENGLISH HERITAGE

Contents

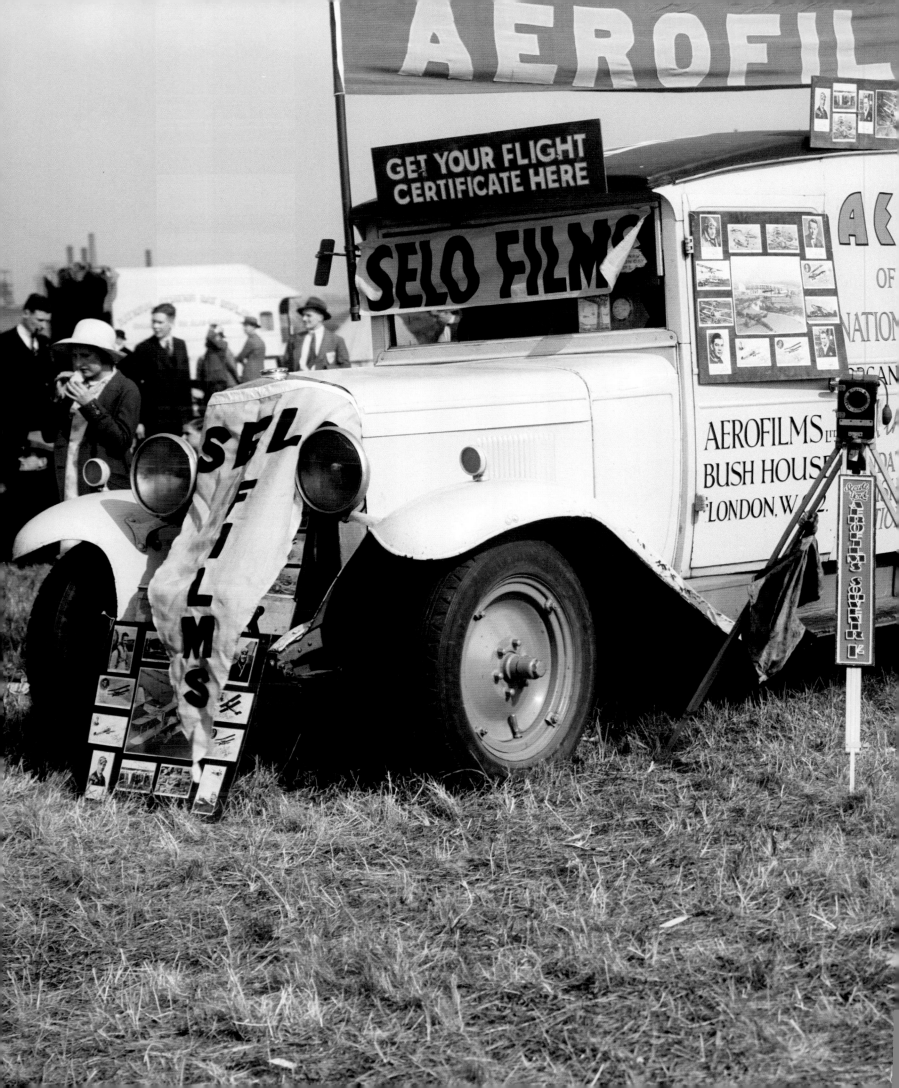

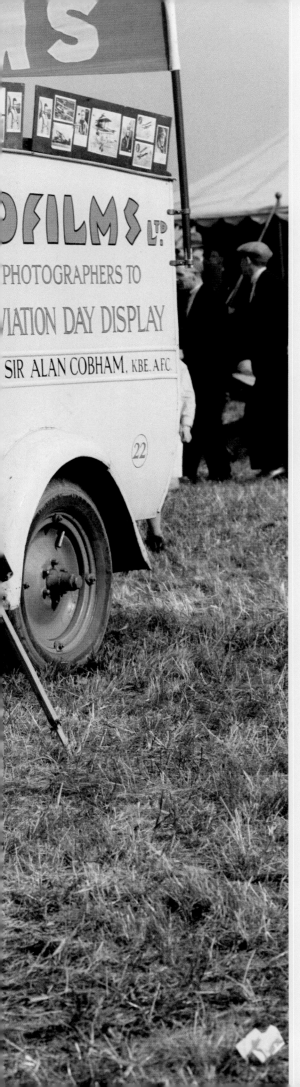

Introduction

READ THIS Exceptional Offer!
An Aerial Photograph of your own subject – to be selected from a number of views taken from various aspects – for only TEN GUINEAS.
Such a modern picture of your factory, business premises or property, is a decided acquisition. Its value for publicity purposes is obvious; it commands attention; it proves your goods 'British Made'.
Aerofilms Ltd, the pioneers in aerial photography, have been employed by concerns in every branch of Business, Commerce and Industry... Sooner or later, YOU, too, will have particular use for an Aerofilm.

Aerofilms advertising flyer, produced for National Aviation Day 1933.

In 1932, Sir Alan Cobham, a Royal Flying Corps officer turned aviation pioneer, began staging a series of events – he called them National Aviation Days – at venues across Britain. Hundreds of thousands turned out to watch Cobham's famous Flying Circus – a squadron of some fifteen aeroplanes, made up of Tiger Moths and Avros, a Lincock for stunt displays, a glider, an Autogiro, a large Handley Page airliner and a new flyer called the Airspeed Ferry. Over the course of the day, spectators were treated to formation flights, air races, inverted flying, continuous rolling and even 'dancing in the air', where a pilot would attempt to fly in a 'syncopated fashion' to music broadcast from three giant loudspeakers mounted on top of a radio van. Joyrides proved extremely popular. For five shillings, brave spectators could board the Airspeed Ferry and be taken – ten at a time – for a twenty-minute tour of the skies.

Cobham was an evangelist of air travel – and his aim with National Aviation Day was to popularise flying among the British public. In a Pathé newsreel, filmed to advertise the launch of his 1934 tour, he spoke of how the 'importance of flying to the British cannot be exaggerated. It is so essential that the public of Britain should become air-minded.' Cobham predicted that, over the following decade, aeroplanes would become as common as motorcars, and airports and aerodromes would be 'as plentiful as golf courses'. Indeed, he even concluded that, 'the only solution to this road congestion business of the present moment is for us to get in the air'. Behind the audacious stunts, wing-walking, parachute descents and 'pretty girls' flying gliders was a serious mission. 'Any of you that visit this display', he promised the viewing public, 'will be so thrilled and entertained that we will capture your interest for the cause of aviation for all time.'

At every event, parked next to a catering truck and a public address system, was a white Bedford van, sporting a banner that read 'Aerofilms'. Boards propped up against the van were covered in printed photographs, all billed as having been taken 'From the Pilot's Seat'. Every town that played host to a show was captured from the air. A slogan painted on the side of the van announced that Aerofilms

Aerofilms turned a white, 1930s Bedford light delivery van into a mobile advertising hoarding, which travelled to National Aviation Day displays across the country.
c1930s ENGLISH HERITAGE. AEROFILMS COLLECTION

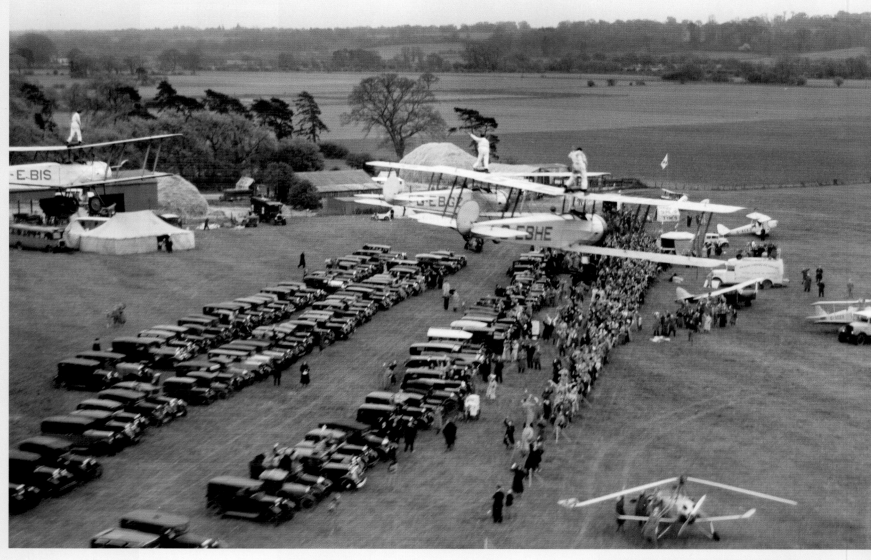

was the official photographer for National Aviation Day. Cobham himself had been one of the pilots who originally flew for the company.

Aerofilms Limited were founded by Claude Grahame-White, a wealthy entrepreneur and one of the very first Englishmen to pilot an aeroplane, and Francis Lewis Wills, a demobbed Royal Naval Air Service veteran, who had flown over the North Sea and the coastlines of France, Belgium and northern Germany as an air-reconnaissance photographer during the First World War. The choice of the company name was revealing – the original aim was to specialise not in aerial photography, but in aerial cinematography. As an early 'advertorial' explained, 'Aerofilms Limited make it possible for producers to introduce aerial incidents into film productions. Their sole job in life is to supply aeroplanes, aerodromes, pilots, cameramen, and cameras, solely for aerial cinematography, in which there is so much practically unlimited scope for rousing public interest.' As Wills later reminisced, however, his vision for Aerofilms was never really this narrow: 'We were out to do anything and anybody from the air.'

By the early 1930s, Aerofilms had taken some 33,000 images of Britain from above. It was a remarkable output for a business that, when established just over a decade earlier, had produced only seventeen glass negatives in their first six months

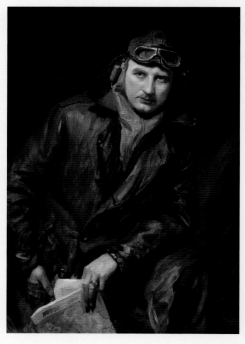

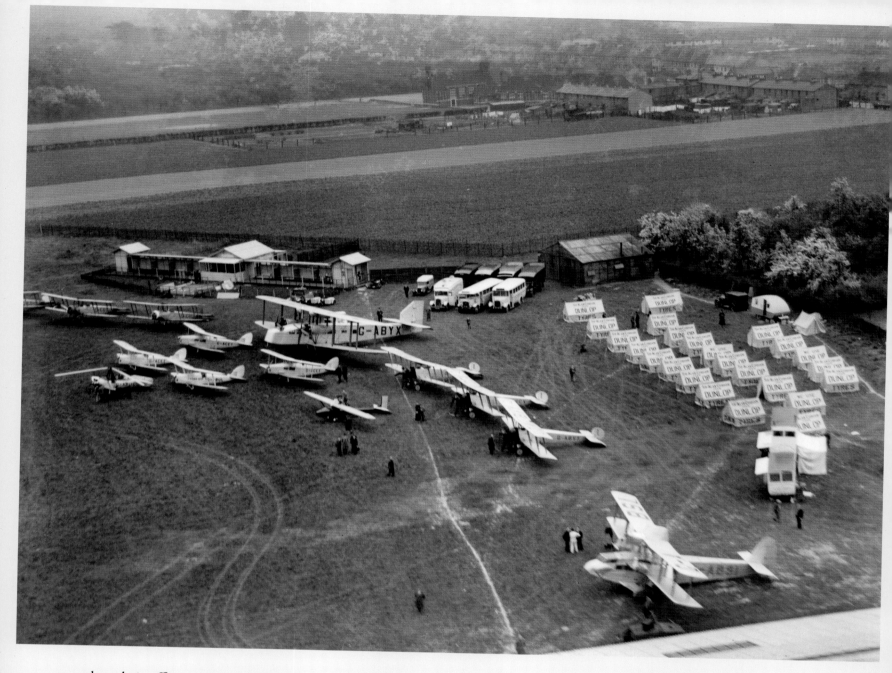

— when their office was a suite in the London Flying Club in Hendon, and the photographs were developed in an adjoining bathroom turned darkroom. This was a new, unique venture – untried, untested, exciting, eccentric and dangerous. Wills and Grahame-White saw themselves as pioneers, and Britain as their canvas. Their aim was to take to the skies to capture the nation, looking down with their cameras on towns, cities and countryside. Their philosophy – later to become one of the company's many advertising slogans – was characteristically bold and ambitious. 'There is no limit', they believed, 'to the possibilities of the unusual AERIAL PHOTOGRAPH.'

The origins of Aerofilms can be traced back to some of the earliest days of powered flight. On 25 July 1909, the French aviator, engineer and inventor Louis Blériot had achieved worldwide fame as the first man to cross the English Channel in an aircraft. This remarkable feat instilled in Grahame-White – an engineer and balloonist turned wealthy motorcar dealer – a lifelong passion for flying. He contacted Blériot, and agreed to purchase one of his aircraft, a new invention known as the No XII. On 28 August of that same year, just a month after the Channel crossing, Blériot broke the world air-speed record while flying the No

ABOVE LEFT AND RIGHT

Alan Cobham's 'Flying Circus' aimed to provide 'thoroughly good aerial entertainment'. On the left, wing-walkers are carried above a National Aviation Day crowd at Thatcham by three Avro 504s flying in close formation. On the right, the fleet is at rest at Heston Airfield. The Dunlop tents acted as accommodation for the display staff.

1933 EPW041021, 1933 EPW040991

BELOW LEFT

Cobham was painted in full flying gear for a 1926 portrait by Francis Owen Salisbury. Described by *Flight* magazine as 'a colourful pioneer of aviation', Cobham was an evangelist of early air travel, determined to 'make Britain air-minded'.

1926 NATIONAL PORTRAIT GALLERY, LONDON

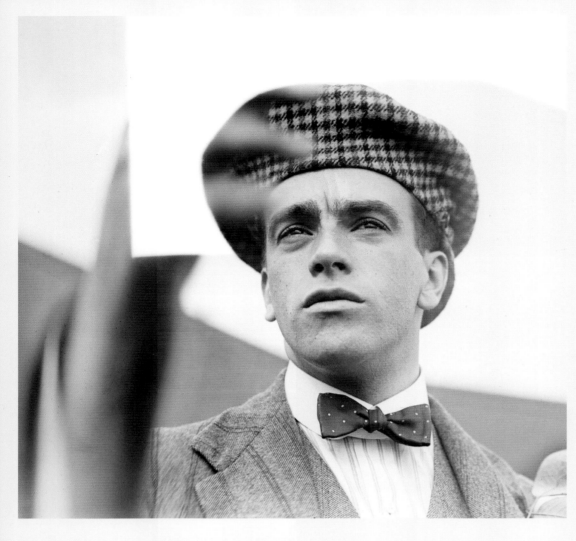

Claude Grahame-White was one of Britain's first ever aviation celebrities. In 1910, less than a year after he had received widespread media attention for making a solo flight without a single lesson, he employed a press agent and instructed him 'to circularize the whole of the British and foreign press', to give his flights 'every publicity'. When he travelled to America for a Boston–Harvard air race in September 1910, local journalist Phoebe Dwight gave a wonderful summary of Grahame-White's appeal. She advised Boston's men to watch out for their wives and daughters if they brought them along to the airshow, 'For before you know it these hearts may be fluttering along at the tail of an airplane wherein sits a daring and spectacular young man who has won the title of the matinee idol of the aviation field.'
1910 GEORGE GRANTHAM BAIN COLLECTION. LIBRARY OF CONGRESS

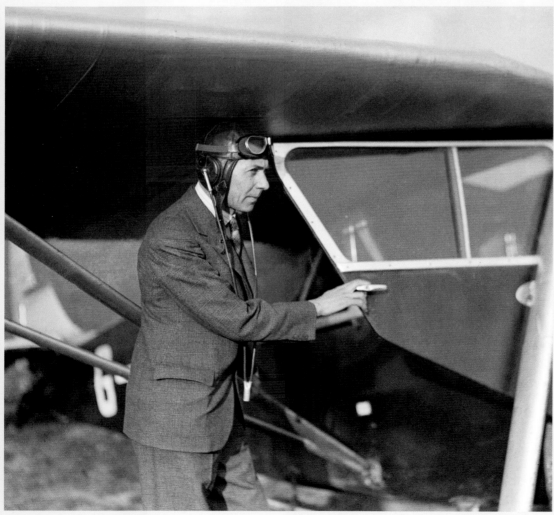

Francis Lewis Wills was the co-founder of Aerofilms – and the foil to his ostentatious celebrity partner Claude Grahame-White. While Grahame-White's public profile made him valuable as the company's figurehead, Wills was the true driving force behind the business, a man who was passionate about the many and varied potential applications of aerial photography, and who was always working at the cutting edge of aviation and photographic technology. He was not completely averse to self-promotion however. In this image from the 1930s, he is pictured in lounge suit, flying helmet and goggles, in what is surely a staged shot.
c1930s ENGLISH HERITAGE. AEROFILMS COLLECTION

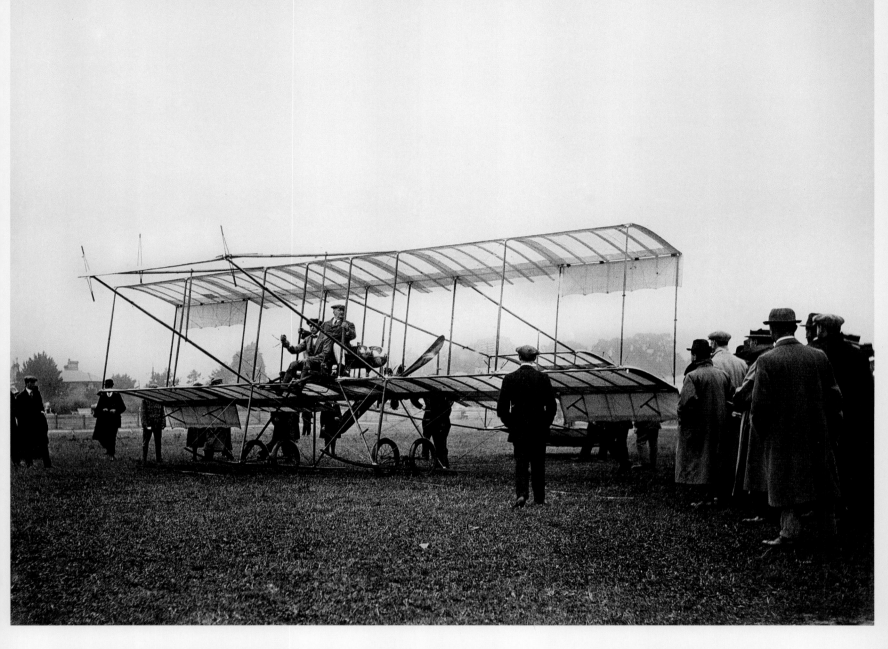

XII at Reims. On another record attempt a day later, however, the aircraft burst into flames and crashed to the ground from a height of 100 feet – with Blériot at the controls. Grahame-White, who was waiting to take possession of the No XII, reacted to the news of its destruction with 'a great disappointment'. The Frenchman 'was fortunate enough to escape with nothing worse than burns about the face and hands, and a general shock', and Grahame-White, seemingly unconcerned by the accident, soon made a deal to buy a replica. After three months of impatient waiting – where he visited the Blériot factory every day to 'superintend the construction' – the aircraft was complete. He was ready to embark on his maiden flight.

At dawn on 7 November 1909, at Issy-les-Molineaux aerodrome on the outskirts of Paris, Grahame-White spun the 8-foot propeller of his new No XII monoplane, and started its 60 horsepower engine. In his eagerness to fly he had not slept at all the previous night, and had set off with a friend for the flying grounds at 2am. By first light, the Blériot mechanics had still not arrived to instruct him on the technicalities of the aeroplane, and so he resolved to start it himself. As the engine fired, the aircraft leapt forward, and he was knocked to the ground. It was an inauspicious start, but Grahame-White was not discouraged.

Claude Grahame-White sits at the controls of an incredibly fragile-looking Farman biplane – a construction of ash wood, wire and fabric driven by an 8-foot propeller. This photograph was taken during the Bournemouth Aviation Meeting in July 1910 – the same meeting that highlighted the extreme dangers of early aviation. On 12 July, Charles Rolls became the first Englishman to die in an aeroplane crash, after his aircraft fell to the ground in front of thousands of spectators. 1910 ENGLISH HERITAGE ARCHIVE

Instead, he moved quickly round to the driving seat to take his place at the control levers, and motioned to his friend – who had been holding the restraining ropes – to cast them loose and jump into the passenger seat alongside him. The pair then sped along the ground of the aerodrome, accelerating up to 50 miles an hour. Grahame-White did not attempt to take off, as his intention was to first familiarise himself with the controls. Most pressing was how to stop – it was only after they had set off that they realised the No XII had no brakes. As the boundary wall of the aerodrome came racing towards them out of the morning fog, Grahame-White shouted to his friend to 'jump out of the machine as best he could, and catch hold of the wooden framework … allowing the machine to drag him along the ground and so using the weight of his body as a brake'. The aircraft came to a standstill just a foot from the wall.

It was, Grahame-White admitted, a chastening experience. Yet still he was determined to press on. After some 20 minutes running the machine back and forth across the aerodrome, he decided that he was ready to rise into the air. 'I told my friend my intention, calling to him above the noise of the motor; and I admired him for the calm way in which he received my news.' He accelerated the aircraft, raised the rear elevating plane, and, within a few seconds, had risen some 30 feet off the ground. Once again, Grahame-White was presented with an immediate challenge. 'I made up my mind at once to descend,' he recalled. Yet that manoeuvre 'of making contact with the ground after a flight,' was, he had been told, 'the most difficult of all'. Remarkably, he was able to land the aeroplane without accident. Emboldened by this success, the two men turned the machine around, and decided to make another flight.

As Grahame-White brought the No XII back down to earth for a second time, he saw a crowd of people running across the aerodrome towards them. In the lead were the Blériot mechanics, closely followed by a bank of reporters and photographers from the Paris newspapers. As Grahame-White later realised, the press had been tipped-off by the mechanics, 'in the expectation of being able to record, with their notebooks and cameras, some catastrophe in which we were expected to play the leading parts'. Whether through fortitude or blind luck, this 31-year-old novice English pilot had turned catastrophe into triumph. 'Though there was nothing gruesome to chronicle, they found ample material, when they learned of them, in the early morning adventures of myself and my friend,' recalled Grahame-White. 'Next day, in fact, our exploits were given prominence in the newspapers, and I received a number of congratulatory telegrams.' Among the telegrams was also a message from Blériot – warning Grahame-White of the dangers of what he had done, and pleading with him to be more cautious in the future.

In the years following his first flight in the No XII monoplane, Grahame-White's passion for aviation made him a household name – and something of a national hero. In 1910, he competed against the French pilot Louis Paulhan in a Daily Mail-sponsored London to Manchester air race, for a prize pot of £10,000. Although Paulhan won, Grahame-White's endeavours – which included the world's first ever night-flight – endeared him greatly to the British public. Later that same year, he won the Gordon Bennett Aviation Cup, a prestigious race held in Long Island, New York. It was the start of an incredible run of success. Over the course of the 1910 air-racing season in America, he amassed some $250,000 in winnings and appearance fees – approximately $6 million in equivalent terms today. He also showed a considerable flair for self-publicity. On 14 October of that same year, he performed a dramatic landing on Executive Avenue in Washington DC – bringing his aircraft to ground right in front of the White House. It caused

With a small crowd of spectators looking on, Claude Grahame-White fixes broken wiring on the wing of his Farman biplane. In his 1911 book *The Story of the Aeroplane* Grahame-White gave a tantalising and gripping account of his own experiences of learning to fly. In once incident, while attempting to impress a watching crowd by gliding to earth with his engine off, he lost control in a strong headwind and, 'before I could think out any form of action the machine had struck the ground with terrible force, head first'. Landing in gorse and bramble bushes, and with a head wound after hitting his face on a steel upright, Grahame-White admitted that 'the shock to my nervous system made it necessary for me to remain quiet for a few days. It is such incidents as these, however, which teach one how to fly.'

1910 HARRIS & EWING COLLECTION. LIBRARY OF CONGRESS

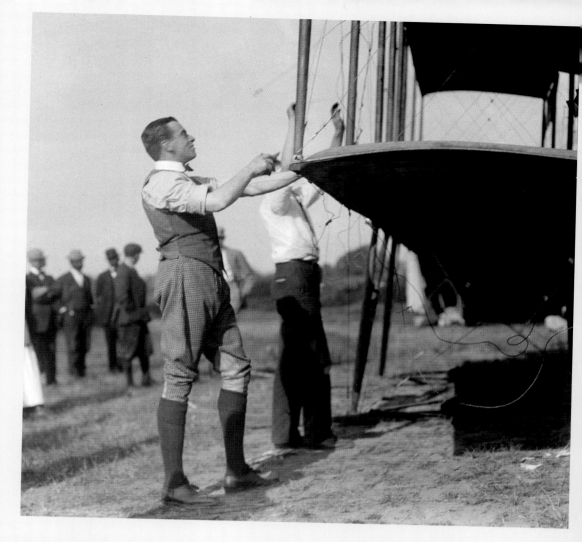

On 14 October 1910, Claude Grahame-White flew a Farman biplane along Executive Avenue in Washington DC – before landing right in front of the gates of the White House. The next day, an awestruck *Washington Post* described the feat as, 'the most remarkable and daring landing ever made from such a height by an aviator, either native or foreign'. After circling the Washington Monument at 500 feet, Grahame-White 'undertook the glide which never before has been successfully carried out', as his machine 'shot earthward at a safe angle and landed in the middle of the narrow street'.

1910 ERNEST L JONES COLLECTION. LIBRARY OF CONGRESS

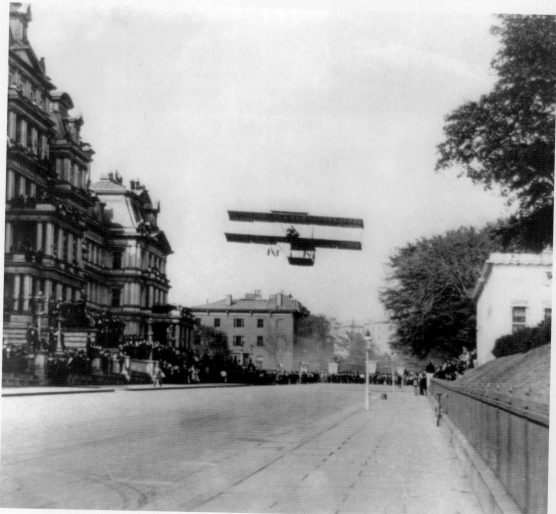

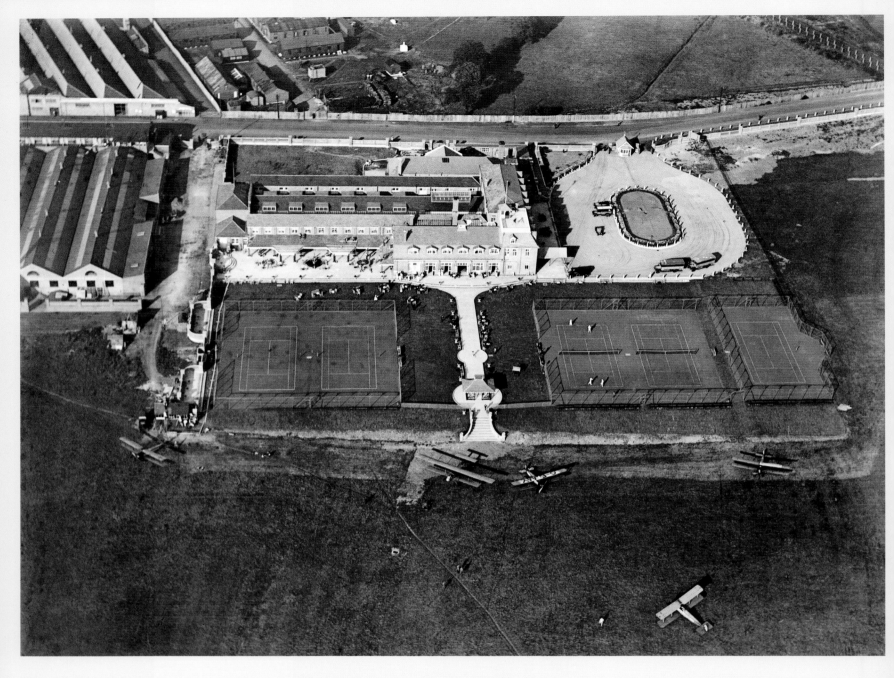

a media sensation, and helped to cultivate his image as a debonair and fearless gentleman aviator.

In August 1911, he established the Grahame-White Aviation Company, and purchased the airfield of the London Aerodrome Company at Hendon. Twenty years before Cobham's National Aviation Day, Grahame-White embarked on a 'Wake Up England' tour, part of a concerted campaign to popularise flying – and, of course, to generate demand for his new aircraft construction business. Over the summer of 1912, he visited 121 towns and gave some 1,200 passengers their first experiences of flight. One of those passengers was the writer H G Wells – author of *War of the Worlds* and *The Time Machine* – whose account of a flight with Grahame-White over Eastbourne acted as a fantastic endorsement for aviation: 'Hitherto my only flights have been flights of imagination but this morning I flew. I spent about ten or fifteen minutes in the air; we went out to sea, soared up, came back over the land, circled higher, planed steeply down to the water, and I landed with the conviction that I had had only the foretaste of a great store of hitherto unsuspected pleasures. At the first chance I will go up again, and I will go higher and further.'

Claude Grahame-White's London Flying Club in Hendon was styled in the fashion of American Country Clubs, and was intended to serve as 'a social centre for private aviation'.
1919 EPW000010

A London Underground poster advertises an RAF Aerial Pageant taking place at Hendon.
1924 TFL from the LONDON TRANSPORT MUSEUM COLLECTION

Despite these promotional efforts – and the considerable public interest – aviation remained the preserve of wealthy enthusiasts. It took the onset of the First World War to truly transform demand. The Grahame-White Aviation Company and London Aerodrome were requisitioned by the Admiralty, and Grahame-White's flight school was contracted to train pilots for active service. The huge boom in aircraft construction provided just the impetus needed to fast-track improvements in reliability, endurance, speed and capability – rapid technological advances that could only have taken place under the unique pressures of conflict. At the outbreak of the First World War, the Royal Flying Corps (RFC) was made up of 146 officers and fewer than 100 aircraft, and the Royal Naval Air Service (RNAS) had 727 personnel, 6 airships, 2 balloons and 93 aircraft. Over the next four years, the pace of change was quite incredible. By November 1918, the newly formed RAF – which merged the RFC and RNAS – comprised 27,000 officers and 260,000 other personnel, operating some 22,000 aircraft.

Driving this vast expansion was a new tool in the battle for supremacy in military intelligence – photographs of enemy positions, taken from the air.

Both Grahame-White and Wills served with the RNAS during the war. Grahame-White's operational flying was limited to one night patrol over London, and an ill-fated air-raid on German-held ports on the Belgian coast, that ended with him having to ditch in the North Sea. His most significant contribution to the war effort was not, in the end, as a pilot, but as an aircraft constructor, supplying the British airforces.

Wills – a trained architect – joined the Navy in 1915. Two years later, in May 1917, he became a Probationary Observer Officer in the RNAS – one of the most dangerous roles in the war. The Observer sat in an exposed position in the aircraft, in un-armoured fuselage. The month before Wills joined the service, 43 Squadron of the RFC reported that only eight of its eighteen pilots were still flying – but all eighteen of its Observers had either been killed or injured. As one Observer recalled, there was a unique quality to the dangers faced during wartime flying: 'In the trenches you face death every second, not knowing when it might come… In the air you could see death coming.' Remarkably, Wills volunteered for the job.

The first official British reconnaissance mission had taken place in France on 19 August 1914. Two pilots flew alone in separate aeroplanes, both lost their bearings in the clouds, and on their eventual return to Maubeuge aerodrome on the French-Belgian border, they were unable to report on the positions and movements of the German Army. Observers like Wills were introduced to support the pilots, and they acted as everything from navigator, gunner and radio-operator, to spotter, sketcher – and, ultimately, photographer.

The British military had been slow to appreciate the value of the aerial photograph. For decades prior to the War cameras were taken up in balloons, and as far back as the 1880s the Royal Engineers were using photographs for map-making. They had even created an official balloon section in 1905 – responsible for the famous photograph of Stonehenge from the air. Yet by 1912, the newly formed RFC still saw aerial photography as a distraction. Cameras were only being taken aboard non-rigid airships, and, as Group Captain Victor Laws, the Lieutenant in charge of his Squadron's photographic section recalled, even this met with considerable reluctance. 'I soon found that air photography did not receive a very high priority. The impression given was that its importance was more or less what I chose to make of it. The greatest problem confronting the photographer was to get into the air, such was the demand to fly that one had to persist to a point where pilots became irritated by my presence on the airfield

In one of the earliest examples of aerial photography of an archaeological site in Britain, Lieutenant Philip Henry Sharpe captured Stonehenge from a Royal Engineers Balloon in 1906. This photograph was most likely taken from a 'captive' balloon – one that was tethered to the ground by a winch to allow its altitude to be raised or lowered under controlled conditions. It later appeared in a 1907 Society of Antiquaries Journal as part of an article written by Colonel J. E. Capper, head of the Royal Engineer Balloonists, to promote the applications of aerial imagery.
1906 SOCIETY OF ANTIQUARIES OF LONDON

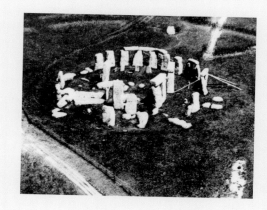

… I recall one occasion when the Captain of an airship about to take off asked why I was hanging about, to which I replied, "I wish to make a flight to take photographs." The Captain suggested that I could do just as well from the top of the balloon shed.'

Attitudes changed rapidly during wartime. In January 1915, Sir John French, Commander of the British Expeditionary Force, ordered the RFC to establish a dedicated photographic section. After seeing a set of incredibly detailed maps of enemy lines, created by the French Air Force's new *Section photo-aérienne du Group des divisions d'entraînement*, he realised the immense strategic value of the aerial photograph. Early attempts at photo reconnaissance were fraught with difficulties, however. The majority of cameras available to Observers were ordinary hand-held models with bellows. These were manually operated, and unsuited to being used at altitude – the bellows would collapse from the air pressure; each exposed glass plate had to be replaced, by hand, with a new, unexposed plate, a considerable challenge given the high wind speeds and often freezing temperatures – and there was no way of compensating for aircraft vibration, which could blur images to such an extent that they were unusable.

Victor Laws – by this time promoted to Sergeant Major – was at the forefront of developing new, custom-built photographic equipment. From a first step of designing protective wooden casings for cameras, the technology advanced to semi-automation and interchangeable lenses to account for variations in aircraft altitude when flying over enemy lines. During the Battle of the Somme, the RFC's photographic section was unable to meet the massive demand for imagery, and so camera reconnaissance was extended to become a dedicated task for every squadron. In March 1917, a photographic map of the entire Western Front was pieced together from hundreds of thousands of individual images – and was updated almost daily. As Major WE Whittaker concluded in 1919, 'During the war aerial photography has grown from an experiment to an exact science.' By the end of the conflict, an incredible 10 million prints had been produced, and the newly formed RAF was using some 4,000 cameras on the front-line, with a further 5,000 employed in exercises at British airbases. Aerial photography had evolved from a curiosity into a fully fledged and equipped discipline, supported by advanced military training and instruction – both in photographic technique and in image interpretation and map-making.

Of course, just as quickly as war can create vast demand, the return of peacetime can remove it. A crash was inevitable. Following the Armistice in November 1918, the government immediately cancelled all aircraft construction contracts. The result was a massive reduction in the size of the aviation industry over a very short period of time. The huge aerial reconnaissance operation – which the many thousands of new aircraft were built to service – was driven by military necessity and the extremes of war. There was nothing to take its place. In 1918, the government's Civil Aerial Transport Committee concluded that, 'The aircraft industry, as it exists today, is an organisation amply equipped with capital, material, machinery, expert knowledge, and trained labour; but at the same time it owes its development and its present position wholly to the phenomenal war demands of the naval and military authorities… There is no past experience of trade on a peace basis to guide the Committee… Viewed, therefore, as a commercial proposition, the Committee do not think that civil aerial transport is likely, at least for some years to come, to develop to such an extent as to involve any appreciable volume of orders being placed with the productive side of the industry in this country.' The clear message: there would be no government-funded development of civil aviation to act as the industry's saviour.

A Royal Flying Corps aerial photograph presents a remarkable top-down, 'vertical' view of the trenches of the First World War. Following the signing of an Armistice between Russia and Germany in December 1917, the Allies were anticipating an all-out attack on the Western Front. This image – one of many thousands captured every day for military intelligence – was taken just north of Saint-Quentin in France, less than a week before the 'Spring Offensive' of 21 March 1918, which saw some one million German soldiers attacking along 50 miles of front.
1918 ENGLISH HERITAGE. AEROFILMS COLLECTION

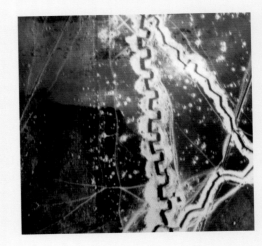

Pilots, photographers, designers, engineers and mechanics – their skills honed in the crucible of war – were demobilised. Aircraft were dismantled or mothballed. Cameras were put, quite literally, back on the shelves. Yet 'air-minded' men like Wills and Grahame-White were not prepared to stay grounded.

Without the First World War, Aerofilms may never have come into existence. Ironically, it was the end of this same conflict that put the company under severe pressure, almost from the moment it was founded. Wills and Grahame-White had an idea, however. They saw the availability of experienced pilots, and cheap surplus aeroplanes and cameras, as a unique business opportunity. They would take a tool developed for military intelligence, and repackage it for the mass market.

They would bring aerial photography to the people.

Sitting either side of pilot Henry 'Jerry' Shaw, are Francis Wills, and the cinematographer Claude Friese-Greene. Wills holds up an aerial photographic camera, while Friese-Greene is gripping a film camera designed to capture moving images. This image was taken in July 1919, just two months after Wills and Claude-Grahame White had formed their new, pioneering aerial photography company.
1919 ENGLISH HERITAGE. AEROFILMS COLLECTION

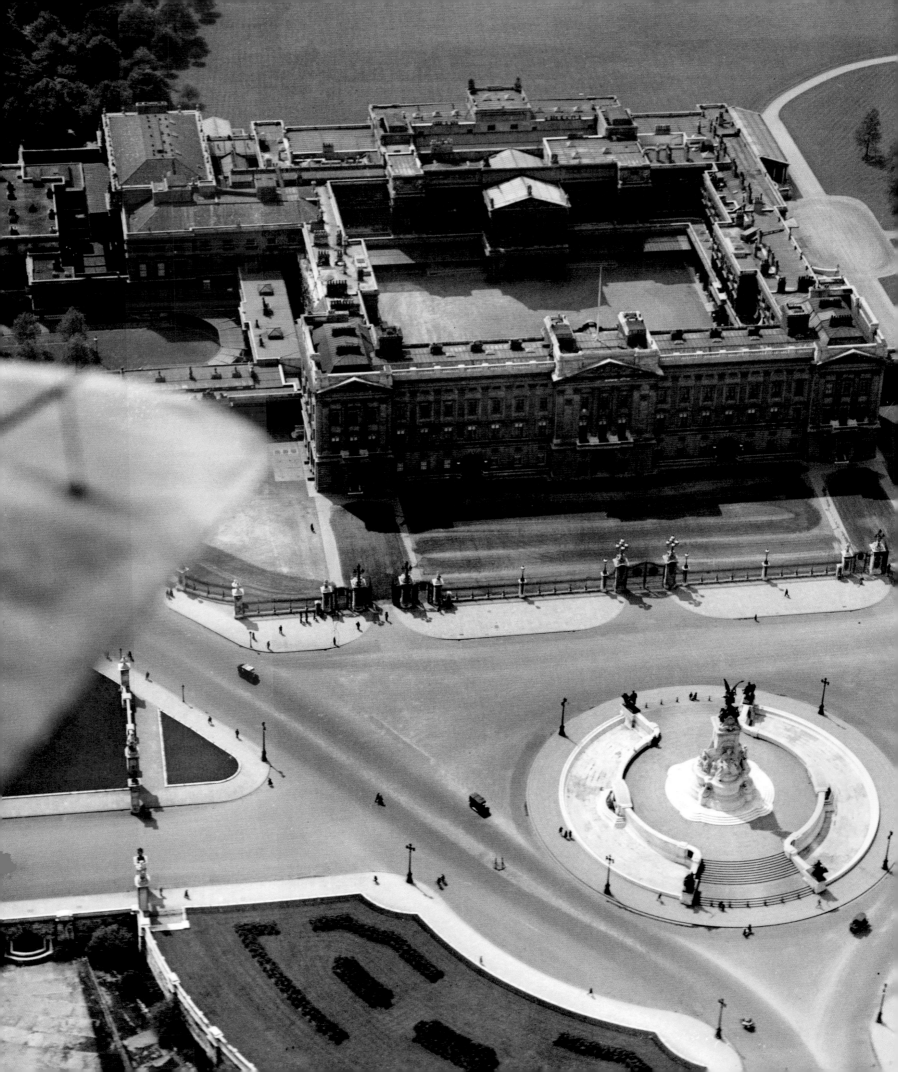

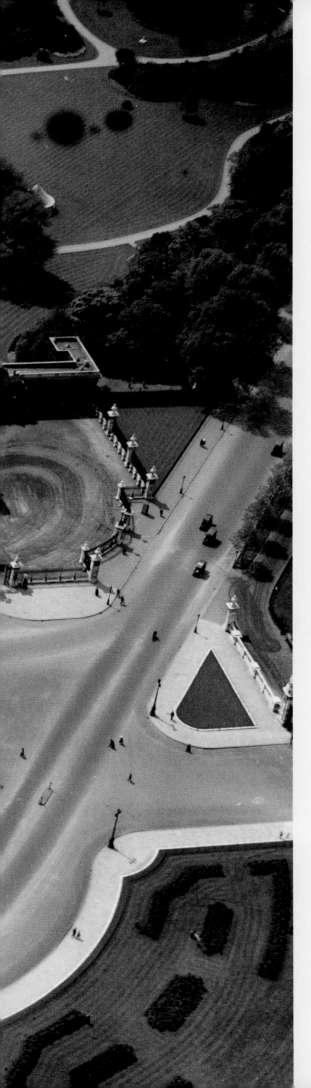

Magnificent Men in their Flying Machines, 1919-1929

In December 1919, the cinematographer Claude Friese-Greene took a Moy hand-held film camera on board an Aerofilms biplane, and set off on a journey across the English Channel. 'Low clouds made the take off rather bumpy,' he recalled afterwards. 'Still, it is filmed, looking back over the tail. Gradually Hounslow and the big white letters 'Customs' on the tops of the sheds pass out of sight... France is sighted just as a miserable drizzling rain begins, which stings the face of the camera man like a thousand pin-pricks... It is now 2.15pm. Right ahead appears a great circle of smoky mist. 2.16! This mist begins to look like a town... 2.18! Good heavens! It's Paris! A fairly low flight around the big city enables a film to be taken... At 2.20 we land at Le Bourget. London–Paris in 1 hour and 50 minutes, and a fine picture version of the route secured into the bargain for everyone to see some day!'

When Aerofilms Ltd were established and registered on 9 May 1919 by Claude Grahame-White and Francis Wills, the company's original Articles of Association appeared to place film as a priority over photography. According to their founding Memorandum, the company would 'provide and supply conveniences for taking cinematograph films of aerial incidents... carry on the businesses of manufacturers of and dealers in films for cinematograph, bioscope or other pictures,' 'engage and employ artistes' and 'provide facilities and conveniences for the taking of cinematograph films'. In a speech given at a staff dinner almost two decades later, Wills boasted of how, 'In film production we engaged fleets of aircraft, parachutists, yachts, complete trains and a station. Provided aerial thrillers for weekly serial films then in vogue, when the daring Eddie Polo was the star, and we had to find for him a substitute for every stunt.' In these early days, Aerofilms advertised their ability to stage special aerial stunts – even offering to recreate dog fights and set fire to aeroplanes in mid-air, with the pilot jumping out and parachuting to safety.

Just like Wills and Grahame-White, Friese-Greene had flown during the War – retraining as a pilot with the Royal Flying Corps in Egypt in 1918 a year after he had been wounded fighting for the British Expeditionary Force in the trenches of the Somme. His skills as a cameraman came from his father, William, a pioneer – some even say 'inventor' – of cinematography, who devised a system known as Biocolour, which created the illusion of colour imagery on black and white film stock. Despite Aerofilms' apparent enthusiasm for the business opportunities offered by moving pictures, only one piece of Friese-Greene's original work for the company still survives to this day – a ten-minute fragment of a feature called *Across England in an Aeroplane*. Light and comedic in tone, it was intended to provide the cinema audience with an experience of the sublime freedom of aviation, taking them 'Far above the world in a region where there are

The blurred wing of an Aerofilms biplane juts into this low-altitude, 1921 photograph of Buckingham Palace and the Queen Victoria Memorial. Today, flight restrictions would make this shot a near-impossibility. 1921 EPW006181

no landlords, no profiteers and no politicians.' In 1921, after the death of both of his parents, Friese-Greene left Aerofilms, resolving to continue the work on colour film processing first pursued by his father. Between 1924 and 1926 he produced *The Open Road,* a unique travelogue of inter-war Britain. Although for a long time forgotten and overlooked, this film is now seen as a classic of early documentary cinema.

Despite the apparent prominence given to cinematography in the early days of Aerofilms, it was really just one of a large number of potential business models being explored by the company. Wills and Grahame-White had created an entirely unique commercial enterprise – no precedent or guide existed for how to make money from civil aviation. Trial and error was inevitable. An added pressure was the government refusal to invest in the industry in the aftermath of the First World War – a decision that had particular impact on Grahame-White. In 1914, his aviation company employed just twenty staff. By 1917, this had grown to over 1,000, and his 50 acres of factory buildings at Hendon formed one of the largest production units in British aviation. He had even custom-built a housing scheme for his workers on site – the wonderfully named Aeroville. Unsurprisingly, the Armistice was very bad for business. It brought some £400,000-worth of cancelled government construction contracts, and, at the same time, saw the Air Ministry refusing to release Grahame-White's airfield for civilian use, or to pay compensation for his loss of earnings – a state of affairs which descended into a long-running and expensive legal dispute.

Diversification was the only option. In May 1919, less than a month after Aerofilms were formed, they were photographing 'Harry Hawker Day' at Hendon. The event was organised by Grahame-White, and its centrepiece was a public auction 'to fly with Hawker', the Australian aviator who, just weeks before, had tried, and failed, to make the first trans-Atlantic air crossing – engine trouble forcing him to ditch in the middle of the ocean after some 1,000 miles. The day proved so popular that Grahame-White had to supplement public tram and bus services with a fleet of his own lorries, which took spectators from Golders Green station to the aerodrome, and, as *Flight* magazine reported, had conductors on board 'selling tickets to the various enclosures and thus forming, in fact, a sort of mobile ticket agency'. The first flight with Hawker went to a Miss Daisy King at auction – for the not inconsiderable sum of 60 guineas.

Joyrides were once again being offered to wealthy aviation enthusiasts. Prestigious passengers including the Earl and Countess of Roden, and Sheiks Abdulla Bin Issa and Mohammad Bin Abdulla – noted in the register book as 'guests of His Britannic Majesty's Government' – were taken into the skies in Avro 504s and Blackburn Kangaroos. Aerofilms photographed these pleasure flights and their passengers to sell both as personal keepsakes and for reproduction on souvenir postcards. To cope with the cancelled aircraft orders, Grahame-White had turned his businesses to manufacturing furniture and motorcar bodywork and interiors – when Aerofilms weren't taking portraits of satisfied joyriders, they were photographing chairs, dashboards and chests of drawers on the factory floor.

In 1920, in the company's first full year in business, they took 2,332 aerial photographs – all exposed on incredibly detailed, yet very fragile, 5 by 4 inch glass plates. This was an admirable output – particularly given that, strictly speaking, the business may not even have been legal. In the immediate post-war period, the newly formed Department of Civil Aviation, under a certain Winston Churchill as the Secretary of State for Air, was tinkering constantly with the regulation of flying. Of particular relevance to Aerofilms were the General Safety Provisions of the 1919 Air Navigation Act. One clause held that 'an aircraft shall not fly over

Claude Friese-Greene, son of the pioneering – yet perpetually penniless – cinematographer William Friese-Greene, is pictured here in the rear seat of a DH9B biplane, cheerfully holding up his Moy hand-held film camera. Although Francis Wills described Claude as the original 'Air Ciné Photographer', film cameras *had* previously been taken into the sky – most notably by a Pathé cameraman who accompanied Wilbur Wright to capture a flight near Le Mans in October 1908. Nevertheless, Aerofilms remains perhaps the first company in the world to be established with the stated aim of making aerial films.
1919 ENGLISH HERITAGE. AEROFILMS COLLECTION

Situated within Hendon Aerodrome, this building was Aerofilms' first proper office. Previously they had operated out of a suite at the London Country Club, located just some 150 yards away along Aerodrome Road.
1921 EPW006132

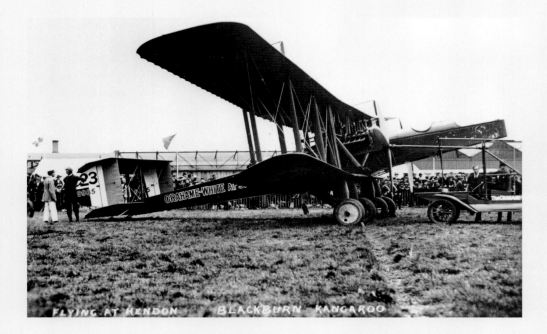

FLYING AT HENDON BLACKBURN KANGAROO

The extravagantly named – and extravagantly proportioned – Blackburn Kangaroo. Claude Grahame-White bought three of the aircraft – along with four Avro 504Ks – to take passengers on joyrides from the London Aerodrome at Hendon. The Kangaroo pictured here was also used by Grahame-White for mail flights between Hounslow and Newcastle, before being withdrawn from service in 1921. The other two aircraft did not fare so well – both crashed at Hendon within a month of each other in the summer of 1919. 1919 RAF MUSEUM

any city or town except at such altitude as will enable them to land outside the city or town should the means of propulsion fail through mechanical breakdown or other cause'. Another stated that 'No person in any aircraft shall carry out any flying which by reason of low altitude or proximity to person or dwellings is dangerous to public safety'. If followed to the letter, these regulations would have required aircraft to operate at such high altitudes as to make aerial photography – particularly of the urban landscape – a near impossibility.

Aerofilms' response was to ignore them.

The company's pilots were First World War veterans who had faced enemy fighter-planes in skies black with shell-fire – by contrast, peacetime aviation held no fears. They thrived on daredevil flying and were experts at carrying their photographers over targets at extremely low altitudes – indeed, this was what made their aerial imagery so compelling. Despite the supreme confidence of the pilots, however, flight technology was still in its relative infancy. Mechanical failure remained a very real danger – as the pilot Gordon Olley discovered while flying an Aerofilms photographer over central London on 31 March 1920. 'Our task was nearly ended,' he recalled, 'and we were about to start out for the aerodrome from which I had ascended when, with nothing more than a splutter of warning my motor failed completely… The position, as one can imagine, was decidedly awkward, because I was still flying above a densely populated area, and the prospect of having to come down among houses, streets and trams was far from inviting.'

With remarkable skill, he made a forced landing of his aircraft in the boating lake of Southwark Park in south London – the plane was damaged beyond repair, but both pilot and photographer were unharmed. This incident did not escape the notice of the authorities, however. Olley – and Wills as company director – were summoned to Bow Street Magistrates Court on a charge of 'flying over London at low altitude dangerous to public safety', which would 'not allow the aircraft to land outside London by means of propulsion'. Neither man attended, the Commissioner of Police took no further action – and Aerofilms continued to flaunt the Air Regulations. Six months later there was another incident, with an aircraft having to come down in Regent's Park. At the same time, Aerofilms were flying over restricted areas that were protected by the 1911 Official Secrets Act. The War Office, the Admiralty, the Air Ministry – and Scotland Yard – began to

When the government cancelled all aircraft construction contracts at the end of the First World War, Grahame-White turned his skilled staff and extensive Hendon workspace over to car production. Aircraft were quickly replaced on the factory and hangar floors by Daimler and Crossley motorcar chassis.
1920 ROYAL AERO CLUB COLLECTION, RAF MUSEUM

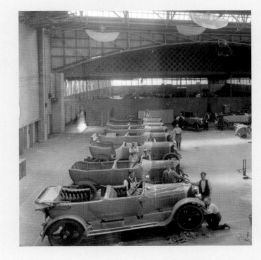

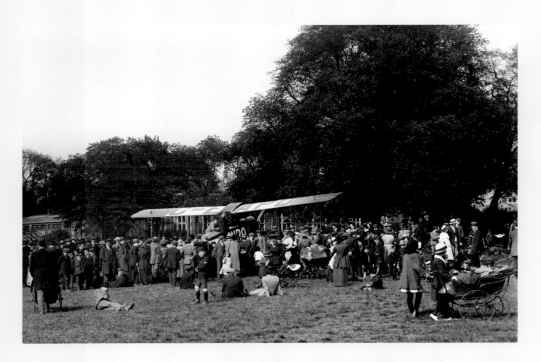

In September 1920, six months after crashing into the boating lake of Southwark Park, another Aerofilms aircraft had to perform a 'forced-landing', this time in Regent's Park in central London. Pictured here are the pilot and passenger standing aboard the fuselage, surrounded by an excited crowd. In this instance, the aircraft – an Avro 548 – was undamaged by the landing, and remained in service for another two years before it was decommissioned. 1920 EPW005067

take an interest in the company's activities, and Wills was given a stern warning by an officer that 'prison cells were not pleasant'.

By April 1921, Aerofilms had moved out of their London Flying Club hotel room, renting an office from Grahame-White's aviation company in the London Aerodrome. The gradual post-war relaxation of restrictions on access to civil airfields was allowing the company to fly further and more widely across the country – and, where no aerodromes were available, aircraft would simply set down in farmer's fields for servicing or to avoid bad weather. Alan Cobham was one of the earliest Aerofims pilots, and, along with the original company photographer Albert Russell, helped to develop the standard practice for cost-effective commercial aerial photography. Working from a target list, they would plan to reach between 30 and 40 sites each day, plotting their positions and routes on maps, with every site numbered in advance. Glass plates were exposed as they went along, with the negatives numbered to tally with the map reference. In one expedition, Cobham boasted that they were able to take in Ipswich, Norwich, Sandringham, Boston, Lincoln, York, Darlington, Newcastle, Sheffield, Huddersfield, the Lake District, Birmingham, Newport, Swansea, Bristol, Cheltenham and Gloucester. 'In five days,' he claimed, 'we did work that might have taken five weeks in bad weather, to the great benefit of our clients.'

For Cobham, a tireless champion of aviation, aerial photography was key to the development of the industry as a whole. 'As the Public continues to see pictures of the earth from above,' he wrote, 'and aerial maps of pictures are continually being used, the world becomes more air-minded.' Increasingly, Aerofilms' imagery was in demand from commercial businesses. Postcard manufacturers and publishers of guidebooks were regular customers, as were the daily press – from the *Sunday Times*, *Manchester Guardian* and *Country Life*, to regional titles like the *Bath Herald*, *Margate Day-by-Day* and the *South Wales Chronicle*.

From a very early stage, Aerofilms played a crucial role in the development of aerial photography as a tool for marketing, advertising and branding. In 1928, they worked with Gordon Hotels to produce *London from Aloft* – one of the first guidebooks in the world, and certainly the first of London, to be made up almost exclusively of aerial imagery. Its contents were described as 'the most remarkable

One of several covers used for the Gordon Hotels publication of *London from Aloft: A Pictorial Survey of the British Capital City from a New Angle* – the first ever aerial photographic guidebook of London. In this watercolour image, a biplane banks ahead of an attractive city skyline, dominated by the dome of St Paul's Cathedral. 1928 FOTOLIBRA

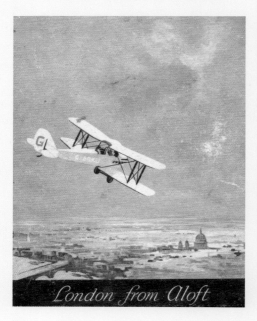

London from Aloft

collection of photographs of London which has ever been made', with the aerial perspective showing 'in a manner which no other form of illustration can the wonderful and intriguing grandeur of this noble old city'. London – often such a confusing and chaotic visual spectacle when experienced at street level – was renewed from above as a majestic imperial cityscape, full of iconic sights and structures. 'There is no better way in which to see and fully appreciate the real beauty of London's layout and planning', claimed the guidebook. All of the major tourist attractions were featured, including a run across the city centre from Buckingham Palace to the British Museum at Bloomsbury, and then continuing east from the Law Courts over St Paul's Cathedral to Tower Bridge. Of course, the sites of the Gordon Hotels themselves were also captured from the air, making an explicit connection between the business and the capital's monumental buildings and landmarks. The implication – aimed at the, often wealthy American, tourists of the roaring twenties – was that a guest at Gordon's would enjoy London from a position of status high above the common crowd. It was a potent message, delivered with a visual punch by the Aerofilms pilots and photographers.

In 1927, Aerofilms produced this *Central London from the Air* poster for the Underground Electric Railways Company. Using mapping techniques pioneered during the First World War, they drew on a total of 477 vertical photographs, all taken from an altitude of 10,000 feet, to create a top-down mosaic showing the exact layout of some 8 square miles of the city centre. The 41 underground stations within the area were each marked with a small red dot.
1927 TFL FROM THE LONDON TRANSPORT MUSEUM COLLECTION

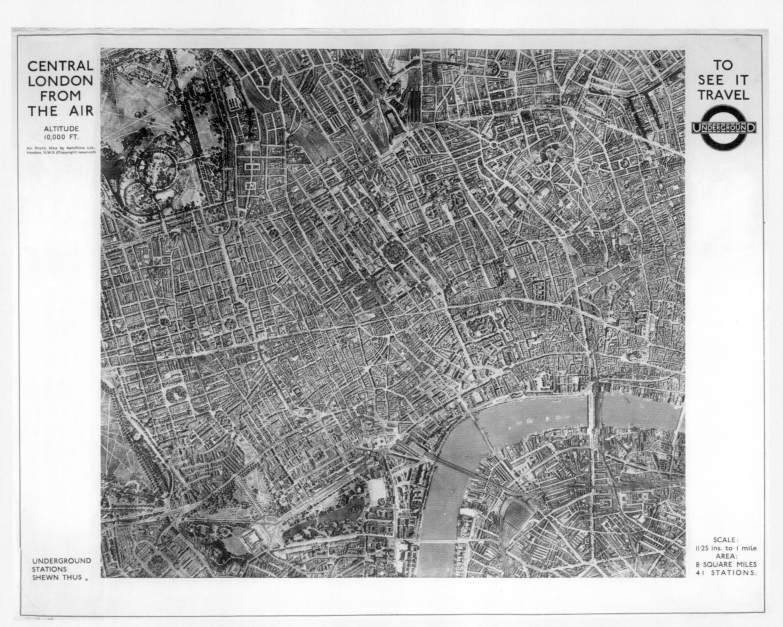

As this 'oblique' photography flourished, the company also experimented with a technique which had been developed specifically for reconnaissance work during wartime – direct, top-down, or 'vertical', imagery, achieved by attaching a camera to the underside of an aircraft. Although early contracts with the Ordnance Survey – for map-making purposes – proved unsuccessful, there were a number of notable commissions for the service. In 1927 they produced a photo mosaic poster for the Underground Electric Railways Company – the precursor of the London Underground. Assembled from large numbers of vertical images, the poster showed some 8 square miles of the city centre, with 41 underground stations marked on the map as small red dots. A similar view of the Thames winding through London is perhaps the most famous vertical mosaic Aerofilms ever produced – becoming, many years later, the backdrop to the opening credits of the BBC soap Eastenders.

Over the course of their first decade in business, Aerofilms had experimented with film, photography – and furniture – and had flirted with bankruptcy and prosecution. Yet, despite the challenges and setbacks, and in the absence of any serious competition, they had gone on to establish themselves as the pre-eminent firm producing aerial photography of Britain – and they had become an attractive asset. In 1925, the company captured the interest of the Aircraft Operating Company (AOC) Ltd, a British-based business which carried out vertical survey work for clients 'in any part of the world'. AOC purchased the majority shareholding in Aerofilms, making them one of its subsidiaries. At the same time, however, Grahame-White resigned, and left behind the pioneering enterprise he had helped to found. Wearied by his ongoing dispute with the Air Ministry over London Aerodrome, he had shifted his attention away from aviation to yachting, speedboats and property.

It was the end of an era for Aerofilms. Their celebrity figurehead was gone, and the carefree eccentricity of the early days was replaced by a more practical, prosaic commitment to building business, under the careful direction of Wills. The company would need this commercial focus to survive. In 1929, Aerofilms had their most productive haul ever – exposing over 5,000 aerial images. In that same year, on 29 October – Black Tuesday – the US stock market crashed.

The Great Depression was coming – and what value could you place on an aerial photograph, in a global economic crisis?

The Blackpool Tower – northern England's response to Gustave Eiffel's famous iron-lattice Parisian landmark – rises up here like a three-dimensional model, almost appearing to break out of its photographic frame. With the Tower standing 518 feet tall, the Aerofilms' aircraft and photographer can have barely been another 100 feet above its spire as they took their shot. There was a daredevil – and somewhat anti-establishment – spirit to the company in its early years: this close-range, vertigo-inducing perspective on the Tower was almost certainly achieved by flouting the government's *Air Navigation Regulations*.
1929 EPW029212

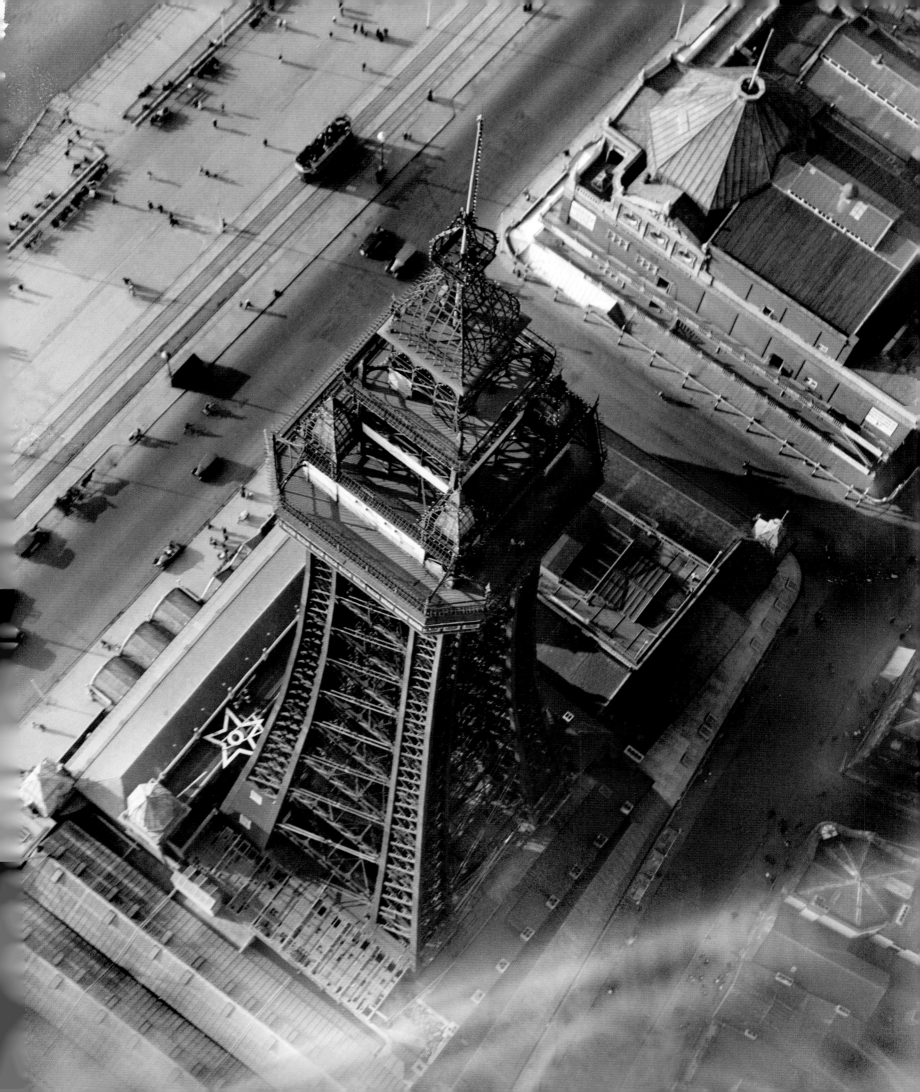

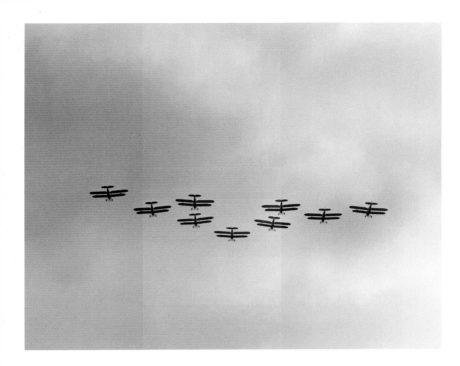
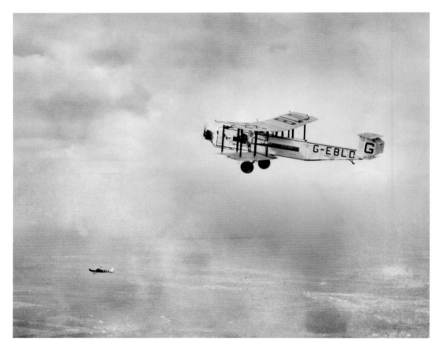

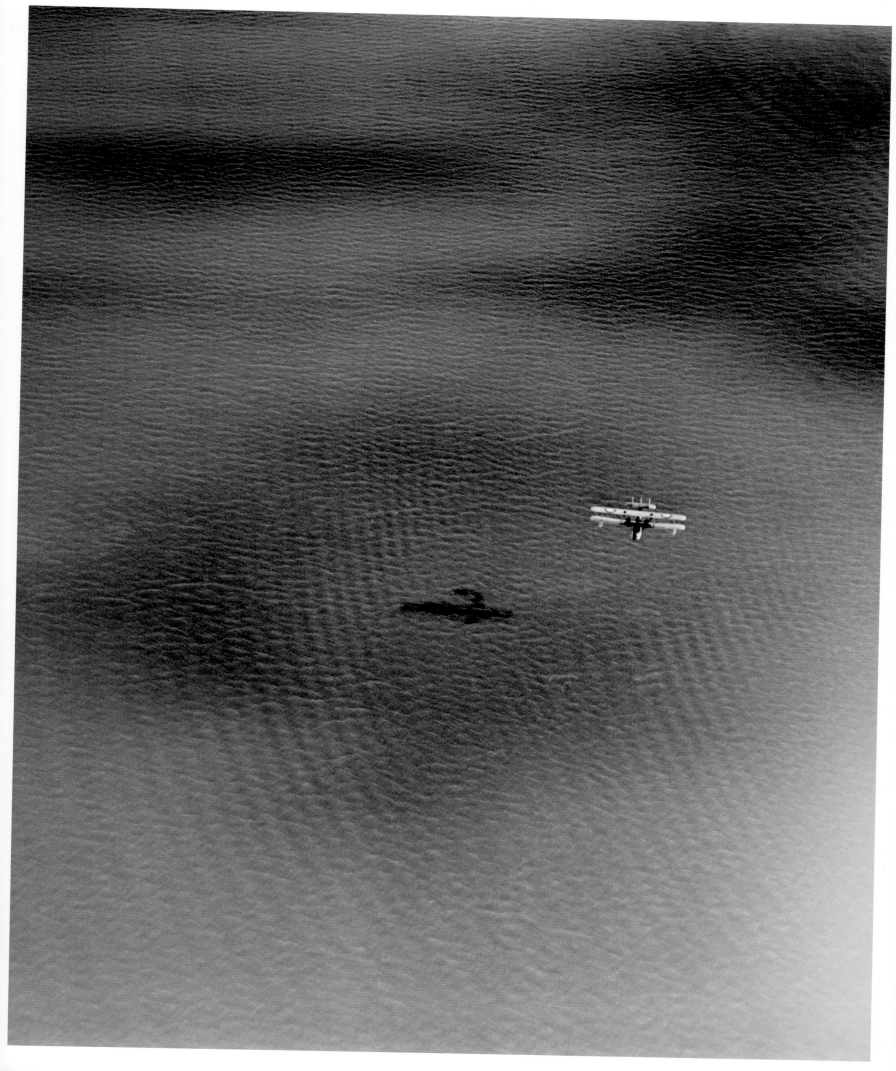

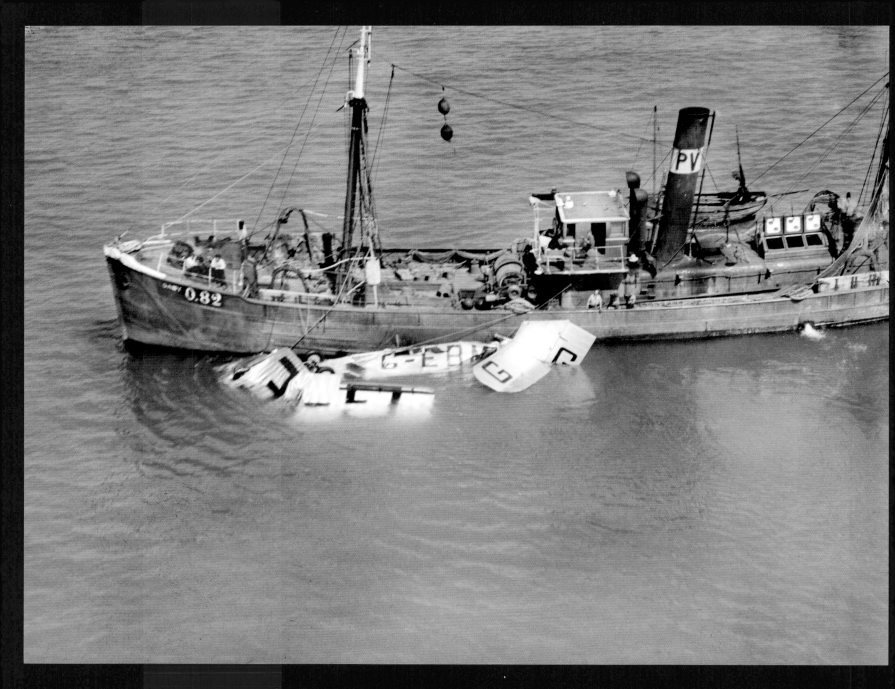

PREVIOUS PAGES

In 1916, Claude Grahame-White published a book called *Learning to Fly: A Practical Manual for Beginners*. Written for the 'novice who is completely a novice', it was quite clear in its view that 'any average man' could become a pilot. 'A fair judgement of speed, and an eye for distance are very helpful', wrote Grahame-White, 'But otherwise… any man of average quickness of movement, or average agility, can learn without difficulty to control an aeroplane in flight. It is wrong to imagine that exceptional men are required.' Indeed, his conclusion was that flying was 'in a sense too easy, and that is just where its hidden danger lies'. In particular he counselled against flying when unwell, as 'the strain of flying, and the effect of swift motion through the air, may cause a temporary collapse; and in the air,

when a man is alone in a machine, any slight attack of faintness may be sufficient to bring about a fatality'.

CLOCKWISE FROM TOP LEFT
1927 EPW018792, 1928 EPW021489, 1927 EPW018790, 1929 EPW025850, 1928 EPW022376, 1927 EPW018798, 1928 EPW022376, 1928 EPW024418

ABOVE
Although the First World War drove forward huge advances in the aircraft industry – and refined pilots' skills in the most extreme of circumstances – flight was still a technology and a discipline in its relative infancy. While men like Grahame-White advised that there was 'no more danger in flying an aeroplane

than in driving a motorcar', the results of aircraft accidents or malfunctions could be at once more serious and more sensational. This Aerofilms photograph was published in *The Times* on Tuesday 18 June 1929, showing the aftermath of the 'Channel Air Disaster'. The Handley Page airliner the *City of Ottawa* – which operated a London to Zurich passenger service – had to make a forced landing just off the coast by Dungeness. The aircraft flipped over on contact with the water, and seven passengers were killed. As a result, a formal Air Ministry investigation recommended – ultimately to no end – that in future, 'no British aeroplane not specially designed for landing on water, shall be permitted to carry passengers abroad'.
1929 EPW027723

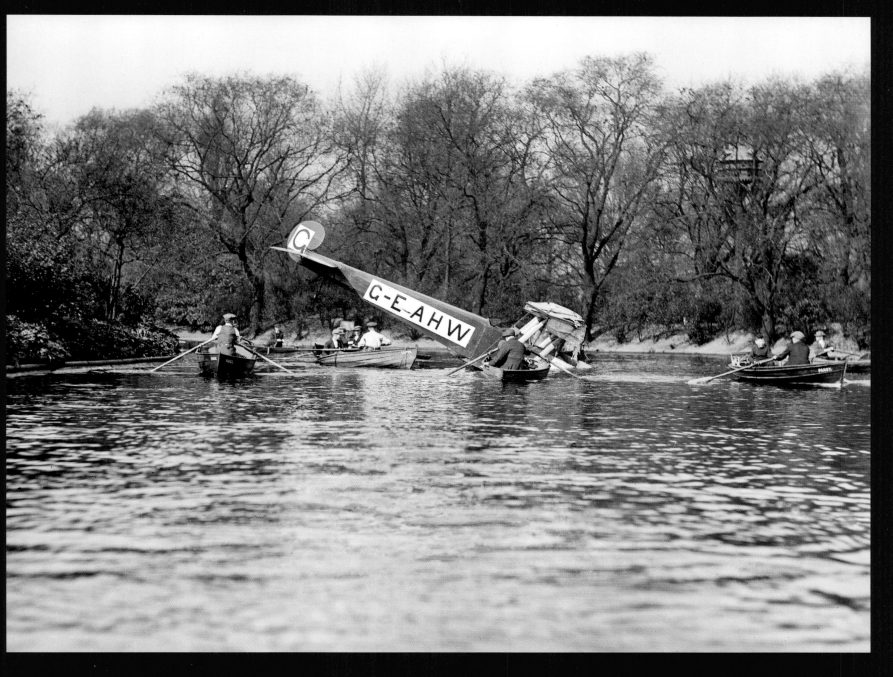

ABOVE

An Aerofilms biplane floats nose-down in
the boating lake of Southwark Park in south
London, amid a crowd of curious onlookers
in their row boats. After an engine failure,
the pilot Gordon Olley – who would later
become the first man ever to officially fly
a million miles – had aimed for the water
to avoid children playing on the nearby
grass. It is thought that the photographer
sitting alongside Olley that day was none
other than the co-founder of Aerofilms,
Francis Wills. Although their Avro 504K
aircraft was damaged beyond repair, both
men escaped unharmed, and indeed Wills
continued – as here – to photograph the
aftermath of the crash. 1920 EPW000213

FOLLOWING PAGES

An Avro 504N of 29 Squadron of the RAF
banks over the plush premises of the London
Flying Club, opened by Claude Grahame-
White in 1920 on the southern edge of the
London Aerodrome at Hendon. The complex
was designed by the architect Herbert
Matthews – one of the original co-directors
of Aerofilms. Grahame-White took his
inspiration from the American Country Clubs
he had visited during his time as an air-racer,
and the site included tennis courts, a golf
course, a ballroom, a theatre and members'
accommodation. When the government
cancelled aircraft construction contracts after
the end of the First World War, Grahame-
White set his factory staff to work producing
furniture for the Club. By the time this
image was taken, the Club had been closed

as a result of Grahame-White's ongoing legal
dispute with the Air Ministry over ownership.
It was not reopened until May 1934, by
which time it had been converted into a new
training college for the Metropolitan Police.
In the second image, two De Havilland
DH9 biplanes fly in close formation above
a landscape of postage stamp fields during
an RAF Aerial Pageant in 1924 – an annual
display show where aircraft performed air
races, aerial combat scenes and even fake
bombing raids. 1929 EPW025849, 1924 EPW010849

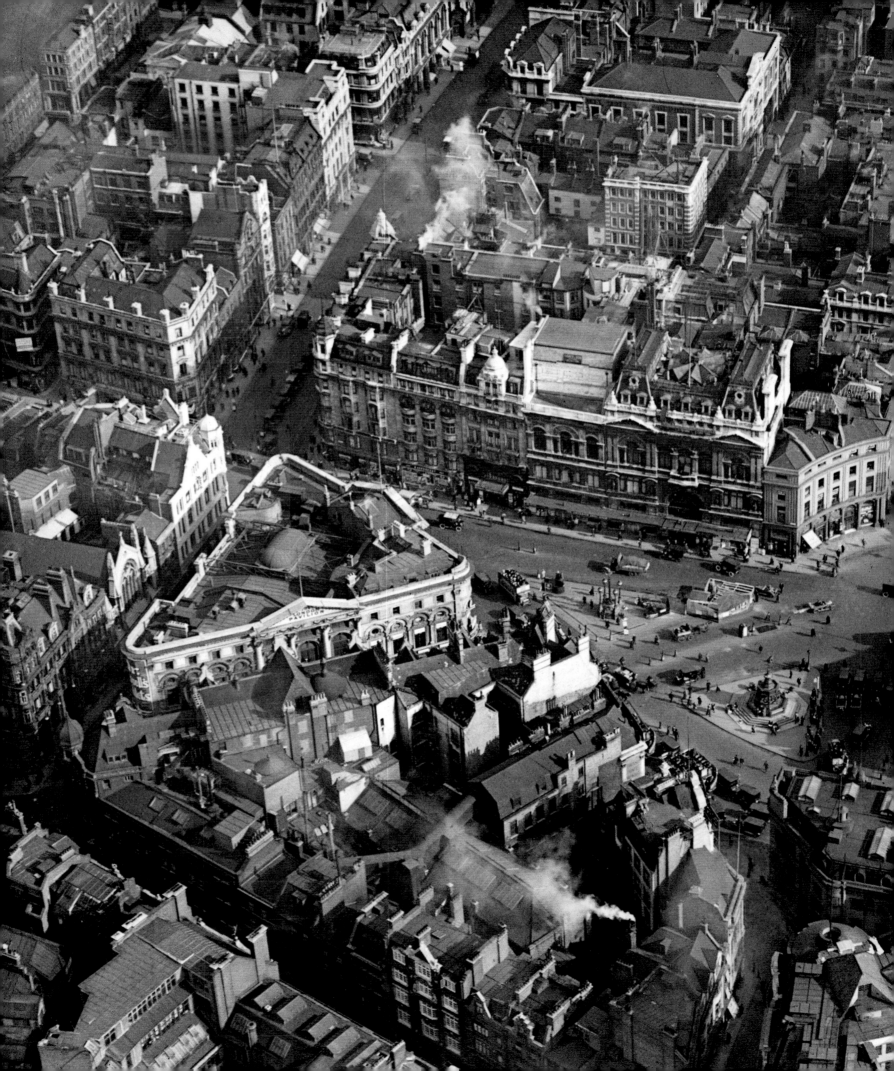

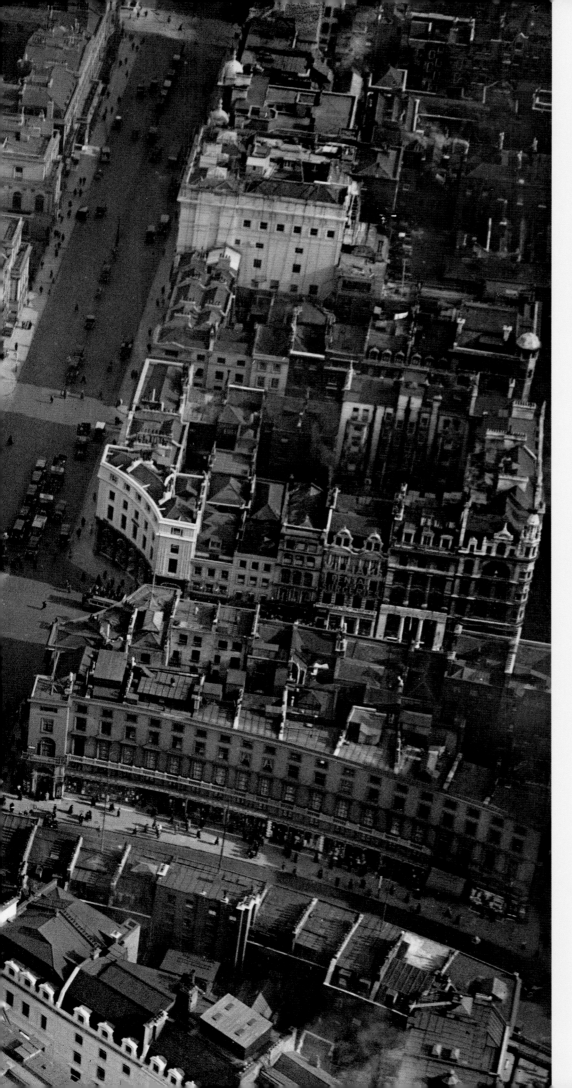

Pictured here in March 1921 – before the installation of any traffic lights – Piccadilly Circus is a busy throng of pedestrians, horse-drawn carriages, omnibuses and motorcars, all revolving around the aluminium-cast statue of Eros. Even at this fledgling stage in Aerofilms' existence, the company was targeting well-known sites and landmarks to sell to postcard manufacturers. Early clients for this kind of material included 'Ludo Press' – a company that is still in business today – and 'LepAerial Travel Bureau', one of the first ever travel agencies to arrange passenger transport on aircraft. That LepAerial also had an office in Piccadilly Circus was unlikely to be a coincidence. 1921 EPW005901

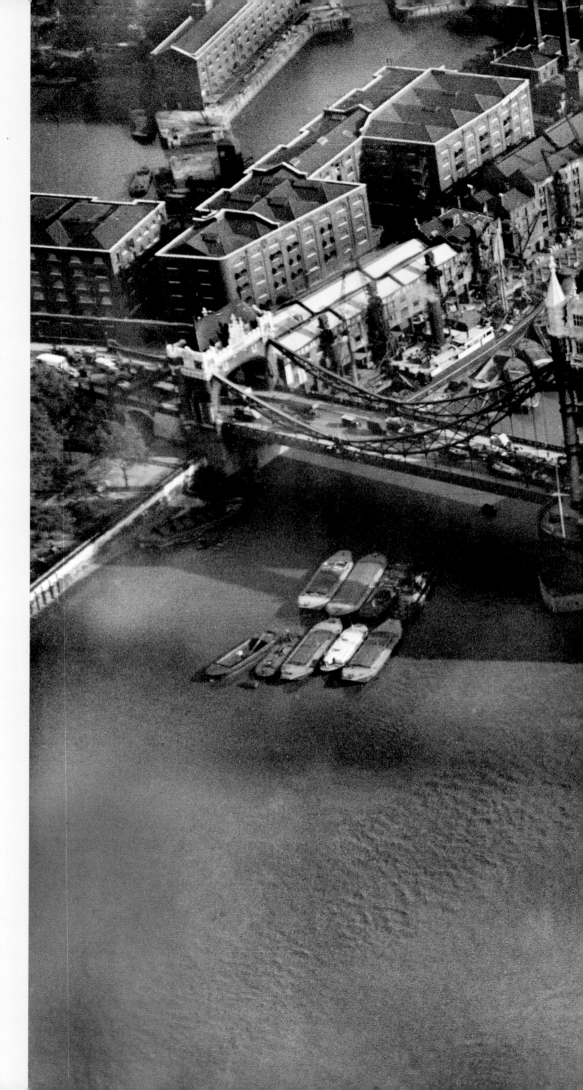

What at first glance stands out as a stunning view of one of London's most recognisable structures becomes more intriguing on closer examination. Here, Tower Bridge is the site of a chaotic logjam of traffic – caused, perhaps, by what seems to be an accident right at the centre of its span. Newspapers at the time reported the closure of the Rotherhithe Tunnel for road works, with Tower Bridge and the Blackwall Tunnel advised as alternative routes. Despite the novelty of horses and carts mixing in the traffic lanes with motorcars, this eight-decade-old image of London congestion may appear wearily familiar to any modern commuter. 1929 EPW030092

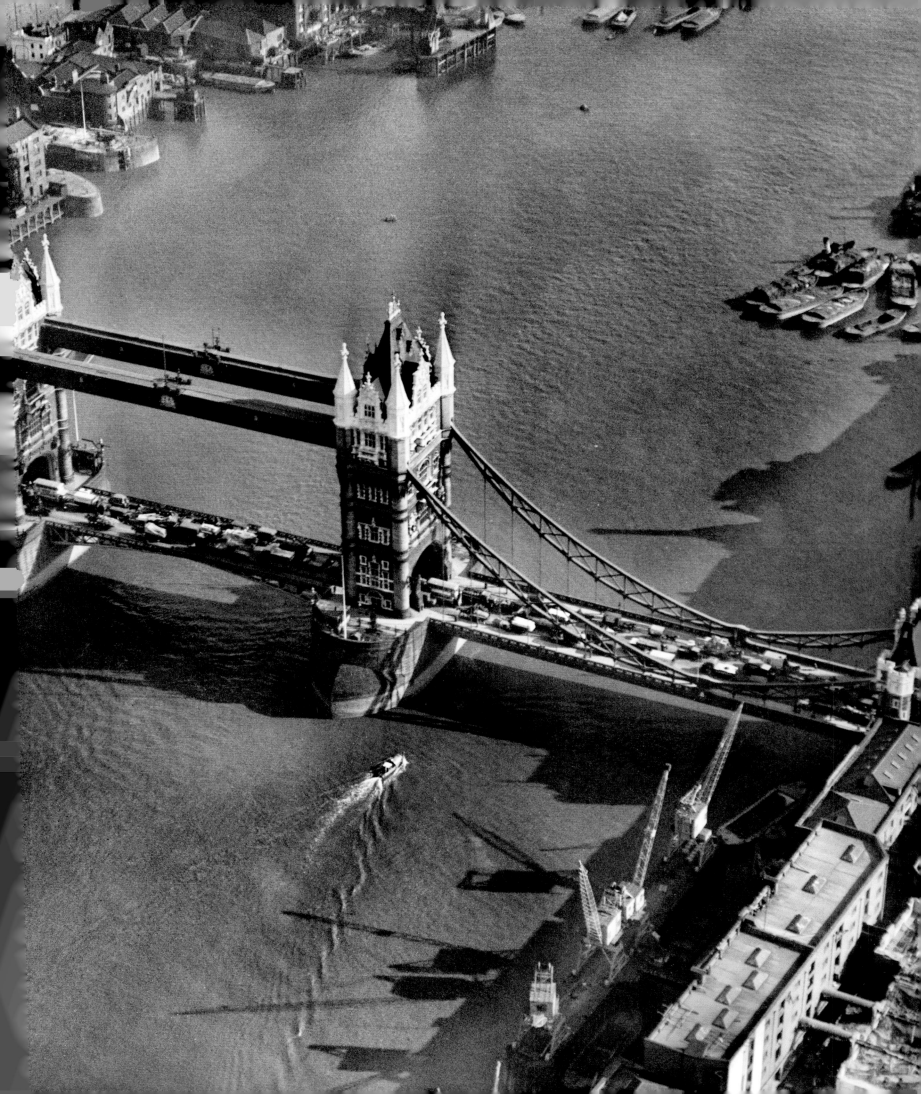

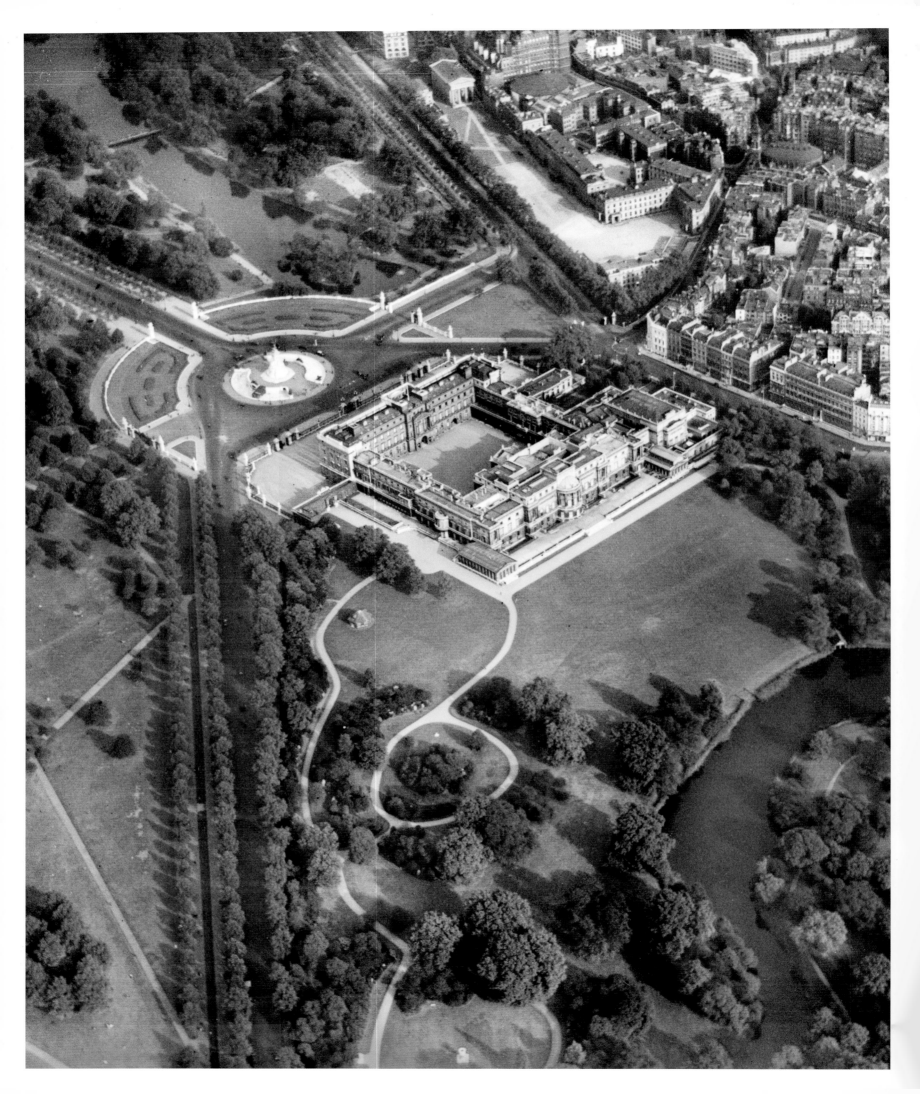

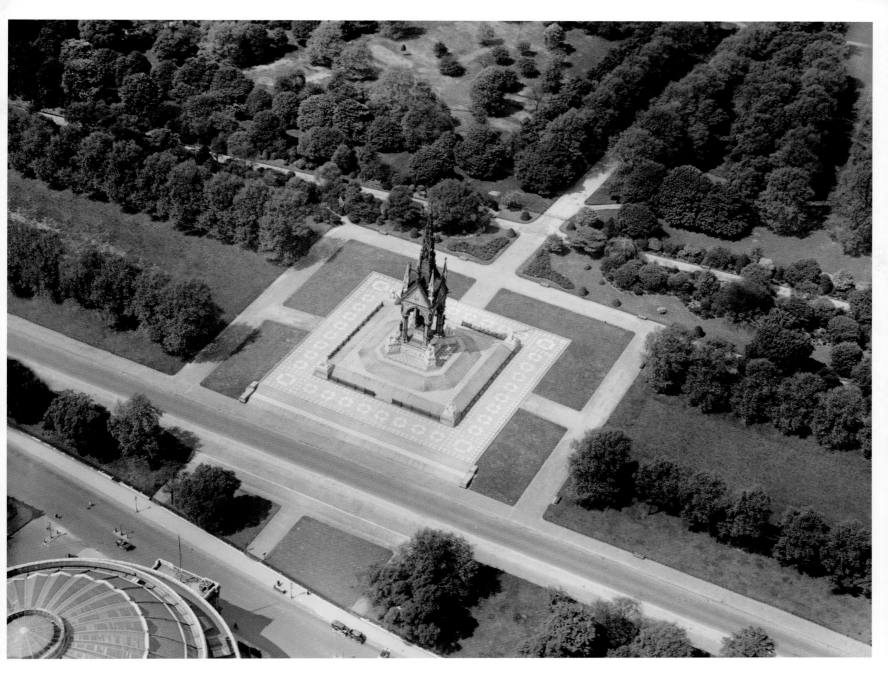

LEFT AND ABOVE

Buckingham Palace and the Albert Memorial appear here as quiet, serene oases at the heart of the capital. The view of the Palace gardens in particular is one that – even today – seems unfamiliar and perhaps even intrusive. In *London from Aloft*, the 1928 Gordon Hotels guidebook to the city, an Aerofilms image of the royal residence was supported by a caption that openly admitted the voyeuristic potential of the aerial perspective. 'The eye of the Airman sees all – even the private terraces, lawns and walks in the secluded gardens of the King's Palace.' Quite a difference from the common outlook from street-level, where 'a screen of trees flanks either side, maintaining complete obscurity from road view'.
1928 EPW024748 1921 EPW006192

FOLLOWING PAGES

According to *London From Aloft*, it was only from above that people could really start to make sense of the grandeur of the capital's cityscape. 'Apart from the happily appropriate conception of picturing London from this novel aspect, there is no better way in which to see and fully appreciate the real beauty and interest of London's layout and planning. It renders it possible to study the fine architectural features of the various well-known buildings from an entirely new viewpoint.' Others were not so convinced, however. In an article titled 'The Airman's View of London', Alan Bott, a First World War fighter-pilot turned journalist – and the founder of Pan Books – wrote that the aerial perspective revealed the capital as 'a jungle of twisting, unplanned confinement', and

concluded that 'we now have a particular occasion for deploring that Christopher Wren did not have his way with the rest of it after the Great Fire'. 1928 EPW021401

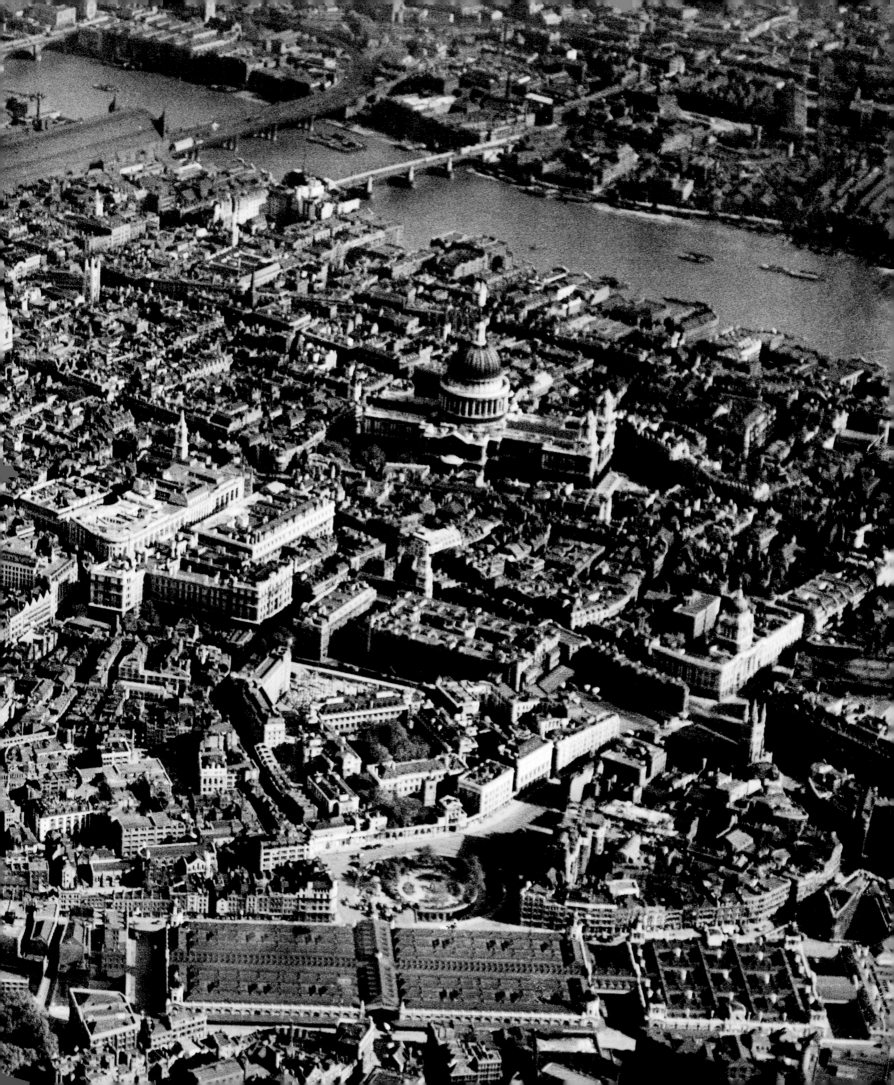

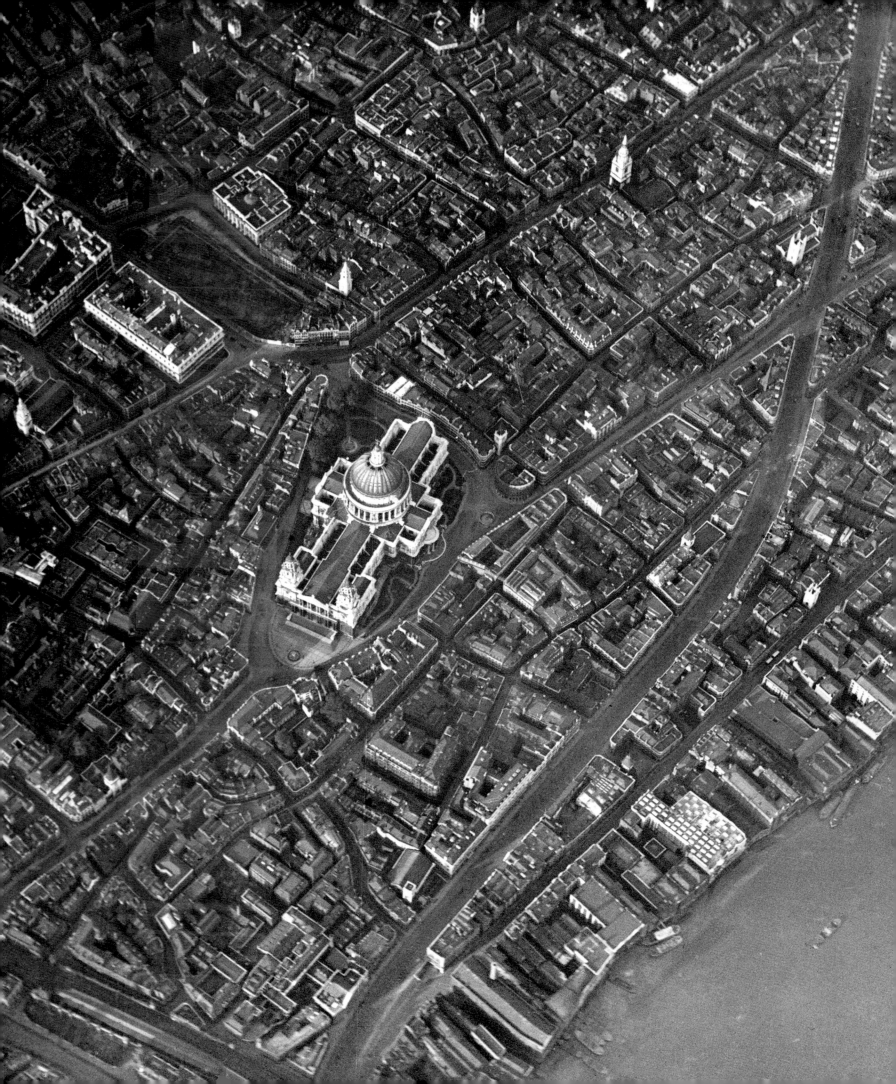

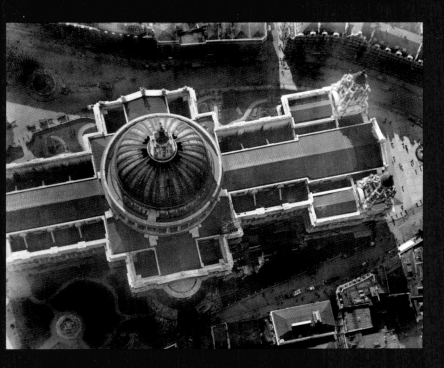
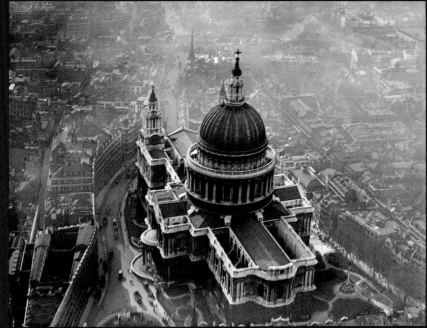
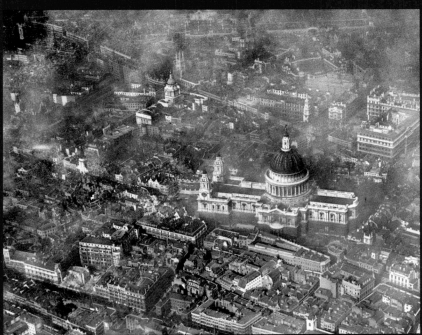
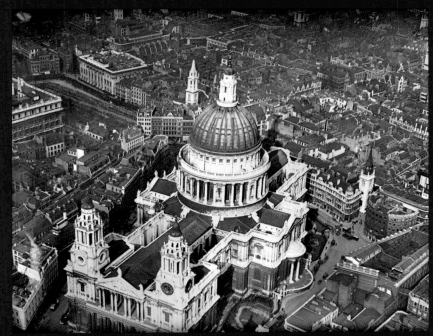

From the moment in 1710 when Sir Christopher Wren finally completed St Paul's Cathedral – the building was under construction for over three and a half decades – his Baroque masterpiece became *the* dominant landmark on the London skyline. Seen from the air, emerging here from a smoky cityscape, its incredible scale and ambition appears even more pronounced – all other surrounding buildings become an indistinct mass when set against the Cathedral's monolithic architecture. While Wren had announced that, with St Paul's, he had 'built for eternity', the reality of maintaining such a substantial public building in the heart of central London was a source of increasing worry for the church authorities. When these images were taken in the 1920s, the Cathedral's stonework had been darkened by the accumulations of centuries of soot and dirt, and the piers supporting its colossal 65,000-tonne dome were in desperate need of repair. As a result, the Cathedral had to be partially closed for five years – from 1925 to 1930 – with services held in the nave whilst the restoration work was carried out.

1920 EPW001613, 1921 EPW005903, 1921 EPW005315, 1921 EPW005922, 1929 EPW030089

Crowds line the streets of Edgware Road, Hyde Park Corner and Park Lane for the homecoming procession of Edward Prince of Wales – the future King Edward VIII. 21 June 1922 marked the Prince's return to London from his 'Oriental Grand Tour', an eight-month sojourn to India, Ceylon, the Philippines, Borneo, Malaysia, Japan and Egypt. The tour was conducted as part of Edward's role as Britain's 'Empire Ambassador' – although it has subsequently emerged that neither the Prince nor his various hosts were enthusiastic supporters of the trip. The writer E M Forster even noted quite bluntly that 'scarcely anyone in India wished the Prince of Wales to come' – a sign perhaps of the increasing fragility of the Empire in the aftermath of the First World War. The Prince arrived back in Plymouth on HMS *Renown* and, after a train journey to Paddington Station, embarked on this elaborate ceremonial procession all the way to the gates of Buckingham Palace. 1922 EPW007997

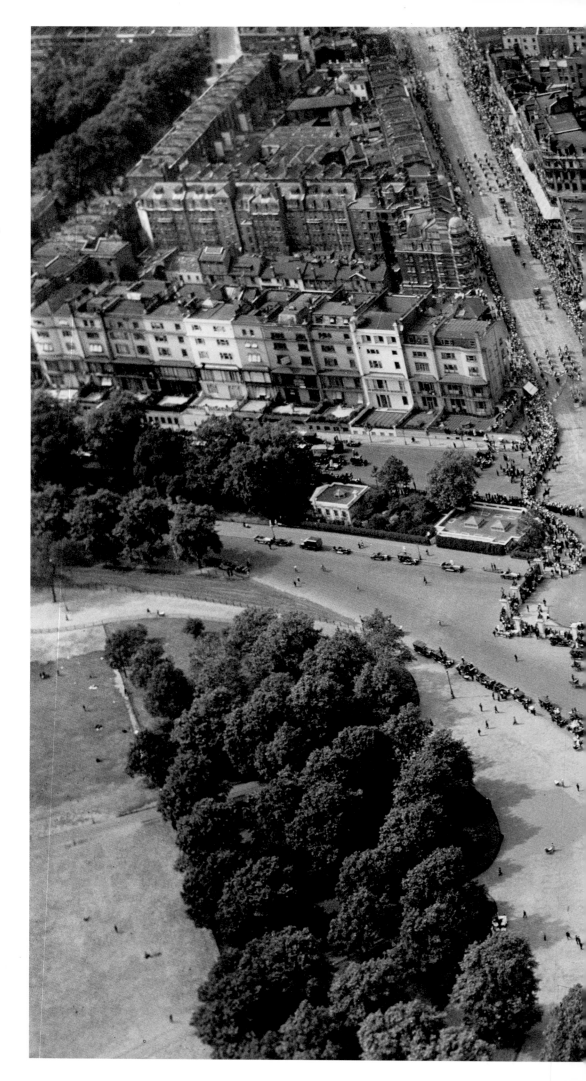

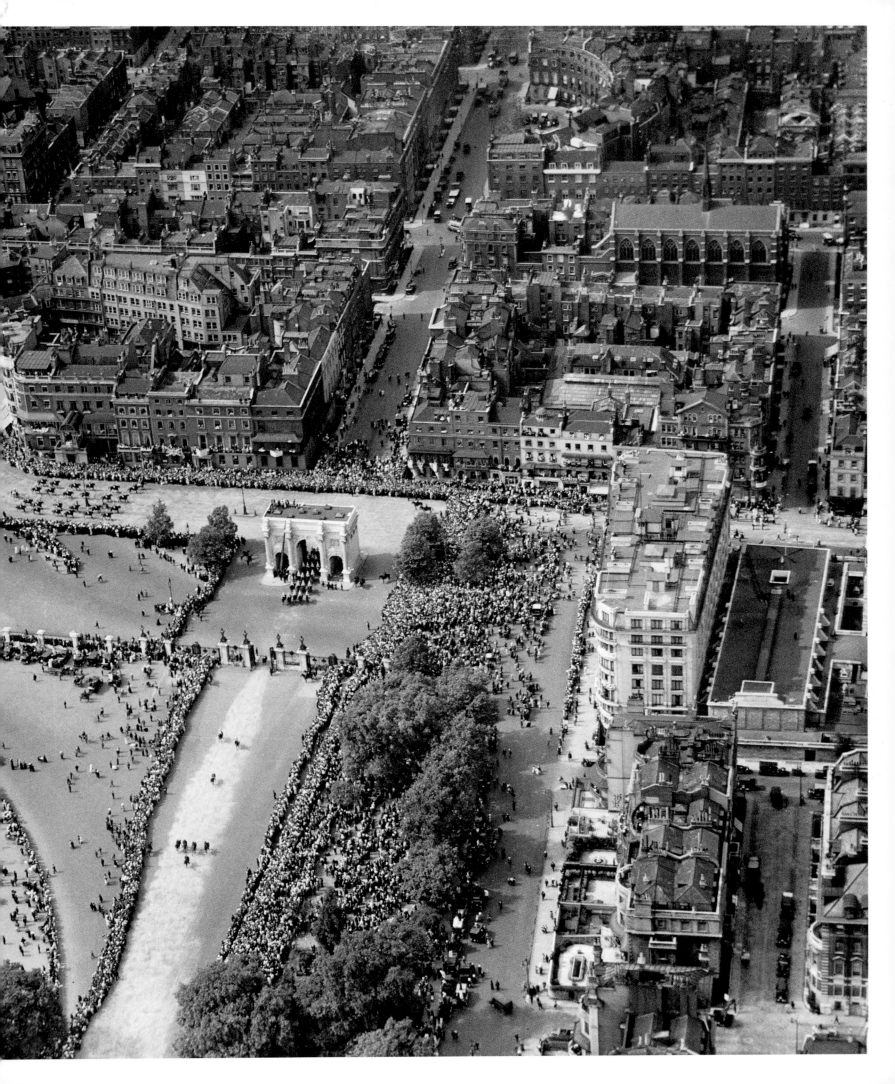

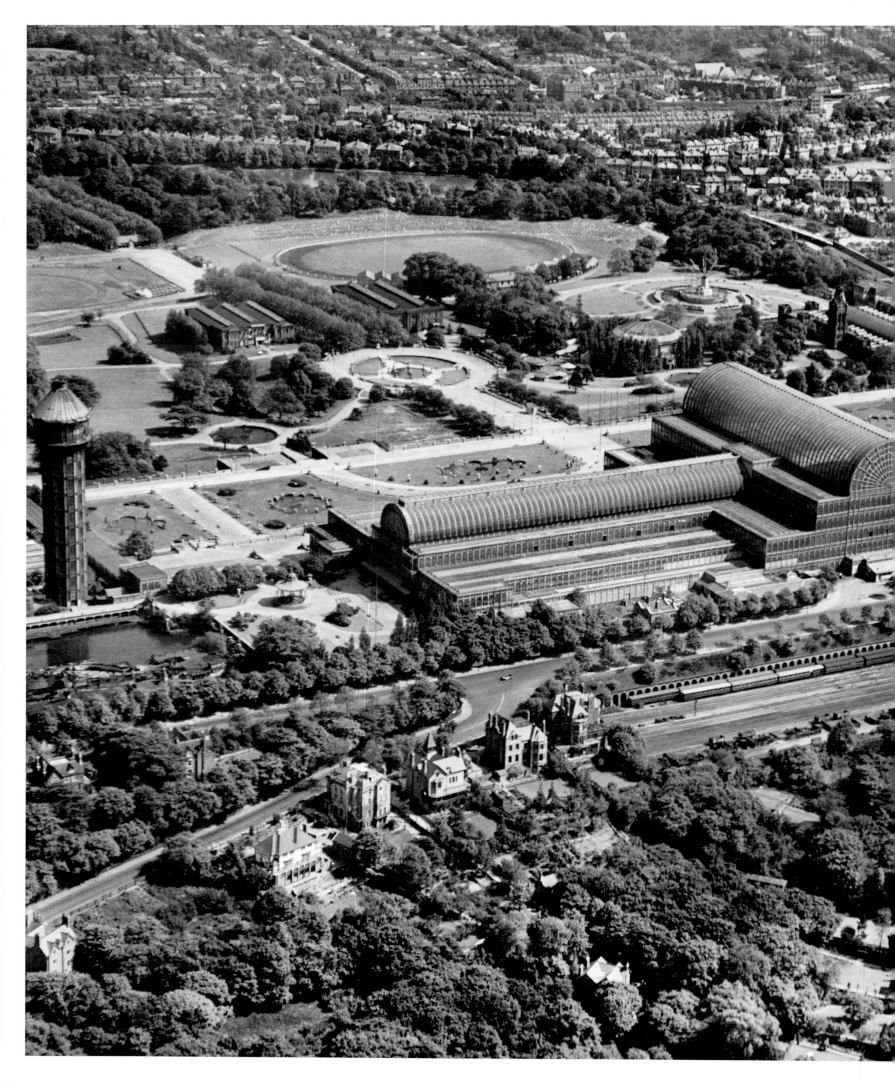

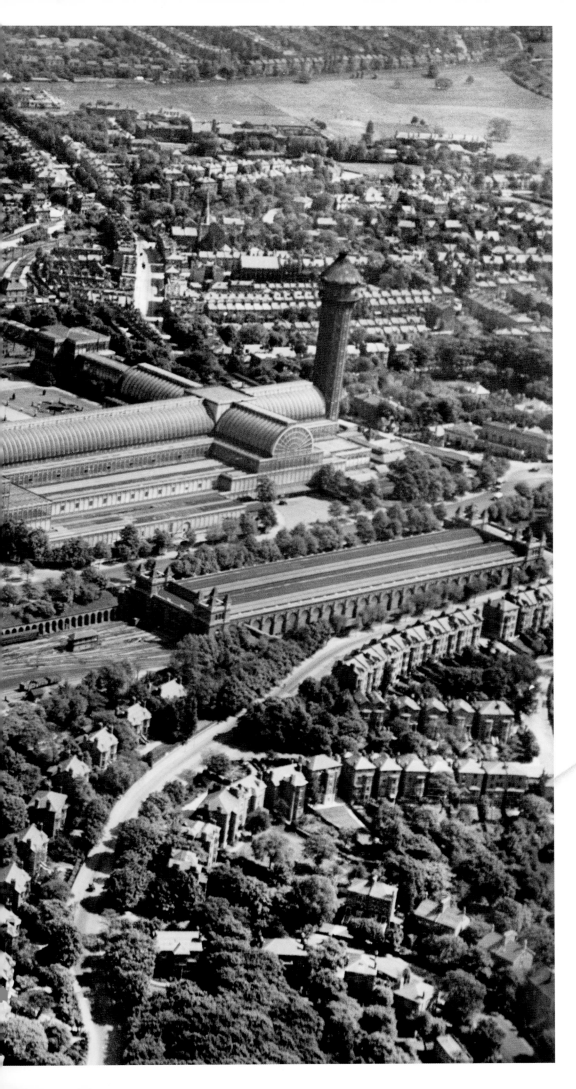

Created to house the 1851 Hyde Park Great Exhibition, the 'Victorian pleasure dome' of the Crystal Palace was dismantled in 1854 and rebuilt over the course of two years on a suburban site at Penge. This new Palace was not an exact replica of the original – it required twice the amount of glass of its predecessor, and, although shorter in length, it was built some 44 feet higher. Used as a concert hall, theatre, menagerie and exhibition space, it also had a long history as the site of aviation displays. The Aeronautical Society held the first ever Aeronautical Exhibition here in 1868 and the grounds soon became famous as the launch point for balloon ascents. Following in this tradition, in 1911 Claude Grahame-White used the Palace as the starting point for a pioneering 115-mile flight from London to Wolverhampton. This image from 1928 demonstrates the scale and ambition of the structure, and is an important record of a work of architecture that is now lost to us. In 1851, the author William Thackery referred to the Palace as a 'blazing arch of lucid glass' – a wonderfully vivid but rather fateful description. On the evening of 30 November 1936, it burned to the ground in a ferocious blaze that brought MPs out of the House of Commons to watch, and whose glow could be seen from Brighton – and even from an aeroplane flying over Margate in the far east of Kent. 1928 EPW021373

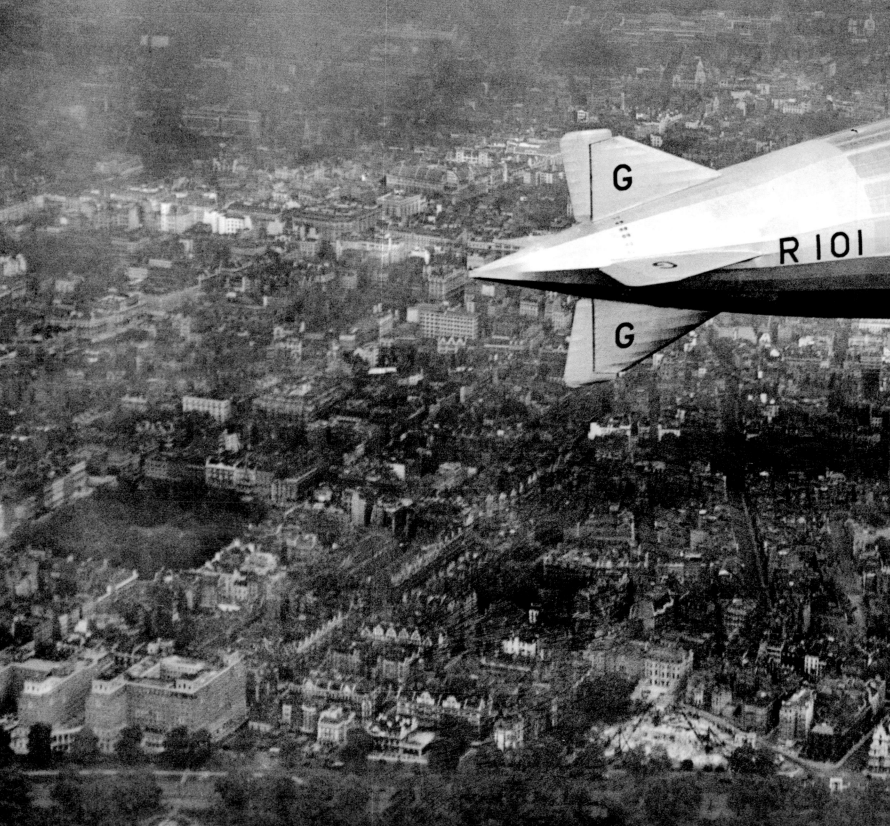

In the 1920s, airships were seen as the future of long-distance flight. Their size was quite incredible, yet they appeared to glide serenely over the landscape. And unlike the visceral thrills of the aeroplane, they offered aviation as luxury travel – the airship superstructure was filled with lounges, dining rooms, promenade decks and even smoking rooms. Pictured here on 14 October 1929 on its very first test flight – from Cardington to London and back – is the R101, the largest man-made object ever to fly. According to *The Times*' Aeronautical Correspondent, as the airship passed over London. passengers could hear 'steamers blowing their sirens and trains whistling, while there seemed a large crowd in Trafalgar Square'. At the same time, 'three attendant aeroplanes could be seen swinging in wide sweeps at a safe distance' – one of which would have been carrying the Aerofilms photographer who took this shot. The world would soon discover, of course, that the airship was an innately perilous mode of transport – filled with highly flammable hydrogen gas, it was, in effect, a floating bomb. At just past 2am on Sunday 5 October 1930 – and just 248 miles into a flight to India – the R101 crashed in a fireball into a field near Beauvais in France, leaving only six survivors from the 54 on board. 1929 EPW030070

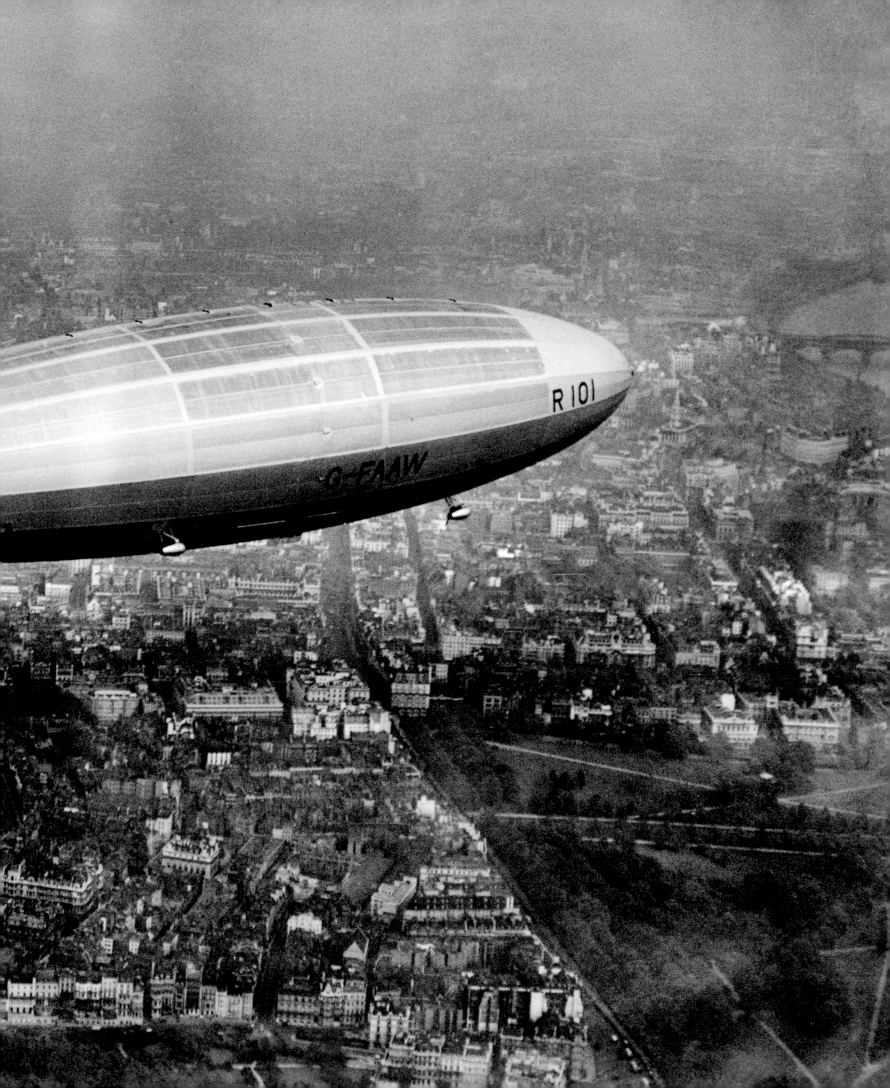

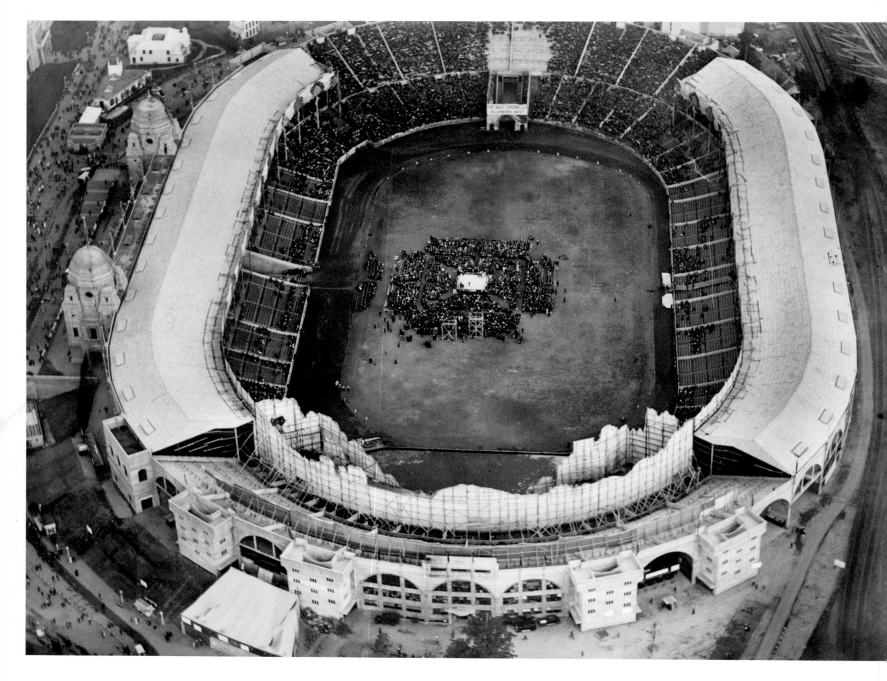

ABOVE

Pictured on 9 August 1924, Wembley Stadium is the somewhat unexpected venue for a boxing match between the American heavyweight Tom Gibbons and his British opponent Jack Bloomfield. The stadium was constructed earlier that year as part of the British Empire Exhibition and was described in glowing terms by the official guidebook: 'There is not in all England a modern building that can compete with the Empire Stadium in the effect it creates upon the mind of the spectator… In a world that has developed so great a devotion to sport there is no arena that can compare with Wembley's.' While the bout – which was won easily by Gibbons – drew a crowd of 50,000, this experiment with boxing in the stadium's wide open spaces was not considered a success. The press reported that the combination of ringside standing room and distant seating failed to create a compelling spectacle or atmosphere, and the fight's promoter, Major Arnold Wilson, had to file for bankruptcy immediately afterwards.
1924 EPW011412

RIGHT

Aerofilms were always alive to the commercial possibilities of photographing major sporting events from the air. Sometimes, indeed, there was no better way of recording the action. In this series of images from 1929 of the 81st staging of the Oxford and Cambridge University Boat Race, the pilot and photographer tracked the progress of the two rowing crews along the Thames from beginning to end – from Putney Bridge, through Hammersmith and Barnes, to the finish line at Chiswick. The last shots capture in vivid and compelling detail a convincing seven-length victory for the Cambridge eight – a result which drew them level with Oxford in the overall number of Boat Race wins.
ALL 1929, EPW025817, EPW025819, EPW025846, EPW025848, EPW025818, EPW025847

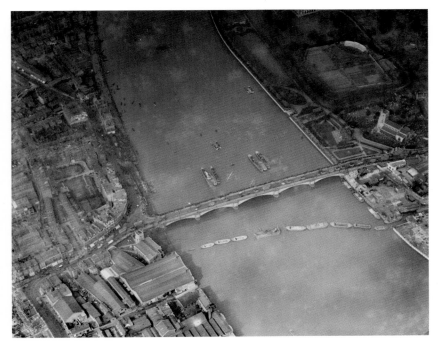
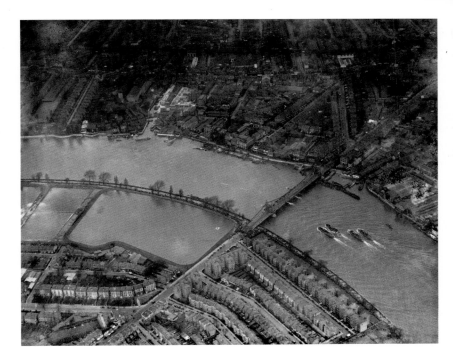
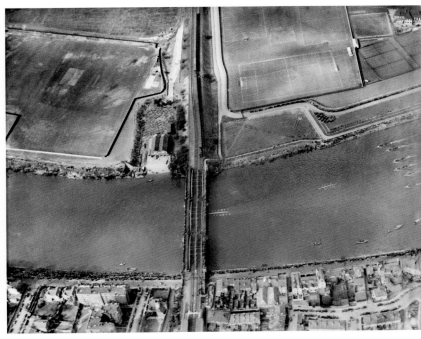
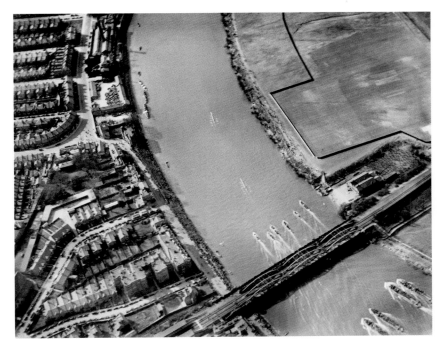

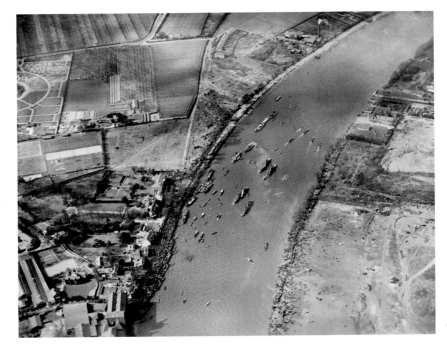

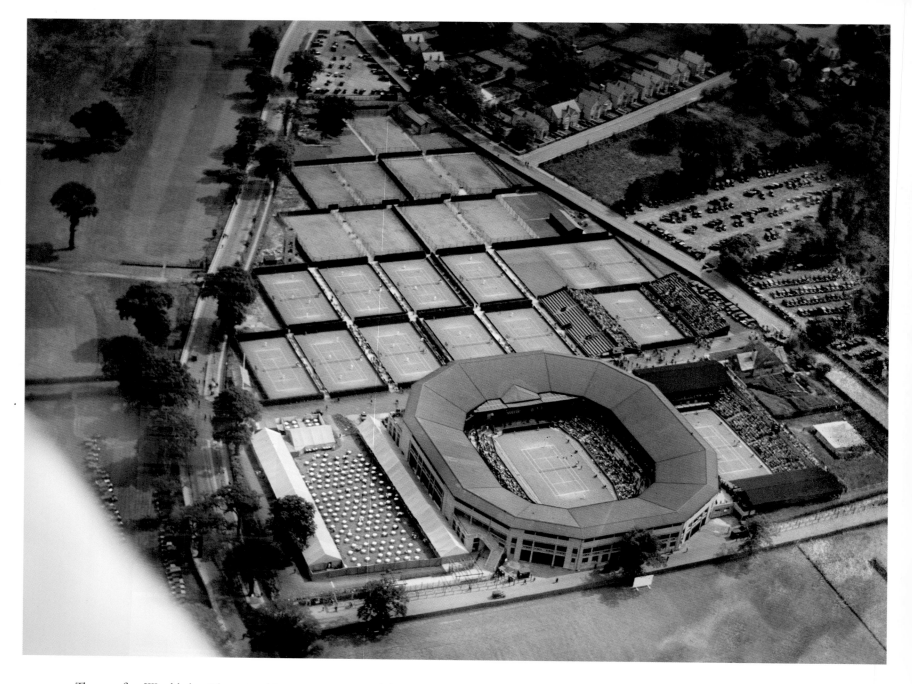

The very first Wimbledon Championship was held in 1877, and was open to any amateur prepared to pay a £1 1s entrance fee, and to bring their own rackets and shoes. Balls, at least, were provided by the club gardener. By the early twentieth century, the popularity of the tournament had grown to such an extent that – after police struggled to control the crowds at the 1919 Championship – the All England Lawn Tennis and Croquet Club had no option but to move from their original home at Worple Road to this new site on Church Road. On 25 June 1926, Aerofilms

captured the tournament as it was happening, with spectators filling the stands of the Centre and No.1 Courts, pictured here. The 1926 Wimbledon was known as the 'Jubilee Championships', and even saw King George VI, the then Duke of York, competing in the men's doubles with his equerry Wing Commander Louis Greig. Although the future King lost in the first round, there was British success elsewhere. The Women's Singles was won by Kitty Godfree, who beat the Spaniard Lili de Alvarez 6–2 4–6 6–3. 1926 EPW015874

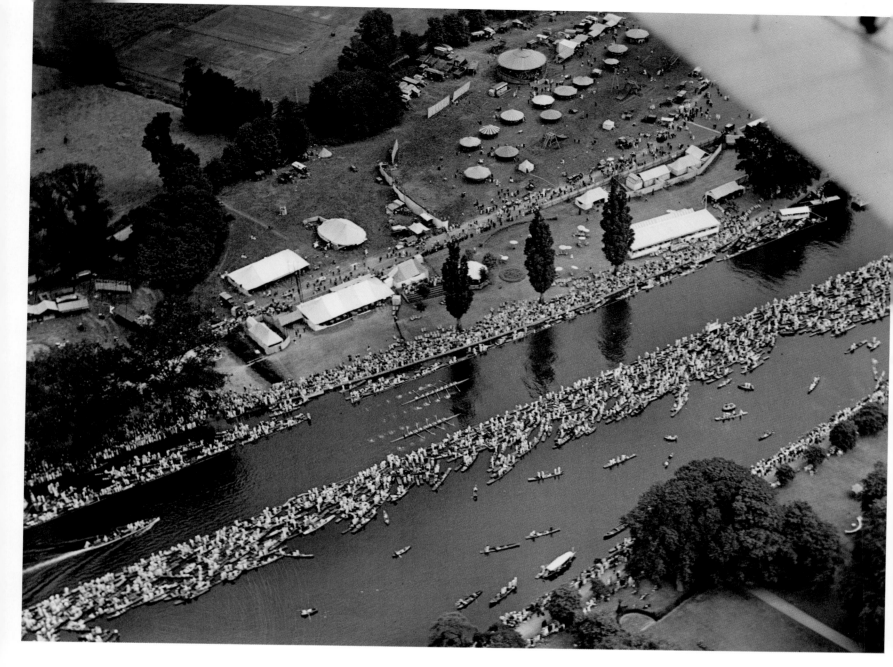

Two crews of eights race between the riverbank and a chaotic jumble of spectator boats to approach the finish line of the Royal Regatta at Henley-on-Thames. First held in 1839, the Regatta has been staged annually ever since – apart from during the two World Wars. This spectacular image from 7 July 1923 – the last day of the Regatta – captures the massed crowds of one of the largest attendances that the event had ever seen. A report in *The Times* two days later remarked that 'in the afternoon it was not possible to hire a boat of any description. Trains from Paddington had to be run in duplicate, and the motor traffic was much heavier than ever before.' 1923 EPW008856

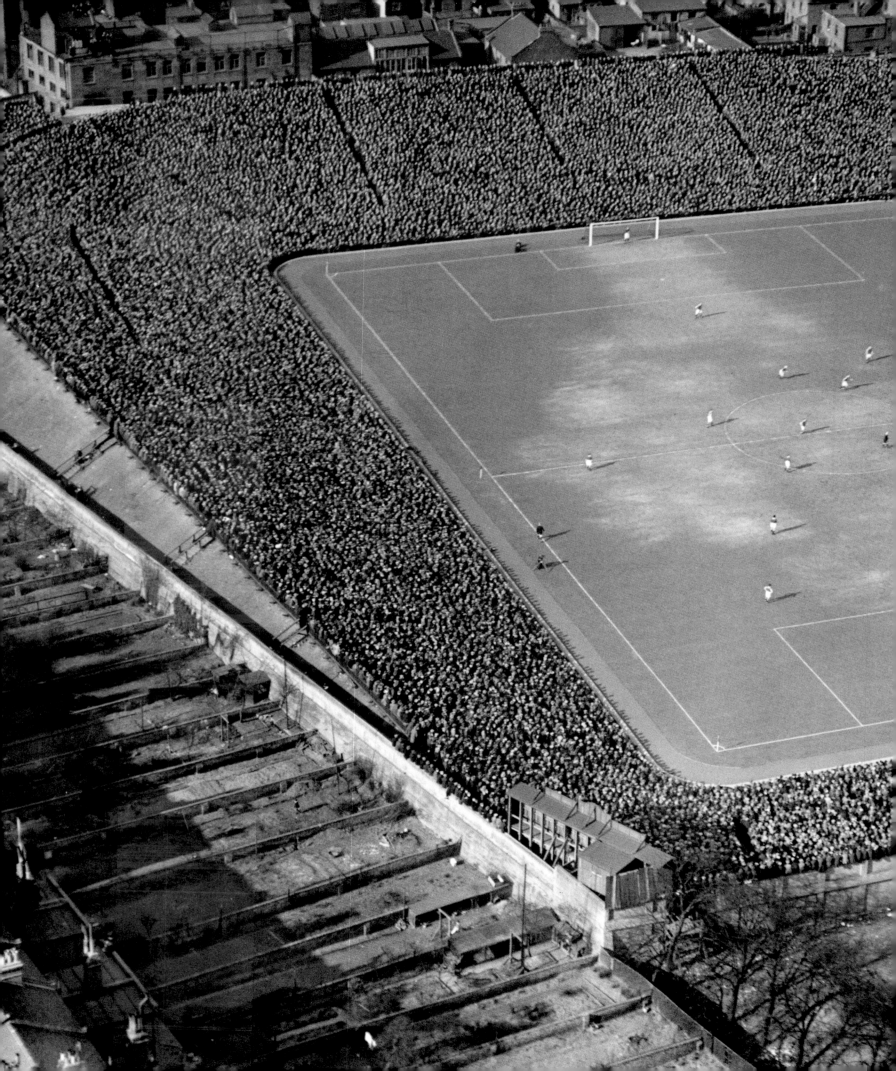

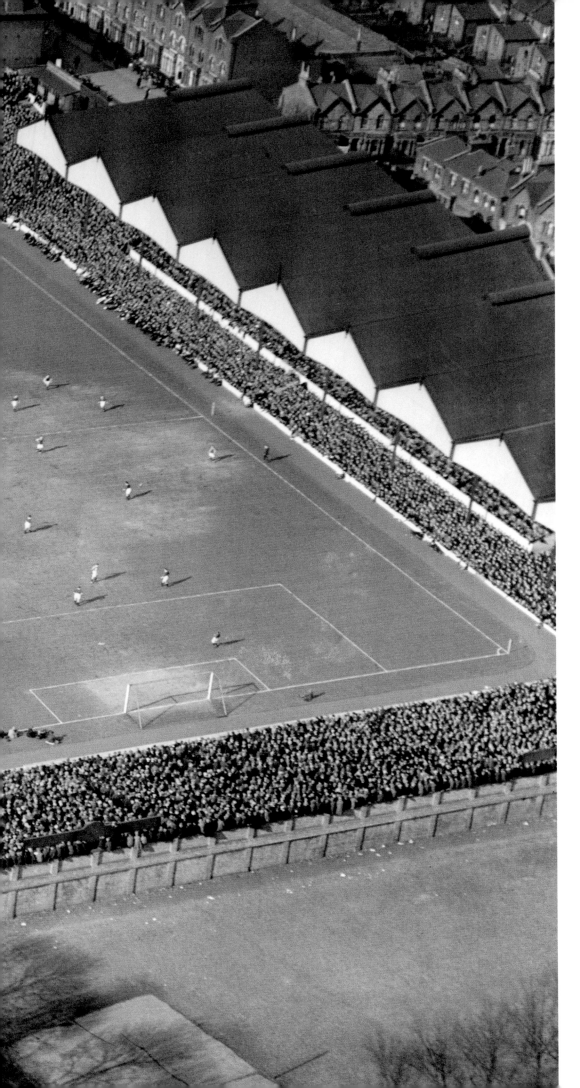

Opposite the main stand of Arsenal's Highbury football ground, a great wedge of tightly packed supporters spreads across curved banking above a row of back-gardens. This photograph from 23 March 1929 captures the action during the FA Cup semi-final between Portsmouth and Aston Villa – a match which Portsmouth went on to win by one goal to nil, before losing to Bolton in the final a month later. Beyond the instant, graphic impact of the image, there is an incredible richness of incidental detail – from the worn patches of turf and the pitchside figure bent over a film camera, to the rows of spectators sitting on the stadium back wall and, beneath the wooden scaffold of the scoreboard, a tiny figure playing on a swing, seemingly oblivious to the match unfolding behind. 1929 EPW025838

This incredibly low altitude photograph looks over the back of Twickenham's South Stand to capture a line-out taking place during the 1929 Army Navy rugby match. On the right is the newly constructed East Stand, a 'double-decker' built in 1924 at a cost of over £13,000. The following year, the stadium attracted a 60,000-strong crowd for a match between England and New Zealand – the largest ever attendance for a rugby match in Britain at that time. The land for the stadium had originally been purchased in 1907 by the Rugby Football Union – a quarter acre market garden bought for £ 5,572 12s 6d. This agricultural history soon gave rise to the stadium's rather unkind nickname of the 'cabbage patch'. 1929 EPW025842

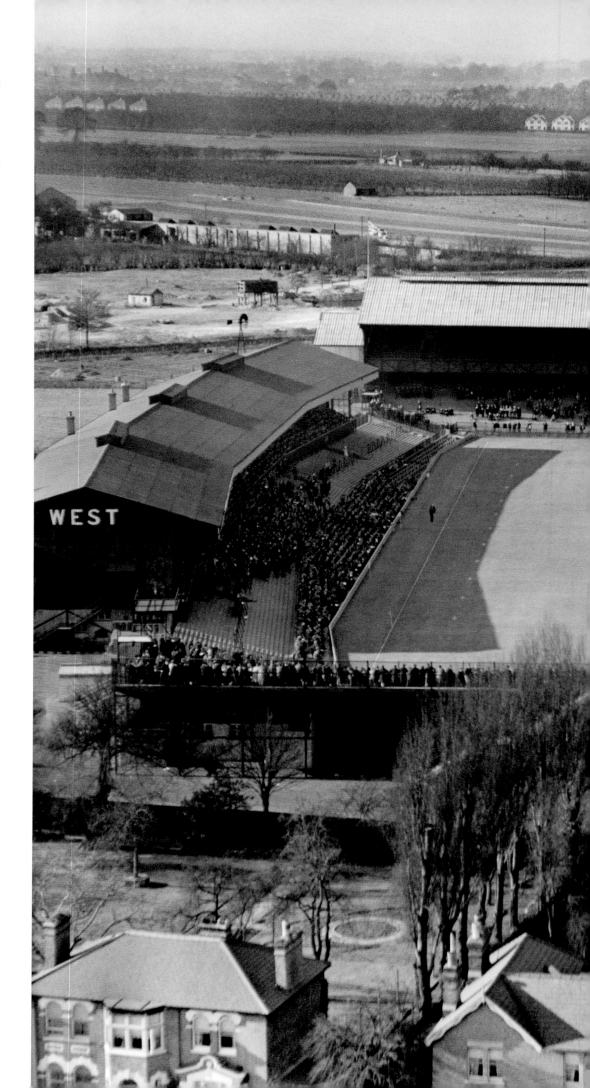

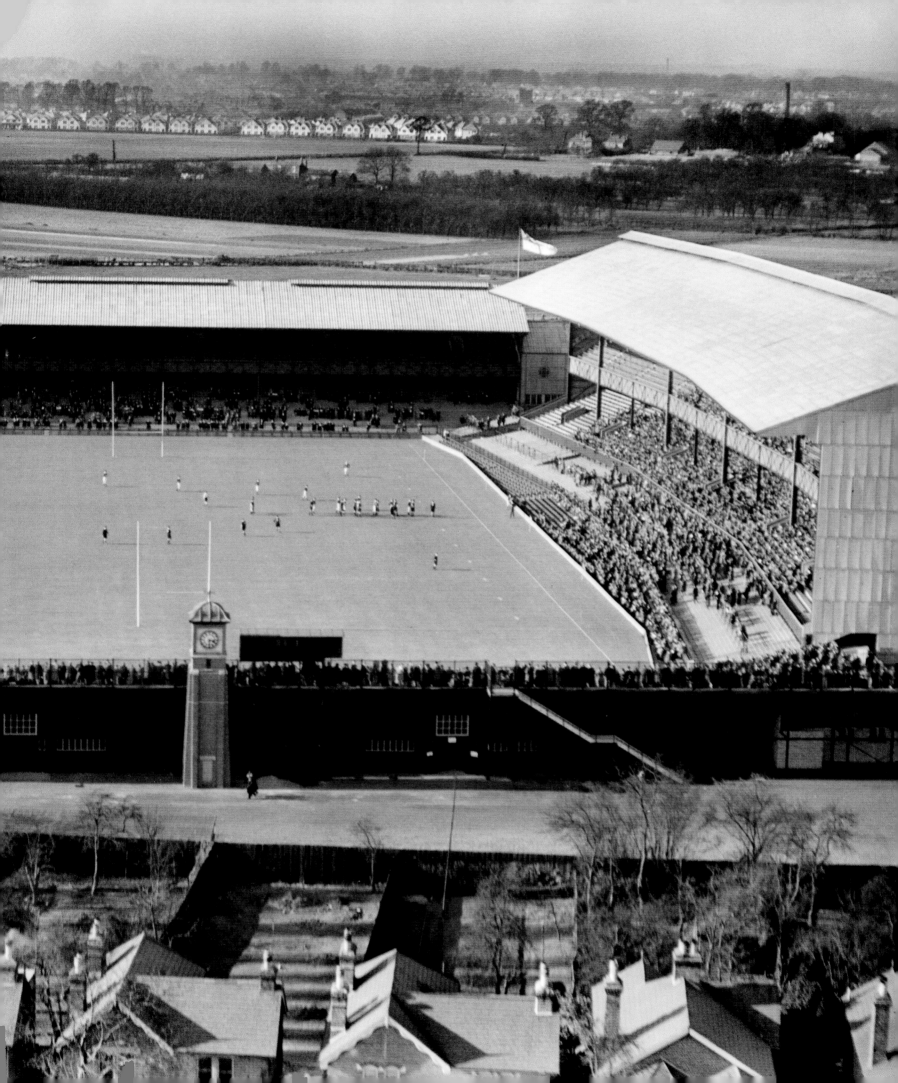

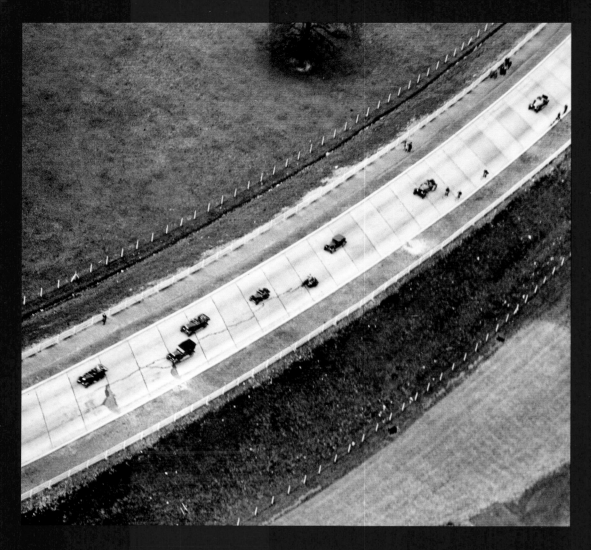

For 'air-minded' men like Claude Grahame-White, Francs Wills and Alan Cobham, flying had the potential to revolutionise civilian transport in Britain. In a Pathé newsreel, Cobham even envisioned a time when aeroplanes would be as common as motorcars, and airports and aerodromes would be as 'plentiful as golf courses and new arterial roads'. This visionary attitude typified the culture and ethos of Aerofilms – the company was constantly operating at the cutting edge, testing the reach of revolutionary techniques. In the midst of all this forward-thinking, however, it was easy to forget that motoring was still a new technology itself. The Highway Code wasn't introduced in Britain until 1931, and driving tests only became compulsory in 1935. This 1928 image of the Kingston Bypass in Raynes Park – now part of the modern A3 – shows a traffic free-for-all, with cars, pedestrians and cyclists all mingling together on the unmarked road surface. 1928 EPW020675

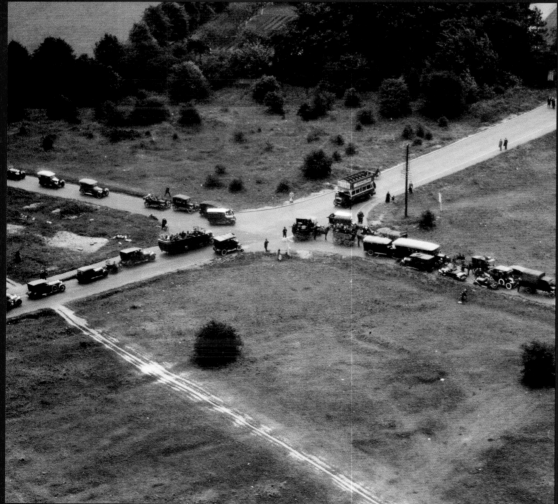

In this photograph of a three-way traffic jam at Fir Tree Road in Banstead in Surrey, taken on the day of the 1923 Epsom Derby, it is easy to see why Alan Cobham saw aviation as the 'only solution' to Britain's 'road congestion business'. In his autobiography *A Time to Fly*, Cobham recalled how Francis Wills came up with the idea of flying over Epsom to survey and photograph the worst of the Derby Day jams to help the police plan anti-congestion measures in the future. They even invited a senior officer to go up in an Aerofilms aircraft to direct operations on the ground by radio. As Cobham recalled, this was a qualified success. Unused to aviation, the officer 'was so horribly sick that he was able to do practically nothing. So the pilot and photographer took over the job, passing messages down to the police on the ground about the traffic situation as it developed, and taking pictures of it at the same time: and the joke is that when they landed the suffering officer was summoned to receive the King's congratulations… Nobody revealed his secret.' 1923 EPW008678

As the Aerofilms' aircraft began to range across provincial England, the company started to make direct commercial advances to municipal bodies. In their advertising leaflets, they explained how the aerial image could show the complete layout of a town 'in one or more panoramic views', where 'the geographical position and other natural attractions are obvious', and 'railway, river and all transport facilities can be seen at a glance' – as this 1920 image of Bath city centre helps to illustrate. 1920 EPW001161

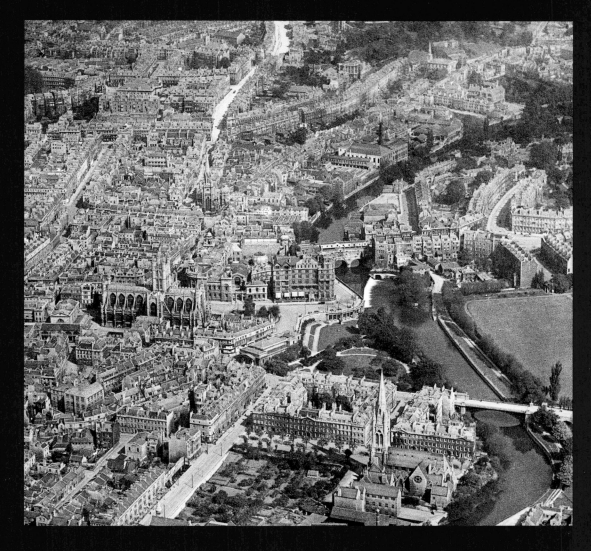

Aerofilms billed aerial photography as a revolutionary new tool for town planning, which 'would assist both the surveyor and the architect in the first place, besides providing a useful means of following progress once the scheme has started'. For a skilled artist or draughtsman to prepare a perspective drawing of an urban area – like this vista of Clifton in Bristol – 'could take days or even weeks to produce with any degree of accuracy'. Why not instead, asked Aerofilms, secure a view of your town 'in the course of an hour or two by taking it literally from the bird's view point'? 1921 EPW005463

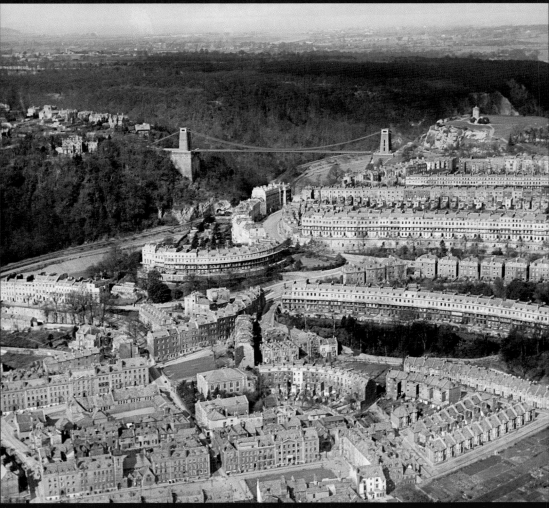

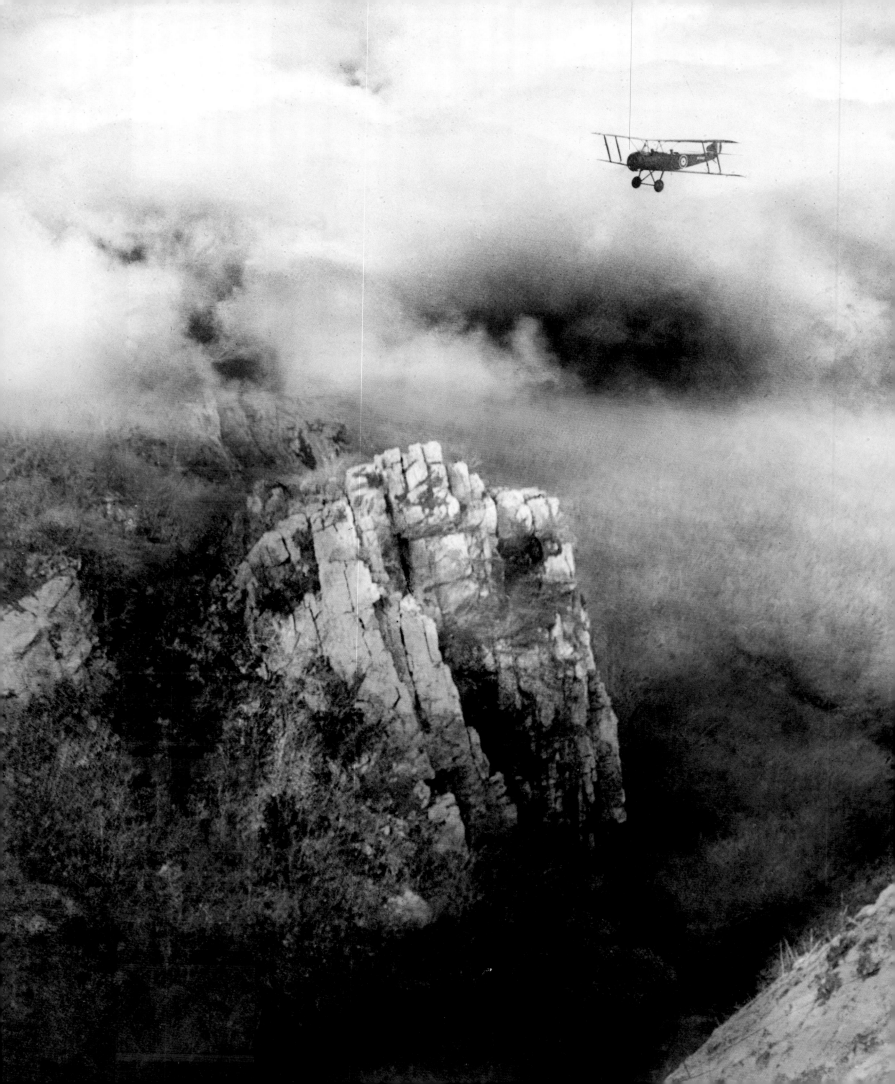

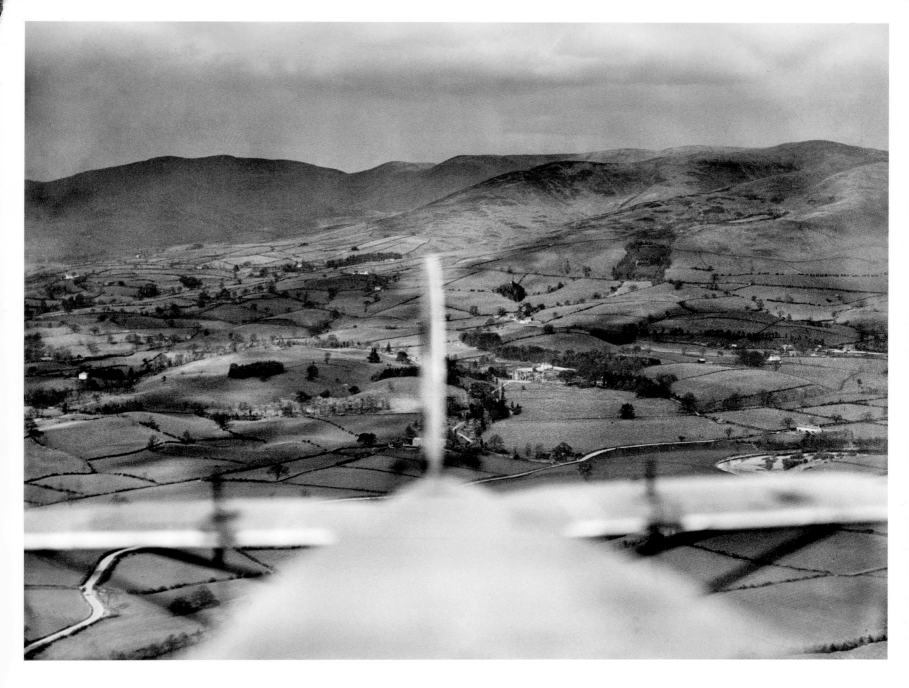

LEFT

While much of Aerofilms' initial photography focused on urban targets close to their home base of Hendon, the company soon set their sights much further afield – their aircraft navigating Britain in a series of short hops, often setting down in farmers' fields and agricultural land in the absence of any nearby aerodromes. In this image a biplane soars above a cloudscape and a steep-sided, wooded gorge. The evocative composition – and the fact the location remains unidentified in any of the Aerofilms' record books – suggests that it may be a composite image put together by the company's 'photographic artists'.

c1920s EPW007181

ABOVE

An Aerofilms photographer captures the rolling fields of Sedbergh on the edge of the Yorkshire Dales, in this unusual view looking backwards from the passenger's seat over the tail of the aircraft. The company took a set of eight photographs of the area during this flight in May 1929, a number of which they sold on to the local newspaper, the *Westmorland Gazette*. While this image did not make the shortlist, it remains a wonderful evocation of the company's ambition to fly over the whole country and photograph the many different landscapes below.

1929 EPW026564

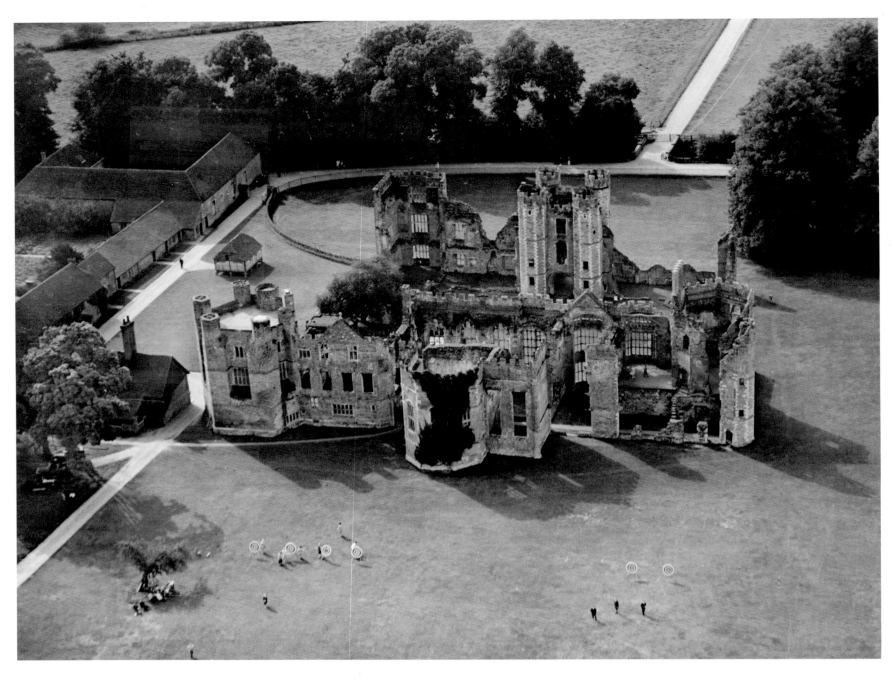

ABOVE

The aerial view had the potential to provide new and fascinating perspectives not just on Britain's modern landscapes, but also on its historical ones. Here, the picturesque ruins of the sixteenth century Cowdray House near Easebourne in the South Downs are pictured as never before. From above, the crumbling shell of the building can be seen in its whole context – a sprawling Tudor pile, with its fallen turrets and empty window frames cast in shadow across the lawn by the summer sunlight. An archery competition appears to be in progress, and tiny figures can be seen exploring the remains of the House. Today, these visitors would very likely be tourists – but as the building only opened to the public in 2007, in the 1920s they must instead have been guests of the owner, the 2nd Viscount

Cowdray. Whether taken by Aerofilms as a special commission, or speculatively in passing, this is an evocative image of the aristocracy at play. 1928 EPW023093

RIGHT

The aerial perspective succeeds wonderfully in capturing the grandiose and majestic ambition of Blenheim Palace and its landscape setting. Designed in the eighteenth century by Sir John Vanbrugh for John Churchill, the 1st Duke of Marlborough, Blenheim has become more than just an aristocratic house – it is also a national monument. Between rows of elm trees a wide avenue runs past a 41-metre-high 'Column of Victory' to a huge bridge spanning Capability Brown's famous man-made lake. Finally, rising up on a low hill, is the Baroque façade of the Palace itself. It is intriguing to wonder what Winston Churchill, a former Air Minister, would have thought of this – perhaps the first-ever aerial image of his ancestral home and the place where he was born. 1928 EPW026923

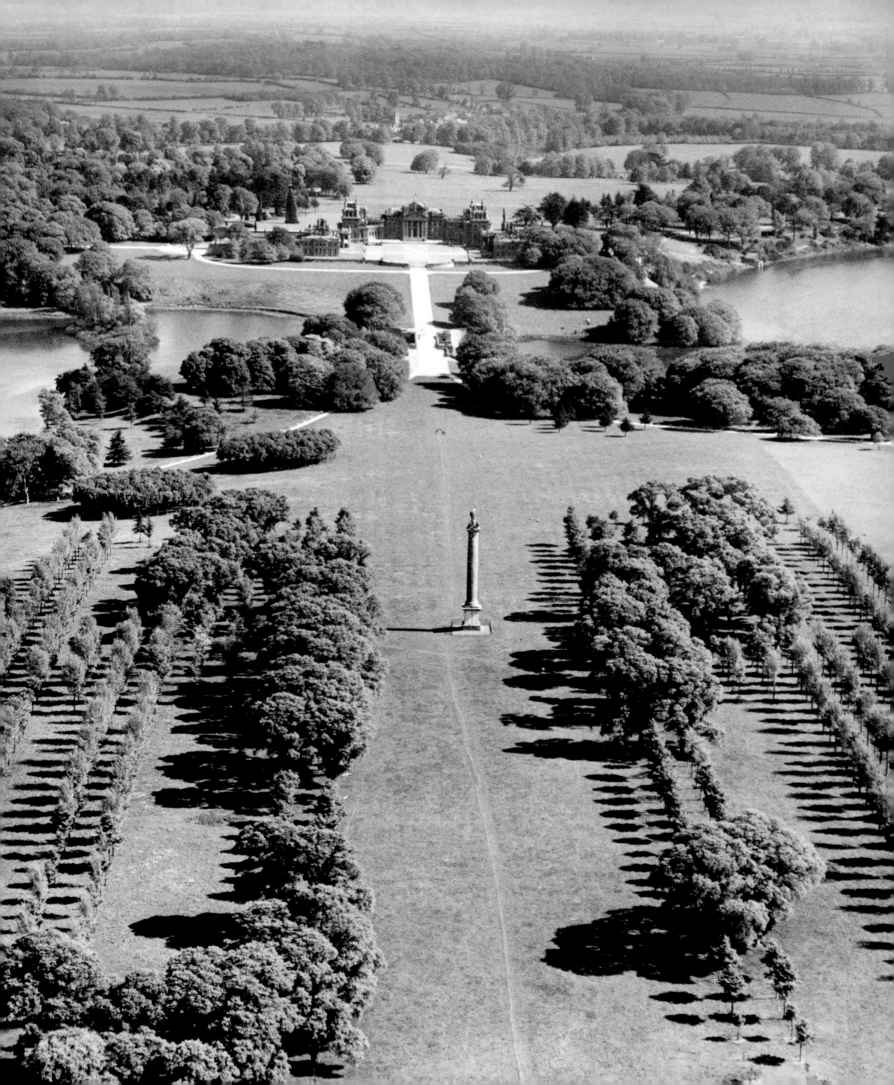

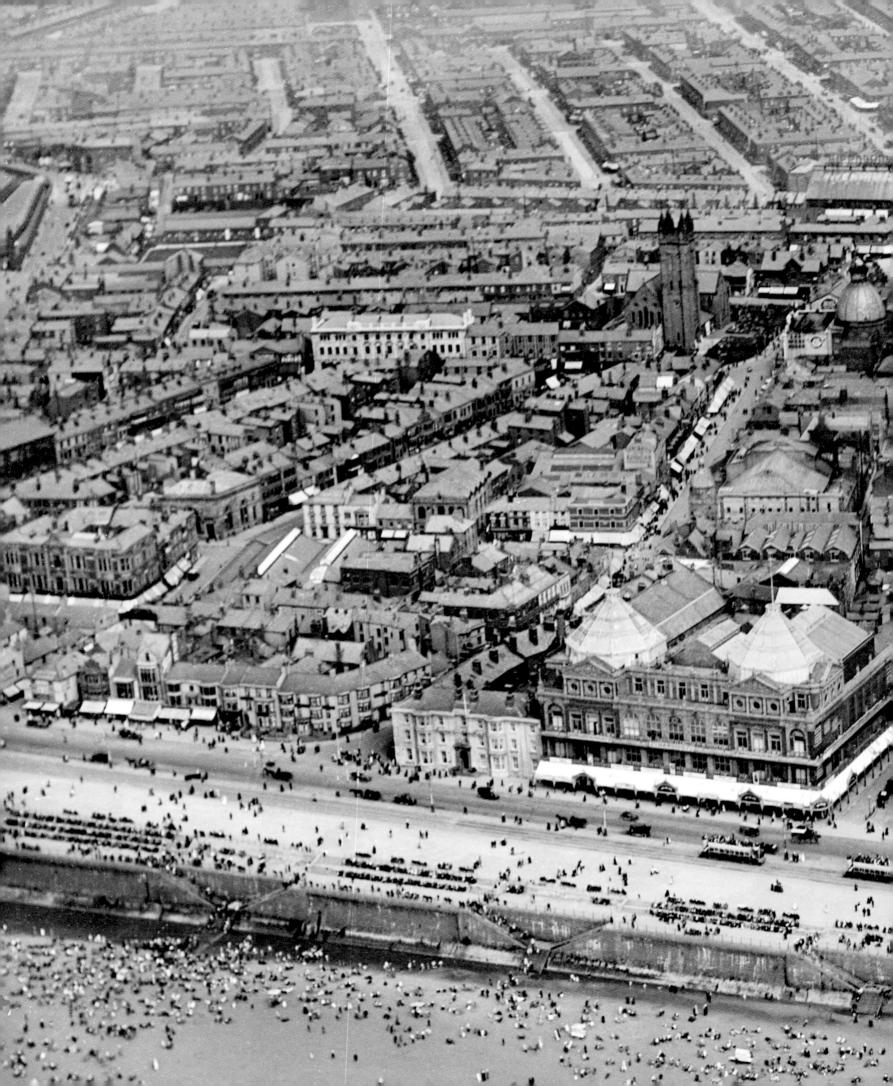

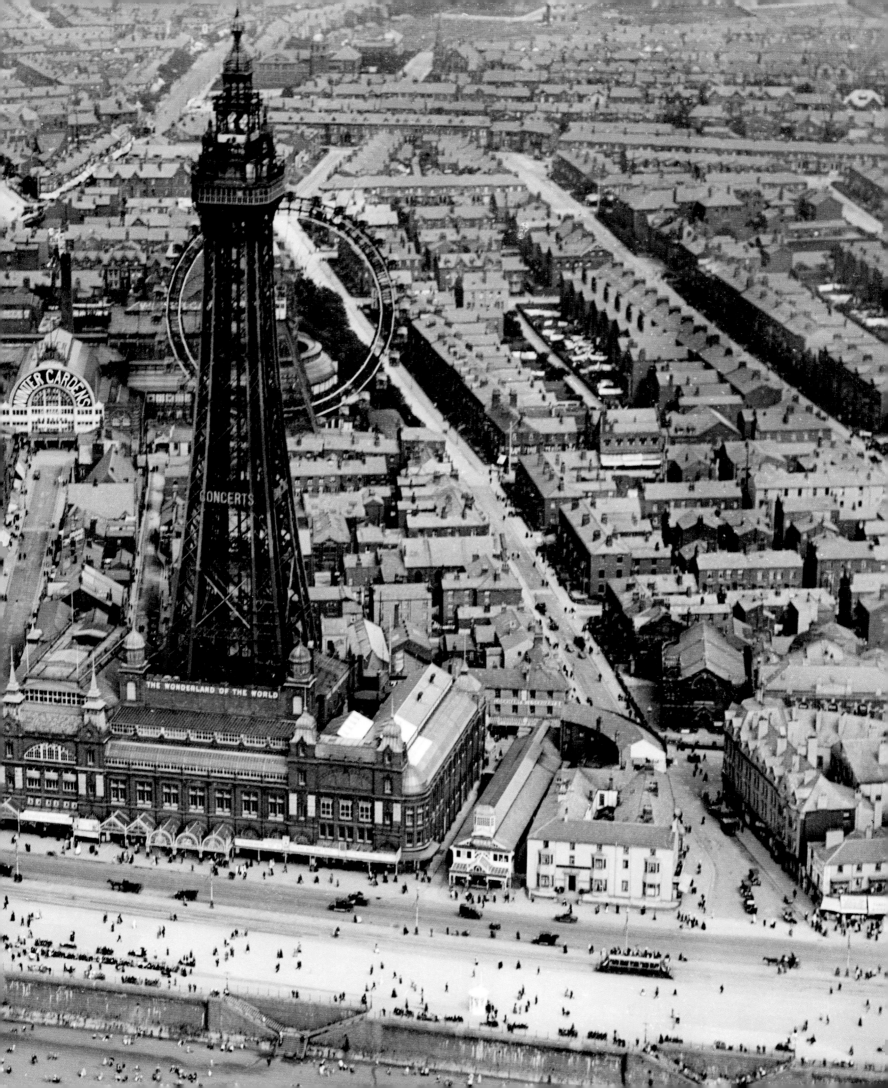

PREVIOUS PAGES

This remarkable shot of Blackpool Tower and the Winter Gardens was a speculative capture by an Aerofilms photographer and pilot as they navigated England's north-west coastline in July 1920. Both the *Blackpool Gazette* and the *Radio Times* bought the image – most likely to advertise the town and its increasingly famous attractions to prospective tourists. The Winter Gardens first opened in July 1878 as a six-acre pleasure park made up of concert halls, skating rinks and ballrooms. The year this photograph was taken also marked the first ever staging of the Blackpool Dance Festival in the wonderfully grand Empress Ballroom. Partly hidden in the background here is the 'Big Wheel', a 220-foot-high ride built by the Winter Gardens as direct competition for the Tower. It remained – literally and metaphorically – in the shadow of its more celebrated counterpart, and was eventually pulled down in June 1929. 1920 EPW002059

RIGHT

Rows of boats rest peacefully in the harbour mouth of the picturesque walled seaside town of Tenby in south-west Wales. In 1806, the merchant banker and politician Sir William Paxton made a considerable investment in Tenby, transforming it into a spa resort by creating a 'fashionable bathing establishment suitable for the highest society'. The town proved enormously popular to the burgeoning British tourist industry, and remained a favourite destination for Welsh and English holidaymakers throughout the Victorian and Edwardian eras. It was also a favourite of the Aerofilms founder Francis Wills. His wife Lily Simmons was born in the town, and their home at Goring-by-Sea in Sussex – where they moved to live after Wills retired in 1958 – was named 'Tenby Cottage'. 1929 WPW029701

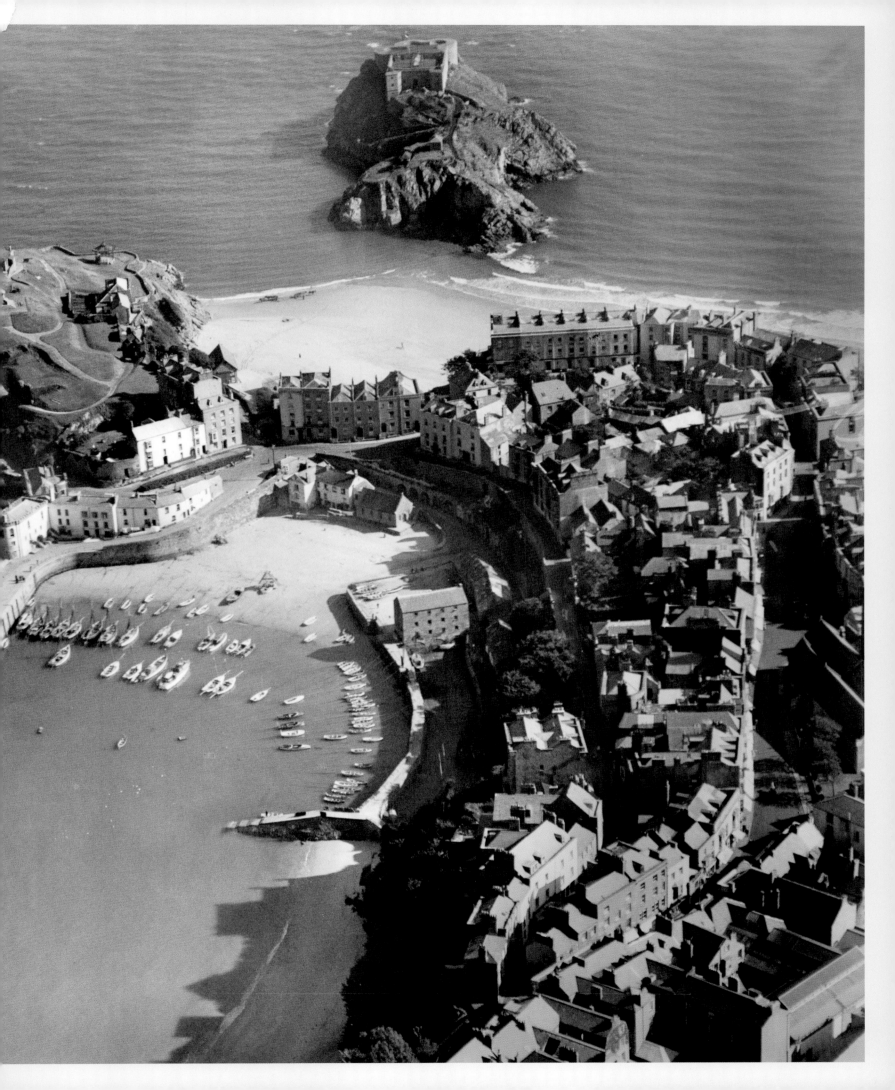

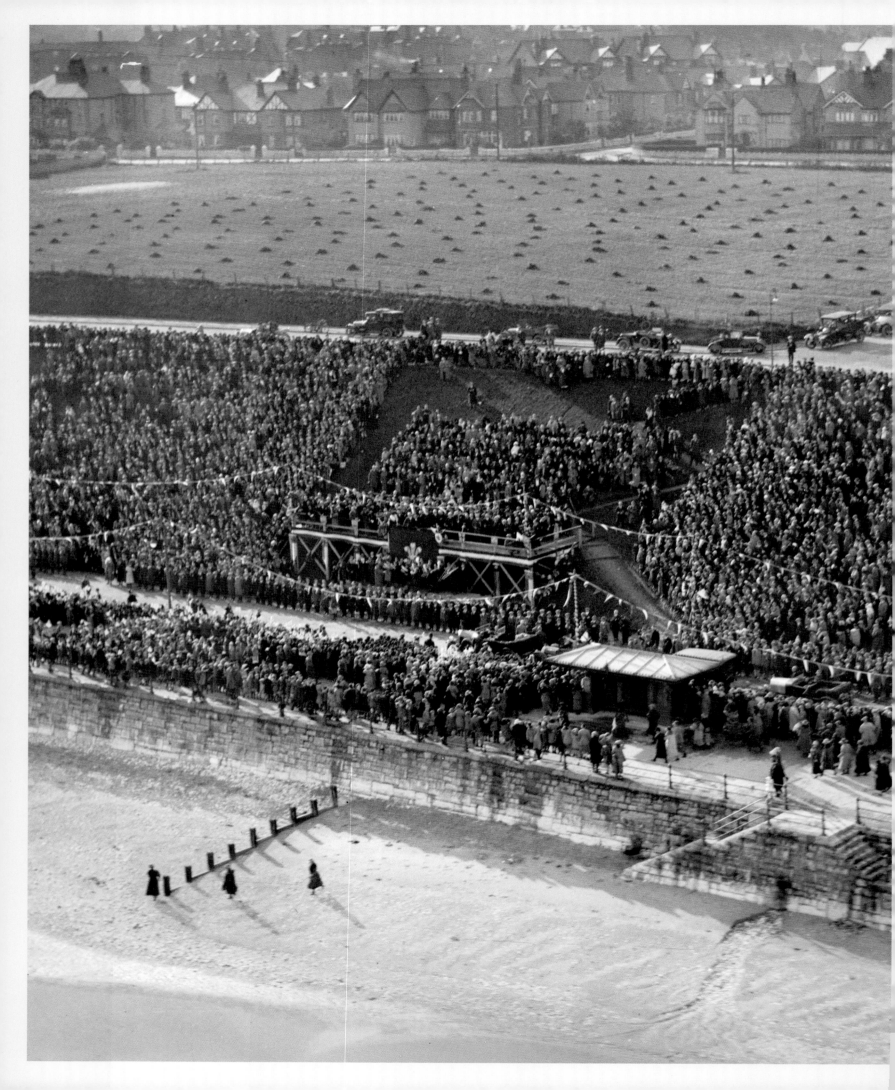

Crowds pack the steep banking leading down to the sea at Colwyn Bay in north Wales. Flying extremely low along the coastline, Aerofilms captured the visit of Edward, Prince of Wales, to the town in November 1923. The Prince was touring the country to mark the fourth anniversary of the end of First World War, unveiling a series of newly built war memorials. Aerofilms followed the Prince throughout his visit, also photographing events at Rhyl, Llandudno and Anglesey. 1923 WPW009514

In the same month, a ceremony was held at the thirteenth century Conwy Castle, to present the Prime Minister – and proud Welshman – David Lloyd George with a silver 'freedom' casket to honour his services to Britain during the First World War. Aerofilms circled the castle over the course of the ceremony, taking a number of photographs from different perspectives, including this image of Conwy with Thomas Telford's suspension bridge in the background, and a close-up shot looking down at the crowd gathered inside the walls. 1923 WPW009499, 1923 WPW009497

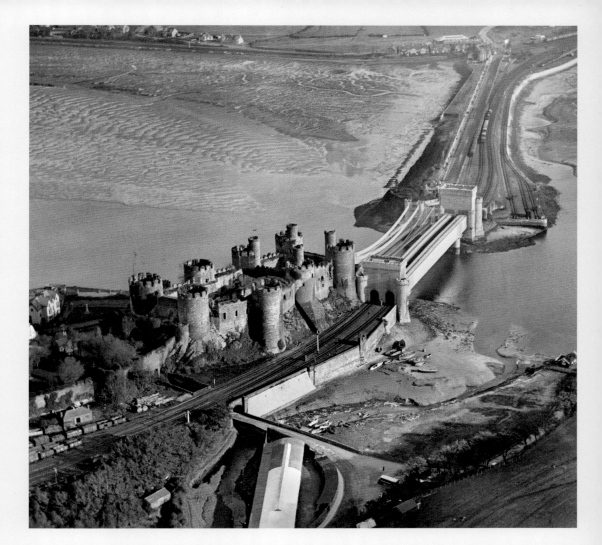

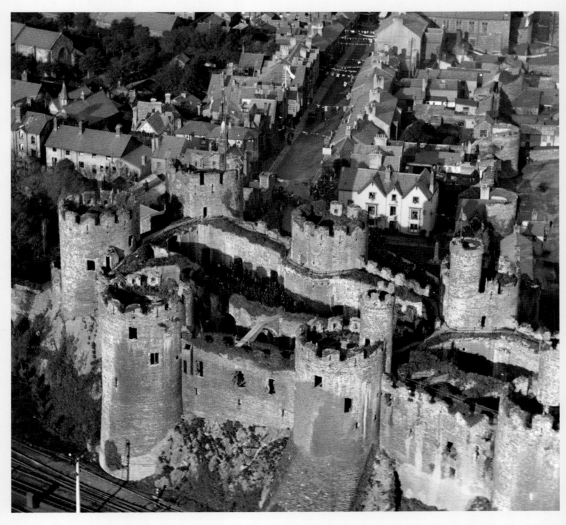

Cardiff's grand Civic Centre buildings
sit serene and stately among the green,
open spaces of Cathays Park. Captured at
the top of the image is the west wing of
the city's university, and then, moving left
to right, are the Law Courts, the City Hall
and the National Museum of Wales.
When this photograph was taken in 1921,
the Museum was still under construction,
as can be seen in the ongoing site works
at the rear of the building – it would be
another six years before it was completed. In
1928 Cathays Park would also become
the site of the National War Memorial,
a circular stone colonnade designed
Sir Ninian Comper, and dedicated by
inscription to, 'the sons of Wales who gave
their lives for their country in the War 1918'.
1921 WPW006084

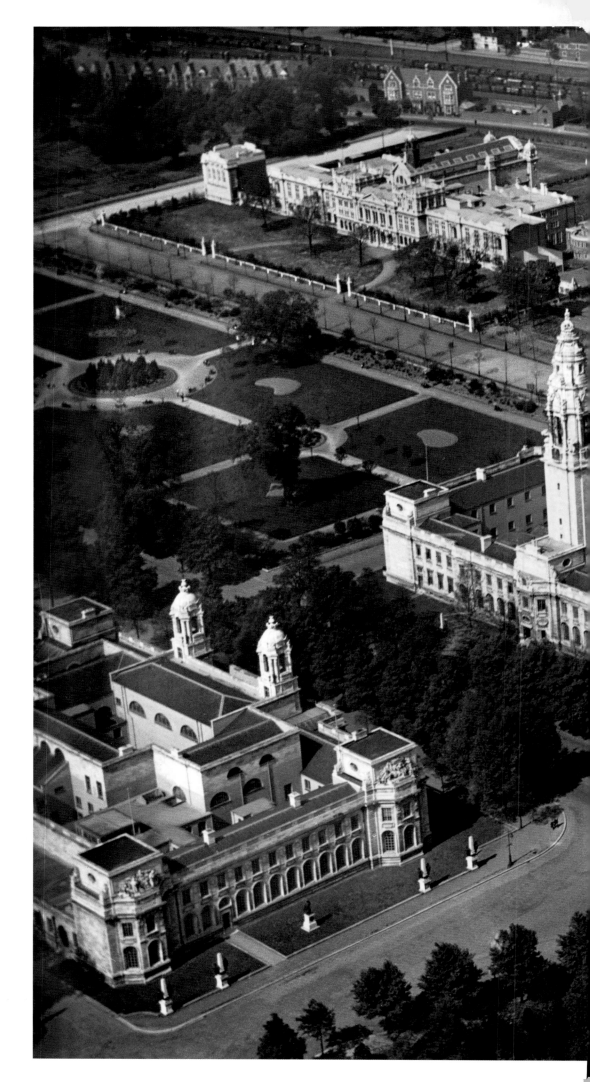

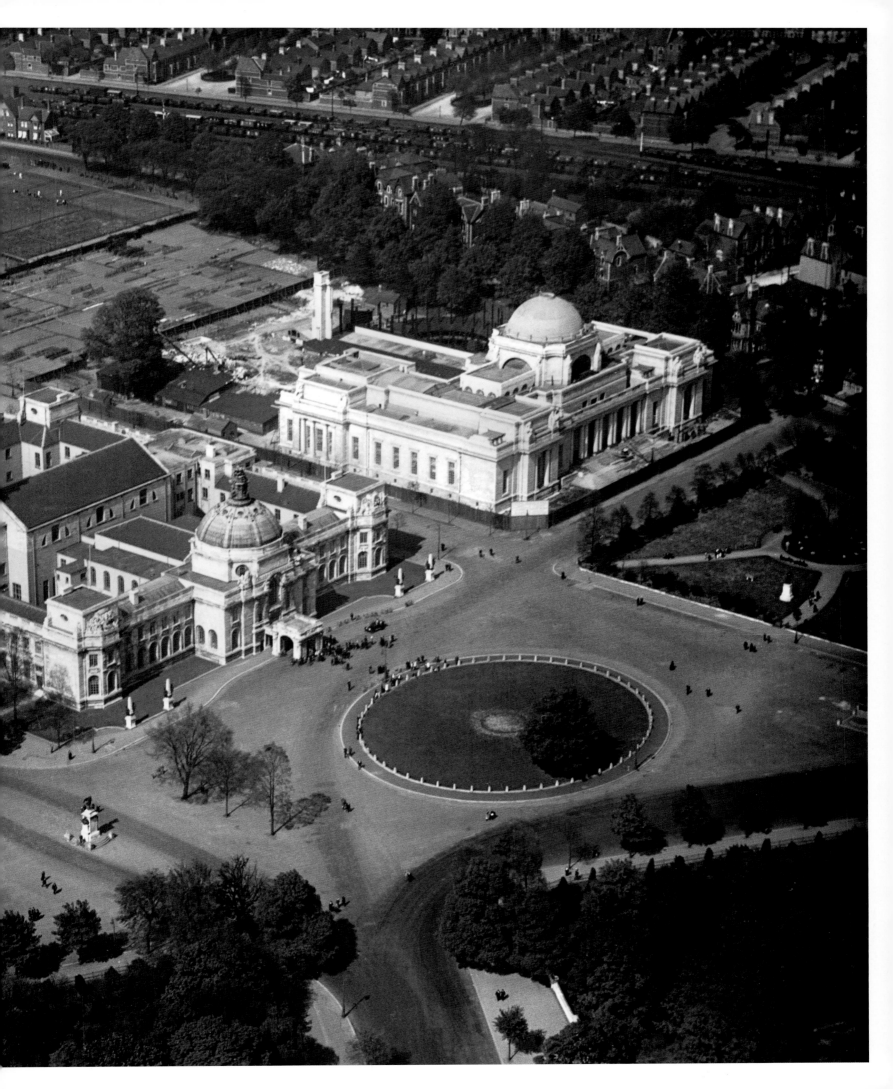

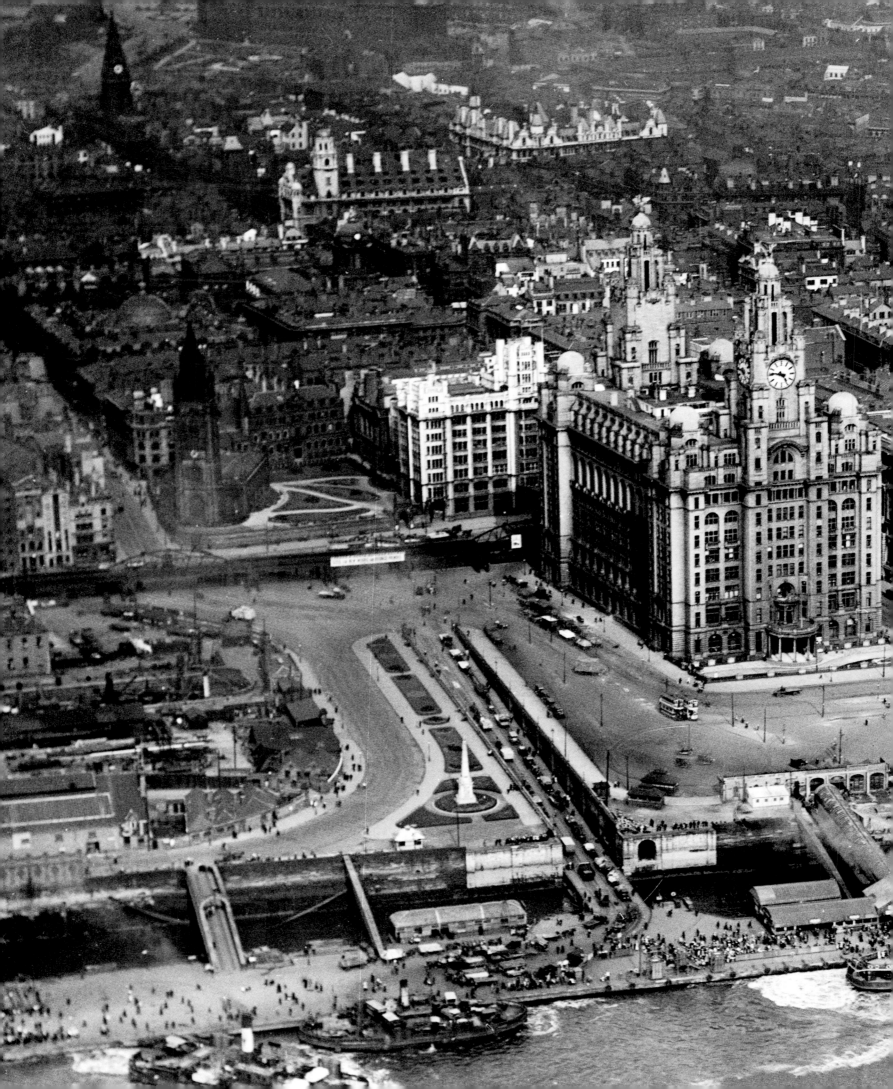

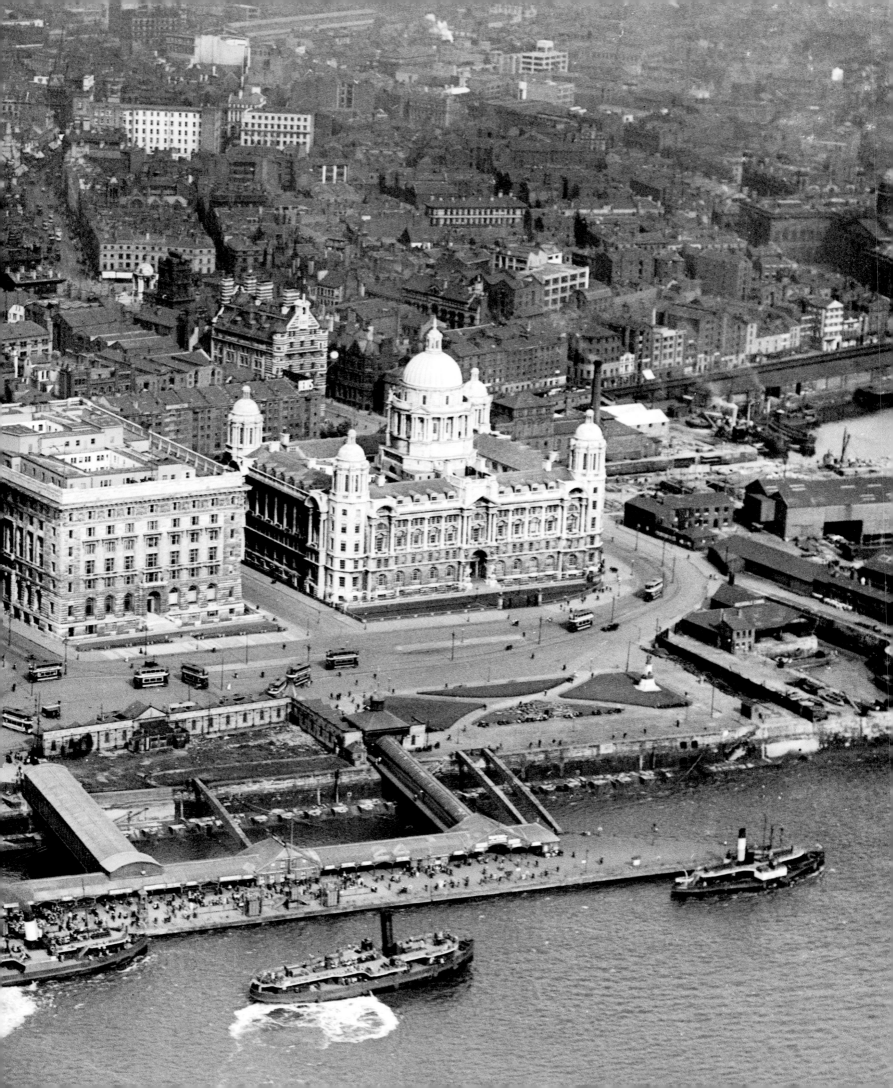

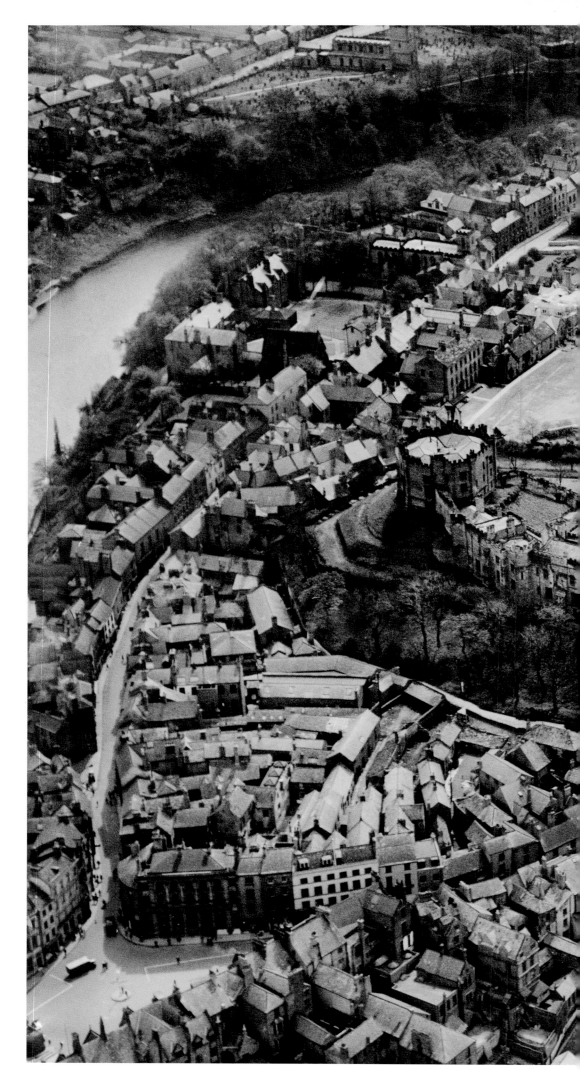

PREVIOUS PAGES
Liverpool's 'Three Graces' – the Royal Liver
Building, the Cunard Building and the
Port of Liverpool Building – here provide
a grand and monumental welcome to
passengers streaming off the Mersey Ferries
and onto the floating George's Landing Stage.
To the left of the Stage's main access ramp is
a newly built, bright white obelisk. Originally
erected in 1916 as the 'Memorial to the
Heroes of the Engine Room of the Titanic' –
the 32 men who remained at their posts as the
great ocean liner was sinking – after the First
World War, its dedication was extended to
commemorate the deaths of all engine room
crews. Perhaps most significant of all, it was
one of the first monuments in Britain created
to celebrate the sacrifices of the working man.
1920 EPW003065

RIGHT

In Aerofilms' early years, the opportunity to
extend their photographic coverage across
the country was often constrained by an
inadequate aviation infrastructure and Air
Ministry restrictions. In August 1919 – three
months after civilian flying had been allowed
to recommence in the wake of the First World
War – only eight aerodromes were licensed
as civil airfields, with a further 15 holding
time-limited, restricted licences. By September
1920, 87 licences had been issued – and six
renewed – but most permitted only very short
operational periods, and the average duration
of a flight in Britain was just 24 minutes.
The north-east of England in particular was a
challenge, as there were very few operational
aerodromes in the area. As a result, major
towns like Durham, Newcastle, Sunderland,
Scunthorpe, York and Middlesborough were
not visited by Aerofilms until 1921 at the
earliest, and some not until much later in
the 1920s. This spectacular image of a sunlit
Durham Castle and Cathedral, overlooking
the Framwellgate Bridge and the River Wear,
was taken in May 1929. The only previous
Aerofilms' imagery of the city appears to have
been taken three years earlier, in 1926.
1929 EPW026647

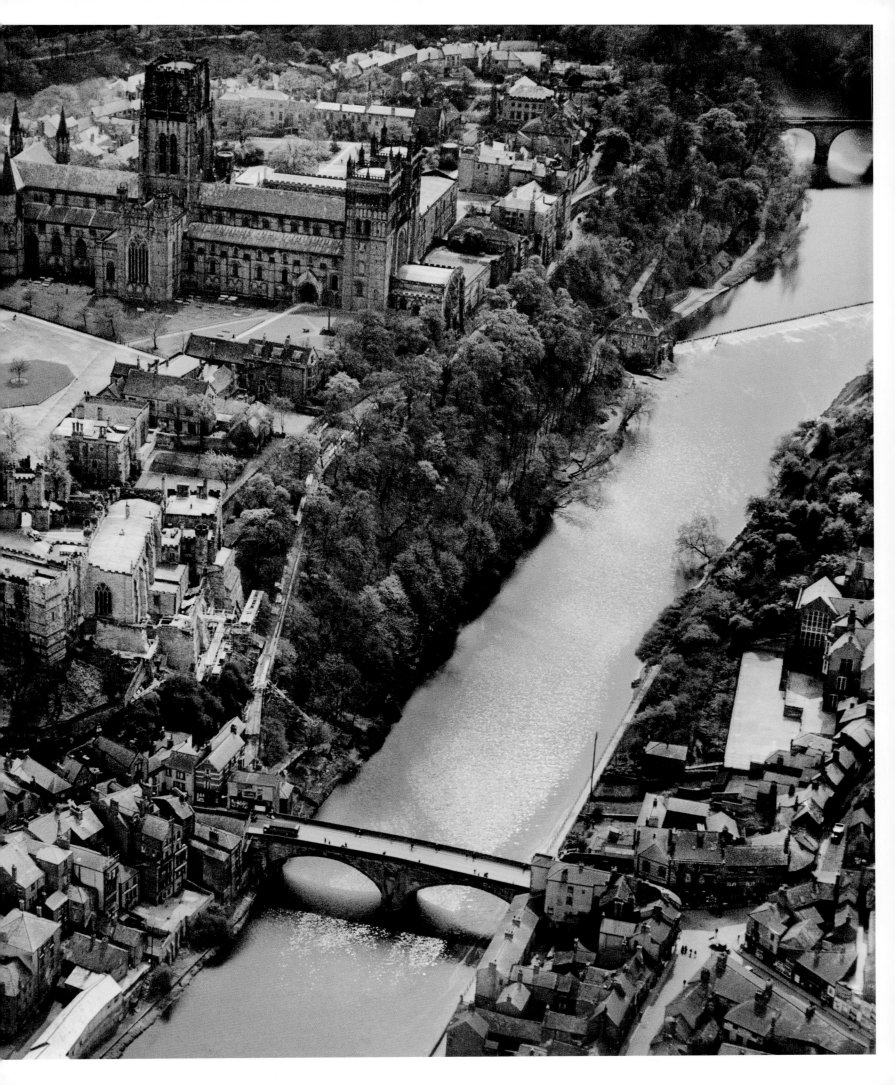

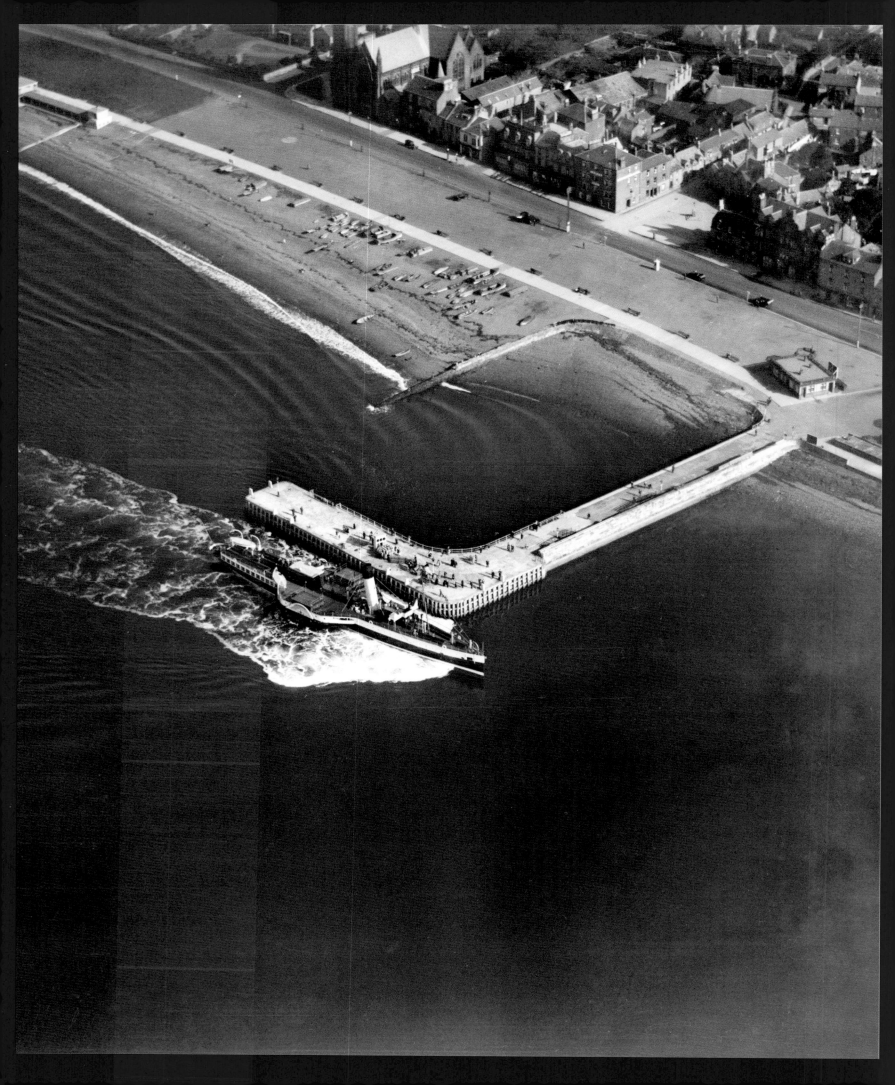

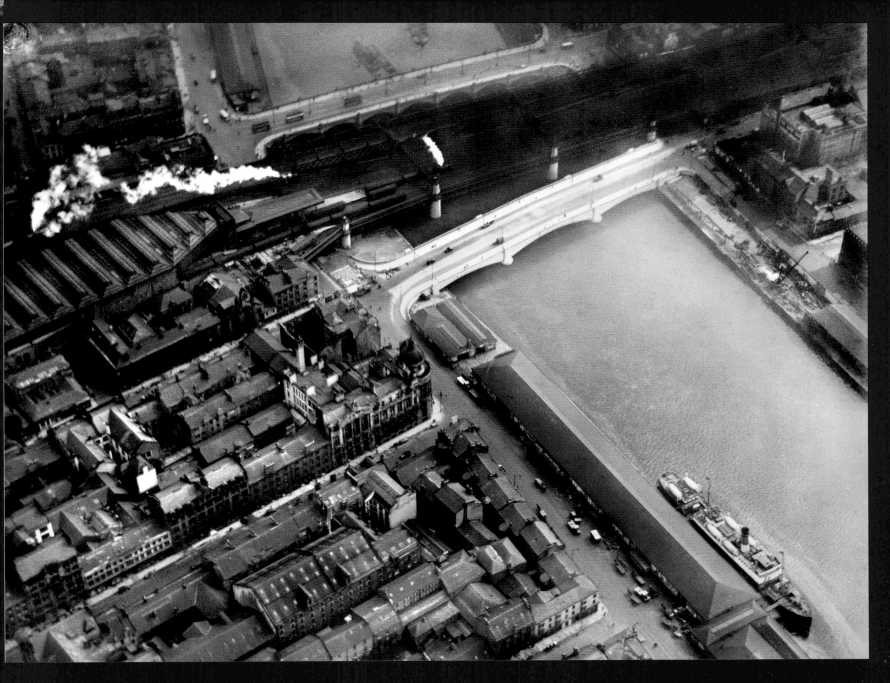

Apart from a handful of speculative flights into Dumfries and Galloway, Aerofilms' first significant visits to Scotland did not come until 1927. From then on, however, there was a substantial increase in the company's work north of the border. In one month in 1928, 337 photographs were taken of locations across the country, with aircraft even reaching as far as the south coast of the Moray Firth, near Inverness. In May of the following year, another 410 images were captured of sites in southern Scotland. By this time, Aerofilms

were flying almost year round, with work starting as early as 3 January and not finishing until 17 December. These two images from the late 1920s capture a vignette of a famous west coast tradition – travelling by paddle steamer from central Glasgow out into the Firth of Clyde. From George V Bridge beside the city's Central railway station, passengers would embark on a journey past some of the largest and most prolific shipyards in the world, travelling on to a series of coastal resorts like Dunoon or Saltcoats, or perhaps

even further, crossing the Firth to the Isle of Bute. One of the most popular stopping points was the town of Largs. Pictured here in October 1927, a crowd on the large harbour pier waits to board the Caledonian Steam Packet Company's *Duchess of Fife*. First built in 1903, the paddle steamer had served as a minesweeper during the First World War, and would go on to take part in the Dunkirk evacuation in the summer of 1940.
1927 SPW019556

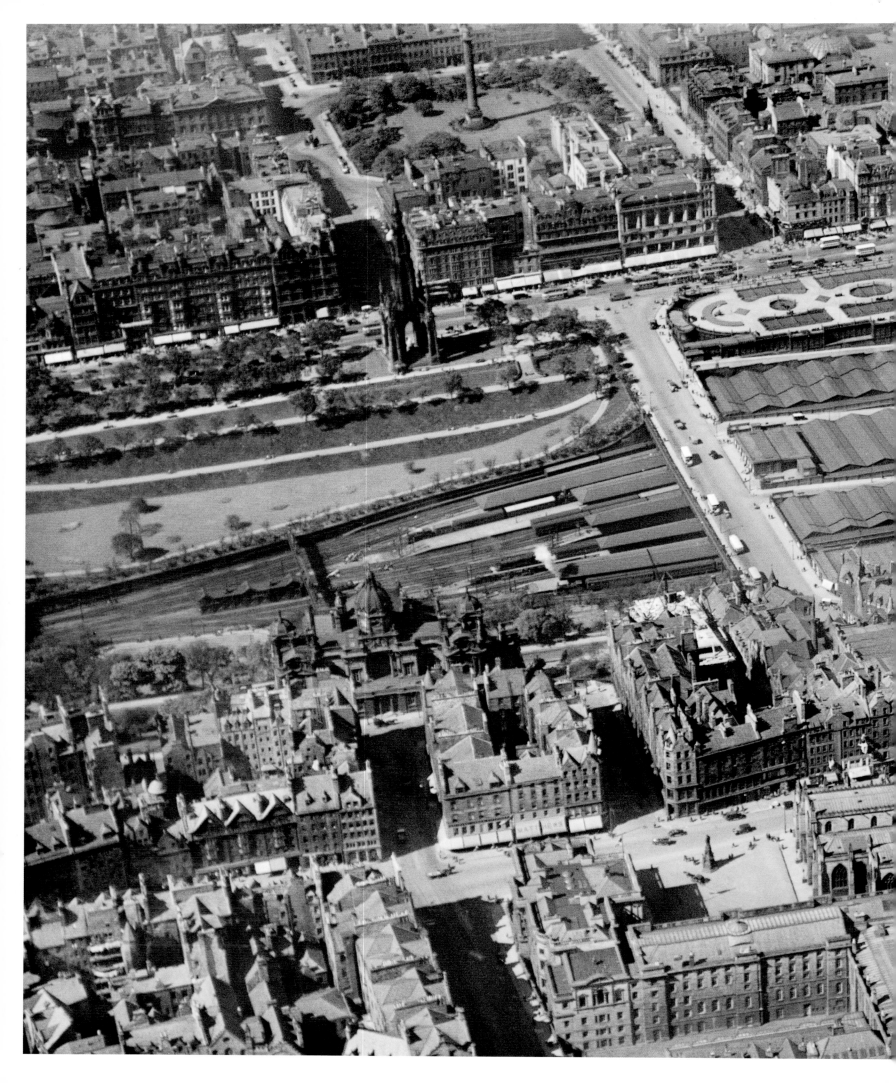

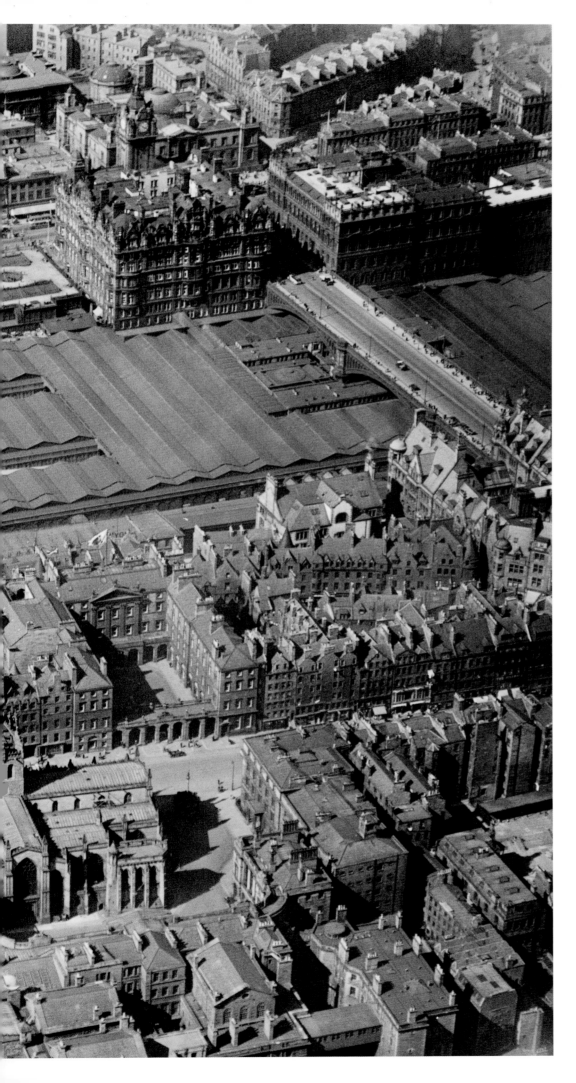

Occupying the steep-sided glacial valley between Edinburgh's Old and New Towns, Waverley Station was first completed in 1846, on the site of the city's fruit and vegetable market. After major reconstruction work in 1892, it was expanded to become the largest railway station in Britain after Waterloo in London. Seen from above, with a series of tracks running into a wide expanse of angled roofing, the structure dominates the city centre. As one Victorian architectural journal put it, railway stations and hotels were to the modern world 'what monasteries and cathedrals were to the thirteenth century. They are truly the only real representative buildings we have.' By 1929, Aerofilms had become a national aerial photography company – their aircraft and photographers travelling across Britain in the pursuit of new business opportunities. This last year of the decade was the most productive in their short history. They took over 5,000 oblique photographs, secured notable commissions from local authorities to help plan new housing schemes, and even established a contract with the Metropolitan Police to monitor London traffic conditions. Aerial photography, an untested – some would even say eccentric – idea, had become a major commercial operation. 1929 SPW027135

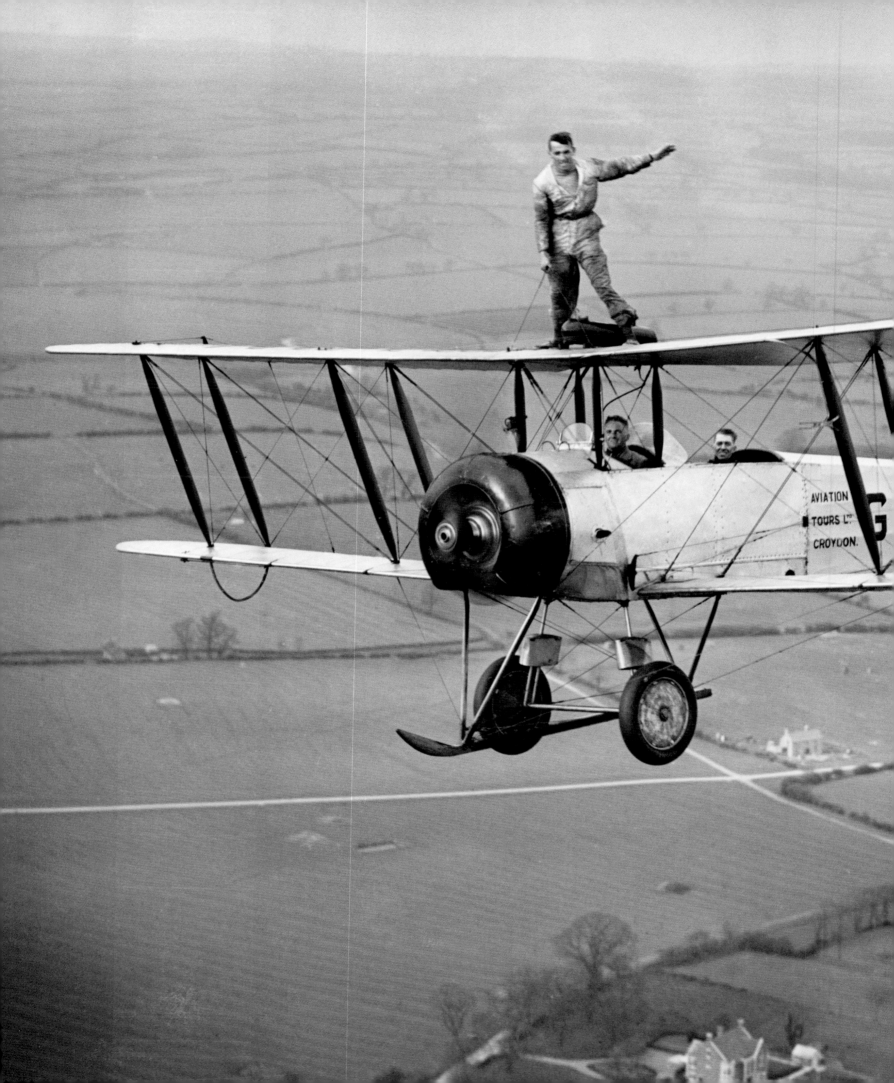

Wot, No Depression? 1930–1936

Looking Down to Build Business Up
Original and always interesting, the Aerial Photograph strikes a new note in modern business propaganda.
Why not make use of the effective up-to-date Aerial Photograph in YOUR business? Aerofilms Limited – the pioneers of Commercial Aerial Photography – will be glad to place their specialised knowledge at your disposal.

Aerofilms advertising leaflet, 1929–30

In May 1931, Cyril Murrell, one of the original Aerofilms photographers, wrote an article for the English inventor and toy-manufacturer Frank Hornby's popular *Meccano Magazine* – a magazine aimed at 'boys of all ages'. Titled 'Taking Photographs from Aeroplanes', Murrell's piece combined evocative reportage with bald self-promotion. 'As we approach an industrial town it will appear as a hazy blur in the middle distance; but soon we are able to distinguish the forest of chimney stacks that form the most prominent features of our manufacturing cities', he wrote. 'Few factories or works are architecturally beautiful, but it is possible to secure an effective picture that will emphasise the extent of the property and make it stand out from its surroundings. The photograph must be taken from just the right viewpoint in order to produce the perfection of detail that is so essential in a picture that may be destined to form the frontispiece of an elaborate and beautifully produced catalogue.'

The early years of the 1930s saw Aerofilms recording a new Britain, one that was emerging – almost unnoticed – alongside the bleak industrial landscapes created by the Great Depression. The 1929 Wall Street Crash, known as Black Tuesday, had devastated international trade and led to an immediate collapse in the demand for traditional British exports. At the end of 1930, official figures for unemployment had more than doubled – from 1 million to 2.5 million – but the real picture, particularly in the regions dominated by heavy industry, was even worse. By 1933 nearly a third of all Glaswegians were out of work, and on Tyneside almost the entire population of the town of Jarrow was made redundant following the closure of their shipyard – a move which prompted the famous 300-mile protest march on Westminster. The new Labour Prime Minister Ramsay MacDonald spoke of the 'dread of an overhanging poverty' and Winston Churchill, who had been Chancellor of the Exchequer until the defeat of the Conservative government in the General Election of May 1929, described the period as 'the years for the locusts to eat'.

A well-worn cliché presents this era as the 'Hungry Thirties' – a time of never-ending dole queues and squabbling, hapless politicians. As ever, the truth was not quite so simple. New industries and diversification were allowing the rise of an affluent middle class – families who benefited from falling prices and living costs and invested in the trappings of early twentieth century consumerism:

Martin Hearn performs a wing-walking stunt during a National Aviation Day display. Alan Cobham described Hearn – who often performed a loop the loop with no harness to keep him in place – as the 'most intrepid' wing-walker in his Flying Circus. 1932 EPW037852

motorcars, wireless radios, washing machines, refrigerators and vacuum cleaners. A new wave of manufacturing – along with the growth of national institutions like the BBC – was helping to shape the Britain of the future. Social mobility sparked consumer optimism, and there was an explosion of interest in leisure pursuits, from the cinema to the seaside.

In the autumn of 1933, J B Priestley – a veteran of the Somme turned novelist and playwright – embarked on a lengthy journey across the country by motorcar and train. He had been commissioned by his publisher, Victor Gollancz, to write *English Journey*, a first-hand Depression-era travelogue – and an unvarnished yet compassionate take on the state of the nation. While he bemoaned the social injustices he witnessed among the 'wilderness of dirty bricks' in the 'blackened' and 'half-derelict' North – Priestley was a proud Yorkshireman – he was also surprised to discover another England 'belonging far more to the age itself than to this particular island'. This was the England of 'arterial and by-pass roads, of filling stations and factories that look like exhibition buildings, of giant cinemas and dance halls and cafés, bungalows with tiny garages, cocktail bars, Woolworths, motor-coaches, wireless, hiking, factory girls looking like actresses, greyhound racing and dirt tracks, swimming pools, and everything given away for cigarette coupons'. It was the England of modern manufacturing buildings 'all glass and white tiles and chromium plate', making 'potato crisps, scent, tooth pastes, bathing costumes'. And it was the England – and the Britain – that helped to keep Aerofilms in business throughout the economic crisis.

Like Priestley, the Aerofilms pilots and photographers were travelling across the United Kingdom, flying further and wider than ever before in the search for new landscapes and new business. The factory heartlands that had once provided the company with a regular stream of image orders – the Midlands, Lancashire, Yorkshire and Tyne and Wear – were being bypassed in favour of rather more picturesque areas, from Devon and Cornwall to the coastlines of Wales and Scotland. The resulting images were turned into postcards or sold on to publishers and the print media – although such speculative flying was not without its hazards. As Francis Wills later recalled, it was around this time that the company was again under scrutiny from the government and the police, accused of 'photographing roof tops of country houses to aid cat burglars'. Over the course

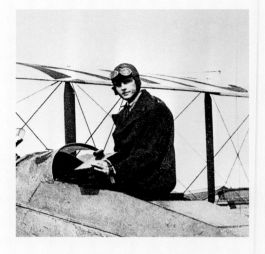

Cyril Murrell, one of the earliest Aerofilms photographers, holds a Thornton and Pickard camera originally developed at the front-line in the First World War.
c1925 ENGLISH HERITAGE. AEROFILMS COLLECTION

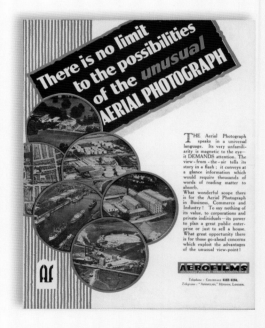

'What wonderful scope there is for the Aerial Photograph in Business, Commerce and Industry!' declared this Aerofilms advertising leaflet. 'The Aerial Photograph', they urged, 'speaks in a universal language. Its very unfamiliarity is magnetic to the eye – it demands attention.' c1928 BLOM ASA

Heston Aerodrome opened in 1929, designed to be a centre for flying clubs and private aviators. Its Customs House allowed the aerodrome to operate international as well as domestic flights.
c1930 ENGLISH HERITAGE. AEROFILMS COLLECTION

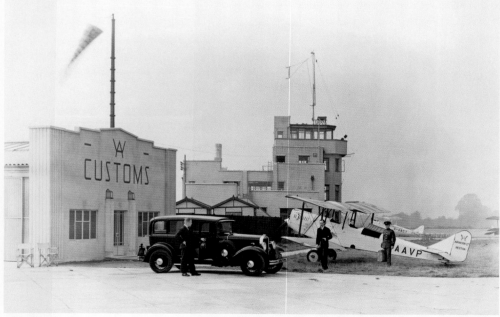

of 1930, the industrial orders that did come in were an eclectic roll call of modern manufacturing: Morris and Vauxhall Motor Cars, National Radiators, the General Electric Company's Electric Lamp Works, Billingham Chemical Works and Synthetic Ammonia Works, the United Sugar Company Sugar Beet Factory and MacFarlane, Lang and Co Imperial Biscuits. Just as they had done with the old industries, Aerofilms told new businesses 'what great opportunity there is for those go-ahead concerns which exploit the advantages of the unusual viewpoint!' The aerial photograph 'DEMANDS attention', they promised, and could be used for 'letter-headings, show-cards, small bill-posters or calendars, and has been proved to form a really useful, inexpensive method of advertisement'.

Despite this forward-thinking approach, Aerofilms did not escape unscathed from the economic downturn. In July 1930, the Aircraft Operating Company (AOC) Ltd – of which Aerofilms had become a subsidiary in 1925 – told *The Times* that 'Air surveys in many parts of the world, particularly in Africa and South America, have now become so large' that they had 'decided to concentrate on this work overseas and to relinquish… interest in the firm of Aerofilms Ltd, which has devoted itself specially to aerial photography in the British Isles'. A company called Airwork Ltd stepped into the breach, taking over the majority shareholding. In an echo of Claude Grahame-White's former business at the London Flying Club in Hendon, Airwork had just opened a new private aerodrome at Heston in Middlesex – complete with restaurant, lounge, clubrooms and offices. Aviation services offered on site included hangars, construction works, a foreign exchange, a customs house, and facilities and aircraft which allowed pilots to offer flying lessons. Aerofilms fitted neatly into this mix, and by August 1931, they had relocated to new showrooms at Heston, where they had 'on exhibition aerial, press and snapshot cameras suitable not only for those engaged upon press work, but also for those pilots who were keen amateur photographers… A complete

Heston was promoted as 'London's most accessible Aerodrome'. Aerofilms used on-site shop premises for exhibitions and to sell cameras and photographic equipment.
c1930 ENGLISH HERITAGE. AEROFILMS COLLECTION

Pictured on the right is Miss W E Clapham at work on her drawing board in Aerofilms' brand new Wembley office. A company employee from 1920, by 1936 she was head of the 'artists' department' and by 1940 was working for a salary of £3 14s 3d per week.
c1935 ENGLISH HERITAGE. AEROFILMS COLLECTION

photographic unit is stationed there well able to deal with commercial aerial photography.' Six months later, Aerofilms opened a second office in the basement of Bush House on Kingsway in central London – a necessary storage space for their substantial and continually growing image library. Over 33,000 glass plates had been created since 1919, and they advertised that 'any particular plate can immediately be reproduced'. At the same time, they also offered bespoke services creating covers for 'new novels', which were 'photographically produced in the Aerofilms studio', where 'many striking effects are obtained'. These designs were the work of Miss Clapham, the 'head of the artists' department' and a company employee since 1920. Multiple negatives were brought together to create spliced, composite images – 'faked' photo-montages constructed to fulfil specific client briefs.

The Aerodrome at Heston was something of a throwback to a different, pre-First World War age – and Airwork were quite open about their elitist approach. As *Flight* magazine reported, they had 'always made it their policy to encourage the people who consider themselves well up the social scale and who can afford more or less what they want in the way of aircraft'. On 22 July 1932, they held what was described as an 'aerial Ascot' at Heston, hosting the Household Brigade Flying Club for a meeting that 'bids fair to become the chief social event of the season in the flying world'. Edward, Prince of Wales, who would later abdicate the British throne over his relationship with the American divorcee Wallis Simpson, was the guest of honour. The Prince was a keen aviator – he even arrived at the event in a 'Puss Moth' after having opened the Royal Welsh Agricultural Show at Llanelli earlier that morning – and his rather louche, playboy reputation ensured the attendance of 'a galaxy of beauty' of 'not only the latest fashions but also the right people wearing them'. For *Flight* magazine, the 'debt of gratitude owed him for his part in furthering the cause of flying is very large indeed'. The Prince, they wrote, 'has not used aircraft to make his hard days easier, but has done so in order that he may cram still more public service into each twenty-four hours, and the way in which he does should make any sceptic ashamed of his doubts as to the utility of aircraft'.

This striking shot of a DC-3 in flight was an advertising image produced by Aerofilms for Nigel Norman, the co-founder – with Frederick Muntz – of Airwork Ltd and the Heston Aerodrome.
c1936 ENGLISH HERITAGE. AEROFILMS COLLECTION

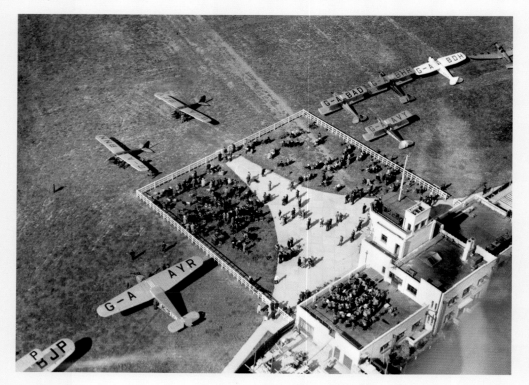

Printed in *Flight* magazine in July 1931, this Aerofilms image captured the moment when Edward Prince of Wales landed at Heston Aerodrome in his Puss Moth, to attend the glamorous meeting of the Household Brigade Flying Club. Seen here on the Club House roof overlooking the assembled crowd is the band of the Grenadier Guards. 1931 EPW036078

For Airwork, the event – photographed, of course, by Aerofilms – was invaluable publicity. Although targeted directly at high society, it highlighted the continuing need to promote the civil aviation industry to the public, politicians and the establishment – a need made ever more acute by the dire economic climate. It was in this same spirit – although rather more democratic in outlook – that Alan Cobham launched his National Aviation Day. Between 1932 and 1935, he toured hundreds of locations across Britain. Heston was one of the venues, but so too were towns and villages without aerodromes, where Cobham looked to recreate the 'barnstorming' shows first popularised in America in the 1920s – so called because aircraft would use farmers' fields as runways, and barns as temporary hangars, as they put on aerial displays. Cobham's strength was his 'faculty of knowing what the man in the street appreciates, and without making his show vulgar he managed to incorporate enough spectacular turns to please John Citizen and Jane, his wife, while not forgetting the educational side'. As the official photographers of National Aviation Day, Aerofilms flew alongside the show aircraft, and captured, often at incredibly close range, a series of dangerous and thrilling stunts ranging from loop-the-loops and wing-walking to low altitude parachute jumps. Once again – and perhaps unsurprisingly – *Flight* magazine was convinced that these entertainments would 'do a tremendous amount of good in getting people all over the country to talk aviation, think aviation and practise aviation'.

In June 1935, perhaps encouraged by the economic upturn in the wake of the Depression, Aerofilms left Airwork, and struck out on their own. Within a year, they were back under the umbrella of their former parent company, AOC Ltd. Rather than a financial necessity, however, this may well have been a calculated move by Wills. Increasingly, he was determined to explore the commercial possibilities of vertical aerial photography. While this preoccupation cost him the services of long-standing photographer Cyril Murrell – who was a resolute 'oblique man' – it also had far-reaching consequences for the future of the company. Increased integration between Aerofilms and AOC combined British-based photographic expertise with mapping knowledge developed during overseas work, including extensive surveys of Iraq and Iran. Aerofilms continued to court the Ordnance Survey – which was struggling to update maps after government budget cuts – and in 1936 carried out a £5-per-square-mile contract which demonstrated the cost-effective potential of aerial photography for map revision.

For a long time, creating maps from 'photo-mosaics' had been a seemingly homespun – yet incredibly effective – process. As an early 'air surveyor' described, photographic prints were 'pinned down with drawing pins along one side only. Each strip was then flapped up and a length of garter elastic was stretched underneath, secured by two pins, one at each end, and each print was

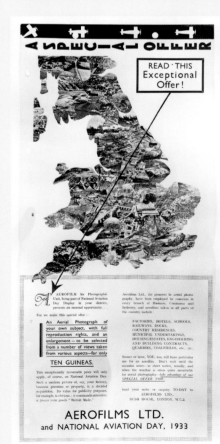

AEROFILMS LTD.
and NATIONAL AVIATION DAY, 1933

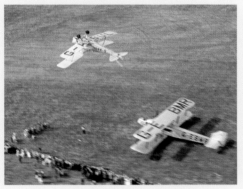

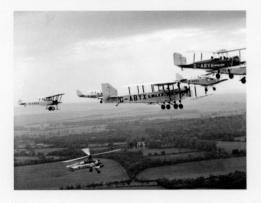

An advertising leaflet (left) produced in association with National Aviation Day (above). The leaflet presents Aerofilms as synonymous with aerial photography. In predicting that everyone would 'have particular use for an aerofilm', they underlined their place as brand leader. 1933 BLOM ASA, 1932 EPW037626, 1932 EPW039906, 1933 EPW041039

stuck to the elastic by means of blobs of Johnson's photo moutant. The lengths of the strips could now be adjusted so as to occasion small but equal misfits between prints by simply altering the tension in the elastic… When the best possible fit had been effected, many more drawing pins were used to pin everything down firmly.' Since the early 1930s, however, Wills had been travelling to Germany and Switzerland to observe the very latest technological developments. Key to this was the discipline of photogrammetry: a method of creating accurate readings of space and distance from aerial photographs. On the continent, advanced new devices – with intimidating names like the 'Wild A5 Stereo Autograph' and 'Professor Hugershoff's Zeiss Aerocartograph' – were revolutionising the process of photogrammetry. Wills realised what this could mean for business – and he was one of a handful of men at the forefront of bringing this specialist knowledge back to Britain.

What he did not know, however, was quite how important this newly acquired expertise would prove to be. As the 1930s progressed, Europe once more became a tinderbox of political tension. Less than two decades after the horrors of the Great War, the world appeared to be lurching inexorably towards another all-consuming conflict. Wills' company – staffed by ex-servicemen and specialising in aerial photography and map-making – was suddenly of great interest to Military Intelligence.

For Aerofilms, King and country were about to come calling.

In times of financial crisis, all eyes look – or, in the case of this image, all roads lead – to the Bank of England. Rather appropriately, as the world economy was enduring a catastrophic slump, Britain's main bank was being rebuilt from the ground up. Between 1925 and 1939, Herbert Baker tore down Sir John Soanes' nineteenth century masterpiece – an act which Sir Nikolaus Pevsner called an 'architectural crime' – and built a brand new building on the same Threadneedle Street site. Herbert's new bank was much larger and more imposing – rising seven storeys high and descending three storeys below ground, to accommodate both extra staff and a series of massive gold vaults. 1932 EPW037970

Aerofilms moved to new offices on Beresford Avenue in Wembley in January 1937. 'With the expansion of the business,' recalled Francis Wills, 'we realised that production work would be better situated outside the centre of London.' These custom-built premises allowed Wills and his company to further diversify and develop their technical skills, with vertical aerial photography and photogrammetry increasingly in demand for commercial mapping and survey contracts.
c1937 ENGLISH HERITAGE. AEROFILMS COLLECTION

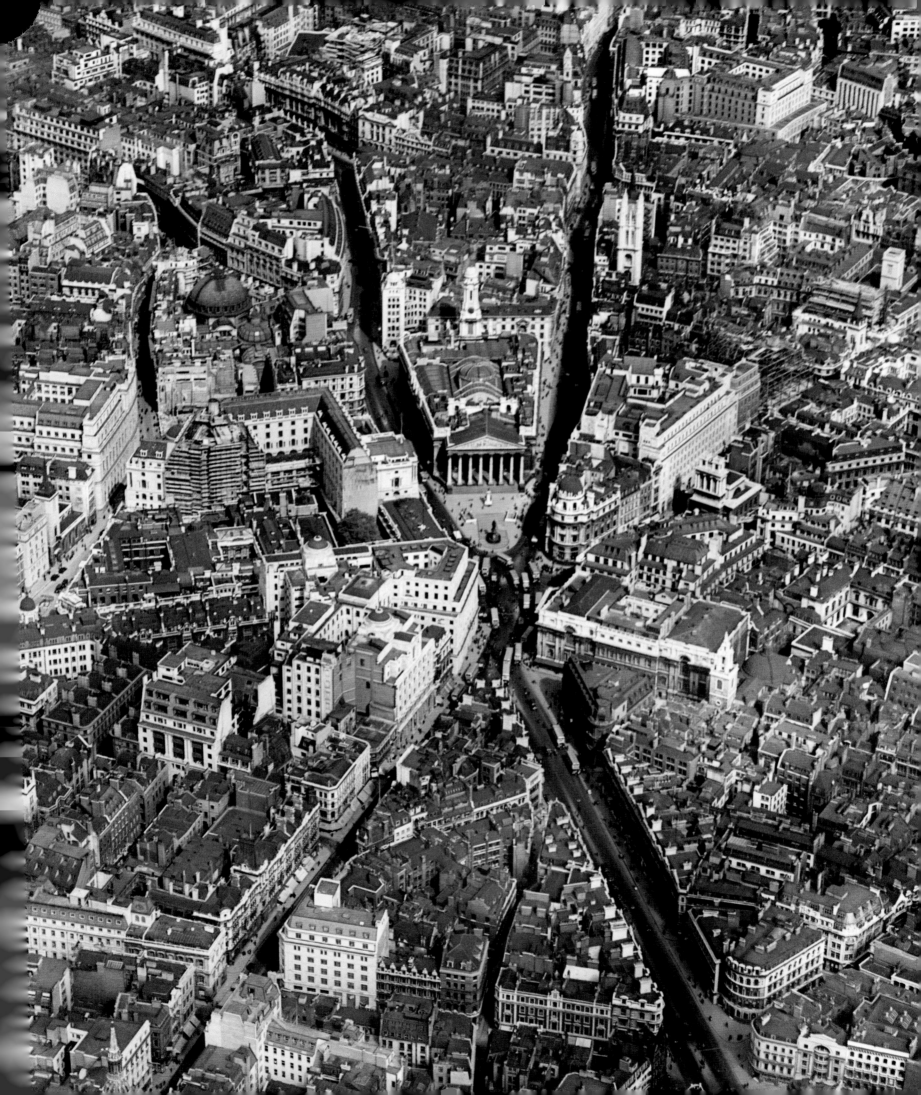

From very early on, industrial clients – like the National Smelting company pictured here in the Swansea Valley – were central to the Aerofilms business model. The company courted the owners of factories, warehouses, power stations, dockyards, railyards, collieries and quarries, sending unsolicited aerial photographs of their premises in an attempt to secure interest. One technique was to sell 'Aero Envelopes' – aerial photographs printed on company stationery. According to the Aerofilms sales pitch, businesses could, by showing the full extent of their works, demonstrate the 'proof of the popularity' of the goods they produced. 'By the general use of these envelopes,' Aerofilms promised, 'one can illustrate many facts to every correspondent, thus securing free publicity.' 1934 WPW043642

In their approaches to potential customers, Aerofilms emphasised both the decorative and the practical benefits of the aerial photograph. 'It presents a picture which arouses curiosity by its novelty, and admiration by the wealth of information portrayed.' The customer 'just as if he were in the cockpit… sees the Works, Property or other area under review truthfully and accurately displayed'. The result, they claimed – and as illustrated here in this 1935 image of the Anglo Continental Guano Works at Silvertown on the banks of the Thames – was that viewers could 'pick out at once the nature of the surroundings, the available routes for transport, the accessibility to sources of supply – all these essential details which only the photographic "birds-eye-view" can show'. 1935 EPW046554

A 1934 book entitled *The Lure of the Grid: Plain Facts About Electricity in the Home*, described how 'great central generating stations have been built and equipped with expensive machinery; steel pylons have been erected all over the country to carry electrical energy to houses, factories and farms'. Only one thing, it said, was lacking: 'There are not enough people who are willing to buy the electricity that is produced; and those who do buy it do not buy enough.' Very soon, however, the growth in electricity users in Britain was the fastest in the world, rising from three quarters of a million in 1920, to 9 million by 1938. Pictured here on the bank of the Lee Navigation is the huge, blocky structure of the Brimsdown coal-fired power station. Built between 1904 and 1907 by the North Metropolitan Electric Power Supply Company, Brimsdown became a key supplier of electricity powering London's infrastructure. In September 1935, just a few months after this photograph was taken, a major fire at the power station resulted in a blackout that saw the interruption of the city's tube and tram services, and forced a number of factories to close down production.

1935 EPW047123

The dark, stocky mass of Tir John Power Station was built between 1931 and 1935 by the Swansea Corporation as part of an unemployment relief scheme. Burning low cost anthracite duff – a waste product produced and supplied by a nearby colliery washing coal at the pithead – Tir John became the largest power station in Britain, with a potential output of some 155 megawatts. Through an agreement with the Great Western Railway Company, sea water was drawn through an underground tunnel from Swansea's King's Dock to act as a coolant for Tir John's condensers. The scale of the station's output required around six million gallons of water per hour – reputedly Tir John had to close for a week every two years to remove the thousands of mussel shells that would build up in the inlet tunnel. 1936 WPW061694

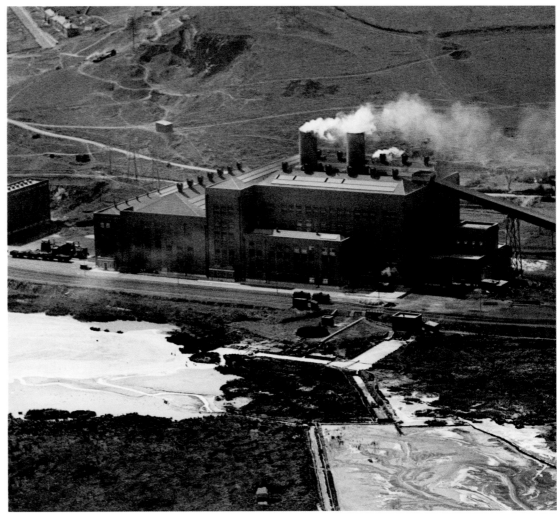

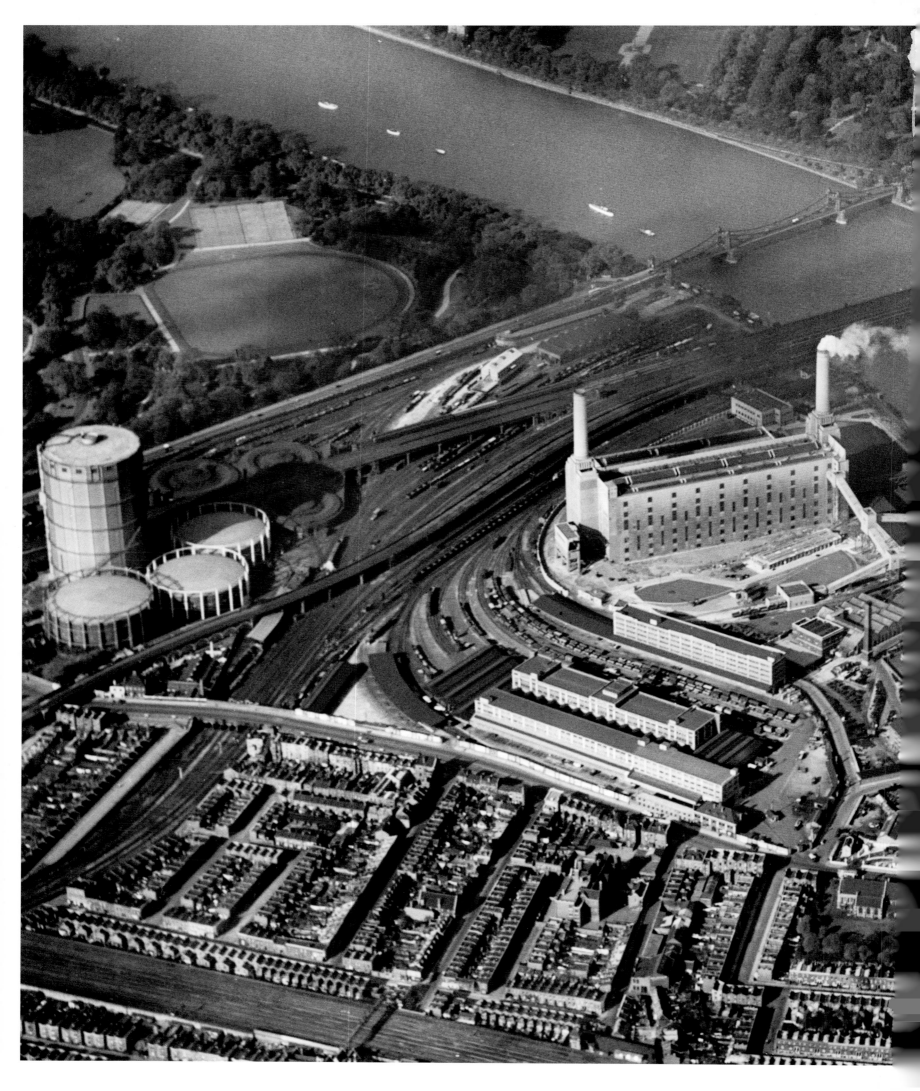

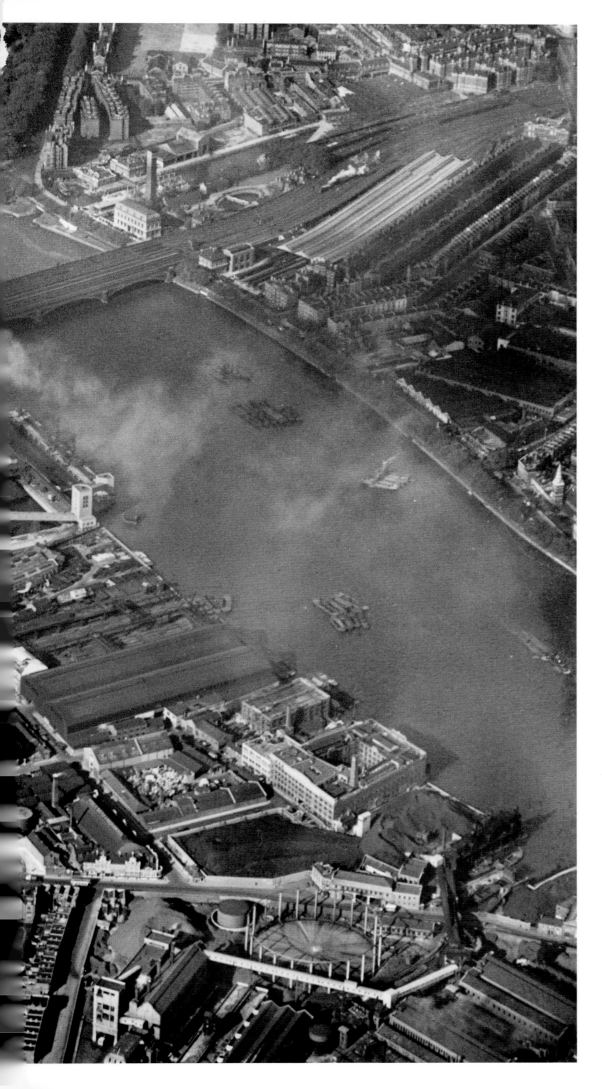

A great plume of smoke billows out of one of Battersea Power Station's distinctive white chimneys. What is perhaps most striking about this image is that there are only two chimneys, not the four we associate with the building today. Battersea was in fact two power stations – designated A and B – with A built between 1929 and 1935, and B not fully operational until 1955. The vast scale of the structure symbolised an escalation in industrial development. Designed as an Art Deco monolith by Sir George Gilbert Scott – who was also responsible for the iconic red telephone box – Battersea was one of a new breed of super power stations, built to feed the revolutionary 'National Gridiron' electricity system. When Aerofilms took this photograph in October 1933, the new system had only just been switched on for the first time. Although Battersea A was still under construction, it had already been pressed into service in order to feed the 'grid'.

1933 EPW043591

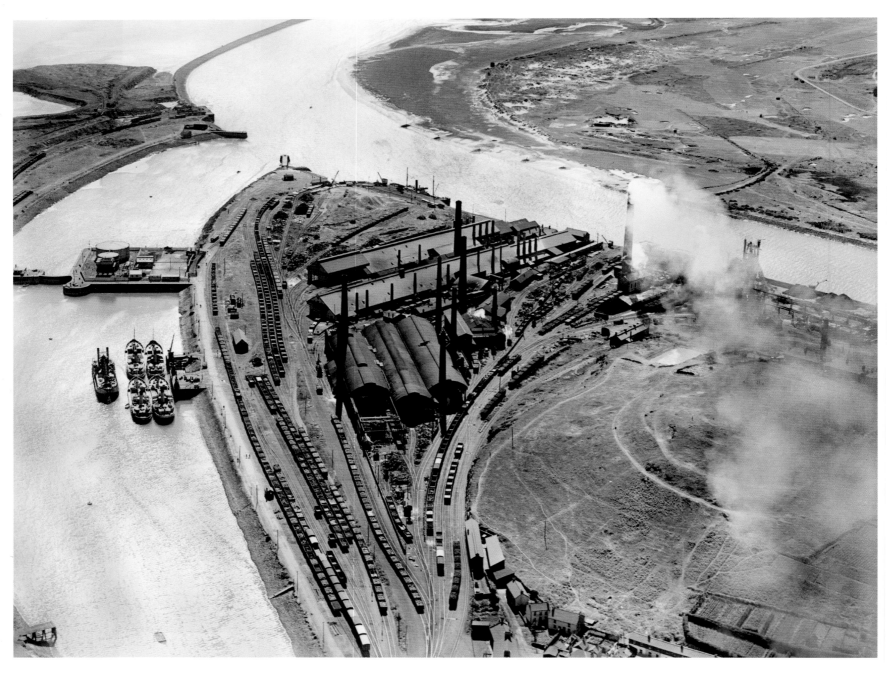

ABOVE

An ironworks had first been established at Baglan Bay near the mouth of the River Neath in the 1840s. Over time it became one of the key industrial centres of south Wales – ideally placed to receive ironstone and coal shipped by canal from the mines and quarries of the Neath Valley, and built with riverside quays to allow finished products to be transported directly on for sale. The Briton Ferry Dock – a state-of-the-art floating dock and tidal basin that covered an area of over 73 hectares – was opened at Baglan in 1861 to a design by Isambard Kingdom Brunel. Seen here on the left, the dock brought even more industrial development, resulting in steel, tinplate and coke works all clustering together alongside the original ironworks on this one spit of land. 1934 WPW045725

RIGHT

With a water area of nearly 250 acres, the Royal Docks at East Ham in London formed the largest enclosed docks in the world. Comprising the Royal Victoria, King George V and Royal Albert Docks, they specialised in the importing, unloading and transportation of food products. Despite the impact of the Depression, for the year ending 31 March 1934, just before this photograph was taken, the Docks had recorded handling a total weight of goods in excess of 1.1 million tons. Dockyards had always been a strong source of business for Aerofilms, and in their advertising literature the company emphasised the particular value of aerial photography for capturing their size and scale. 'From the ground one could see nothing but the hull of a great liner and the line of the quay. From above one is enabled to perceive the whole system of quays and sheds, the placing of the vessels, and the impression is suggested of a well planned scheme of transport working with a beautiful smoothness and precision'. 1934 EPW044121

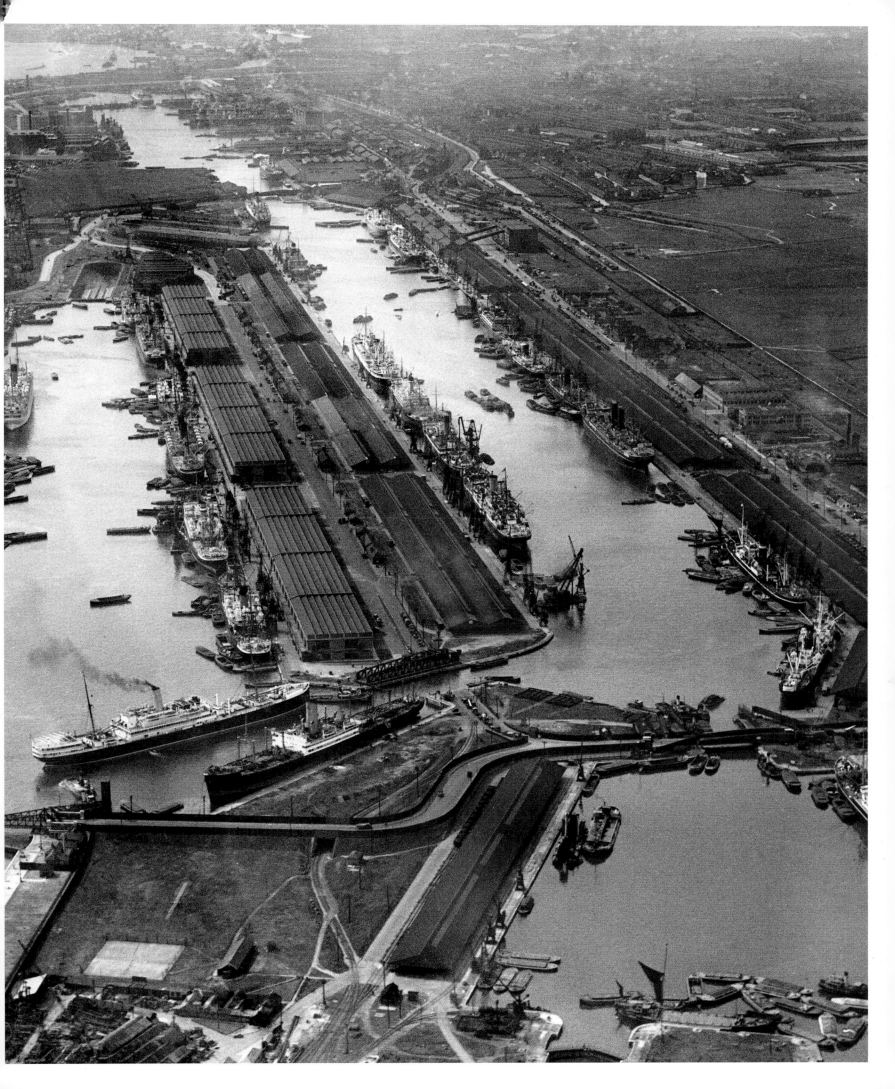

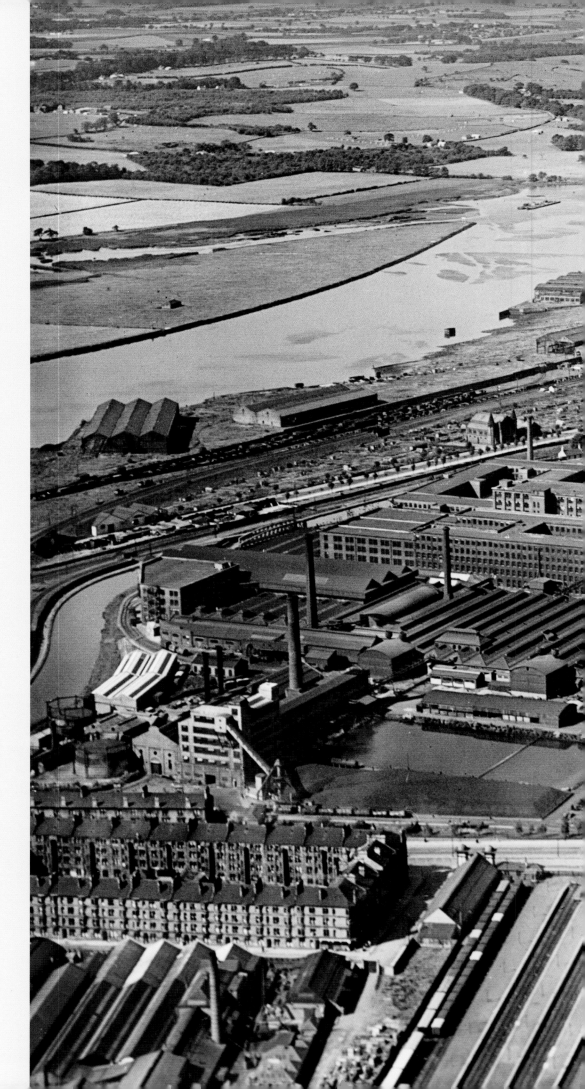

Built on 46 acres of farmland at Kilbowie in Clydebank, the Singer Sewing Machine Factory was for a time the largest factory of its kind in the world. First completed in 1885, its two main buildings were 800 feet long, 50 feet wide and three storeys high. This was a late-Victorian factory on a colossal scale, a machine for mass production that filled its nearly 1 million square feet of space with over 7,000 employees making some 13,000 new sewing machines every week. By the start of the twentieth century, demand continued to exceed supply, and so the main buildings were doubled in height to six storeys, increasing the workforce capacity to nearly 12,000. At the centre of the site, marking out the hours between the morning and evening factory hooters, was the colossal, 200-foot-tall Singer clocktower – once the second highest timekeeper in the world. Today, this huge complex of buildings has disappeared entirely – referenced only in the name of the Singer Station, seen here on the far right of the image, which still remains as a stop on the modern Glasgow train network.
1934 SPW045861

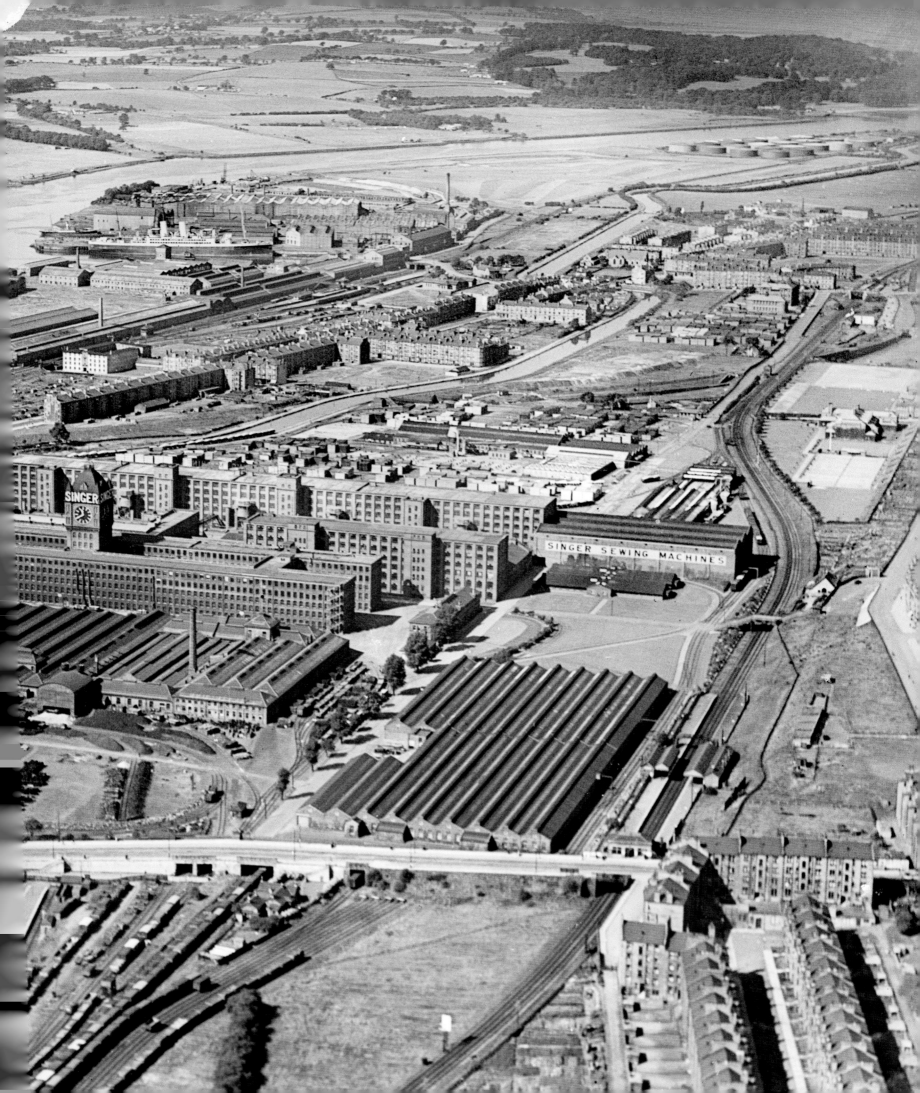

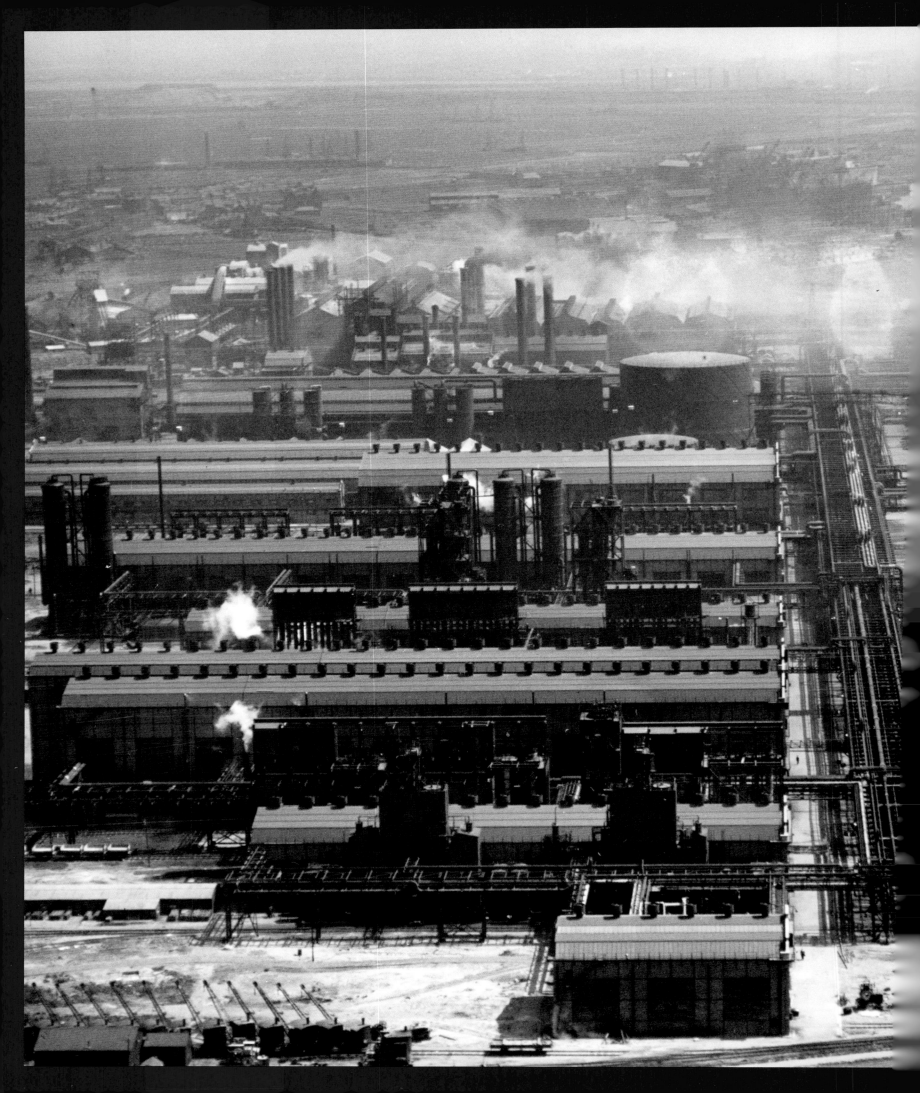

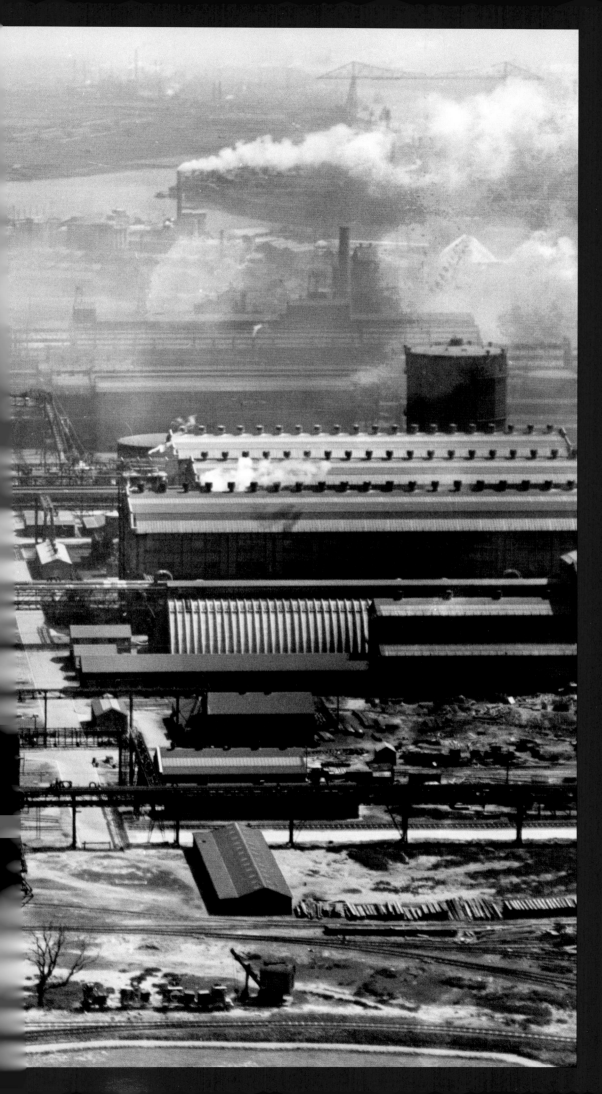

In 1926, the writer Aldous Huxley visited this vast industrial plant at Billingham near Middlesbrough. Its owners were a major new conglomerate – Imperial Chemical Industries Ltd (ICI) – a company formed that same year from the merger of Nobel Industries, Mond and Company, the United Alkali Company and the British Dyestuffs Corporation. Built over several hundred acres, the new plant was designed for the production of synthetic ammonia – primarily for use in fertilisers – and it was one of the most advanced and cutting-edge industrial complexes of its time. Huxley was amazed by what he saw, describing Billingham as a 'triumphant embodiment' of modern planning, and 'an ordered universe… in the midst of the larger world of planless incoherence'. *A Brave New World*, Huxley's ground-breaking 'novel about the future', was first published in 1932, and his tour of the Billingham works served as a major inspiration for the book's vision of a twenty-sixth-century society transformed by industrial science. He even named one of his characters – Mustapha Mond, the 'World State Resident Controller of Western Europe' – after Sir Alfred Mond, the first-ever chairman of ICI.
1930 EPW032745

When Henry J Heinz first founded his bottling and canning business in Pittsburgh in 1869, he can barely have imagined that he would go on to create one of the world's most enduring consumer brands. His success may have been down, in no small part, to an instinctive and pioneering excellence in marketing. In 1896, he introduced the company's famous '57 Varieties' slogan – advertising the number of different 'pure food products' Heinz had to offer. This figure was entirely arbitrary – '5' was his favourite number, and '7' was his wife's – and was inspired by an advertisement he spotted in New York, for a store boasting '21 styles' of shoes. The company's all-encompassing commitment to brand values is made clear in this 1934 Aerofilms image of the Heinz Food Factory at Harlesden. The Heinz name sits above the factory entrance – which looks remarkably like the logo of a baked beans tin – and runs up a central chimney, while the '57 varieties' slogan is repeated along a side-wall, and the number 57 is positioned at both ends of the main building's façade. In this same year, Heinz offered 'to send a birthday present, free and carriage paid, to everybody whose 57th birthday falls on any day in October 1934'. The present was 'an assortment of soup for the birthday party', with a 'double assortment' offered to any couples celebrating 57 years of marriage. 1934 EPW044843

Aerofilms were acutely aware both of their own value as a unique brand – they called themselves 'the pioneers of Commercial Aerial Photography... glad to place their specialized knowledge at your disposal' – and of the services they could offer to established consumer businesses. This image from 1932 captures the Ovaltine Egg Farm at Abbots Langley, over 300 acres of land with accommodation for 100,000 hens. As an Ovaltine company advert of the time claimed, 'By scientific feeding and the use of prize-laying strains of fowls, the eggs obtained are markedly superior in nutritive value than ordinary eggs.' Aerofilms imagery of the farm – showing a mock-Tudor horseshoe house leading to ordered rows of chicken runs stretching off into the distance – was used to illustrate an article in *Country Life* in June 1932. Called 'A Model Egg Farm: Modern Scientific Methods Applied to Large-Scale Poultry Farming', the piece – and the photography – were key branding tools to emphasise that Ovaltine eggs were 'the best and finest obtainable'. 1932 EPW037949

To the *Illustrated London News*, writing in
1933, the opening of the new British factory
Headquarters for the American company
Hoover presented a vision for the industrial
landscape of the future. Here, on the Western
Avenue at Perivale on the outskirts of London,
was 'a gleaming palace in dazzling white and
red, with soaring white towers, the walls
almost all glass, set like a glittering gem in the
midst of green lawns and gay flower beds'.
It was buildings like the Hoover factory that
so confounded the writer J B Priestley's 'idea
of what a proper factory should look like'
when he embarked on his *English Journey*
in the autumn of that same year. Instead of
a 'grim blackened rectangle with a tall
chimney at one corner', here was a 'charming
little fellow' where Priestley felt he could
'safely order an ice-cream or select a few
picture postcards'. Built in an Egyptian-
influenced Art Deco style, the Hoover
factory belonged to a landscape 'where the
smooth wide road passes between miles of
semi-detached bungalows, all with their little
garages, their wireless sets, their periodicals
about film stars, their swimming costumes
and tennis rackets and dancing shoes'.
For Priestley, if Britain could somehow
make a living out of 'the concerns
behind these pleasing facades… what
a pleasanter country this would be, like a
permanent exhibition ground, all glass and
chromium plate and nice painted signs
and coloured lights. I feel there's a catch
in it somewhere.' 1932 EPW039561

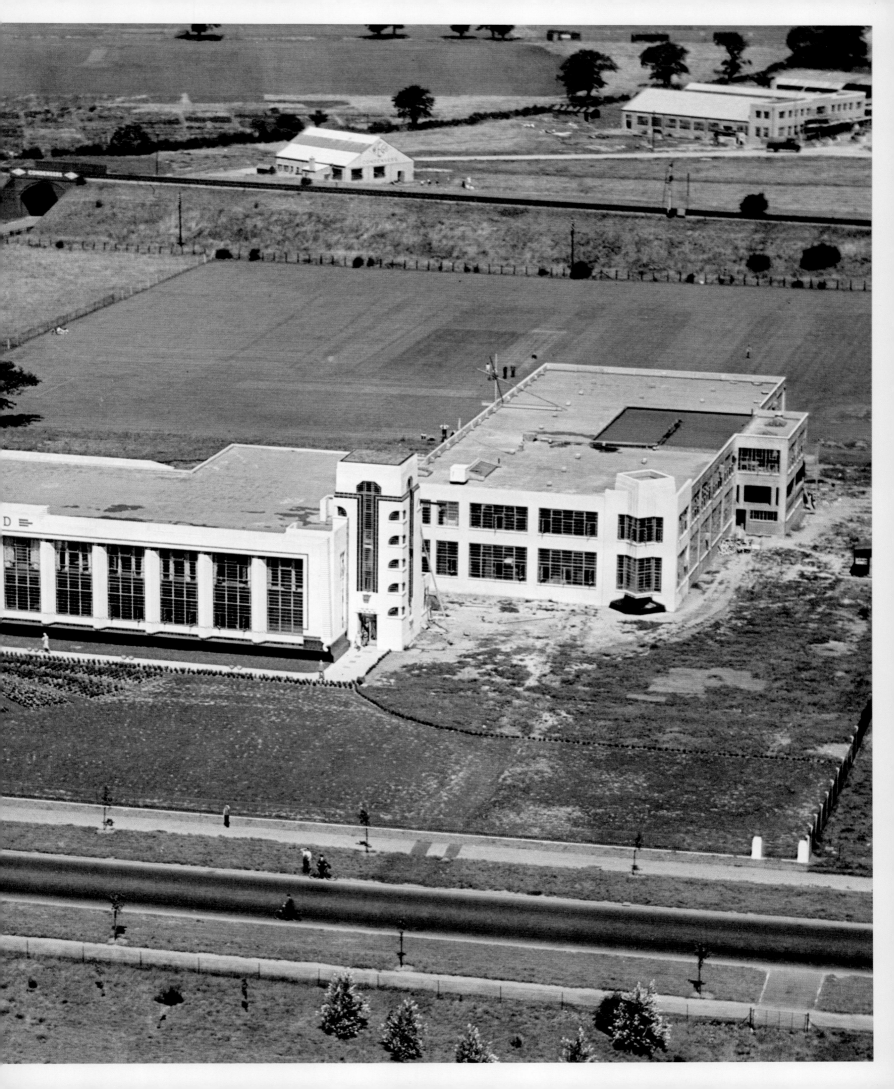

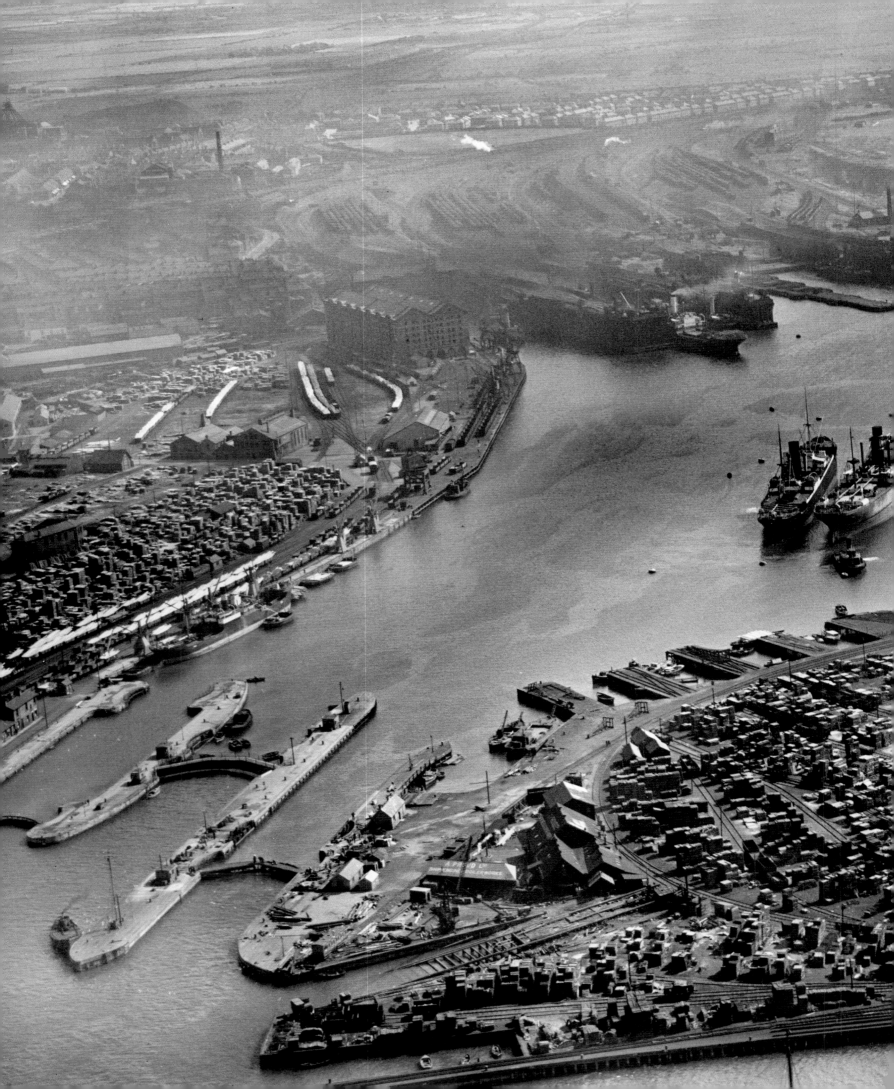

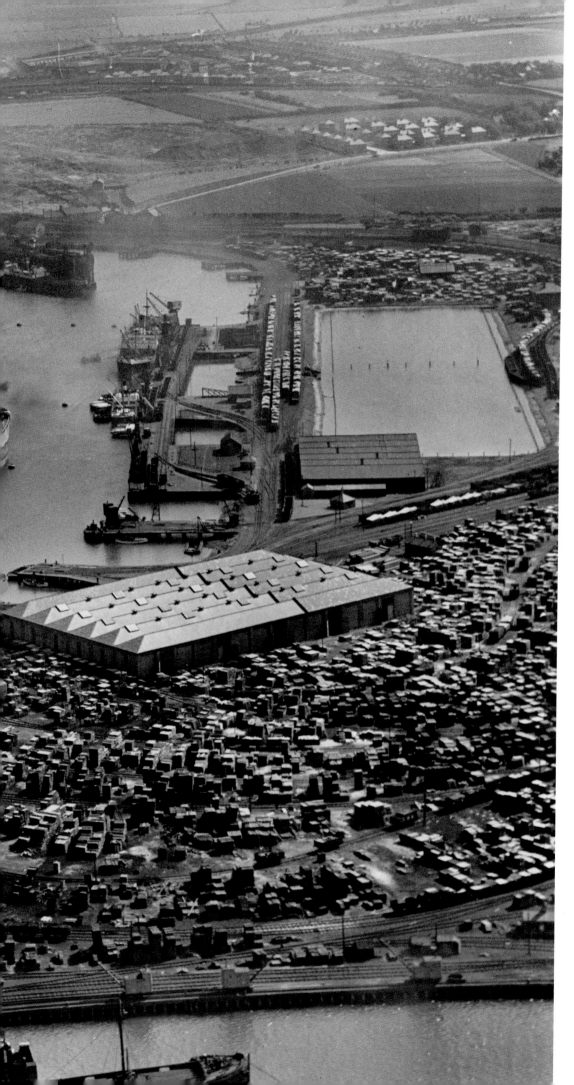

In her 1939 book *The Town that was Murdered*, Ellen Wilkinson, the Labour MP for Middlesbrough East, described Jarrow as 'utterly stagnant. There was no work. No one had a job except a few railwaymen, officials, the workers in the co-operative stores, and a few workmen who went out of the town… if people have to live and bear and bring up their children in bad houses on too little food, their resistance to disease is lowered and they die before they should.' This 1935 photograph of Palmer's Shipyard – which, before its closure four years earlier, had employed almost the whole male population of the town – is a vivid picture of industrial desolation. In August of 1935, the London and North Eastern Railway announced that it would rebuild the West Quay of the dock – seen here in the top right – in an attempt to reinvigorate the area through the import and export of coal and timber. It did little, however, to arrest the town's chronic decline. The following year, in October 1936, a group of 200 Jarrow men embarked on a 300-mile, 25-day march to London, to present an 11,000-signature petition to Parliament. Their aim, as outlined in a report sent from the Ministry of Labour to the Home Office, was 'for the purpose of drawing the attention of the Government to the Unemployment position in the town, and in the hope that by this means the position of Jarrow will obtain wide publicity and sympathy of the general public resulting in the establishment of industry to provide work for unemployed men'. 1935 EPW048811

Pictured in July 1935, passenger carriages sit in the sidings of the Hollingwood branch line of the Lancashire and Yorkshire Railway at Cheetham Hill in the north-east of Manchester. There is a stark stillness to this photograph that captures the Depression as a creeping disease – bringing an absence of people and activity to Britain's former industrial heartlands. Here, abandoned industry lies on top of abandoned industry. The derelict land above the railway carriages is a remnant of a series of clay pits, brickworks and kilns that were closed down towards the end of the nineteenth century. 1935 EPW048637

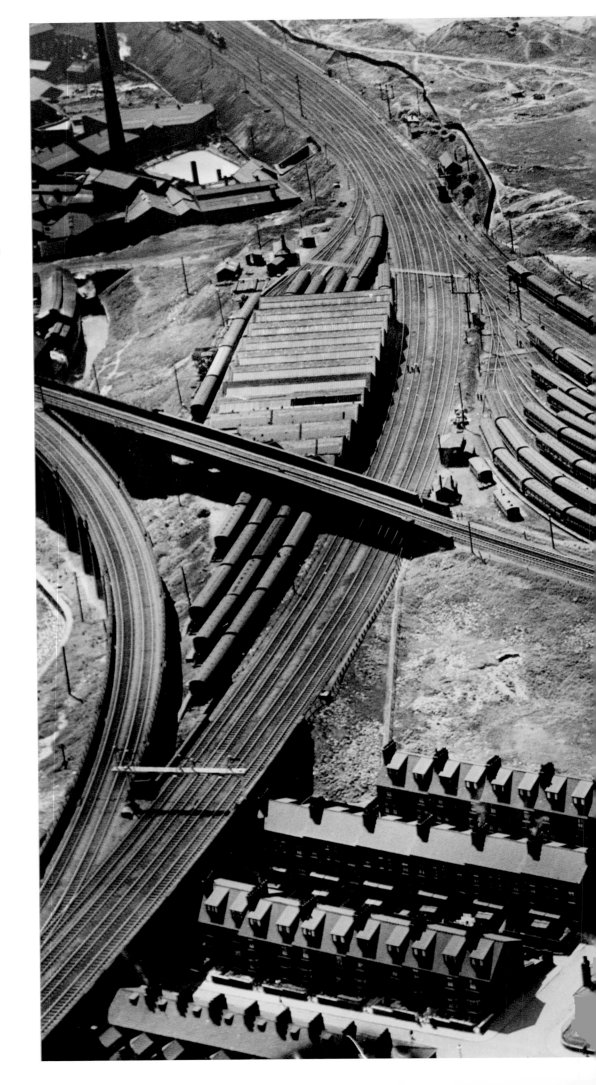

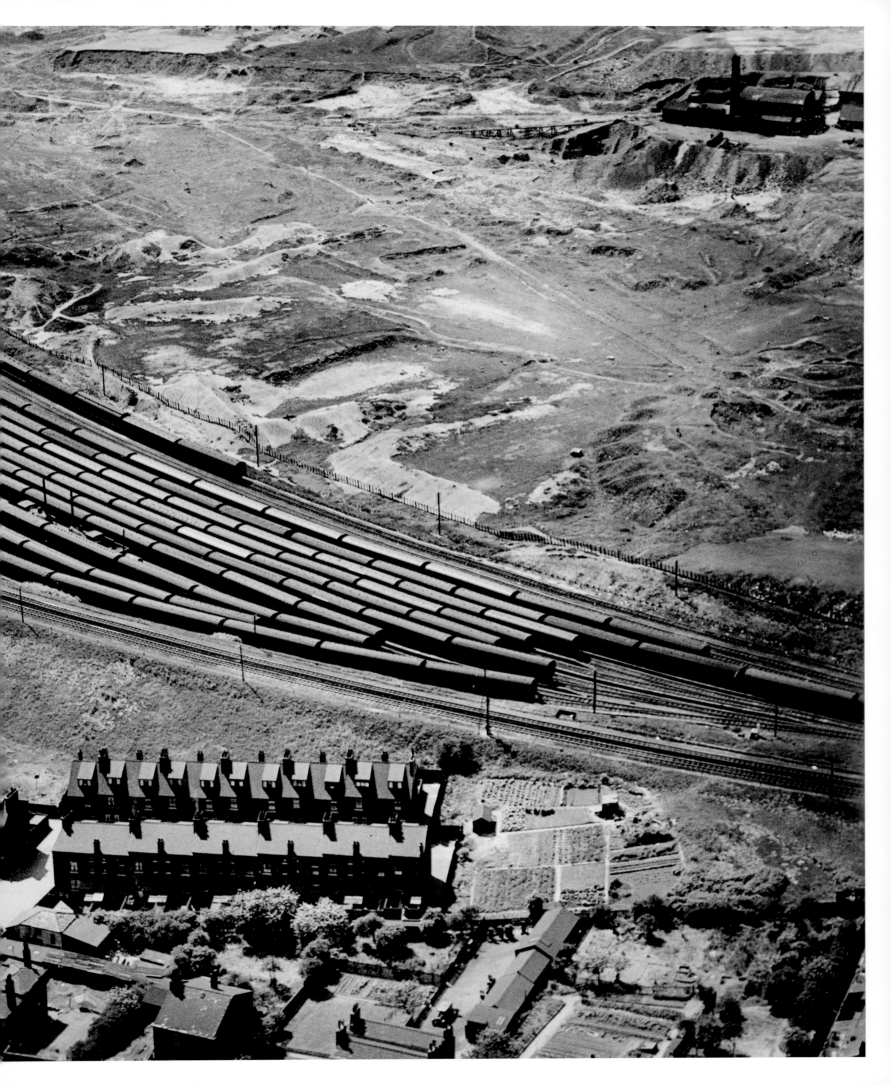

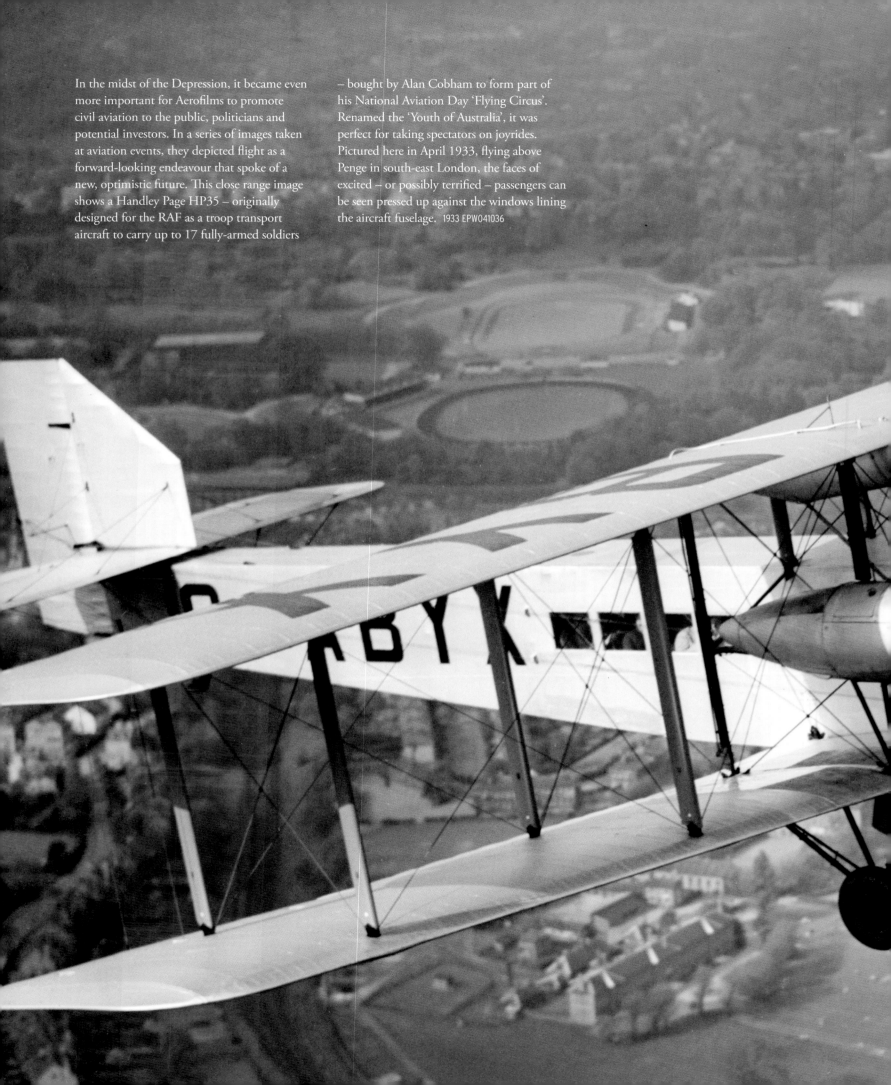

In the midst of the Depression, it became even more important for Aerofilms to promote civil aviation to the public, politicians and potential investors. In a series of images taken at aviation events, they depicted flight as a forward-looking endeavour that spoke of a new, optimistic future. This close range image shows a Handley Page HP35 – originally designed for the RAF as a troop transport aircraft to carry up to 17 fully-armed soldiers – bought by Alan Cobham to form part of his National Aviation Day 'Flying Circus'. Renamed the 'Youth of Australia', it was perfect for taking spectators on joyrides. Pictured here in April 1933, flying above Penge in south-east London, the faces of excited – or possibly terrified – passengers can be seen pressed up against the windows lining the aircraft fuselage. 1933 EPW041036

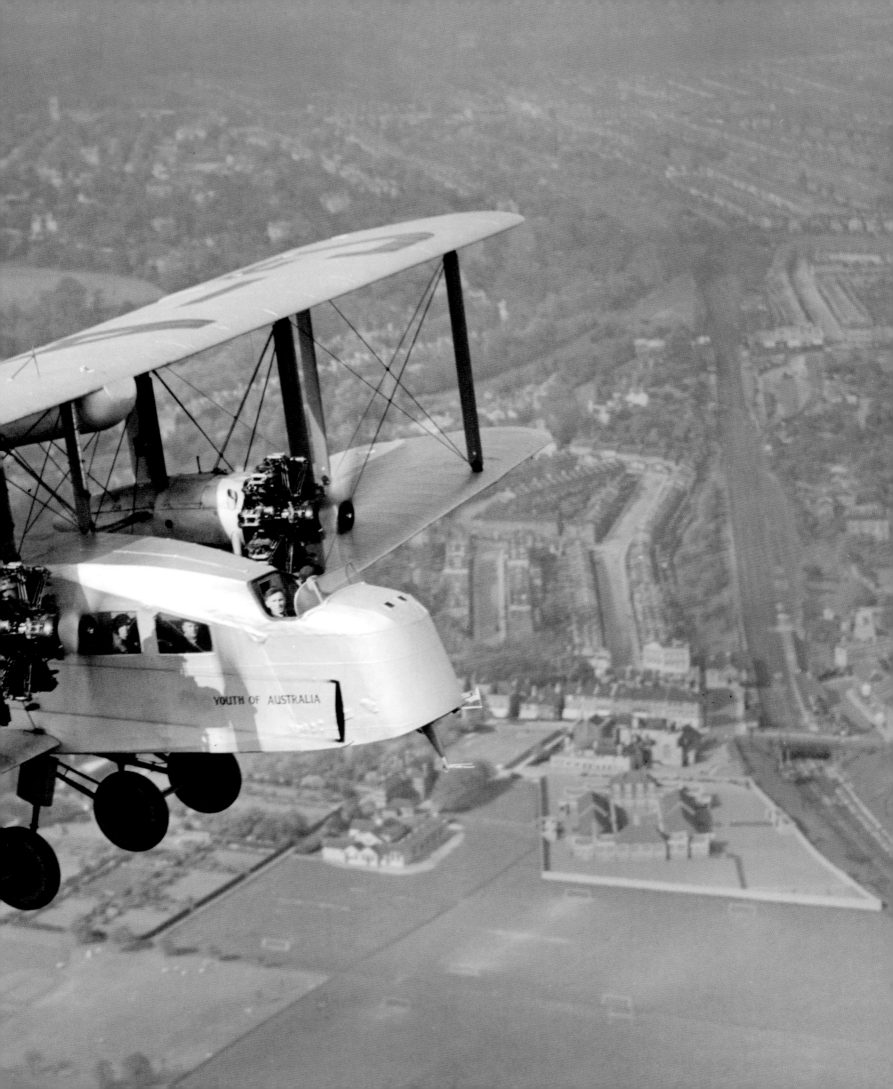

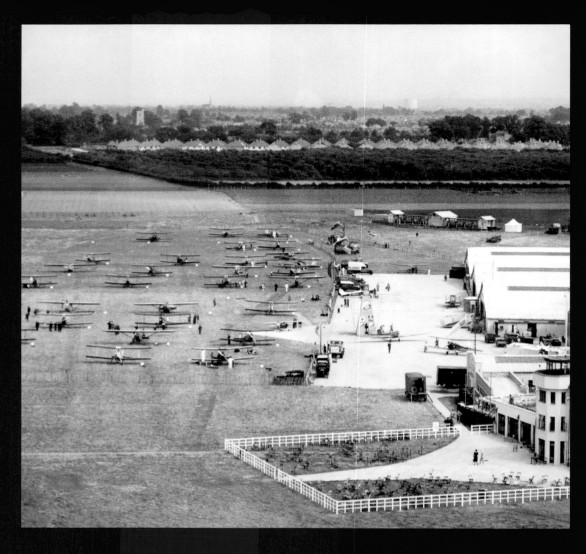

Aircraft take up their positions on the grass of Heston Aerodrome for the start of the 1931 King's Cup Air-Race. First established by George V in 1922, and organised and judged by the Royal Aero Club Racing Committee, this was an 'around Britain' race that saw aircraft navigating through a series of control points. In the year this photograph was taken, the 41 entrants – 37 men and 4 women – raced in a 980-mile loop that passed through Leicester, Norwich, Nottingham, Brough, Sherburn, Castle Bromwich, Woodford, Shoreham, Hamble and Whitchurch, before returning to Heston. 1931 EPW036120

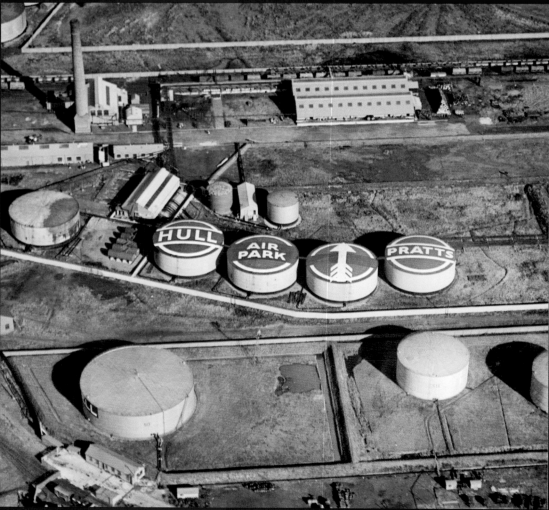

Four motor oil containers at a Pratt's depot at Salt End helpfully point any passing pilot in the direction of Hull's Hedon aerodrome. Pratt's – who would be rebranded 'Esso' in 1935 – were one of a number of companies, including British Petroleum, who promoted and sold their oil to aviators. Clearly the prospect of future business from the aircraft industry justified the time and expense involved in creating this elaborate advertising gimmick – which could, of course, only be seen from the air. 1930 EPW034639

Seven National Aviation Day aircraft –
including a rather bizarre-looking contraption
called an auto gyro – fly in formation above
Cranford in one of Alan Cobham's displays
in April 1933. As *The Times* reported in that
same month, 'The place of aviation among
popular spectacles is apparently growing, and
not many English towns of any size will be left
unvisited this summer by one or other of the
"circuses" which are now taking to the air.'
1933 EPW040990

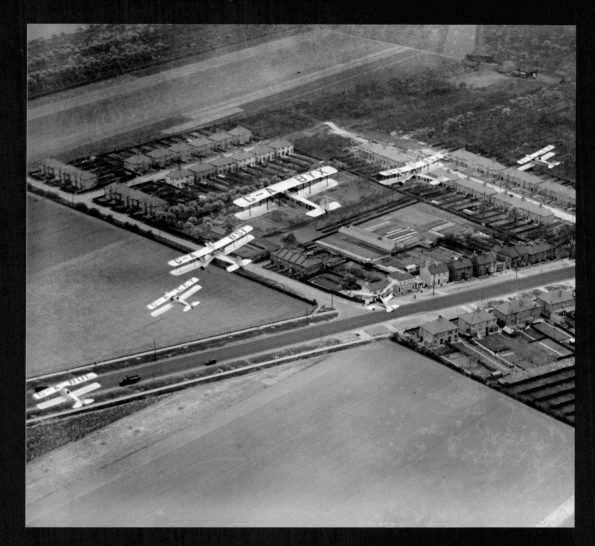

A parachutist descends to earth in a daredevil
stunt from a 1933 National Aviation Display.
There were two regular parachutists in
Cobham's team – Ivor Price and Naomi
Heron-Maxwell. Tragically, Price died at
a display at Woodford in 1935, when his
parachute failed to open. 1933 EPW041040

Increasingly, Aerofims imagery was proving its worth in helping with the planning and construction of major infrastructure projects. This picture-postcard image of Longsleddale Valley in the Lake District – showing Kentmere Pike and Shipman Knots on the left, and Grey Crag and Tarn Crag on the right – was one of a large number commissioned by the Manchester Corporation Waterworks. Manchester's growing population demanded an ever-greater supply of fresh water, and the aerial survey helped to inform the design of a 134-kilometre-long aqueduct running from Hameswater reservoir in Cumbria to Heaton Park Reservoir in Prestwich. Construction took place throughout the 1930s, 1940s and 1950s, with Aerofilms contracted to take photography at various stages in the development. 1935 EPW048581

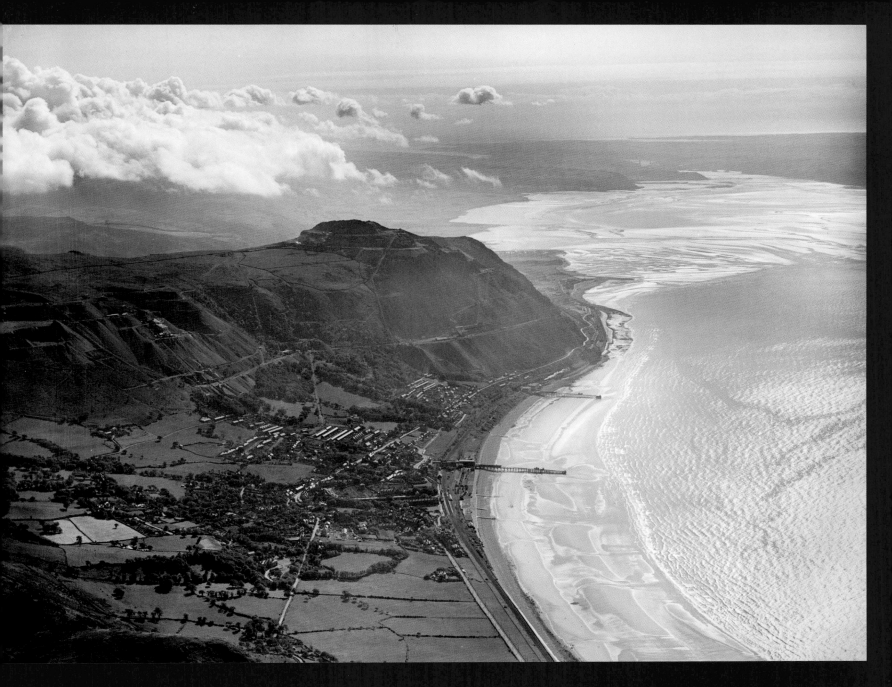

Aerofilms' photography for the Manchester Corporation Waterworks showed a new and novel way of transforming natural features into physical resources. By contrast, in this picturesque view of north Wales Aerofilms captured an image of the human use of the landscape going back several thousands of years. This stretch of coastline – known as Penmaenmawr, Welsh for 'Great Headland of Stone'– had been quarried from prehistory up to the modern day. Said to be the hardest stone in Britain, axe heads of Penmaenmawr granite have been discovered at archaeological sites throughout the country. In the nineteenth century the stone was used to provide ballast for railways built around the world, and in the twentieth century it formed the runway foundations for the many airfields and aerodromes constructed in the 1920s, 1930s and 1940s. 1934 WPW045178

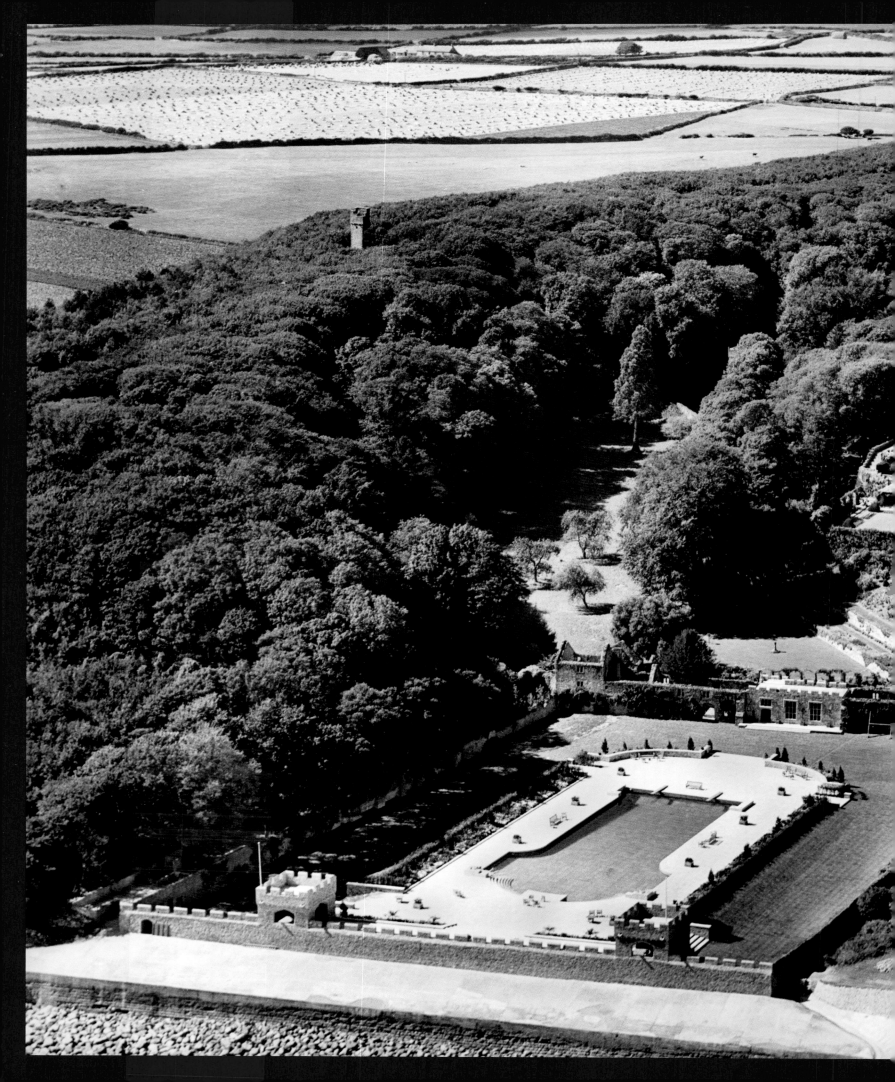

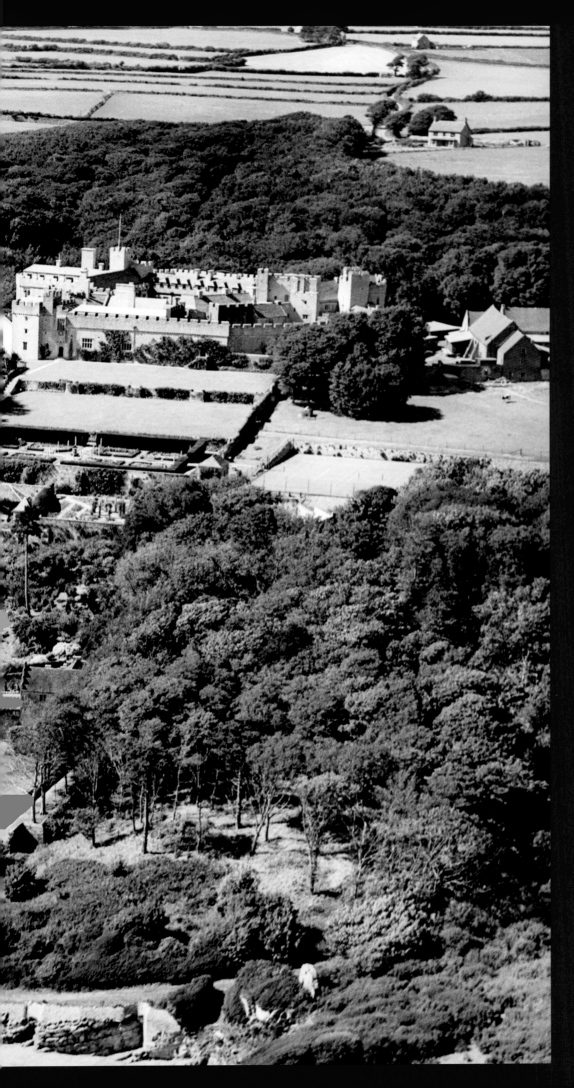

In the 1930s, St Donat's Castle on the south Wales coast was a Gatsby-esque retreat for lavish and decadent parties – an oasis of luxury amid a landscape blighted by the Depression. Acquired by the American newspaper magnet William Randolph Hearst in the late 1920s, the castle had been subject to a series of extravagant alterations, including the installation of a heated swimming pool and 35 new bathrooms, with a number of eccentric fittings repurposed from other historic buildings around Britain, including a fifteenth century stone screen taken from a Devon Church. Hearst's luxurious parties – catered for by chefs from Claridges and butlers from the Savoy – played host to a roll call of famous guests, from George Bernard Shaw and Douglas Fairbanks, to Charlie Chaplin and even a young John F Kennedy.
1934 WPW045741

Overlooking the Ochil Hills at the gateway to Highland Perthshire, Gleneagles Hotel was the dream of Donald Matheson, the General Manager of the Caledonian Railway Company. Intended as a new kind of resort hotel – a luxury getaway, built around first class sporting facilities, including golf, shooting and fishing – the hotel's original construction was halted by the First World War, and it was not finally completed until some ten years later. Gleneagles had its own railway station, with disembarking guests – and their luggage – transported by chauffer-driven car up a long, tree-lined avenue to the hotel front door. The opening gala, a dinner dance on the night of 24 June 1924, was broadcast live on the BBC, and featured a specially composed piece of music by Henry Hall and his band, called 'Glen of Eagles'. The press response to the hotel was rapturous, describing it as 'A Riveria in the Highlands', 'The Switzerland of Scotland', 'The Playground of the Gods' – and even 'The Eighth Wonder of the World'. This was a world seemingly untouched by the Depression. By the 1930s, Gleneagles was an established fixture on the high society calendar. At the end of each summer, and after Cowes week and the Henley Regatta, the 'London set' would decamp north for golf and grouse-shooting at Gleneagles. 1930 SPW033680

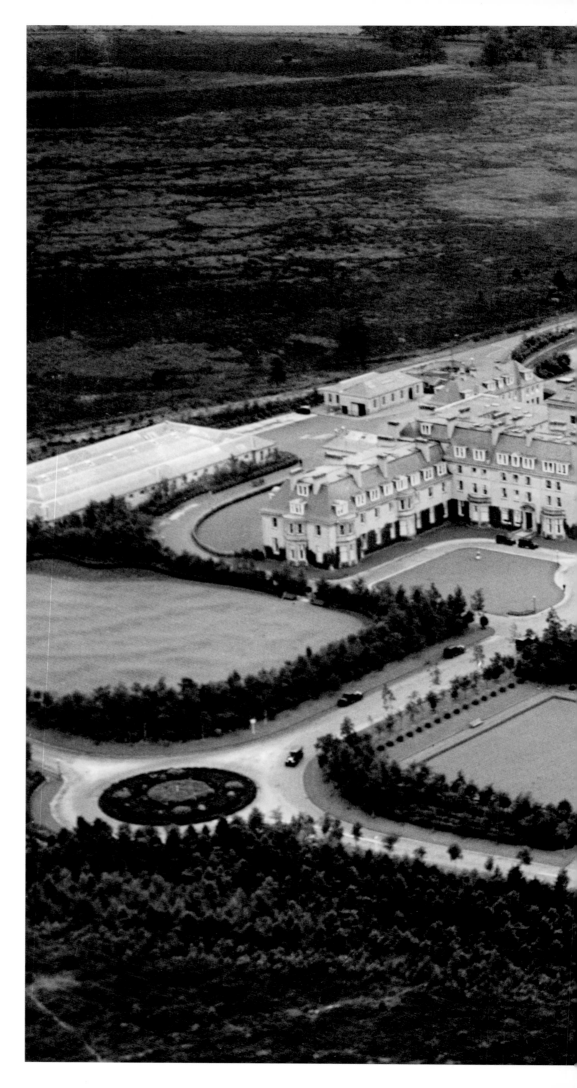

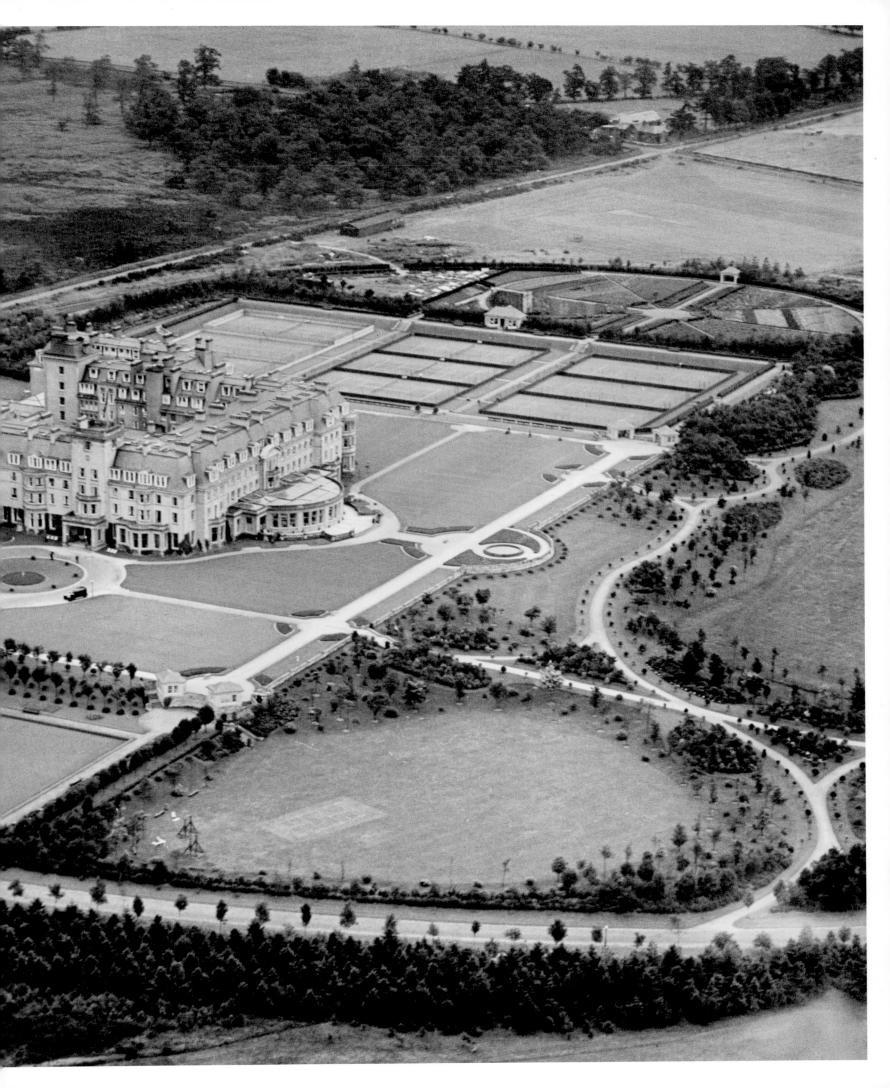

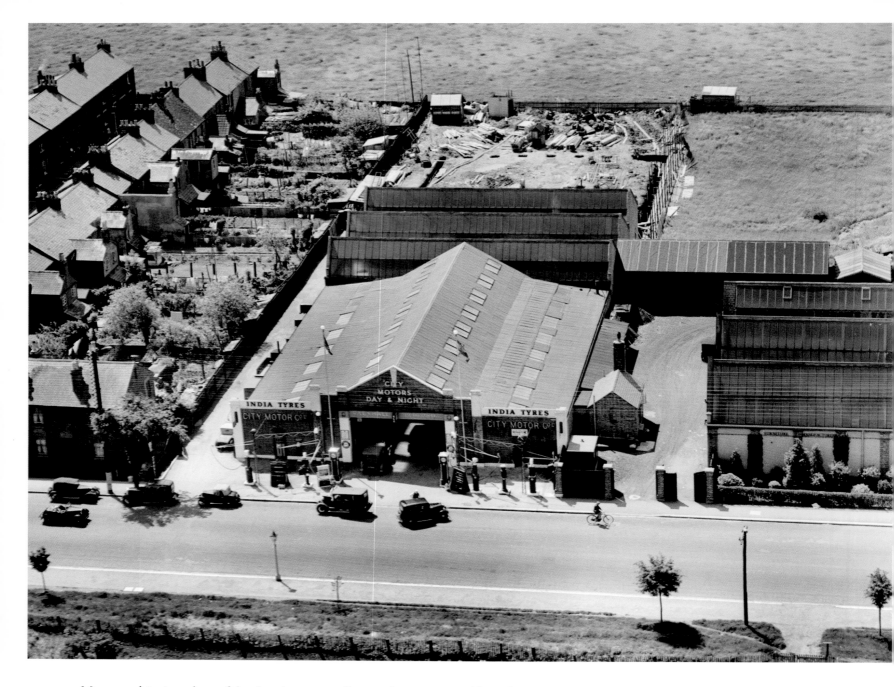

Motorcars drive in and out of the gleaming new entrance of the City Motor Company Ltd garage at New Botley in Oxford. By the mid-1930s, nearly two and a half million motor vehicles were being driven on Britain's roads – with over half of them in private ownership. Despite the introduction of roundabouts, road signs and traffic lights – originally called 'traffic control robots' – the explosion of motoring, and the absence of firm regulation, very quickly made cars the scourge of the pedestrian. Predictably, drivers did not see it that way. As an early motoring magazine wrote, 'Nobody who drives a motor vehicle in the streets of London can fail to be astounded at the folly of which pedestrians are capable. The risks they take appal the man at the wheel who – it is no exaggeration to say – is constantly saving the lives of walkers.'
1935 EPW047761

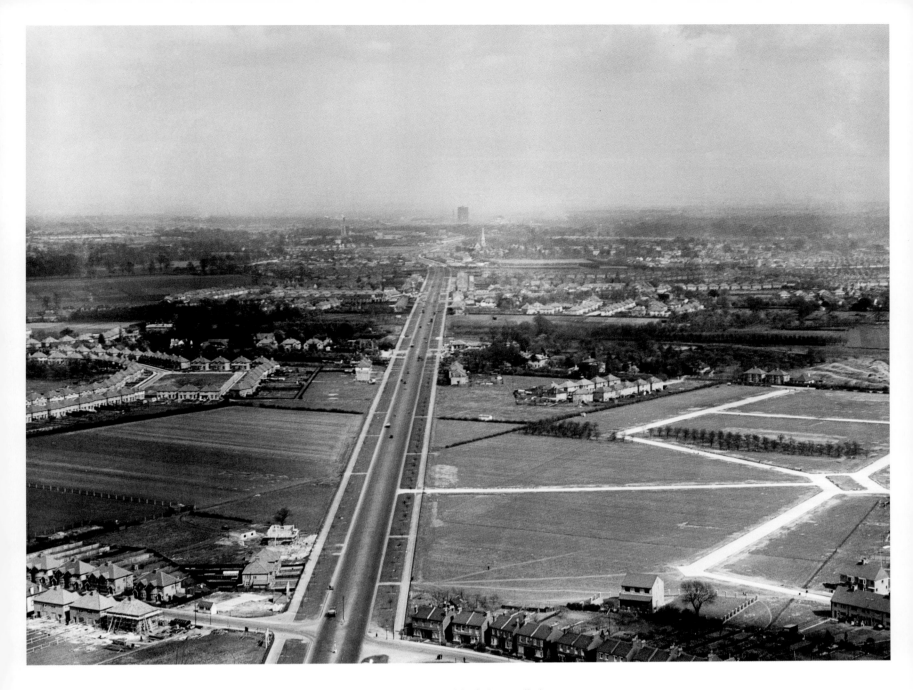

The arrow-straight line of the near-deserted Great West Road at Hounslow disappears into the distance, like a motorist's dream of freedom. Opened by George V on 30 May 1925, the bypass was constructed on agricultural land north of Brentford, and was intended to trigger 'a decade of development'. When J B Priestley travelled this way for his 1934 book *English Journey*, he was struck by just how unusual this development turned out to be. 'After the familiar muddle of West London the Great West Road looked very odd', he wrote. 'Being new it did not look

English. We might suddenly have rolled into California.' What transfixed him most were the lines of modern factories arranged on each side of the road. 'These little buildings, all glass and concrete and chromium plate, seemed to my barbaric mind to be merely playing at being factories… Actually, I know they are tangible evidence, most cunningly arranged to take the eye, to prove that the new industries have moved south. You notice them all decorating the western borders of London. At night they look as exciting as Blackpool.' 1931 EPW035041

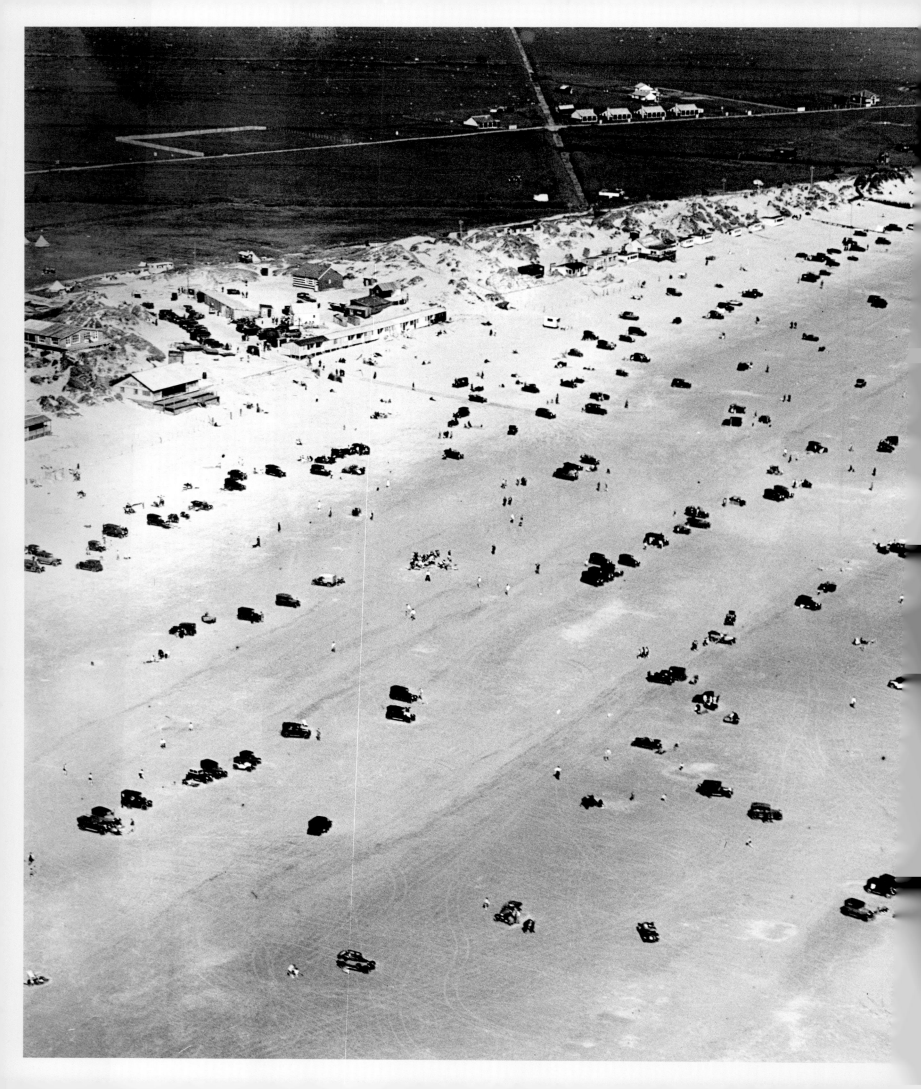

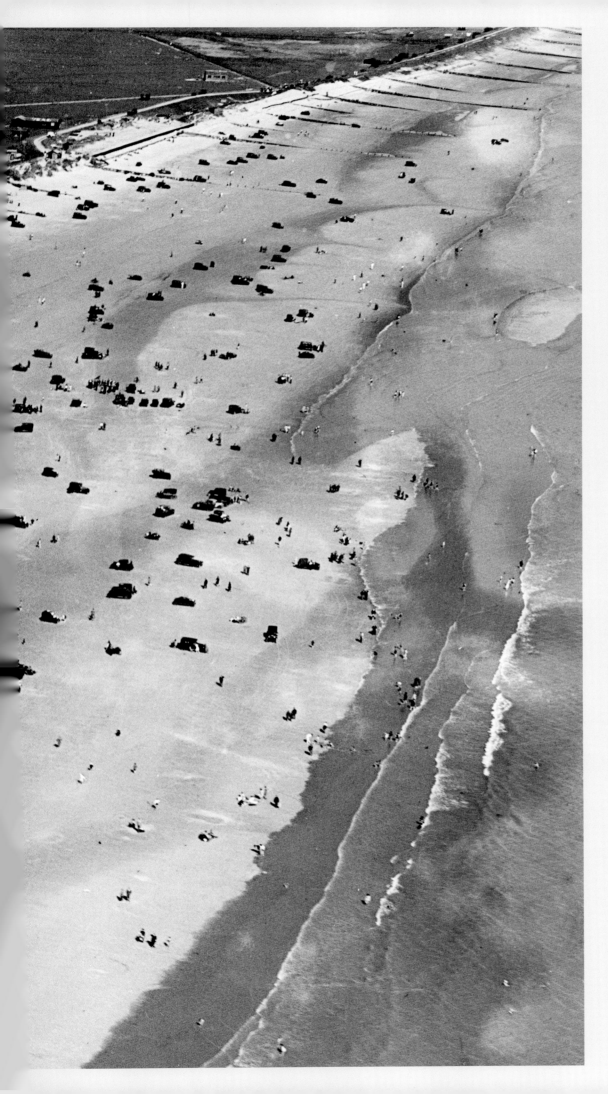

Motorcars are spread out across the Camber and Broomhill Sands on a Spring Bank Holiday in May 1931. For the London motorist, Camber had become an easy destination for a day or weekend trip, and drivers thought nothing of taking their vehicles down onto the beach to claim their spot. The new freedom of travel provided by the motorcar was not appreciated by all, however. In a 1935 letter to *The Times*, a local complained that 'this summer there has been an enormous increase of trippers to the Camber Sands near by. Their bungalows disfigure the coastline, and their sardine tins desecrate the foreshore.' The famous writer G K Chesterton was inclined to agree. He compared the massed ranks of motorcars heading to the country with the tanks of an invading army. Motoring, he believed, made people more, not less, ignorant of their surroundings. While the motorist looks 'inward at his speedometer', he takes his car along roads that are not going 'to places but through places'. 1931 EPW035369

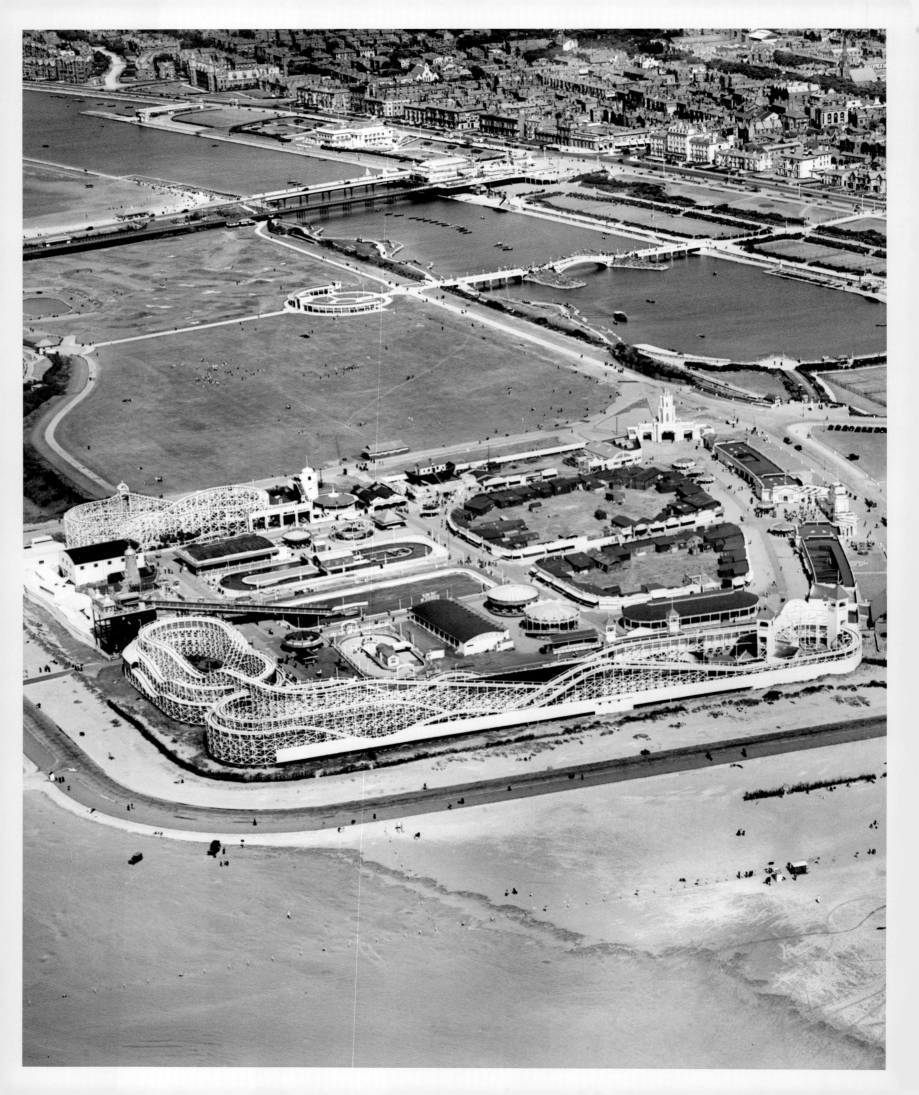

Remarkably, amusement parks thrived during the Depression – providing a welcome escape, perhaps, from the drudgery of everyday life. Here, the Aerofilms imagery acts almost as a site map to help visitors find their favourite rides. Southport's 'Pleasureland', pictured on the left, boasted a Figure Eight Toboggan, Mountain Caterpillar, House of Nonsense, and the intriguing-sounding Maxim's Captive Flying Machine. At the Kursaal in Southend-on-Sea in Essex, above – the name coming from the German word meaning 'Cure Hall' – attractions ranged from the Harton Scenic Railway, Mont Blanc Carousel and Bostock's Zoo, to the Water Chute, Aerial Flight and 'Wall of Death' – a stunt first performed at New York's Coney Island Fairground, where motorcyclists would ride around the sheer wall of a wooden barrel. Dominating

the Kursaal in the 1930s was a rollercoaster known as the 'Alpine Ride'. The year after this photograph was taken, a man was killed on the ride after standing up in his car while it was travelling at 35 miles an hour. 'I suppose he stood up', speculated an eye-witness called to the inquest, 'to get a bigger thrill than he would have got in the ordinary way.'

1934 EPW045243, 1930 EPW032925

A 1933 article in *The Times* described how Margate's Clifton Baths 'contain a large covered public sea-water Swimming Bath, together with a modern range of 50 private baths' and 'a solidly built Concert Hall'. Most impressive of all, however, was to be found by the Marine Promenade running around the cliff side, 'beyond which has been built out some 70 yards into the sea… a vast swimming pool, which is undoubtedly the finest of its kind in the country'. The 1930s was the golden age of the outdoor swimming pool. A government drive to boost public health – and stimulate the Depression economy through new building projects – saw an incredible number constructed in the early years of the decade. Often known as 'lidos' – a name which comes from the sand island in Venice – they were designed on an epic scale, conceived as modernist, Art Deco temples for communal sport, sunbathing, rest and relaxation. 1931 EPW035474

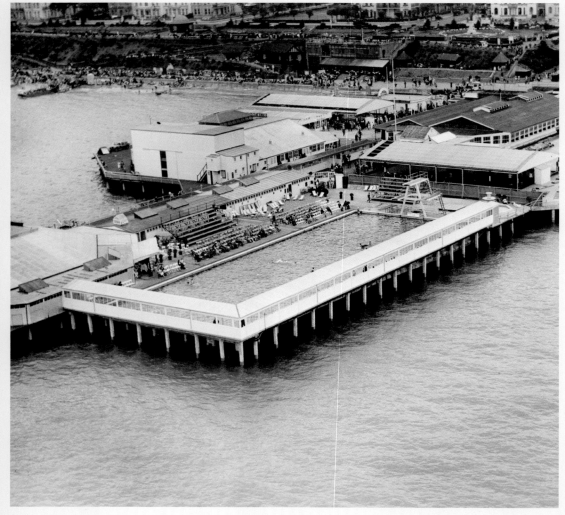

Almost every major city or town soon had its own lido or outdoor pool – it was almost essential to build at least one as a matter of municipal pride. In 1934, Herbert Morrison, the London County Council Chairman, even pledged to turn the capital into a 'city of lidos', where every citizen would be within a mile of their nearest pool. At Clacton-on-Sea, the pool was built into the town's Victorian pier. Constructed entirely of concrete raised 24 feet above the sea bed, it was 165 feet long by 60 feet wide, and even benefited from a system of underwater lighting. 1932 EPW039141

Aerofilms photographed Britain's lido phenomenon at its peak – both through commissions from local authorities and as speculative captures to sell on to postcard manufacturers or the press. The Bathing Pool and the Marine Lake in New Brighton formed one of the largest and most ambitious lidos ever built in Britain. Opened by Lord Leverhume in 1934, its Art Deco entrance block – which stretched for 238 feet along the promenade – opened onto a huge amphitheatre surrounding a concrete pool, which sloped gradually down into deeper water, like an artificial beach. Three weeks after opening, on Saturday 7 July 1934 – around the date this photograph was taken – a remarkable 34,000 people paid to enter. By the end of the first season there had been nearly one million admissions. Although lidos remained in use into the late twentieth century, they never regained their incredible popularity of the 1930s. Today, many – like the New Brighton Bathing Pool – have since been demolished. 1934 EPW045205

The craze for outdoor pools did not appear to be confined just to the municipal environment. In this unusual, low altitude photograph from June 1935, Aerofilms have captured a summer scene at a private pool – where there is rather more space for each individual bather. Although there are a number of people milling around in the wooden stand – suggesting this could still have been a place that hosted competitions – in this image, one solitary swimmer has the whole pool to themselves. There is no definite location for this site, although analysis of the Aerofilms records suggests it may be near the hamlet of Egypt in Hampshire. 1935 EPW047540

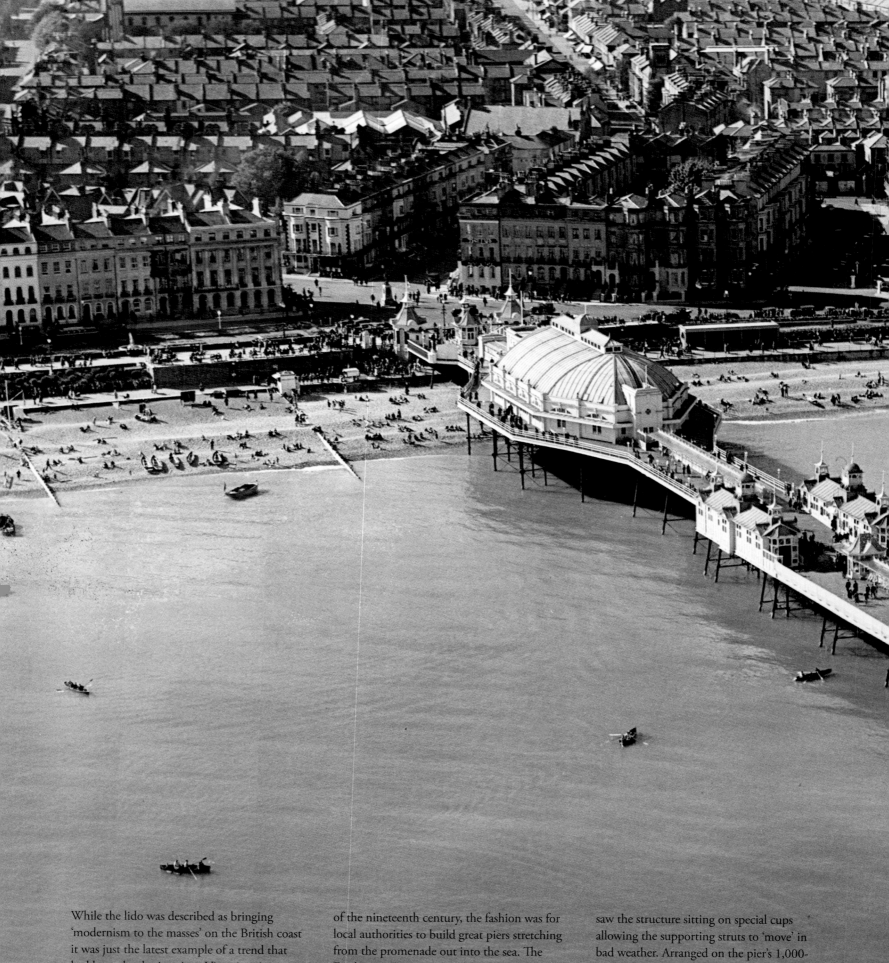

While the lido was described as bringing 'modernism to the masses' on the British coast it was just the latest example of a trend that had been developing since Victorian times – transforming seaside towns into resorts for leisure and entertainment. In the latter half of the nineteenth century, the fashion was for local authorities to build great piers stretching from the promenade out into the sea. The Eastbourne Pier, pictured here in May 1931, was erected between 1866 and 1870 to an ingenious design by Eugenius Birch, which saw the structure sitting on special cups allowing the supporting struts to 'move' in bad weather. Arranged on the pier's 1,000-foot length were kiosks, a theatre, a ballroom and a camera obscura.

1931 EPW035324

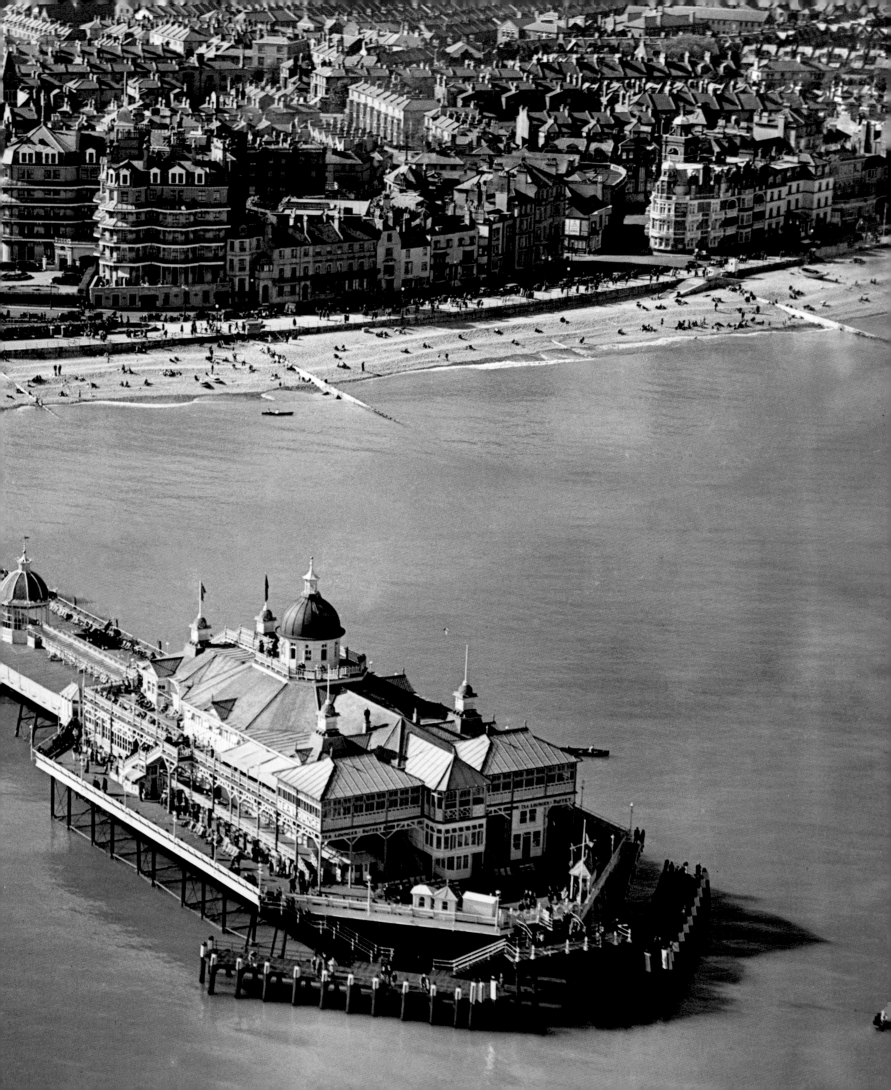

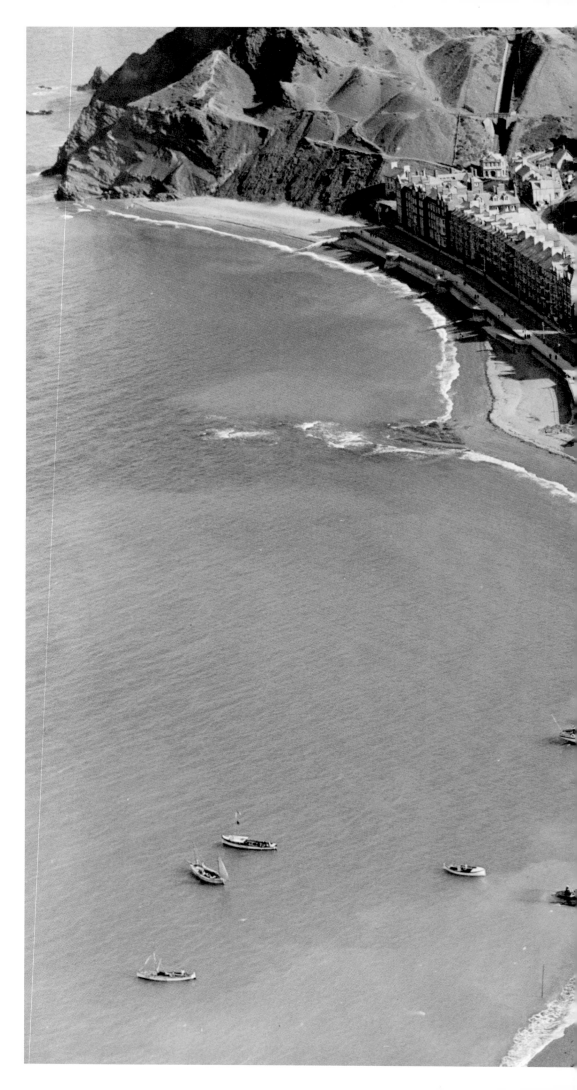

RIGHT

RIGHT

The dignified seafront of Aberystwyth is
captured here in the summer of 1932, with
pleasure boats moored on the beach ready to
take holidaymakers on trips around Cardigan
Bay. This mid-Wales market town enjoyed a
sustained tourist boom following the arrival of
the railways in the latter half of the nineteenth
century – which also coincided with the
evolution of the religious ceremony of 'wakes
week' into a regular summer holiday for
industrial workers from the West Midlands.
As the nearest seaside resort to the Midlands,
Aberystwyth quickly became a popular
destination, and was even billed as the
'Biarritz of Wales'. The Great Western Railway
Company promoted the town intensively
during the 1930s through a series of eye-
catching graphic posters. When Aerofilms
toured west Wales in 1932, Aberystwyth was
an obvious target for aerial photography to
sell on for potential publicity and marketing
purposes. 1932 WPW040024

FOLLOWING PAGE

With the benefit of the aerial view, the
positioning and impact of new buildings
within the urban landscape became even more
pronounced. In this view of central London,
the new BBC Broadcasting House, erected
beside All Souls' Church in Marylebone,
stands out an incredible pristine-white
when set against its older, soot-darkened
surroundings. Its architect, Lieutenant
Colonel Val Myer, was tasked with designing
one of the world's first ever buildings
dedicated to broadcasting – and in his vision,
'the studios and their suites', where 'insulation
from external noise is the first need, have
been grouped in a vast central tower of heavy
brickwork ventilated by artificial means and
protected from the streets by the complete
outer layer of offices'. When first opened in
August 1932, the *Architectural Review* called
the building 'novel and refreshing' – as a
direct result of 'all its manifold faults'. For
the *Review*'s critic Robert Byron, in the end
it represented 'the outcome of a struggle
between moribund traditionalism and
inventive modernism'. Sir Nikolaus Pevsner
was less kind, declaring that it 'cast a blight on
the whole Georgian neighbourhood' and that
its windows made the 'grimness of its sheer
stone walls twice as painful'. 1931 EPW036441

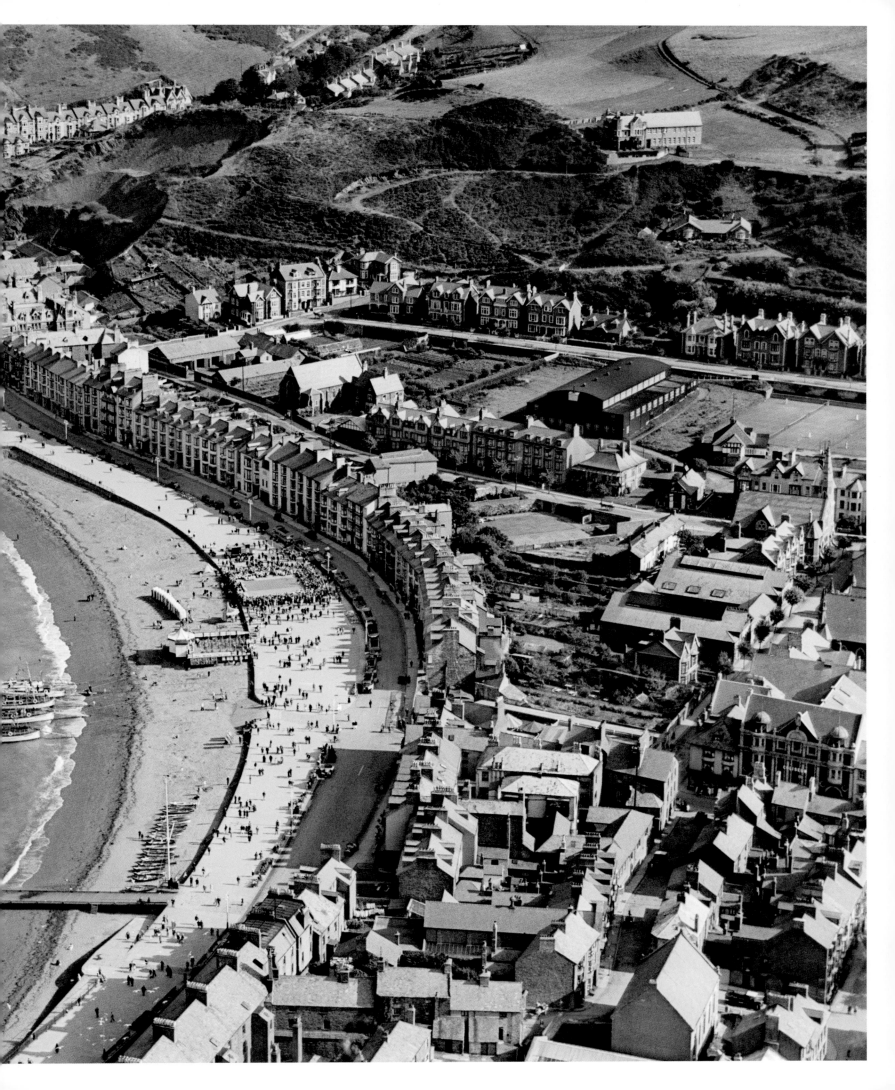

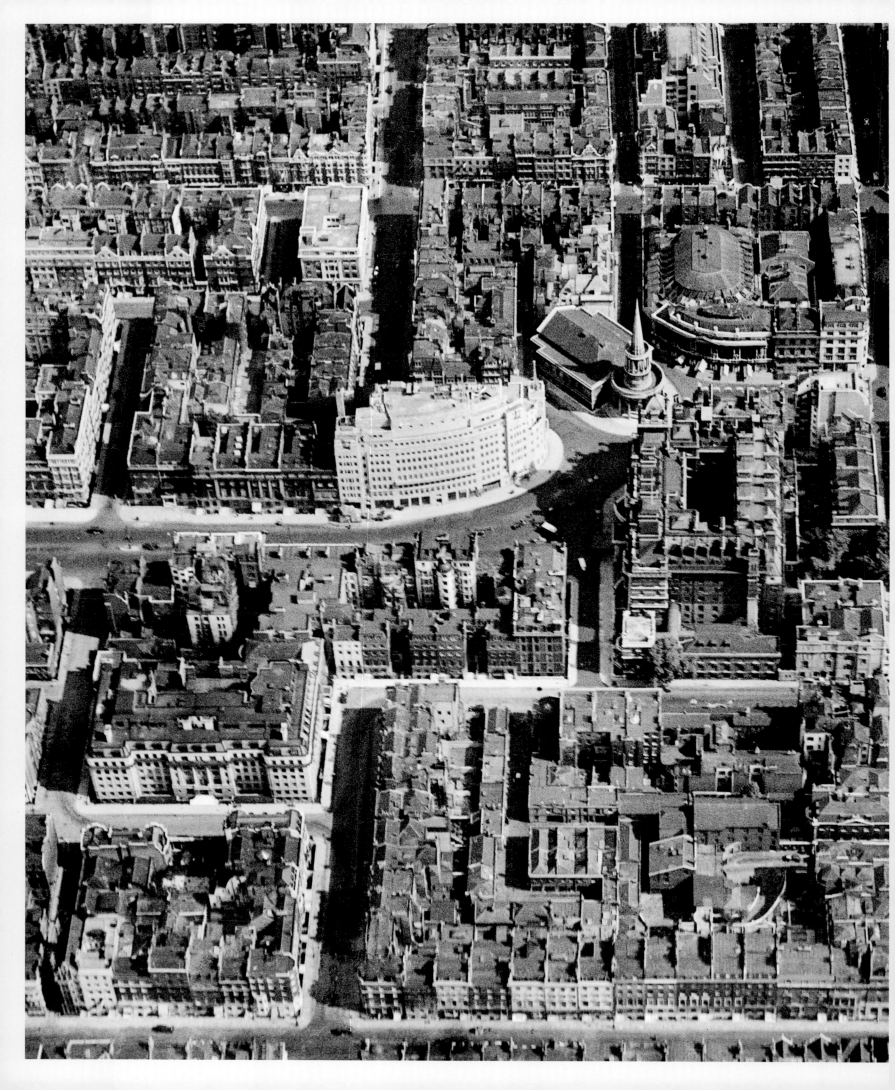

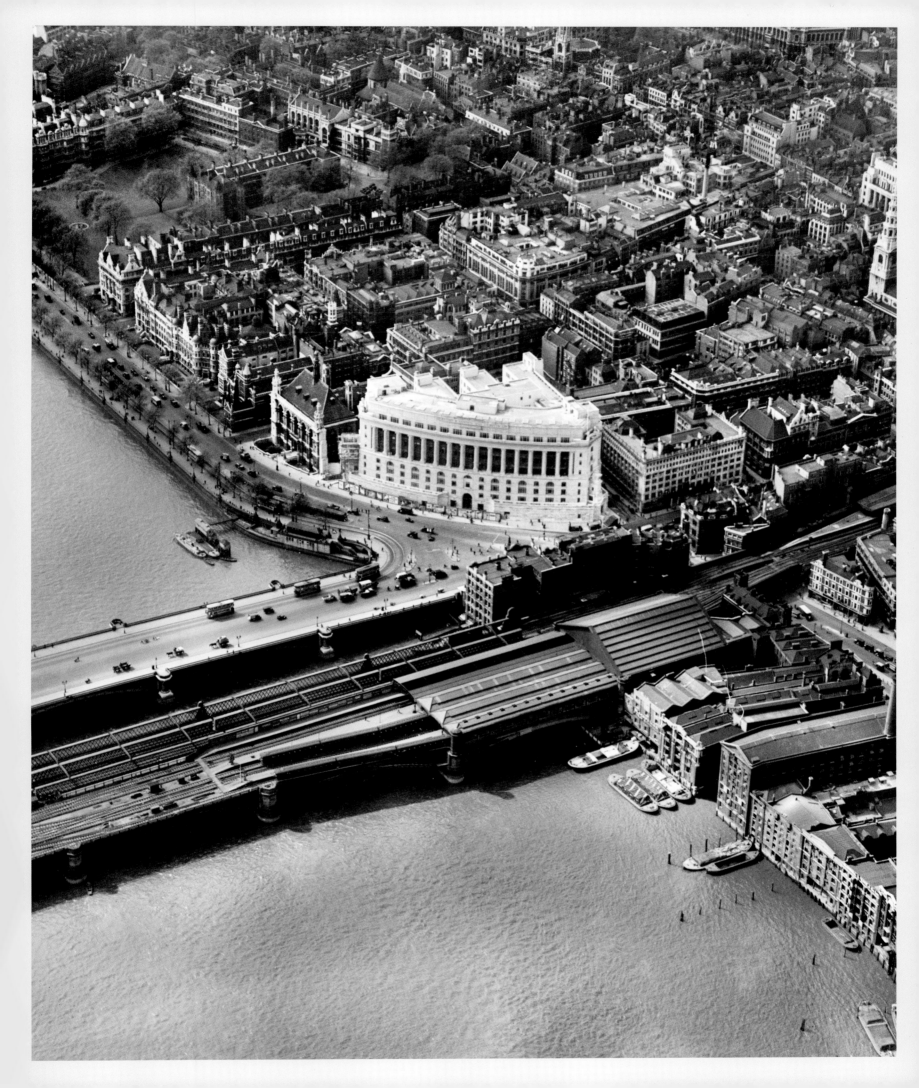

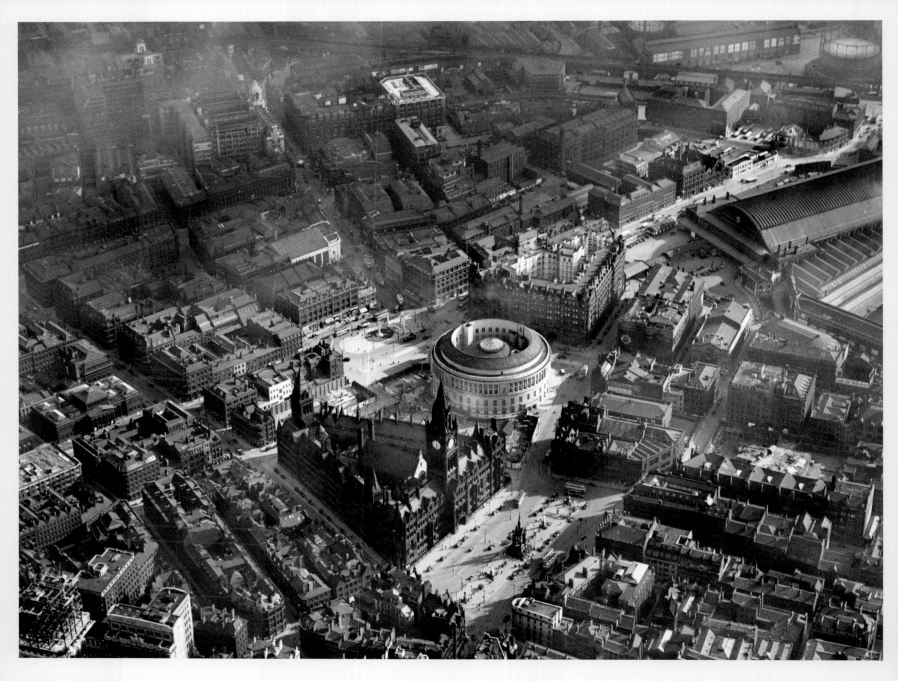

PREVIOUS PAGE

Although assuming a similar form to the new BBC building, 'Unilever House' beside Blackfriars Station received a warmer response from the architectural community. When first opened in July 1932 – just two months after this photograph was taken – *The Times* described it as 'all that could be desired; simple, masculine and well-proportioned. It takes the curved river site boldly and firmly, but without arrogance. . . The object which the architects set out to achieve was to give a building which should obviously appear as the home of one commercial enterprise and not merely a "block of offices".' Where Pevsner had been cutting in his assessment of Broadcasting House, here he was rather more opaque, remarking of the building that it was 'the largest of the City's interwar prestige

headquarters' and that its 'composition can be taken in at a glance in long views' – a loaded phrase if ever there was one.
1932 EPW037974

ABOVE

In this image of Manchester Central Library, the value of Aerofilms' photography to city and town councils is made strikingly clear. Photographed here just two months after it first opened – at a ceremony attended by George V and Queen Mary on 17 July 1934 – the building appears almost to gleam and shimmer in its newness. The city's ambition for its public library was evident in its architectural design – a neoclassical rotunda redolent of the Pantheon of ancient Rome. With no words, the aerial view made this abundantly clear. As an Aerofilms advertising pitch at the time aptly explained, 'The value of such an informative illustration for the purposes of publicity is so very obvious that particular emphasis is unnecessary.'
1934 EPW045995

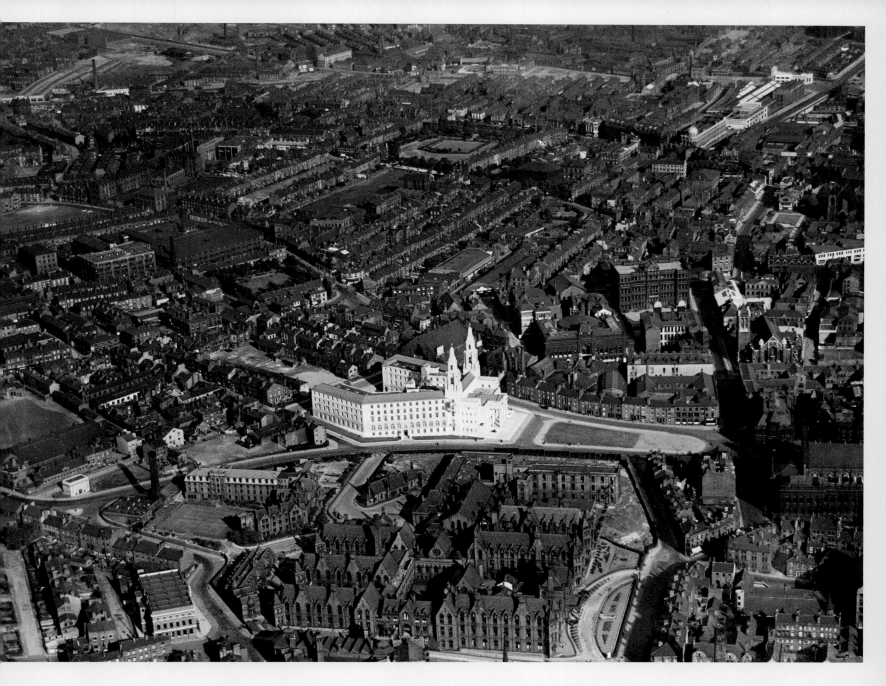

ABOVE

Leeds Civic Hall is a monolithic beacon
of bright Portland Stone at the centre of a
low-rise grey-black cityscape stretching in
all directions. The Hall was first opened on
23 August 1933 – again by George V – and
Aerofilms captured this startling image of it
just a month later. A plaque on the building
attributes its construction to the 'unemployed
building workers of Leeds'. Here, civic pride
– and a need 'to serve the ever-expanding
municipal functions and duties of Leeds City
Council' – became a vehicle for tackling the
chronic economic hardship of the Depression.
As ever, Aerofilms were on hand to offer their
services and to remind municipal clients of
what they described as the aerial photograph's
unique 'power to plan a great public
enterprise'. 1933 EPW043169

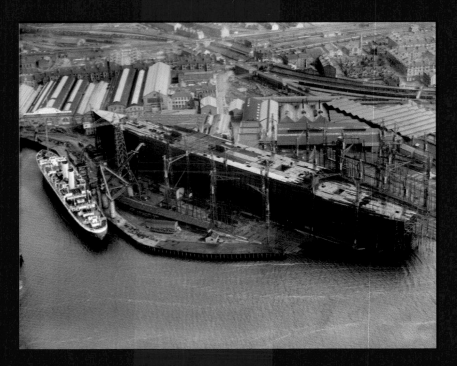
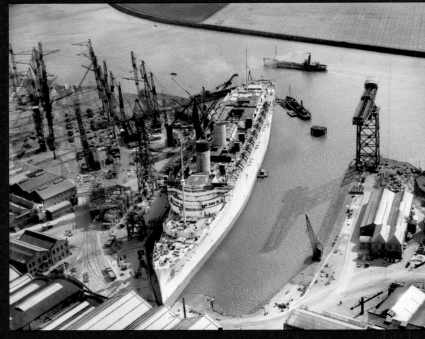
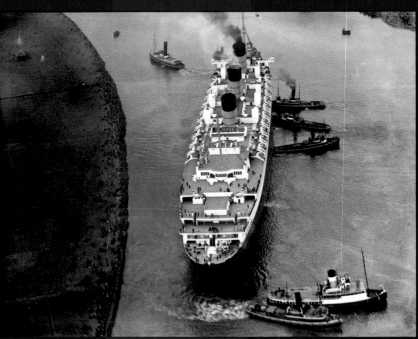
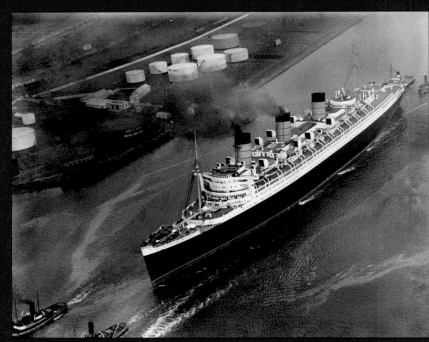

Pictured top right under construction at John Brown's famous shipyard in Clydebank, is 'Hull Number 534'. Surrounded by cranes and a skeleton of steel struts, this gigantic superstructure can be seen here undergoing a transformation into Cunard's flagship new ocean liner – the RMS *Queen Mary*. Work had begun on the ship in December 1930, but had to be halted as a result of the Depression. It was only a government loan to Cunard – with the condition that the

company merge with its competitor White Star Line – that, some three years later, allowed work to restart on Hull 534, and the ship to finally make its way to completion. When Aerofilms captured the *Queen Mary* sailing down the Clyde on 24 March 1936 for its speed trial to the Isle of Arran, it seemed a symbol that the Depression was over. As Bill Freeman, who took the pictures, recalled in a BBC radio interview, they flew from Renfrew through low cloud and rain, only to

emerge from the murk to find that, 'the sky was beautifully blue and the sea ahead looked perfect. The sun was shining and the *Queen Mary* looked an absolute picture.' Britain had survived and was back to doing what it did best. The reality, however, was not so optimistic – as the ocean liner left its berth, unemployment in Glasgow, the city which had built it, was still over 30 per cent.

1934 SPW040275, 1934 SPW048771, 1936 SPW049785, 1936 SPW049832, 1936 SPW049834

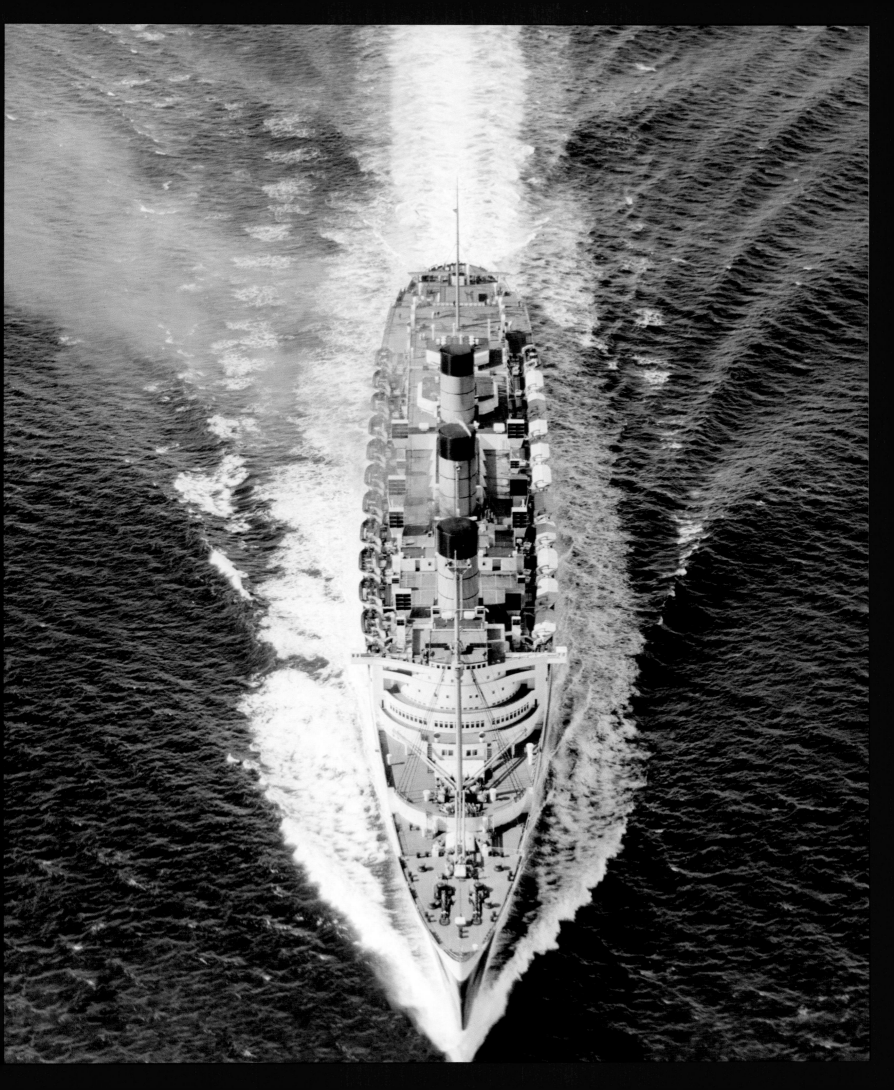

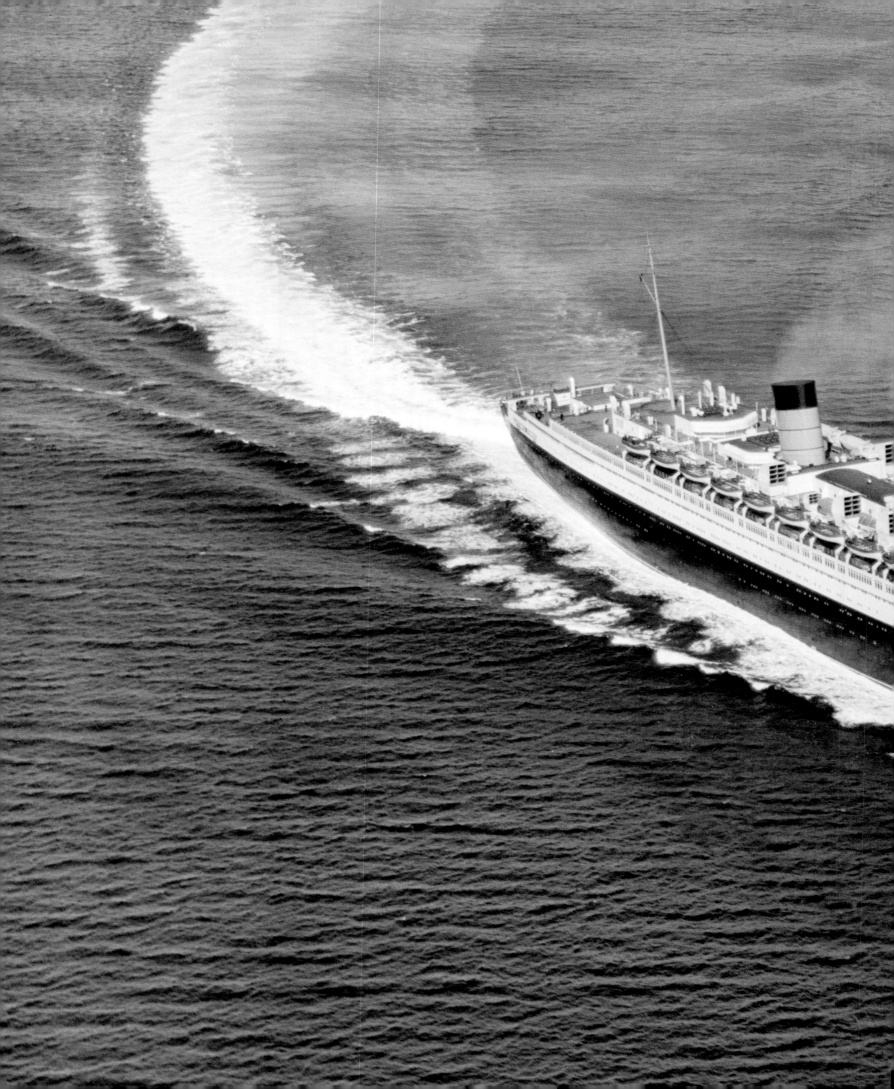

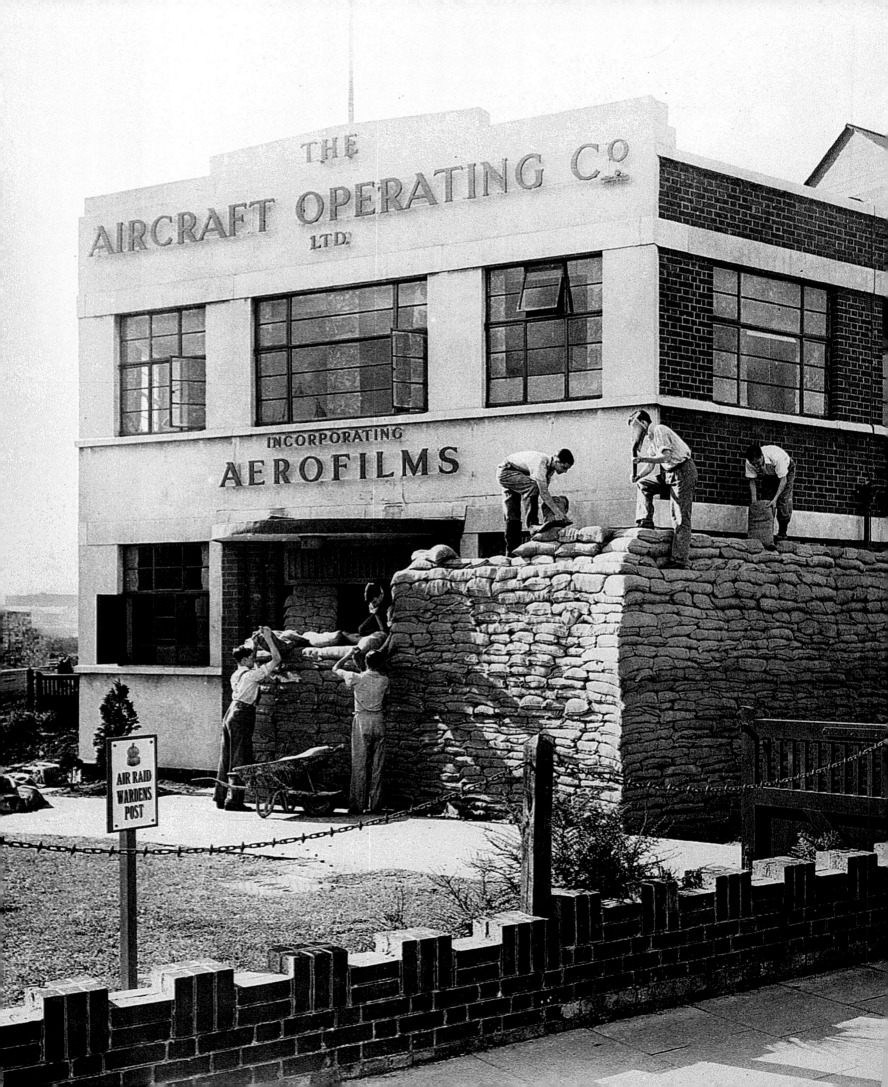

Eyes in the Sky, 1937–1945

In September 1938, Francis Wills volunteered for a secret military mission. Against the backdrop of the Munich Crisis – sparked by German demands for the 'return' of the Sudetenland territories in Czechoslovakia – Wills was invited to a party held at an apartment on Park Lane. Soon after arriving, he was taken into a side room by Major Harold Hemming – a member of the board of both Aerofilms and the Aircraft Operating Company (AOC) Ltd, and a former Royal Flying Corps (RFC) flight instructor – and introduced to a man called Sidney Cotton. Yet another ex-Royal Naval Air Service (RNAS) pilot, Cotton was an Australian entrepreneur – and inventor of the famous 'Sidcot' silk and fur-lined flight suit – who was passionate, in equal measures, about aviation, money and women. Earlier that year, he had been approached and recruited by the Air Department of the MI6 Intelligence Service.

Wills was asked by Cotton to support 'a so-called commercial flight into Germany to endeavour to locate where the German Army were amassing inland'. Cotton had specially modified a De Havilland DH9 aeroplane for the flight, but he needed the help of Aerofilms for the photography. 'He wanted our cameras', recalled Wills, 'plus one operator, with him as pilot to obtain an air photo record.' As managing director of Aerofilms, Wills was 'the only person who could get involved in view of the "hush hush" nature of the scheme, as if we had a forced landing, we could only plead that we were undertaking a commercial photographic flight without any government authority'. For fourteen days Wills kept the camera equipment in his car, taking it with him everywhere he went. All that time, he was waiting 'for the secret code call, which never materialised because Neville Chamberlain reached an agreement'.

This 'agreement' was held triumphantly in the air by the British Prime Minister Neville Chamberlain as he stepped out of his aeroplane at Heston Aerodrome on 30 September 1938. Counter-signed by the German Chancellor Adolf Hitler, it was said to be symbolic of the desire of Britain and Germany 'never to go to war with one another again'. Later that day, as he stood before the door of 10 Downing Street, Chamberlain announced to the nation – and to the world – that he had succeeded in securing 'peace for our time'.

Others did not share Chamberlain's optimism. Hemming in particular was a sceptic. Just six days after the Prime Minister's return from Munich, he contacted the Air Ministry to offer the services of Aerofilms and AOC to the RAF. If war was coming, the Major knew that the unique skills and experience of his staff, and the cutting-edge techniques that they had developed over two decades of commercial enterprise, would prove invaluable.

Since the beginning of 1937, Aerofilms and AOC had been housed in new, custom-built premises on Beresford Avenue in Wembley. The buildings combined photographic laboratories, showrooms, darkrooms, a drawing office, a studio, a mapping room and a photo library. Both businesses had survived the Great Depression and were thriving – in 1937 and 1938, nearly 8,000 glass negatives

The Aerofilms and Aircraft Operating Company building on Beresford Avenue in Wembley is sandbagged in preparation for war.
1940 MEDMENHAM COLLECTION

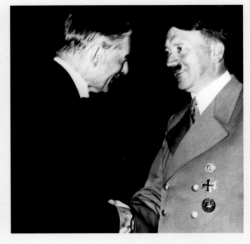

Landing at Heston Aerodrome in a British Airways Lockheed-10 Electra, Neville Chamberlain held up the 'Munich Agreement' signed by the German Chancellor, Adolf Hitler, and addressed the gathered crowd. The British Prime Minister placed his hopes for peace in a policy of appeasement, but others were preparing for the gathering storm. From this same aerodrome, MI6 were already in the process of exploring how best to use aerial photography in wartime. 1938 GETTY IMAGES

of oblique aerial photographs were exposed; AOC survey expeditions were still ongoing in Iran; and there was a huge increase in domestic survey work for local authorities, from informing the revision of 1:2,500 Ordnance Survey maps, to helping planning for housing estates and road networks. Another new contract had also emerged – from the Home Office. Beginning in 1938, a number of Aerofilms' negative wrappers were marked with the initials 'ARP' – 'Air Raid Precautions'. The task was to photograph industrial sites that could be of potential strategic significance in any future war. While some of this work was carried out by the RAF to serve Air Ministry interests, increasingly the Home Office was turning to Aerofilms.

For years Wills had been one of the key figures driving operational and technological advancements in the business. In each of the three previous summers, he had travelled to the German city of Jena to take courses in photogrammetry with the company Carl Zeiss AG, and in 1938 he returned with Wing-Commander Percival Burchall, Aerofilms' Air Survey Manager, to source new equipment. The two men first toured the Zeiss works at Jena, where Professor Reinhard Hugershoff demonstrated a huge photographic mapping machine called the Aerocartograph – a machine which, the Professor was happy to admit, he would rather sleep with than his wife. They then moved on to Switzerland to view another new device: the Wild – pronounced 'Vilt' – A5 Stereo Autograph. Encouraged by Wild's 'super salesman Albert Schmidheini, who demonstrated the precision of the machine', Wills concluded that the A5 was 'constructed on the basis of their country's Swiss watch-making craftsmanship, thus producing a much smaller machine than the German type, with greater precision of operation, introducing ball-bearing movements ensuring the least amount of wear and tear'. On their return to Britain, Wills and Burchall reported to the board of directors their 'strongest recommendation' to buy Wild equipment.

A Wild A5 arrived at the Wembley offices later that year. Bought for £5,500, it was a great deal smaller than the Zeiss, but still had to be assembled in an air-conditioned room, and set on a 15-foot-thick concrete base – essential measures to reduce vibration and climatic interference to ensure the accuracy of

Sidney Cotton – said to be one of Ian Fleming's main inspirations for the character 'Q' in the James Bond novels – was recruited by MI6 in 1938 with the task of masterminding a new aerial espionage operation. MEDMENHAM COLLECTION

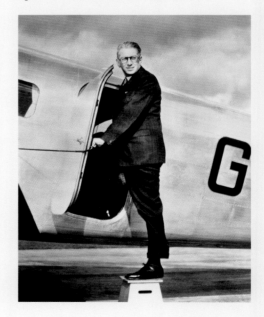

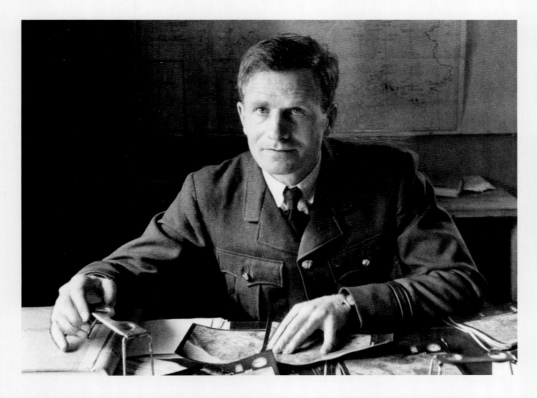

The colossal, Swiss-built Wild Machine – pictured above in its custom-built, air-conditioned laboratory in Wembley – used powerful optics to allow the precise measurement of the three-dimensional data contained within aerial photography. Winston Churchill, then First Lord of the Admiralty, was stunned by the speed and quality of the intelligence information produced by the Wild's operator – Aerofilms' employee Michael Spender, pictured left – and interpreted by the company's skilled staff.
c1940 MEDMENHAM COLLECTION

its plotting results. It also required a specialist operator: someone with a keen scientific mind and the most acute eye for detail. Michael Spender, an Oxford graduate who had worked as a surveyor on expeditions to the Great Barrier Reef, Greenland and the Himalayas, was appointed as Aerofilms' first ever 'photogrammetrist'. Wills' intention was to establish the company as the market leader in map-making from aerial photography, and Spender was in post to handle customer demand for this revolutionary service. At the same time – and given the dramatic political events unfolding across Europe – the potential military applications for the new technology were obvious. Or at least they should have been.

Remarkably, Hemming's approach to the Air Ministry in 1938 was rebuffed. Aerial reconnaissance photography had proven its worth time and again over the course of the First World War – becoming one of the most valuable sources of intelligence information. Indeed, in 1919 Winston Churchill as Air Minister had approved a Memorandum from the Chief of the Air Staff, Hugh Trenchard, which identified aerial photography as one of the 'primary necessities' of the newly formed RAF. Yet somehow, over the intervening years, it had been neglected. A combination of a lack of practical applications for reconnaissance work during peacetime, and a steady skills drain to the commercial sector – specifically to companies like Aerofilms and AOC – had critically undermined military capabilities. The RAF were using Lysanders and modified Blenheim Bombers for reconnaissance flights, aircraft which were utterly unsuited to coping with the new German Messerschmitts, and their cameras produced imagery of such limited definition that they required missions to be flown at 12,000 feet. With developments in anti-aircraft gunnery, this height was considered almost suicidal.

After the Munich Crisis, however, Cotton had continued his programme of carrying out illicit photographic surveys overseas – as part of a new MI6 unit known as 'Special Flight'. In the spring and summer of 1939, he flew a modified Lockheed 12 Electra Junior – painted duck-egg green for camouflage and fitted with extra fuel tanks and three cameras with warmed

Major Harold Hemming, pictured left on the front steps of Aerofilms' Wembley office, is immediately recognisable by his trademark black eye-patch – the result of an injury sustained when his aircraft hit a scoreboard during a Royal Aero Club race meet in 1927. Beside him, in the centre, stands Francis Wills, and on the right is General Boulnois, Chief of the Geographical Section of the General Staff.
c1938 ENGLISH HERITAGE. AEROFILMS COLLECTION

lenses to prevent condensation forming and freezing at altitude – over sites in the Netherlands, Belgium, Germany and Italy. Much of the photography taken during these flights Cotton passed on to Aerofilms for interpretation. At that time, the RAF had only seven trained interpreters, and a fraction of the skills and experience available among Wills' and Hemming's staff. In August 1939, Flying Officer Maurice 'Shorty' Longbottom, a key member of Cotton's team, submitted a report to the Air Ministry which advised that, in future wartime conditions, successful aerial reconnaissance missions would require fast, light-weight aircraft, adapted with extra fuel supplies, operating at high altitudes well above the range of anti-aircraft fire. Perfect for the job, he concluded, was the Supermarine Spitfire.

In October of that year, a month after Britain had declared war on Germany, Fighter Command reluctantly gave up one of their Spitfires. Testing began with Longbottom undertaking a series of high-altitude flights over Germany and the Low Countries. The results of these missions – along with reports from sorties flown by the adapted Blenheim Bombers – were considered at an Air Ministry conference on photographic reconnaissance which took place in early January 1940. While sixteen Blenheims had already been lost – with a one-in-five survival rate for their crews – the modified single-seater Spitfire had returned unscathed from all fifteen of its sorties. The next key consideration, however, was the quality and usefulness of the photography. Bomber Command's response to the Spitfire imagery was that it was beyond 'interpretation, reduced the effort expended to futility and the writer to tears', and that its 'sole achievement is waste of petrol, time, paper, energy and imagination'. What this proved to Cotton, however, was that it was not enough just to take the photographs and bring them home – it also needed a team with specialist skills to analyse and explain them. This was where Aerofilms came in.

In February 1940, the Admiralty received the troubling report that the German battleship *Tirpitz* was no longer at dock in Wilhelmshaven. The RAF had failed to confirm the news, and on 10 February, Longbottom took off from RAF Debden in Essex in a new Type B PR-Spitfire and set a course for the north-west coast of Germany. After flying at 33,000 feet above the ports of Emden and Wilhelmshaven, he returned safely to British soil, where his photos were rushed into development and passed on to the Air Ministry for assessment. Their response was one of extreme exasperation – the tiny scale of the images, they said, made them impossible to analyse. At the same time, however, Cotton had also supplied copies to Aerofilms. At the controls of the Wild machine, Spender produced a map of Emden to a scale of 1:10,000, while his colleague David Brachi marked specific vessels in the harbour. Crucially, they were also able to identify that, contrary to the Admiralty intelligence, the *Tirpitz* remained in its dry dock. Churchill – in his new role as First Lord of the Admiralty – called Cotton immediately to the Admiralty War Room to learn more about how this map had been put together. The result of this meeting was a pointed message from Churchill to Sir Kingsley Wood, the Secretary of State for Air. 'Major Hemming's organisation,' wrote Churchill, 'including the expert personnel, should be taken over by one of the Service Departments without delay… if for any reason the Air Ministry do not wish to take it over, we [the Admiralty] should be quite prepared to do so'. In May 1940, Aerofilms and AOC merged with the Air Ministry's photographic interpreters, to become a fully fledged military intelligence unit. It was the official recognition of a surreptitious relationship that had been developing ever since the Munich Crisis in 1938.

Hemming and Wills were acutely aware that government contracts were crucial to the future of their business. Aerofilms had taken their last commercial

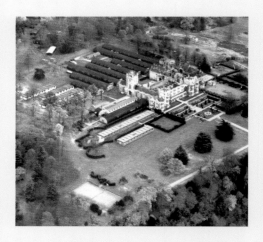

On April Fools Day 1941 Aerofilms and AOC left their Wembley offices for RAF Medmenham, near the town of Marlow, in rural Buckinghamshire. Pictured here, a labyrinth of Nissen huts surrounded Danesfield House. This would become the Central Interpretation Unit – the Second World War home of Allied Photographic Intelligence. MEDMENHAM COLLECTION

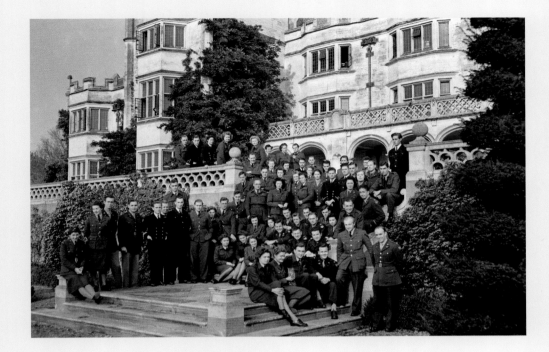

RAF Medmenham helped in the planning stages of practically every operation of the war and informed every aspect of military intelligence. Winston Churchill developed a great affection for the men and women of the unit, and dubbed their unconventional new home the 'Chalk House with the Tudor Chimneys'. 1945 MEDMENHAM COLLECTION

aerial photograph on 31 August 1939 – it would be six years before they would take another. On 3 September, an Air Navigation (Restriction in Time of War) Order banned all civilian flying – and it was only a government necessity that had allowed the company back into the air. In October of that year, six Aerofilms staff were co-opted to the 'No.1 Camouflage Unit', relocating to Baginton airfield – now Coventry Airport. Their mission, an extension of the earlier Home Office ARP contracts, was to photograph factories and military installations across the country to help plan and then assess the effectiveness of camouflage schemes. The imagery was supplied to a team of British architects, artists and theatre set-makers based in the Regent Hotel of Royal Leamington Spa, who would create elaborate designs to help hide buildings from enemy bombers.

The Aerofilms and AOC offices at Wembley became the 'Photographic Interpretation Unit'. Tasks ranged from analysing the increasingly large amounts of reconnaissance photography to using maps and plans to create elaborate scale models of enemy sites. An unconventional mixture of – often quite eccentric – civilian workers, and military staff, the unit was dubbed the 'irregulars'. As Hemming noted, 'the Unit appears in some quarters to be regarded rather as a "nuisance", because it does not conform to service practice in all respects. This, of course, is largely due to the pioneering nature of the work.' It was not long before the sheer scale of the operation was outgrowing Wembley. The office was open 24 hours a day, with staff taking shifts of 12 hours on, and 24 hours off. Sometimes, however, given the urgency and importance of processing specific intelligence imagery, interpreters would endure 38-hour stints without rest. 'It was entirely due to the keenness of the staff to participate in the war effort', wrote Hemming, 'that they were able to undertake the excessive volume of exacting work without cracking up.'

There was also another, rather more serious consideration: the Blitz. The unit's location in Wembley meant that the vast majority of Britain's photographic intelligence expertise and equipment was concentrated near Luftwaffe flight-paths out of central London – surrounded by bridges, factories and a main railway line. Almost inevitably – and along with most areas of the city – the offices found themselves in the line of fire. On 2 October 1940, an incendiary bomb destroyed the hut containing the photographic interpreter 'school', smashed a hole in the

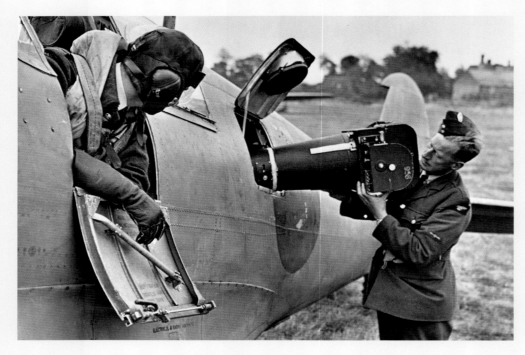

Sidney Cotton was instrumental in developing RAF photographic reconnaissance into an operation with the capacity to win the intelligence war. One of Cotton's key innovations was to explore the modification of the Supermarine Spitfire – at the time the fastest aeroplane in the sky – into a high-speed, high-altitude, mobile camera. Here, a pilot watches as photographic equipment is loaded into the fuselage of his aircraft. RAF

roof of the main building, and killed RAF policeman Robert Ammon. The interpreter school was hastily relocated to the upstairs room of an adjoining house, and tarpaulin was stretched across the Wembley roof. Just over a fortnight later, two more bombs fell on a nearby factory complex. The only option was to leave London.

On 17 January 1941, the Wild A5 Autograph was taken apart piece by piece and transported from Wembley to the basement of Danesfield House, a large Victorian mansion set between the River Thames and the Chiltern Hills, near the village of Medmenham in rural Buckinghamshire. This was to be the new home for photographic intelligence – renamed, once again, as the 'Central Interpretation Unit'. The last of the Wembley staff moved in April 1941 and the government contracts with Aerofilms and AOC were officially ended.

RAF Medmenham – as Danesfield House became known – was a fully operational military Service station, in which commercial and civilian business had no place. As an Air Ministry memorandum concluded, 'The Central Interpretation Unit has evolved in such a way that the company's personnel, though still paid by the company, are working side by side with service personnel under service orders; the identity of the company within the unit has been lost… the contract has become entirely unreal in these circumstances. Provided that satisfactory arrangements can be made for the absorption of the civil staff of the company to the unit or their replacements, the only course now open would seem to be the cancellation of the contract.' Aerofilms and AOC had laid the foundations for the establishment of a top-secret military intelligence unit. Yet, under the pressures of war, the two companies had effectively ceased to exist. Hemming moved to work with Bomber Command, as did Wills, who was their liaison officer with RAF Medmenham. Spender continued to operate the Wild machine at Danesfield House, and was also tasked with developing photographic reconnaissance capabilities at outlying RAF stations at Wick in Caithness and St Eval in Cornwall.

Everywhere, staff swapped civilian clothes for military uniforms. And as they did so, the men and women of Aerofilms and AOC became instrumental in coordinating one of the largest spying operations ever undertaken – photographing the Second World War from the air.

Two Griffon-engined Spitfire Mark 19s sit ready for take off on the hangar apron. Belonging to the south Oxfordshire-based 541 Squadron, during the war their orders were to fly over and photograph targets across mainland Europe. 1950 NCAP 006-025-019-793-C

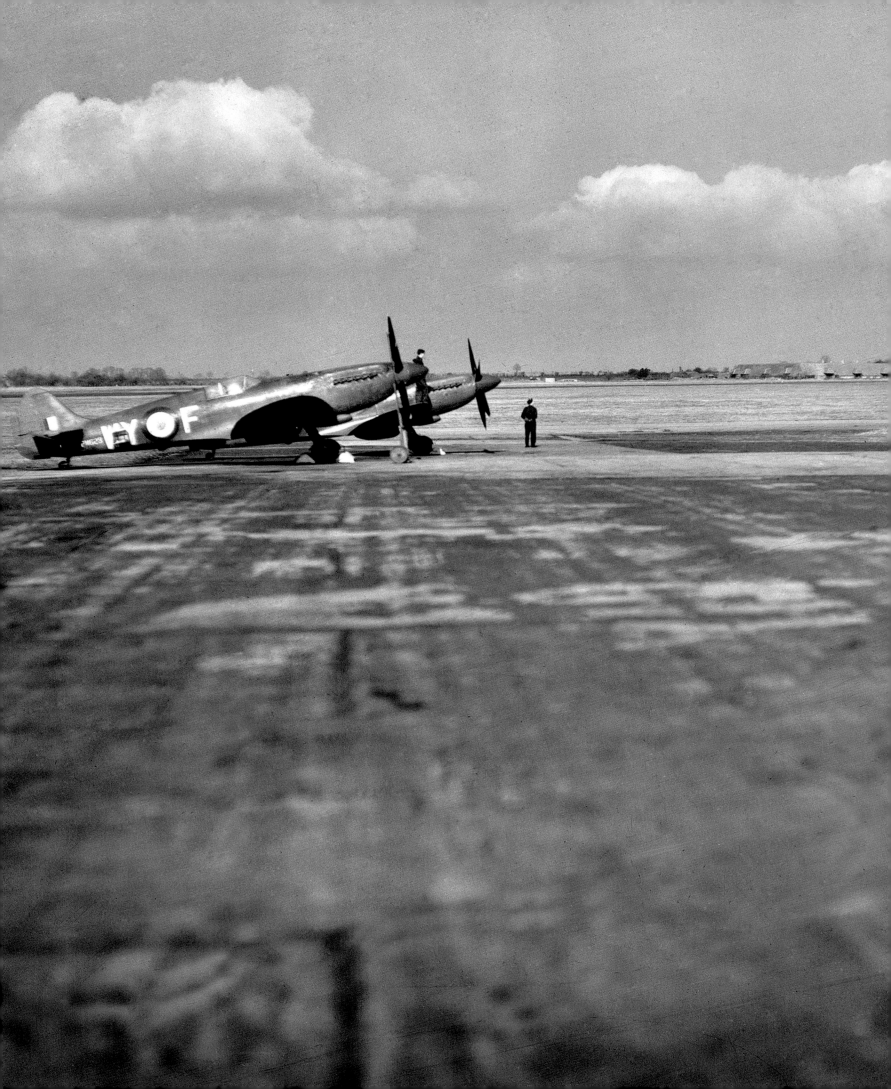

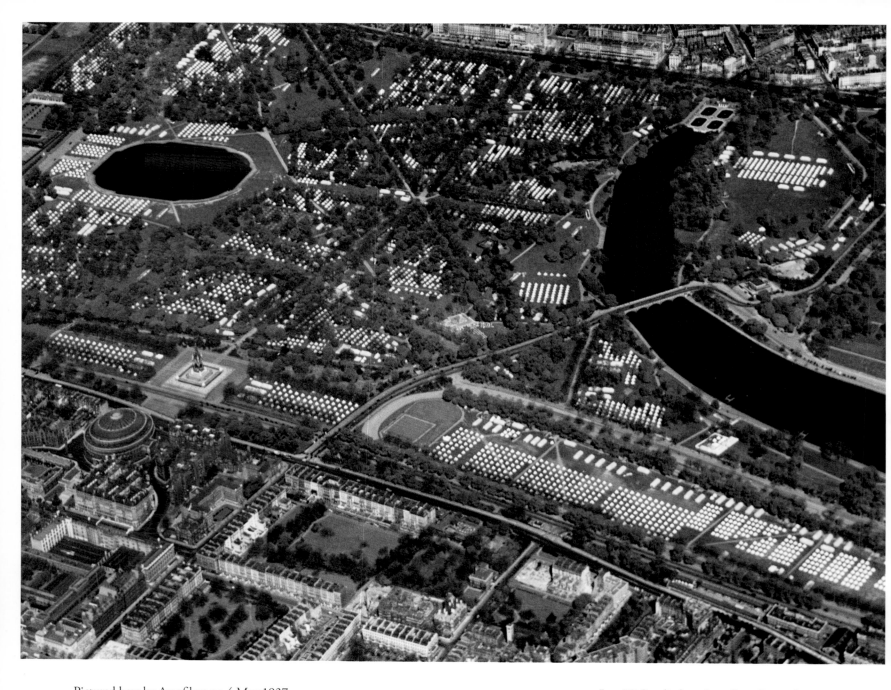

Pictured here by Aerofilms on 4 May 1937, Kensington Gardens and Hyde Park have been transformed into one vast, regimented army encampment. The thousands of canvas tents were used as accommodation for the officers and men of the Royal Air Force and the Regular and Territorial Armies, who were preparing to take part, just a week later, in the coronation ceremony of King George VI. This was also a remarkable demonstration of Britain as a militarised society – as *The Times* wrote on 8 May 1937, 'Once past the red-capped Military Police who now keep the general public outside the gates, the visitor is in a completely military world and London might be many miles away.' 1937 EPW052911

In a BBC radio broadcast from September 1938, Prime Minister Neville Chamberlain bemoaned 'How horrible, fantastic, incredible it is that we should be digging trenches and trying on gas-masks because of a quarrel in a far away country between people of whom we know nothing.' Pictured here on 28 February 1939, air raid shelters can be seen emerging out of the grass and soil of Hyde Park, alongside Park Lane and opposite the Dorchester Hotel. An Air Raid Precautions department had been in active operation since 1935, to plan and direct 'passive' air defences including protection, shelter, first aid and fire protection. A new Air Raid Precautions Act came into force on 1 January 1938, and later that same year Aerofilms were approached by the Home Office to produce aerial surveys of the ongoing work. 1939 EPW060542

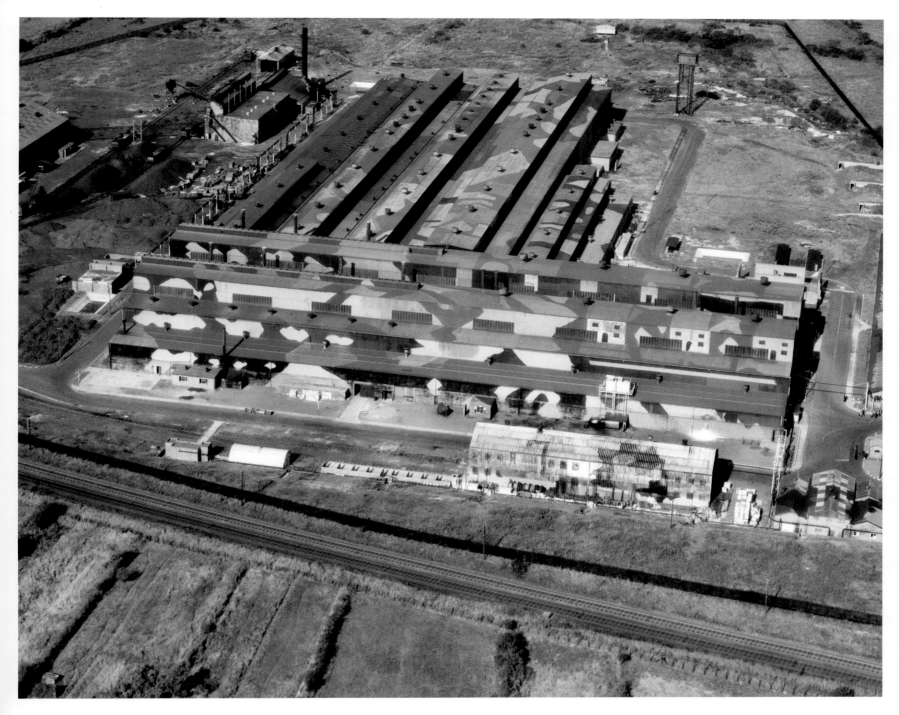

Headquartered in the commandeered Regent Hotel in the elegant Georgian town of Royal Leamington Spa, the 'Camouflage Directorate' devised and designed elaborate schemes to hide key sites and buildings from enemy aircraft. Six Aerofilms staff were recruited to the unit, to fly and photograph structures before and after camouflage work had been carried out.

Left, at RAF Leuchars in Fife, Scotland – staging post for some of the most dramatic photographic reconnaissance missions of the war – disruptive patterning is being used to disguise the airfield and aircraft hangars. Even more elaborate was the scheme introduced at the Imperial Chemical Industries aluminium plant in the south Wales town of Gowerton, pictured above.

A key manufacturer of aluminium sheet for the aircraft industry, the factory was painted to look like rows of terraced houses, complete with smoking chimneys.
1942 NCAP 006-004-005-159-C, 1947 WAW011622

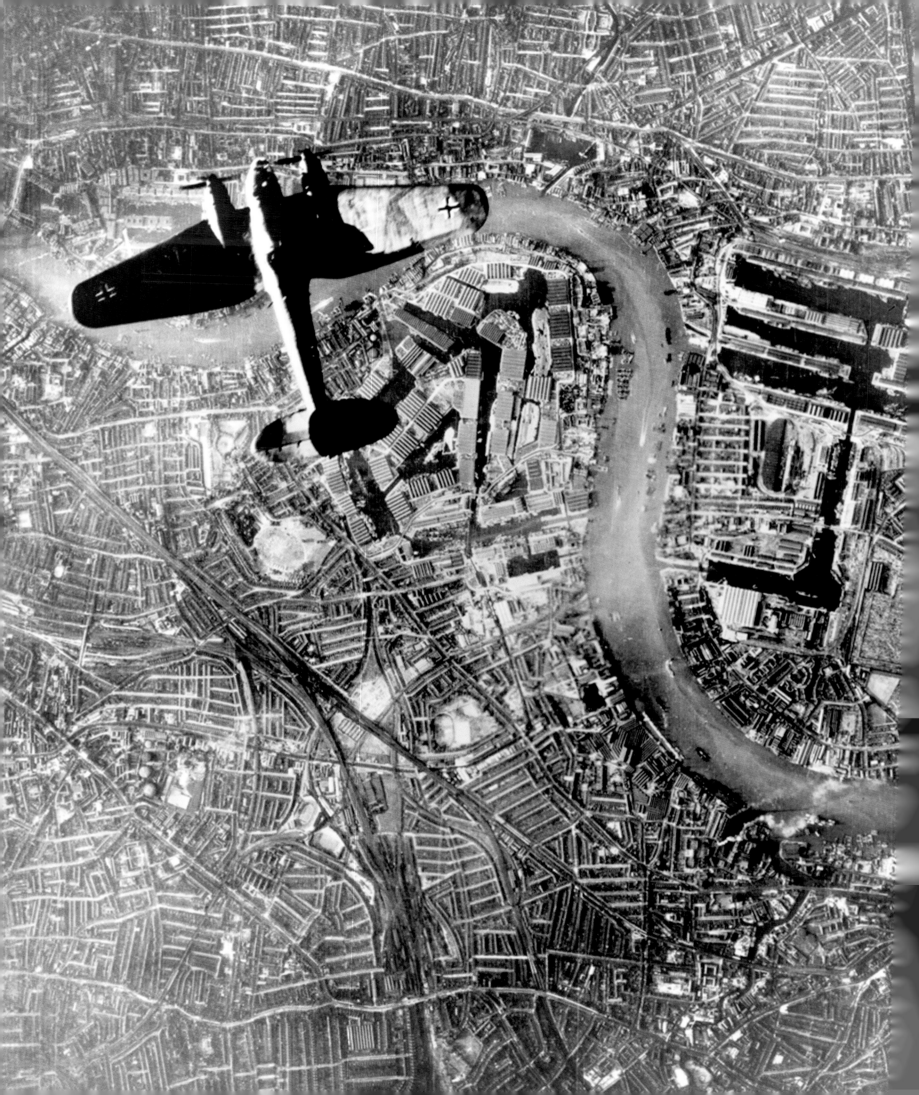

A Heinkel He111 bomber flies over central London on 7 September 1940 in this shot taken by the Luftwaffe, and found in a German archive of aerial photography seized by the Allies after the War. Visible directly below is one of the city's key targets – the huge industrial complex of the Royal Docks. 1940 US NATIONAL ARCHIVES

The location of Aerofilms' Wembley offices in a built-up area close to a marshalling yard, a main railway line and a series of bridges and factories made it particularly vulnerable to Luftwaffe raids. These two images show the damage caused by two high-explosive bombs which were dropped on the night of 17 October 1940 between two nearby factories. The company drawing office was destroyed, and much of the main building was rendered structurally unsafe. With the photographic interpretation unit growing in size and importance, the Air Ministry knew that it had no option but to secure alternative accommodation for its invaluable staff and equipment. 1940 MEDMENHAM COLLECTION

ABOVE

In 1938, David Brachi, pictured top right, went straight from studying geography at St Catherine's College, Cambridge, to working for the Aircraft Operating Company (AOC) and Aerofilms. Along with Michael Spender, he played a key role in the operation in February 1940 to locate the German battleship *Tirpitz* – pictured above – after it was reported to have left its dry dock in Wilhelmshaven. While Spender used the Wild machine to measure the size of the battleship, it was Brachi – who had always maintained a keen interest in naval warships – who carried out the interpretation work. The intelligence report that they produced amazed Winston Churchill with its detail. This was *the* key moment that led to Aerofilms' and AOC's civilian staff forming the core of the RAF's new photographic interpretation unit. As Churchill recommended in his letter to the Secretary of State for Air, 'the expert staff, should be taken over by one of the Service Departments without delay'.

TOP TWO MEDMENHAM COLLECTION, BOTTOM 1942 GETTY IMAGES

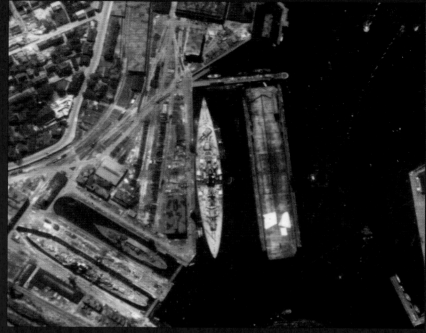

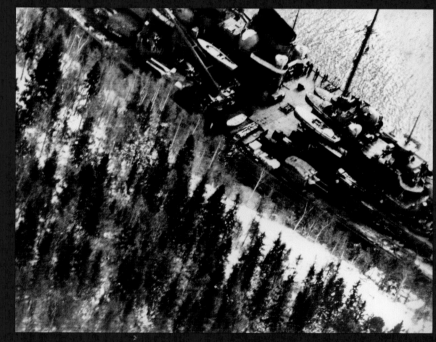

TOP LEFT AND RIGHT

A formidable Bismarck-class battleship – and the centrepiece of the German Baltic fleet – the *Tirpitz* would prove to be a constant menace to Allied shipping, and in particular to North Atlantic convoys bound for the Soviet Union. As a result, aerial reconnaissance was used to track its movements in painstaking detail throughout the course of the war. The Germans knew that the *Tirpitz* was being watched, and would often use bad weather conditions to break cover – resulting in frantic Allied efforts to relocate and re-photograph the battleship. Pictured here in 1941, the *Tirpitz* was being monitored closely at its base in the Baltic port of Kiel in northern Germany.

1942 NCAP ACIU/B/0189/0602

BOTTOM LEFT AND RIGHT

At the beginning of 1942, the *Tirpitz* was deployed to Norway to act as a deterrent to any Allied invasion of Scandinavia. For months, it engaged in an elaborate game of 'hide and seek' with the Allied aerial reconnaissance Spitfires. Warships could enjoy perfect natural camouflage as they moored up among the fjords, and were extremely difficult to spot in aerial imagery – and could even be rendered invisible by resting in the deep shadows cast by high cliffs. In the image above left, the shape of the *Tirpitz* can just be made out alongside a spit of forested land. The photograph to the right is much more conclusive, however. On 28 March 1942, Flight Lieutenant Alfred Fane – a racing

driver before the war – took this remarkable low-level oblique photograph of the battleship while it was moored in the Aas Fjord, near Trondheim. BOTTOM LEFT NCAP ACIU/N/0509/1118, BOTTOM RIGHT MEDMENHAM COLLECTION

Claude Wavell was a brilliant mathematician who worked for the Aircraft Operating Company (AOC) and Aerofilms before the war – including overseeing a pioneering survey of Rio de Janeiro in the 1930s. He initially declined, however, the offer to join his colleagues in the new military photographic interpretation unit in Wembley – on the basis that his local Home Guard needed him. He changed his mind after the evacuation of Dunkirk. Wavell wired his former AOC boss, Major Harold Hemming, with the message 'If you still want me I'll come.' Hemming's immediate reply was 'come at once'.
c1940 MEDMENHAM COLLECTION

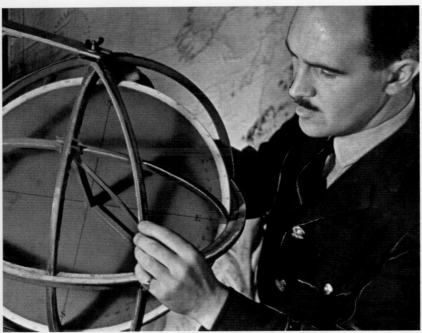

LEFT AND RIGHT

By the summer of 1944, Allied aerial reconnaissance had created an incredibly comprehensive photographic map of the Normandy coast, and could see in graphic detail the terrifying extent of the German 'Atlantic Wall' – a relentless line of barbed wire, machine gun emplacements and reinforced concrete pillboxes. *Operation Overlord* – the codename for the D-Day landings – had been planned in meticulous detail. Key to ensuring its success, however, was the need to deceive, jam or physically destroy the German radar systems. This was where Wavell and his team came in. Their task was to measure the height of every single radar mast running from Spain to Scandinavia – and the distances between them. If the heights could be established, Allied radio scientists believed they would be able to calculate the wave frequencies being used, and devise countermeasures to block them. Initially, this process required the height-finding of radio masts through the study of shadows on aerial photographs – a process that could take a skilled mathematician at least half an hour. Wavell, however, had another idea. He turned to a device that he had been experimenting with in the Wembley offices of AOC and Aerofilms. The result was a machine he called the Altazimeter (left), which used the principles of spherical trigonometry to calculate the heights of the masts in just a few minutes. Wavell's invention was crucial to jamming the German radar and ensured that D-Day retained the element of surprise. On the morning of 6 June 1944 – captured here in reconnaissance imagery of landing craft on Juno and Gold beaches – the Allied invasion fleet was entirely undetected until its arrival on the coast of Normandy. ABOVE AND MIDDLE LEFT 1945 MEDMENHAM COLLECTION, LEFT NCAP 006-026-009-996-C AND RIGHT 1944 NCAP 006-026-006-193-C

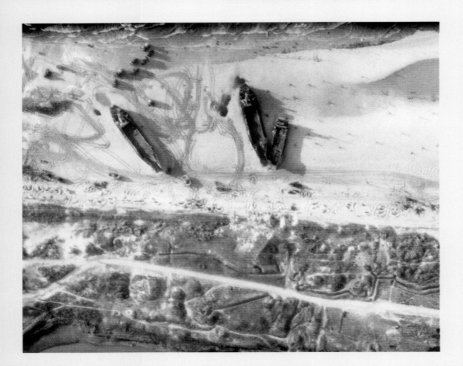

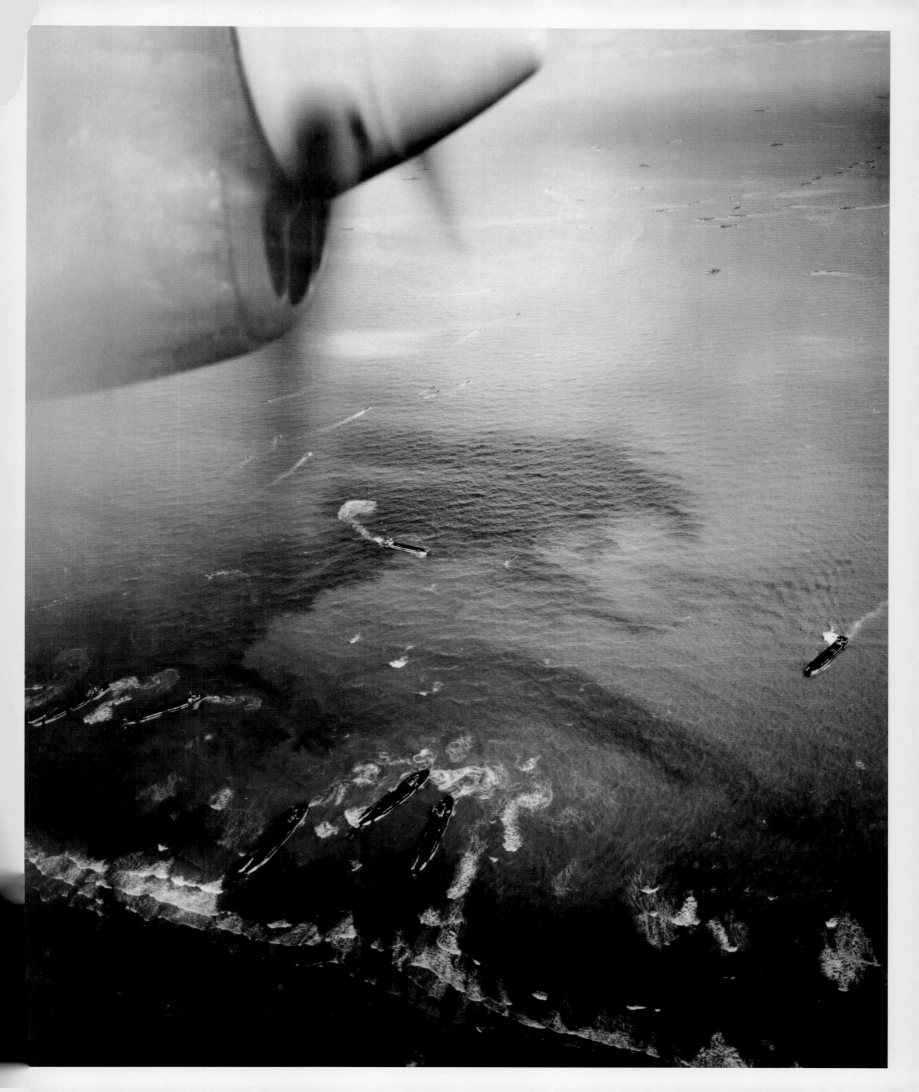

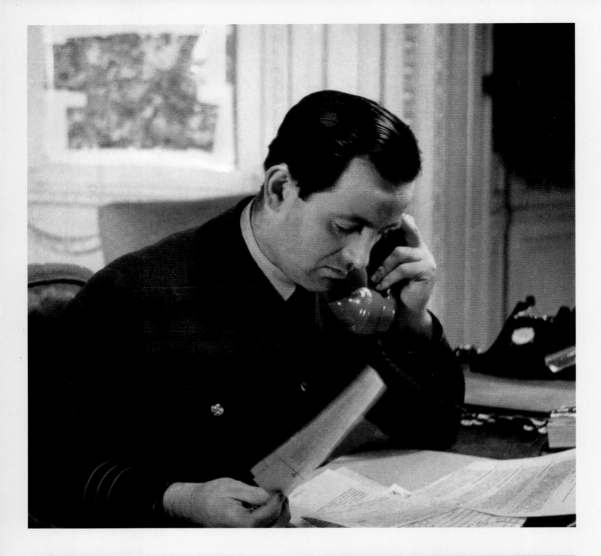

Douglas Kendall had previously worked for the Aircraft Operating Company and Aerofilms in the 1930s, where he had helped pioneer a number of new techniques in aerial survey. When war was declared, he was recruited once again by Major Harold Hemming, working first at the company offices at Wembley, before becoming Technical Control Officer at RAF Medmenham. One of Kendall's key responsibilities was to lead the hunt for Nazi secret weapons – and in particular the rumoured development of a so-called 'flying bomb' or 'V' weapons. Known as *Operation Crossbow*, the mission to locate, identify and eliminate Hitler's V weapons – the V standing for 'Vengeance' – required incredible dedication on the part of the pilots and interpreters of the Central Interpretation Unit. A remarkable 3,000 missions were flown and 1.2 million photographs taken and analysed over the course of the operation.

1945 MEDMENHAM COLLECTION

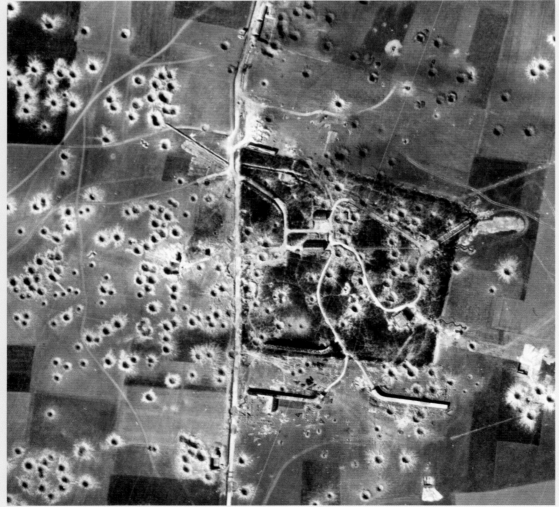

Once the interpreters at Medmenham believed they had identified a V-weapon launch site, the Allied bombing response – as can be seen here at Bois Carre in the Pas de Calais region of northern France – was decisive and devastating.

1944 NCAP 006-008-000-854-C

Set against the dome of the Methodist Central Hall and the spire of St Martin-in-the-Fields, the cruciform silhouette of a flying bomb is captured during its descent on Victoria in central London. Bystanders recalled that an eerie 'deafening silence' always filled the air before the inevitable explosion. Coming so soon after the morale-boosting success of the Normandy landings, the bombardment of the capital by technologically advanced long-range weapons marked a chilling new turn in the course of the war. c1944 US AIR FORCE MUSEUM

Pictured here is the devastation caused by the impact of a single V1 flying bomb, which landed near the junction of Edridge and Coombe Roads in Croydon on the night of 21 June 1944. A total of 142 flying bombs hit Croydon – more than any other area of London – resulting in the deaths of 211 people. c1944 US NATIONAL ARCHIVES

On the morning of 12 September 1944, a photographic reconnaissance mission was flown over the German city of Darmstadt, to record the impact of a Bomber Command raid the previous night. Once the smoke of the many fires had cleared, a devastated cityscape was revealed, with innumerable 'box-shadows', the tell-tale signs of buildings whose roofs had been destroyed completely. 1944 NCAP ACIU/106G/2813/3170

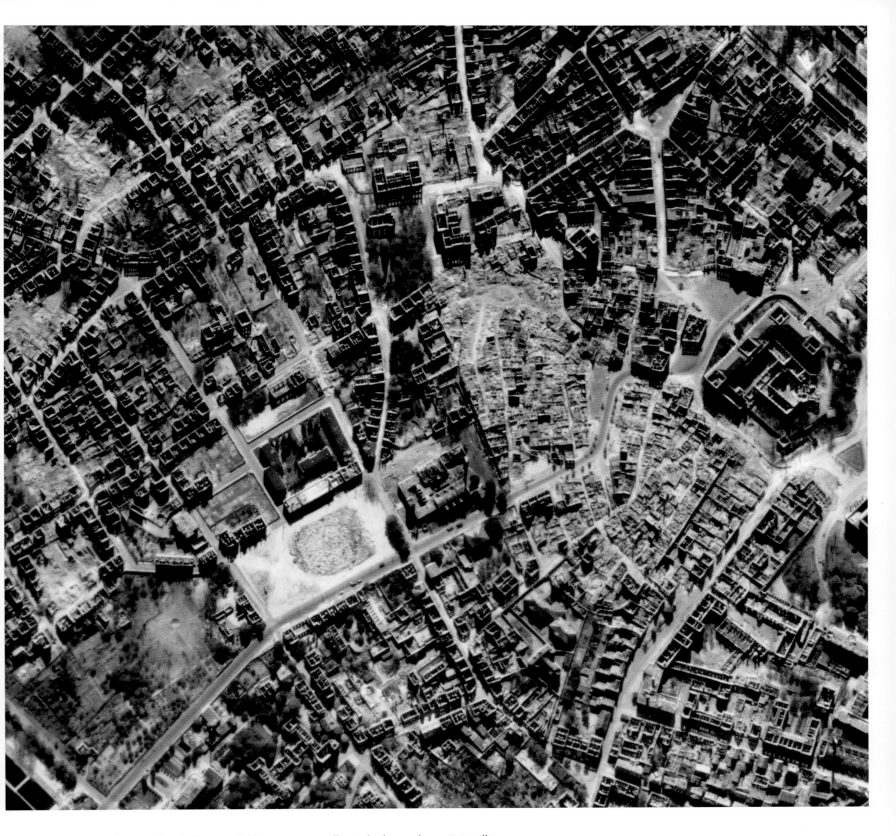

To accurately assess bomb-damage, RAF Medmenham systematically analysed aerial photographs taken before, during and after each raid. The Allies flew more than 1.4 million bomber and 2.8 million fighter missions during the War in Europe, and collectively dropped over 2.7 million tons of bombs. From the relative serenity of an English country house, the Medmenham photographic interpreters witnessed the progressive mass destruction of continental Europe. 1944 NCAP ACIU/106G/2991/4077

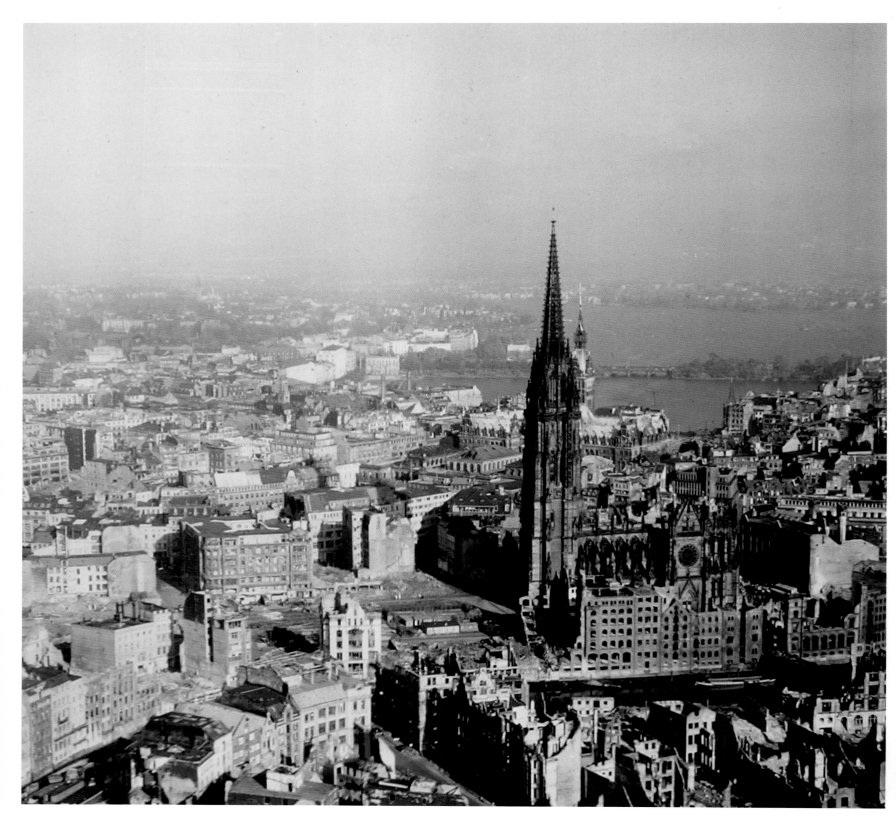

By the time of *Operation Gommorah* – the Battle of Hamburg in July 1943 – the scale and destructive force of RAF Bomber Command had increased to unprecedented levels. The German city was subjected to the heaviest assault yet known in the history of aerial warfare, resulting in a terrifying firestorm and the deaths of more than 40,000 people. Here, the crumbling facades of ruined buildings surround a gutted St Nicholas' Church. The building's 147m-high spire remained standing, however – and was even used as a key orientation marker by the Allied pilots. 1945 NCAP 006-015-002-061-C

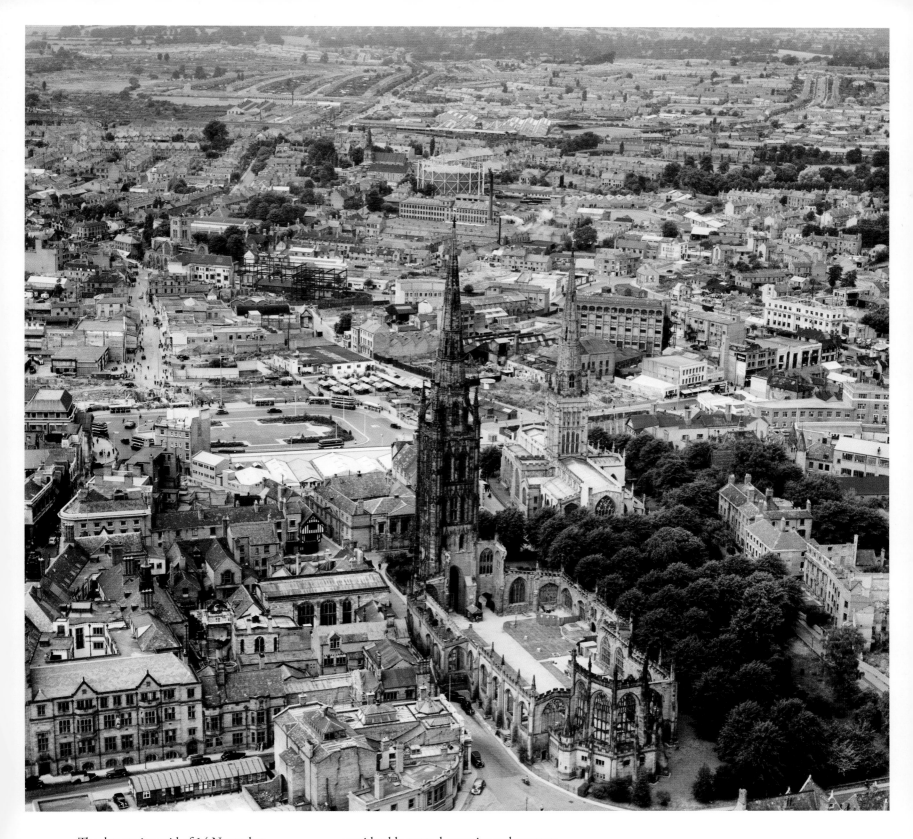

The devastating raid of 14 November 1940 on Coventry, codenamed *Operation Moonlight Sonata* by the Germans, prompted Hitler to invent a new verb: *Coventriren* – to Coventrate – meaning 'to destroy'. Aerial photography of the flattened city taken in the aftermath was analysed at the Wembley office of Aerofilms and the Aircraft Operating Company. Their sobering report identified that the Luftwaffe bombing campaign was considerably more destructive and accurate than the British offensive – a conclusion which would go on to have a significant impact on the future tactics, and effectiveness, of Bomber Command. Pictured here in July 1946, there is an almost strangely serene quality to this panorama of a depleted Coventry – most notable in the shell of the ruined Cathedral, which has been recast as a picturesque garden. 1946 EAW001829

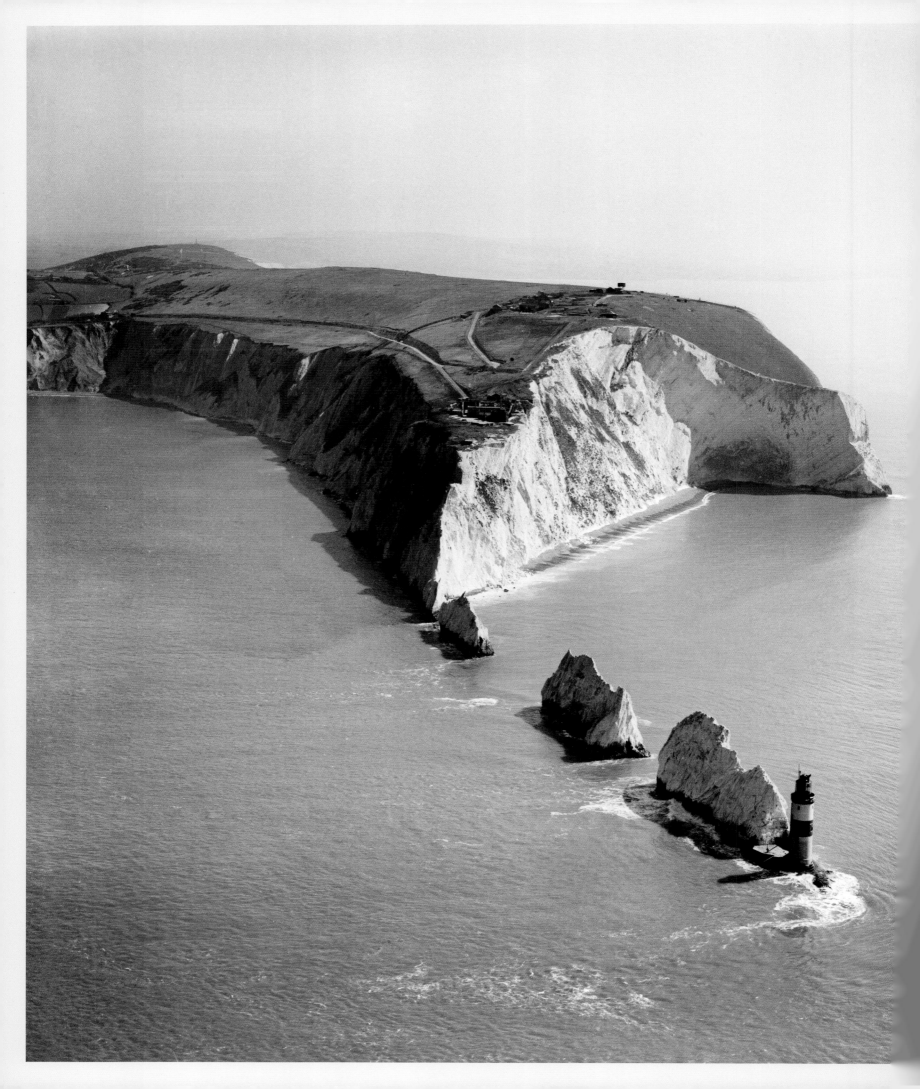

Brand Britain, 1946-1953

In May 1945, after the fall of Berlin and the unconditional surrender of the German armed forces, Francis Wills sent out letters to everyone who had worked for Aerofilms before the War. 'The Victory in the West', he wrote, 'enables us to contemplate re-starting the Company's business and once again establish ourselves as a recognised Air Survey organisation.' Ever the conscientious administrator, Wills asked his former staff for 'details of your release Group, so that we may be able to calculate when your services will be available to the Company'. Enclosed in the letters were pro-formas to be filled-in and returned as soon as possible. Wills' aim for a reconstituted Aerofilms was typically bold: 'It is hoped that the Company will play its part in world reconstruction.'

By the end of the war, Aerofilms had a new majority shareholder – Percy Llewellyn Hunting, a shipping tycoon from Newcastle upon Tyne. Hunting, who had served with the Royal Flying Corps in Iraq during the First World War, was seeking to diversify into aviation, and saw the opportunity to buy out the interests of Major Harold Hemming and his partners in the Aircraft Operating Company (AOC) Ltd. A new Board was convened in October 1943, and by 1944 monthly meetings were being held – timed to coincide with Wills' day off from military service. AOC was renamed Hunting Aerosurveys, but Wills reached an agreement to keep the Aerofilms brand and identity.

Bringing the staff back together was just one of a number of challenges facing the company in the immediate post-war period. Aerofilms had been broken down into its various component parts – not just personnel, but also equipment, cameras, photographic materials, offices and aircraft – and redistributed according to military necessity. Wills' task was to reassemble a complex corporate jigsaw – and to begin work again as soon as possible. In January 1946 he set up a new home for the business in Elm Lodge in Elstree – a fifteen-room house with a large basement, available on a short lease from a brewery. The Wild A5 Autograph machine was recovered from Danesfield House and installed in the kitchen. Wills managed to acquire new F-24 roll film cameras from the RAF, but he had also kept one of the company's old glass plate cameras, along with boxes of unexposed 5 by 4 inch negatives which had been left untouched over the course of the War. There was also the – not inconsiderable – matter of the Aerofilms library. Since 1919, the company had produced more than 62,000 exposed glass plates, and had compiled over 550 albums of prints, as well as acquiring an archive of survey film canisters from AOC. Fortunately, this invaluable collection had survived the war intact, but its storage – along with two decades of registers and company accounts – was becoming an increasing problem.

Civilian flying restrictions were lifted on 1 January 1946. The skies were open to Aerofilms once again. Except things weren't quite as simple as that. Rationing had been imposed on aircraft fuel. In the whole of Britain, only nine

The 'Needles' at the Isle of Wight's westernmost tip. By the middle of the century, this was already a popular view of southern Britain, and Aerofilms probably took this photograph to sell on to publishers and postcard manufacturers. 1949 EAW022201

aerodromes had been made available for general civilian use – others were retained by the military, or, in the case of some joint civilian and air-force stations, flights required specific permission from a Commanding Officer. Nevertheless, Aerofilms were able to take their first photograph for six years on 24 January 1946, part of an oblique survey for Hertfordshire County Council. In the spirit of 'Waste Not Want Not', the first 151 of the company's new images were captured by using up the last of the outmoded 5 by 4 glass plates.

Further obstacles to re-establishing the business came with new Air Navigation Regulations, brought into effect on 1 March 1946. Areas of 'prohibited' airspace were enforced, as were restrictions on low altitude flying, and flying over urban areas. At the same time, the Admiralty, the War Office, the Air Ministry and the British Press had come together to reconvene the 'D-Notice' Committee. The D-Notice system – the 'D' stands for 'Defence' – dates back to 1912, and was established with the aim of securing press cooperation to avoid printing anything that could endanger national security. In effect, it saw the media colluding with the government in voluntary self-censorship: one early example was avoiding mentioning the military use of carrier pigeons in the First World War. In the aftermath of the Second World War – perhaps in acknowledgement of the hugely successful intelligence operation run out of RAF Medmenham – aerial photography came to the attention of the Committee. The result was D-Notice 33, which advised that aerial photographs of specified sites important to defence purposes, including industrial establishments, were not to be published without suitable consultation.

This was not just a temporary measure – the intense scrutiny of imagery produced by Aerofilms and their contemporaries continued for a full decade, right up to 1955. Assistant Chief of Air Staff Intelligence, Air Vice Marshal Sir Lawrence Pendred, sent letters to businesses to seek their compliance. 'I have been invited by the Service Ministries and the Ministry of Supply to approach you confidentially for your co-operation in preventing the taking of air photographs which might be prejudicial to the defence of the country,' wrote Pendred. 'Appropriate arrangements have already been made with several sources of publication – the Press, the aircraft industry and mapping agencies… We are now anxious to enlist your help to block other ways in which such photographs may be taken or published, since the daily work of your company may involve the taking of photographs from the air.' In February 1951, the D-Notice Committee even began discussions on broadening the definition of the kinds of information that might put at risk British capabilities for any future war-effort. The result was the 'War Potential' restrictions, which extended the previous D-Notice to include 'factories which are making products that would be essential to the successful prosecution of war', and 'marshalling yards, docks and public utility installations'.

The potential impact of these measures on Aerofilms was considerable – particularly given the continued importance of industrial clients to the balance sheets, and the almost unlimited scope of the phrase 'essential to the successful prosecution of war'. Between 1952 and the moderate easing of the restrictions in 1955, large numbers of Aerofilms images were passed on for security checks – either by the company itself, or by newspaper editors and publishers. Yet Aerofilms still retained a strong rebellious streak. Restrictions were bent and regulations broken in the pursuit of the best aerial photographs. Altitude limits were ignored, and pilots continued to take their aircraft over urban areas. Indeed, 33 years after Gordon Olley had ditched in the boating lake of Southwark Park, and received a summons for endangering public safety, Aerofilms found themselves back at Bow Street Magistrates' Court. On 8 June 1953, pilot Frank Hargreaves was called

After the war, the Wild A5 machine – which had played such an important role in winning the intelligence war for the Allies – was reacquired by Francis Wills for Aerofilms. Once again it was dismantled, before being transported from the basement of Danesfield House at RAF Medmenham, to a temporary home in the kitchen of the company's new premises in Elstree c1945 MEDMENHAM COLLECTION

In the Spring of 1948, King George VI and Queen Elizabeth visited the new offices of Aerofilms at 6 Elstree Way, Borehamwood. During the War, the Wild machine had calculated accurate landscape measurements from aerial photographs, and this information was used to create scale models of everything from enemy radar installations to the D-Day beaches. Aerofilms employed these same techniques to build the Royal couple a landscape model of the Balmoral estate.
1948 ENGLISH HERITAGE. AEROFILMS COLLECTION

to answer charges of contravening Air Navigation Regulations, after flying an Aerofilms 'Auster' over London's South Bank, 'in such a manner, by reason of low altitude and proximity to persons and dwellings, as to cause unnecessary danger to persons and property on land'. The company may have been rebuilt after the war, but it had not been reformed.

Wills' conviction that Aerofilms would 'play its part in world reconstruction' was typical of the prevailing post-war attitude in Britain. The nation had emerged from the conflict as a victor, one of the 'Big Three' alongside the United States and the Soviet Union. By the end of the war, it had over two million men stationed in nearly every continent, from Europe, Africa and the Middle East to Asia and Central America, and it was the centre of the Commonwealth and the Sterling financial zone. Psychologically, Britain was not prepared to relinquish its lead role on the global stage – after all, it could look back to a proud history as perhaps the pre-eminent imperial power in the latter half of the nineteenth century and the early years of the twentieth century. Yet, in reality, the national economy had been devastated, and was little different to that of a defeated country. Britain was effectively bankrupt. In August 1945, John Maynard Keynes, the chief economic advisor to Clement Attlee's newly elected Labour government, told ministers that the nation's ambition to remain a 'superpower' was a burden which 'there is no reasonable expectation of our being able carry'. Keynes instead warned of a 'financial Dunkirk', with a 'sudden and humiliating withdrawal from our onerous responsibilities with great loss of prestige and the acceptance for the time being of the position of second-class Power, rather like the present position of France'.

However acute this advice, it was politically unpalatable. Keynes was sent to Washington, and after months of fractious negotiations, he managed to secure a loan of nearly 4 billion dollars from the American government. This helped fund the Labour dream of the Welfare State, while at the same time shored up the vast administrative and military costs of a disintegrating Empire. As early as 1949, however, Herbert Morrison, Attlee's deputy prime minister, admitted his worries that Britain was 'in danger of paying more than we can afford for defences that are nevertheless inadequate or even illusory'. Nevertheless, successive post-war prime ministers opted to hide the truly parlous state of Britain's economy from the public – there was too much national pride at stake.

Francis Wills co-founded Aerofilms in 1919, when he was just 26 years old. After nearly 40 years working as the company's Managing Director, he finally announced his retirement in 1958 – although he remained an active member of the Board of Directors until the 1970s. No man had done more to promote and professionalise aerial photography in Britain over the course of the twentieth century. 1958 ENGLISH HERITAGE. AEROFILMS COLLECTION

All the same, the Britain now passing beneath the wings of the Aerofilms' aircraft was undergoing major reconstruction – even rebirth. Large tracts of the landscape had been transformed into something of an extended building site, as infrastructure projects brought a physical reality to the ideology of welfare reform. Techniques of mass production in manufacturing – which had been honed by the extreme demands of war – were being repurposed by the Ministry of Works to introduce the concept of the 'pre-fabricated' house. Massive estates – filled with the shells of identikit homes – were erected in huge numbers and at remarkable speed. The nationalisation of electricity, and a sustained upsurge in public demand, saw the government construct power stations on an unprecedented scale. Giant concrete cooling towers – that came to dominate the skylines of towns and cities across the country – were new monoliths of post-war industrial architecture. Change was everywhere. And Aerofilms were there to capture it on camera.

The company had no rival when it came to documenting the whole of Britain in such a concerted fashion over such a continuous period. Yet because they were a commercial enterprise, the imagery that they secured for their clients would often display a particular bias – towards the new, the novel and the picturesque. They regularly presented the best of Britain – from famous landmarks and landscapes, ambitious construction projects and gleaming new factory complexes, to national celebrations and major sporting occasions. From the air, a city like London, for instance, could be transformed from a dense, incoherent urban mass, into a sequence of discrete, iconic and often spectacular architectural monuments. By picking the right Aerofilms images, advertisers could repackage it cleverly as a tourist-friendly destination, with a sightseers' hit list running from Big Ben and Buckingham Palace to St Paul's Cathedral and

According to its official guidebook, the Festival of Britain was 'a challenge to the sloughs of the present and a shaft of confidence cast forth against the future'. This bright and colourful drawing of the site – which borrows the perspective of the aerial photographer – sets a vibrant, carnival-esque South Bank against an otherwise darkened London cityscape. As the real site emerged along the riverside, Aerofilms were able to follow its progress all the way from construction to grand opening.
1951 SSPL VIA GETTY IMAGES

Tower Bridge. These and other vistas – like the Welsh valleys and the Scottish Highlands – were the building blocks of a visual template that is still in use today, from the 2012 Olympic opening ceremony, to the kitsch pageantry and merchandising of Royal Weddings and Jubilee celebrations.

Aerofilms were not just pioneers of flight and photography, but also of marketing – providing the raw materials, either for themselves or for others, to define the 'look' of the nation. From the moment that the company first started, they found that they were able to photograph, in a single flight, everything from William Blake's 'green and pleasant land' to his 'dark Satanic mills' – over one wing there was cricket on the village green, over the other the smoking uprights of the factory skyline. Throughout the company library, exposed negatives of traditional Arcadia could be found slipped between hundreds of images of thriving industrial Empire. Over the first half of the twentieth century, they built up a picture that, when we view it today, is instantly familiar and comforting, yet at the same time can feel achingly distant. In effect, the story of Aerofilms – the men and women behind the company, the photographs that they produced, and the businesses who bought them – is also a story of the making of 'Brand Britain'.

Wills retired as Managing Director of Aerofilms in 1958. He had been born into a world where there was no such thing as powered flight, had established his company before anyone had managed to fly across the Atlantic, and left in the decade that saw the arrival of the world's first international passenger jet airliner, the De Havilland Comet. Although Aerofilms stayed in business – for another 46 years in fact – Wills' departure marks an irrevocable split both in the history of the company and the nation. The struggles of the post-war period were about to give way to the social revolution of the late 1950s and the 1960s. This new world was already beginning to be captured in Technicolor: in film, on television – and in aerial photography, a technique which Aerofilms first trialled in 1948, and then launched on a commercial scale in 1954. Wills' retirement came at the end of one of the most tumultuous chapters in all of British history. He was a man who had strived throughout his career to operate at the cutting-edge, who was deeply passionate about the utility of the aerial photograph, and whose focus was always on the present and the future, rather than the past. It is ironic, then, that in Aerofilms he has left behind a precious record of a Britain that is now lost to us – an Empire, an industrial engine room, a superpower.

Perhaps the most appropriate endpoint to the story comes not in 1958, but at the start of the decade, with a series of Aerofilms images of a construction site by Waterloo station on the South Bank of the River Thames. The photographs showed dilapidated warehouses and slum housing being cleared away. By the spring of 1951, strange new buildings began to emerge on the riverfront. There was a mushroom-like structure called the 'Dome of Discovery', an 'egg in a box' auditorium that would become the Royal Festival Hall, and a cigar-like, 90-metre-high aluminium-clad tower known as the 'Skylon'. These formed the centrepiece of the 'Festival of Britain', an event devised by Attlee's Labour administration to act as a 'tonic for the nation' after years of post-war austerity. Herbert Morrison oversaw the creation of the Festival along with Gerald Barry, the editor of a national newspaper called the *News Chronicle*. When Morrison described it as 'the British showing themselves to themselves – and to the world', he could almost have been writing one of Aerofilms' famous advertising tag-lines. Except that this was a different Britain – the futuristic and modernist works of architecture erected on the South Bank had never really been seen before in this country. They presented visitors with an optimistic vision for a resurgent nation, and promoted the potential of technology, planning, design and culture to create a better life for

On 2 June 1953, the 25-year-old Elizabeth was crowned Queen of Great Britain and the Commonwealth. Some 3 million spectators lined the streets of central London, or took seats in specially built stands – as here, overlooking Trafalgar Square – to watch a procession of soldiers, sailors, airmen, foreign royalty and heads of state make their way to Westminster Abbey. 1953 ENGLISH HERITAGE

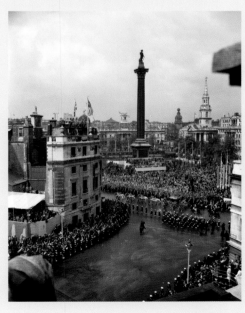

all. There were exhibitions on housing, art, architecture, space-exploration and atomic energy. As the guidebook proclaimed, 'here is the modern world itself, standing straight and handsome on its base of science.'

The Festival did look backwards as well as forwards – which was wholly appropriate given that the event took place at almost the exact mid-point of the twentieth century. This was a symbol of one era ending and another beginning. Yet, quite ironically, its romanticised accounts and depictions of the past – worked on by innovative new designers and graphic artists – also helped to create an enduring brand for British nostalgia. And for all the Festival's utopian self-confidence, there was an underlying uncertainty. In the new, modern world, where should Britain look for its inspiration? In the second half of the century, what would it actually mean any more to be British? These were questions which the Festival guidebook was quite happy to ask, but less prepared to answer: 'If, on leaving this Pavilion, the visitor from overseas concludes that he is still not much wiser about the British national character, it might console him to know that the British people are themselves still very much in the dark.'

Set against the backdrop of the Festival of Britain, the Aerofilms of Francis Wills and his erstwhile partner Claude Grahame-White seem of a different age entirely. The archive built up over the company's first three decades remains something discrete and different, something special. To look through these images is to experience both the joy of recognition and the pang of loss. We can also see, time and again, the remarkable skills of the pilots and the photographers. They created a unique record of a time of immense social and political change. It is a history of Britain, from above. It is a history that is often partial, sometimes eccentric, and largely incomplete. It is a history full of flaws, uncertainties and omissions. And, as such, it succeeds in capturing the elusive, contradictory and often determinedly sentimental character of the nation.

Aerofilms *is* Britain showing itself to itself – and to the world.

Set directly against the River Thames and alongside the Westminster Bridge, the Houses of Parliament and Big Ben are two of our most familiar and enduring national landmarks. In the immediate post-war period, they were also potent symbols of British fortitude. The buildings had suffered damage on fourteen occasions throughout the Second World War, most severely in May 1941, when incendiary bombs hit the chamber of the House of Commons and reduced it to smouldering rubble – the cleared site can still be seen here at the centre of this image from May 1946. Winston Churchill was adamant that the main chamber of British government and politics would be rebuilt exactly as it was before. As he emphasised in a speech given on 28 October 1943 – in the Commons' temporary home in the Lords' Chamber – 'we shape our buildings and afterwards our buildings shape us'. 1946 EAW000524

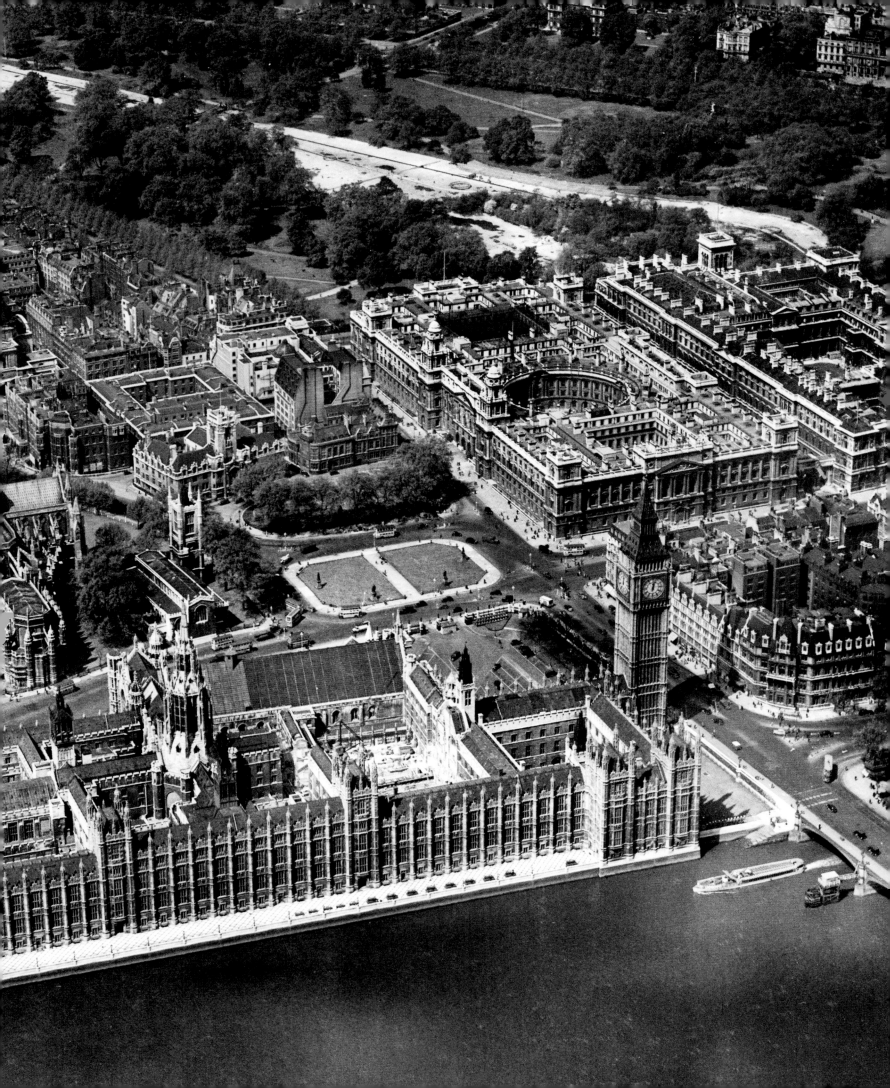

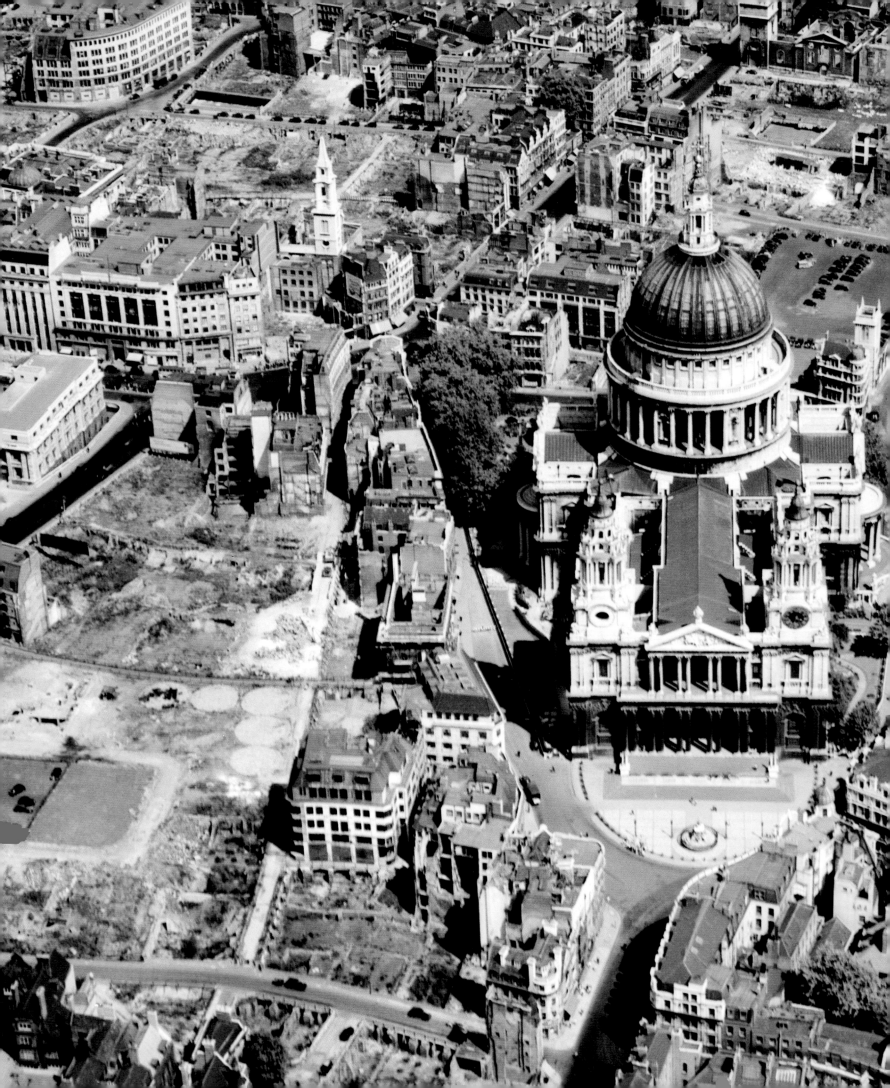

St Paul's Cathedral sits seemingly untouched at the centre of a scene of urban devastation. At the height of the Blitz, London's largest religious monument was transformed into a symbol of resolve, resilience and hope. Winston Churchill was keenly aware of the role that Christopher Wren's Renaissance masterpiece could play in maintaining national morale and pride, and he issued the order that 'the cathedral must be preserved at all costs'. Patrols monitored the building day and night, with fire fighters on constant standby. Despite mass incendiary bombing raids on central London – including an attack on the night of 29 September 1940, which saw the lead in the roof of the Cathedral's dome begin to melt after a direct hit – St Paul's remained standing. The media used imagery of the building as potent propaganda, with the famous BBC war correspondent Ernie Pyle going as far as describing it as 'a picture of some miraculous figure that appears before peace-hungry soldiers on a battlefield'. Pyle used the building's survival to allude rather neatly to a collective spirit of fortitude: 'St Paul's was surrounded by fire, but it came through.' This symbolism remained just as important after the War. In this photograph from 2 June 1947, Aerofilms captured a perfect image of the cathedral as a source of inspiration to begin the rebuilding process – both in London, and in Britain as a whole.

1947 EAW006469

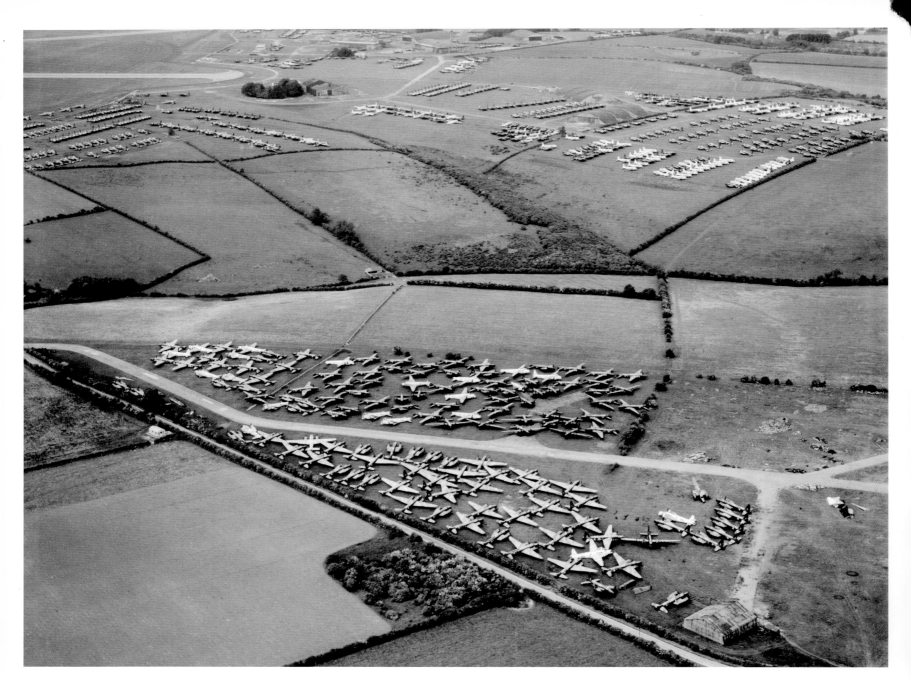

Military aircraft lie scattered across Little Rissington Airfield in Gloucestershire – ready for repair or, more likely, breaking up. In the foreground are arranged ranks of Vickers Wellington twin-engine bombers, some still complete, but others with their wings or tail fins already removed. Written in red capitals next to this image in the Aerofilms company register was the message 'not for publication'.

Whether the shot was taken intentionally or simply in passing, the company remained under scrutiny from the Air Ministry for its civilian flying and commercial photography practices, and was attempting to comply diligently with government D-notices – which restricted the publication of any imagery of sites considered important to the defence of the nation. 1947 EAW006505

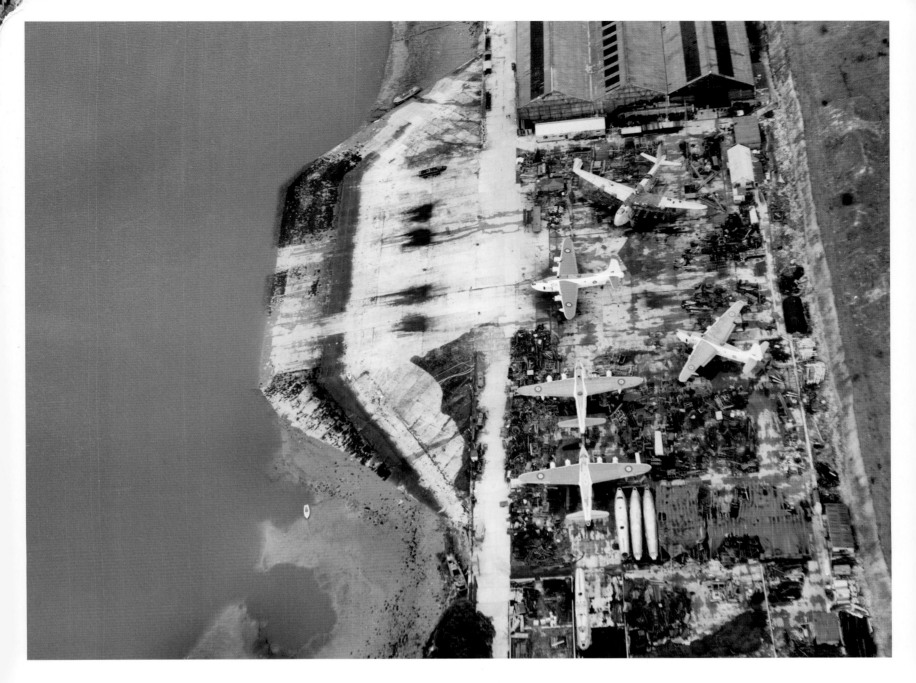

Five seaplanes wait above the concrete entry ramp to the River Medway at the Short Brothers Seaplane Factory in Rochester. Horace, Oswald and Eustace Short first started building aircraft in 1908, when they set up their company in Battersea. They moved to Rochester in 1913 to begin specialising in the manufacture of seaplanes, and by the end of the 1930s they had extended their factory site to some 18 acres, employing a workforce of over 2,500 men.

Just as in the First World War, however, conflict created an artificial and inflated market for the construction of aircraft, which could not be sustained in peacetime. In 1946 the Ministry of Supply declared that the Rochester works were 'inadequate to modern requirements' and that the Medway was unsuitable for testing flying boats. The factory closed a year later in 1947, and the business moved on to Belfast. 1946 EAW002345

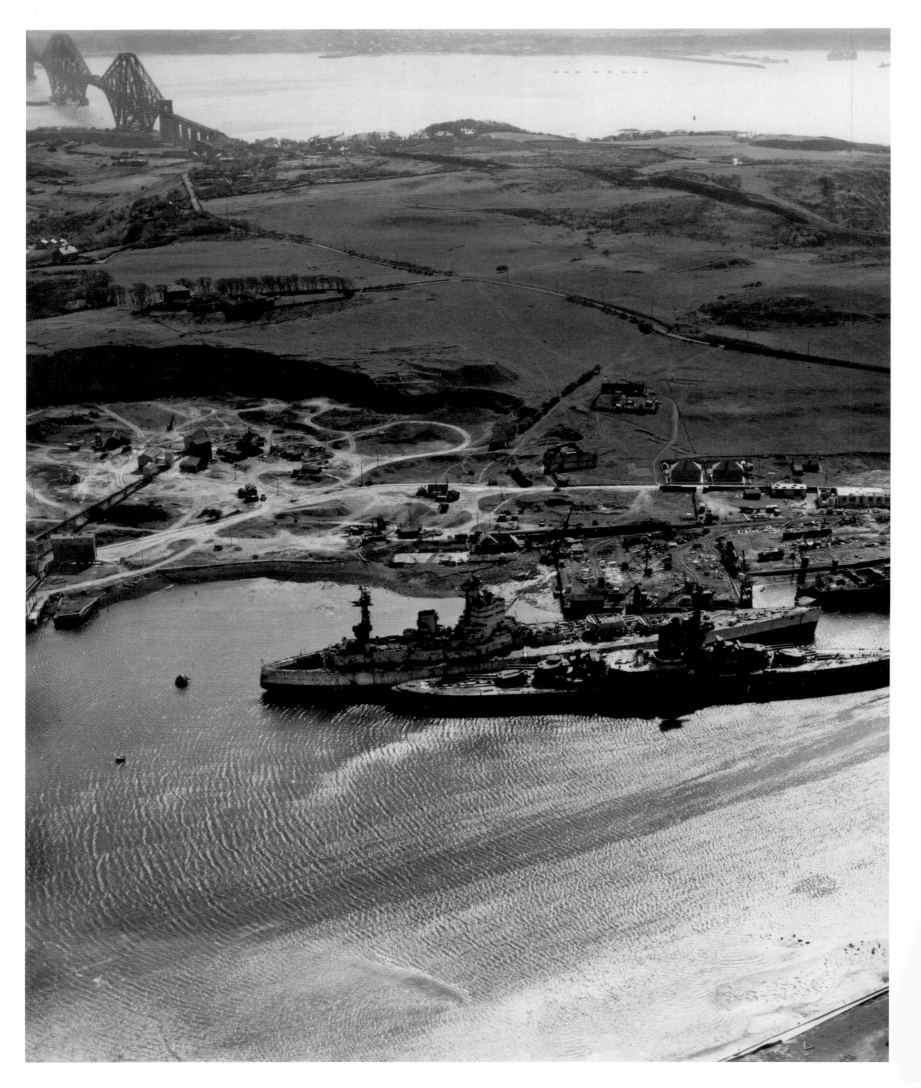

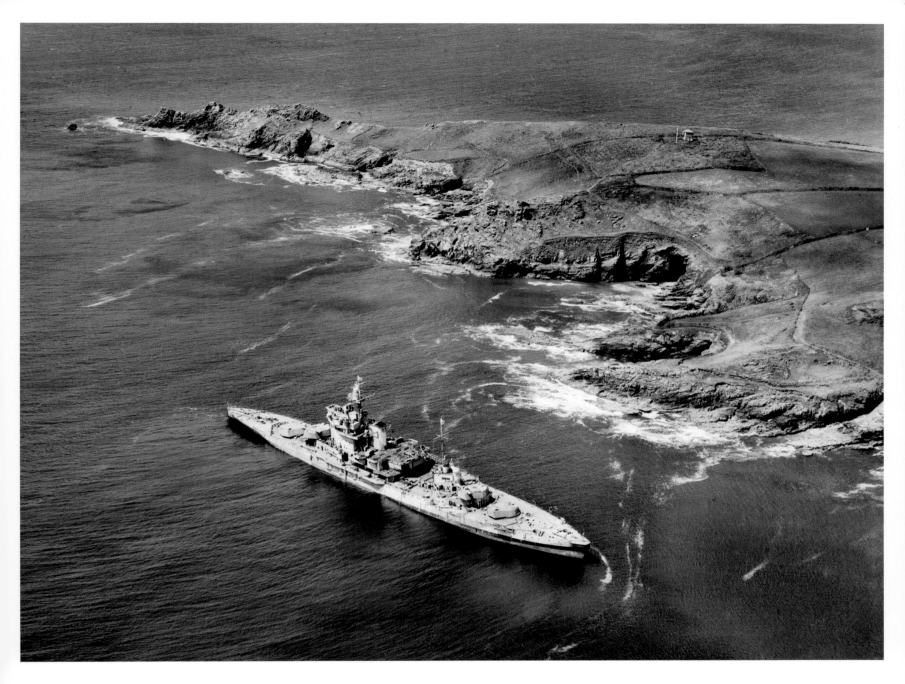

LEFT

With the distinctive cantilever structure of the Forth Rail Bridge in the background, two war-weary battleships – the HMS *Revenge* and, behind it, the HMS *Nelson* – are moored for dismantling and scrapping at Thomas Ward and Sons Shipbreaking Yard in Inverkeithing. First launched in 1925, the *Nelson* had fought in the Battle of the Atlantic, before being reassigned in 1941 to protect Allied convoys in the Mediterranean. By 1947, the ship was moored in the Firth of Forth, to serve as a target for bombing practice. The *Revenge* had an even longer service history –

completed in 1915, just in time to be rushed into action at the Battle of Jutland, it had also served during the Second World War as part of the Pacific Eastern Fleet based at Colombo. Life for the *Revenge* – at least in some small part – would go on after scrapping however. The ship's gun turret rack and pinion gearing were reused in the state-of-the-art radio telescope built at Jodrell Bank in the 1950s. 1949 SAW022473

ABOVE

Just like the HMS *Revenge*, the HMS *Warspite* served with distinction in both World Wars, yet it faced an ignominious end after running aground here at Prussia Cove in Cornwall in April 1947. While being transported from the Clyde to Portsmouth for breaking up, the ship was caught in a storm which snapped its tow wires and drove it on to the rocks. In a poem published in *The Times* later that year, the author writes from the perspective of the *Warspite* to lament that, on her final voyage 'the sea remembered me, and flung me where / Not man but her proud waves shall strip me bare.' 1947 EAW005979

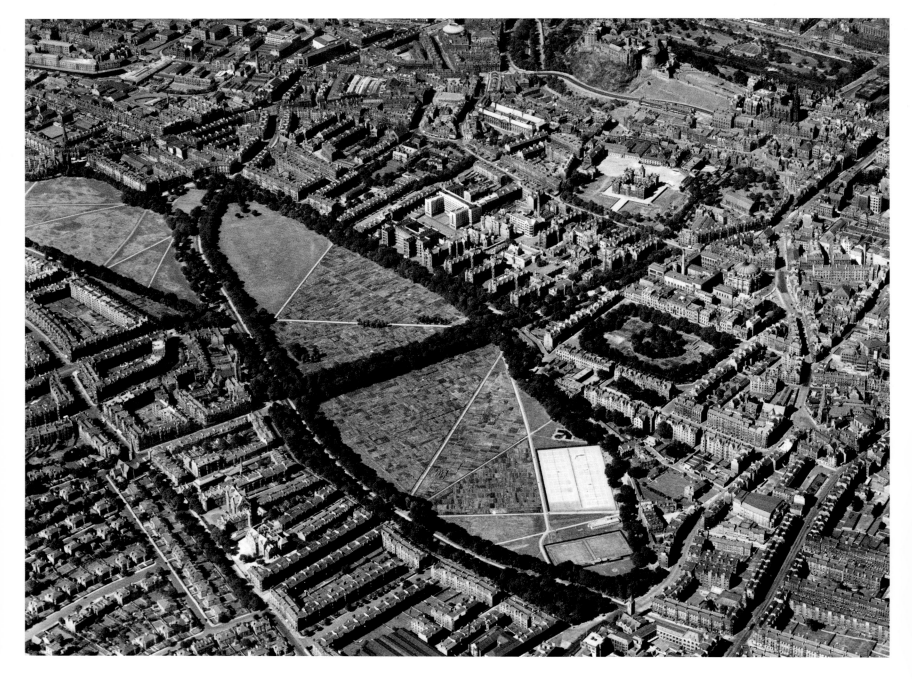

Captured here by Aerofilms in August 1947, 'the Meadows' – a 63-acre public park found just to the south of Edinburgh's historic Old Town – has been transformed into a vast garden plot for some 500 allotments. This was the government's famous 'Dig for Victory' propaganda campaign in action. As a German U-boat blockade threatened Britain with starvation, all citizens were encouraged to start cultivating any available land, and to rely on 'spades not ships!' As the Minister of Agriculture Sir Reginald Dorman-Smith explained in an address to the nation in October 1939, 'we want not only the big man with the plough, but also the little man with the spade to get busy this autumn… Let "Dig for Victory" be the motto of every one with a garden and of every able-bodied man and woman capable of digging an allotment in their spare time.' The results were remarkable – by 1942, almost half of the civilian population was part of the 'Garden Front' working on some ten thousand square miles of land, and by the end of the War, there were nearly 1.4 million allotments in Britain, producing around 1.3 million tonnes of produce. 1947 SAW010246

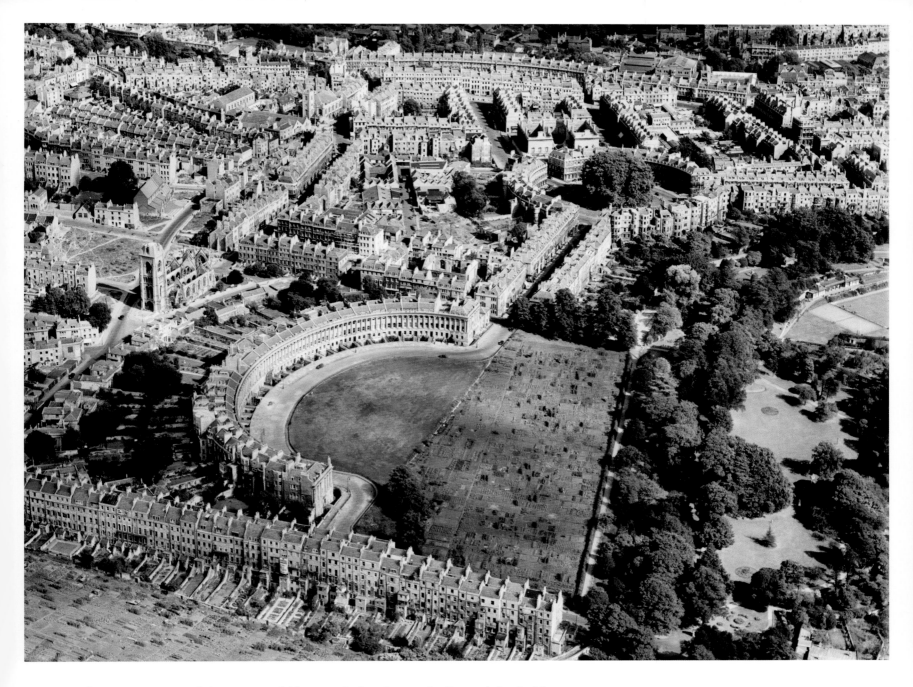

Allotments soon covered almost any available scrap of ground, from school playing fields and public gardens to football pitches and railway embankments. In London, Kensington Gardens dug up its flowers and planted rows of cabbages, the Tower of London turned its grass moat into a vegetable patch, and Hyde Park even had its own piggery. Each Saturday an audience of 3.5 million tuned into the Home Service to hear Cecil Henry Middleton – Britain's first 'celebrity' gardener – give tips on everything from spade-work to sowing seeds. 'An allotment is like the army', he said. 'The first month is the worst: after that you begin to enjoy it.' In this image of Bath from 1949,

the broad rectangle of ground ahead of the Royal Crescent remains the site for some 72 allotments. The land directly in front of the Crescent itself was always kept clear, however. As *The Times* reported on 5 April 1944, this lawn 'was saved from being used for allotments' by 21 votes to 5 at a Bath City Council meeting. The 'Dig for Victory' campaign continued for many years after the war – indeed, this strip of land at the centre of Bath was only transformed back into lawn in 1957. As the Minster for Agriculture Lord Woolton urged in a speech at the end of 1944, 'Do not rest on your spades, except for those brief periods which are every gardener's privilege.' 1949 EAW026453

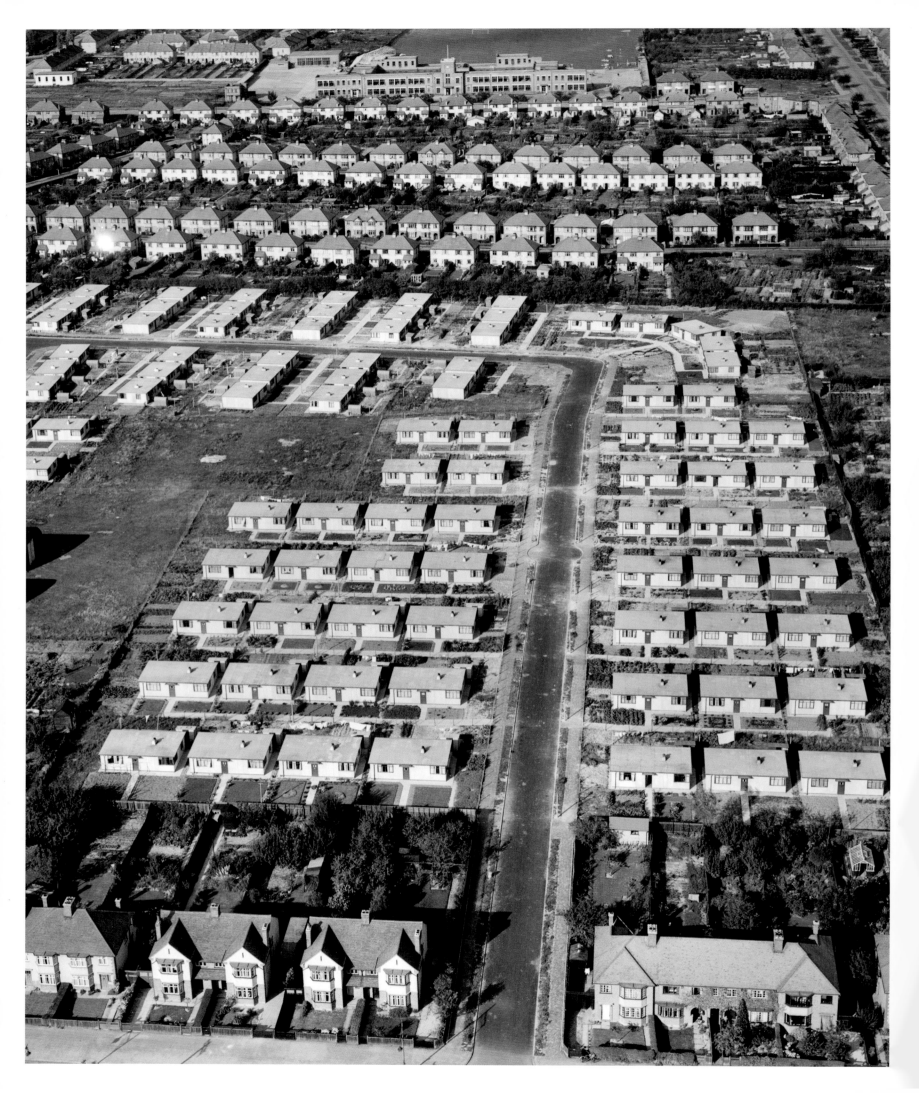

Perhaps more than any other period in the first half of the twentieth century, in the years immediately after the Second World War, a flight above Britain revealed a national landscape undergoing rapid and irrevocable change. The techniques of large-scale mass production of certain single items – which had been so essential to the war effort in relation to, among other things, aircraft and armaments – were suddenly applied to more domestic concerns, like housing. The result was the Ministry of Works' concept of the prefabricated house – the 'pre-fab' – a set of basic designs and templates for temporary accommodation that could be produced in large numbers and at unprecedented speed. Pictured on the left here in 1946 are the ordered ranks of a new pre-fab estate at Lichfield Road in Cambridge. Above, the Aerofilms photographer captures the shadow of his own aeroplane racing across an estate emerging from felled woodland at St Paul's Cray in south-east London.

1946 EAW002930, 1948 EAW020739

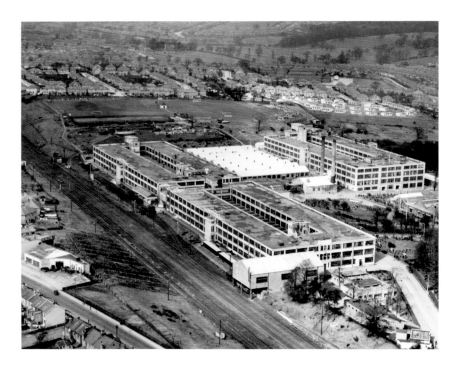

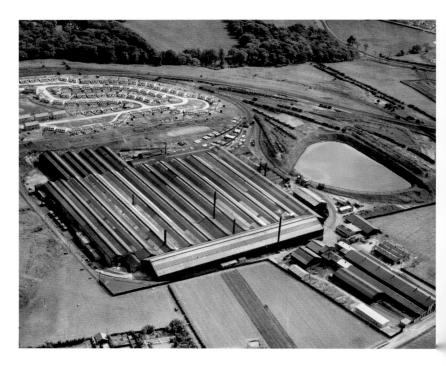

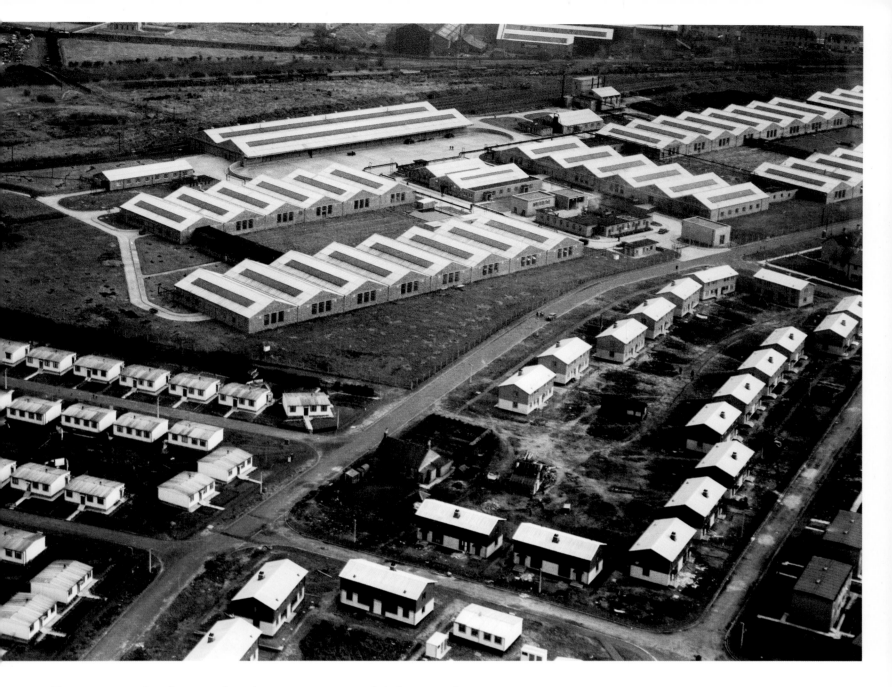

The one constant thread running through the history of Aerofilms in the first half of the twentieth century is the company's relationship with their industrial clients. Encapsulated in their wonderful advertising slogan from the late 1920s – 'Looking Down to Build Business Up' – they promoted, very successfully and time and again, the value of the aerial image to major businesses. While the shape and form of the factories and premises they photographed may have changed – from soot-blackened, gothic Victorian piles to Art Deco monoliths and futuristic buildings of gleaming metal and glass – the principle remained the same. In this series of images, we can see – moving clockwise from top left from Aerofilms' own new offices at 6 Elstree Way in Borehamwood

– a womens' clothing manufacturer in Pontypridd, a plastics moulding factory in Caerphilly, an iron and steel tube manufacturer in Coatbridge, a telephone and cables works in New Southgate, a biscuit factory in Cardiff, and, above, an X-Ray equipment manufacturer in Motherwell. For Aerofilms, photographing industrial buildings was a constantly renewable source of business. 'It is not likely that the novelty of the Aerial photograph will wear off', they claimed, 'for it always presents fresh points of interest. It has so many distinctive advantages that it is assured of a big future in the service of publicity.'

1947 EAW012438, 1950 WAW028548, 1948 WAW018663, 1950 SAW029950, 1947 EAW004114, 1947 WAW010633, 1948 SAW018869

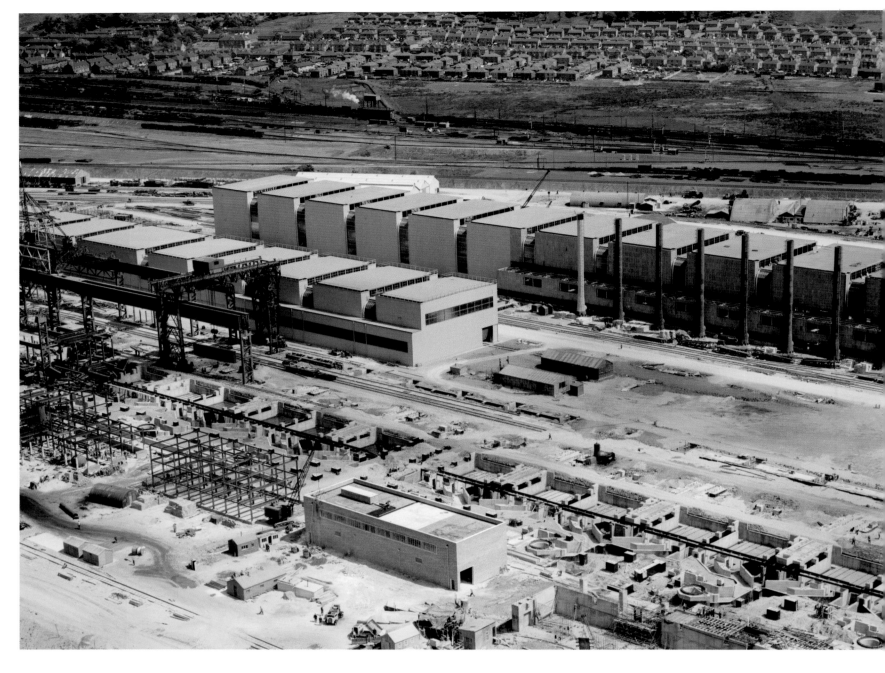

In the late 1940s and 1950s – thanks, in no small part, to post-war loans from the American government – British industry was rebuilt and redeveloped on an immense scale. This was the most radical overhaul since the industrial revolution, as modern techniques led to the creation of vast new factories. Pictured here under construction in 1949 is the Port Talbot Steelworks, a brand new, 1,000-hectare complex which included a dock for importing ore, two blast furnaces and a colossal 1.5km-long strip mill. Capable of producing some 5 million tonnes of steel each year, Port Talbot instantly became the largest steelworks in Britain, and one of the largest in all of Europe. 1949 WAW023799

The 1947 Electricity Act brought some 505 separate suppliers throughout England and Wales under state control, and integrated them into 12 regional Area Boards. The nationalisation of the industry saw the London Power Company – which had built Battersea A and B Power Stations – absorbed into the British Electricity Authority. When Aerofilms flew over Battersea in December 1952, the huge power station had still not taken on the full form that we recognise today. Scaffolding for the construction of the fourth chimney is just visible here on the south-east corner of the B station – although it wasn't until 1955 that it was finally completed.

In 1977, Battersea was transformed into a pop-culture icon after it featured on the cover of the Pink Floyd album *Animals*. In the cover artwork, a giant inflatable pig – which later escaped its tethering ropes to disrupt Heathrow airspace – was pictured floating between the power station's four chimneys. 1952 EAW048057

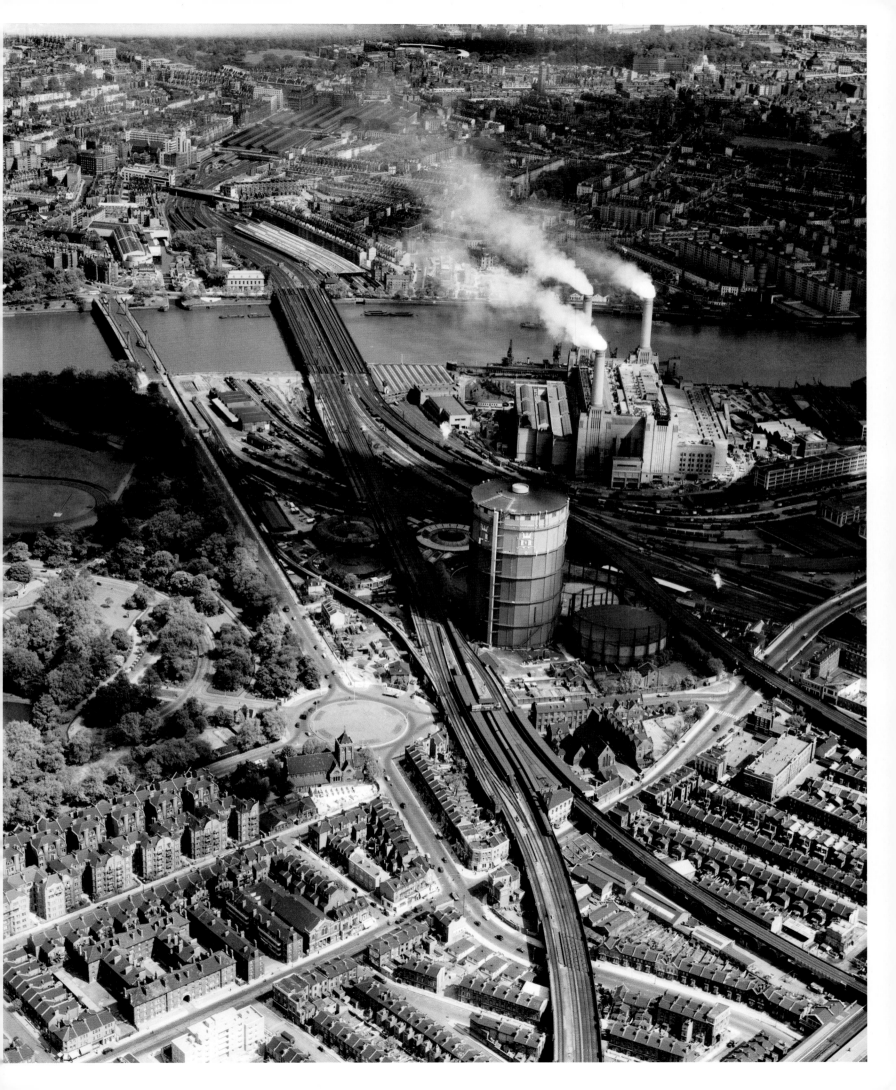

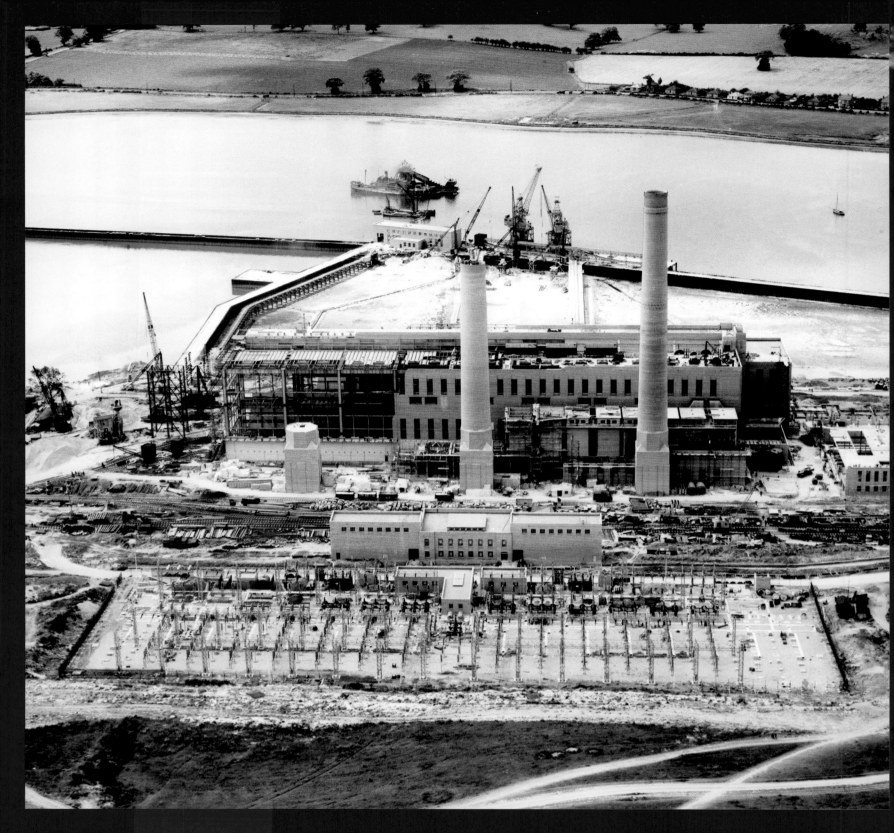

Cliff Quay Power Station in Ipswich, shown
here under construction in July 1948, was one
of 38 stations built under the auspices of the
new, nationalised British Electricity Board.
After its opening in 1950, the Electricity
Board took out adverts in national newspapers
declaring that 'more power from Ipswich means
more power to the nation'. 1948 EAW017575

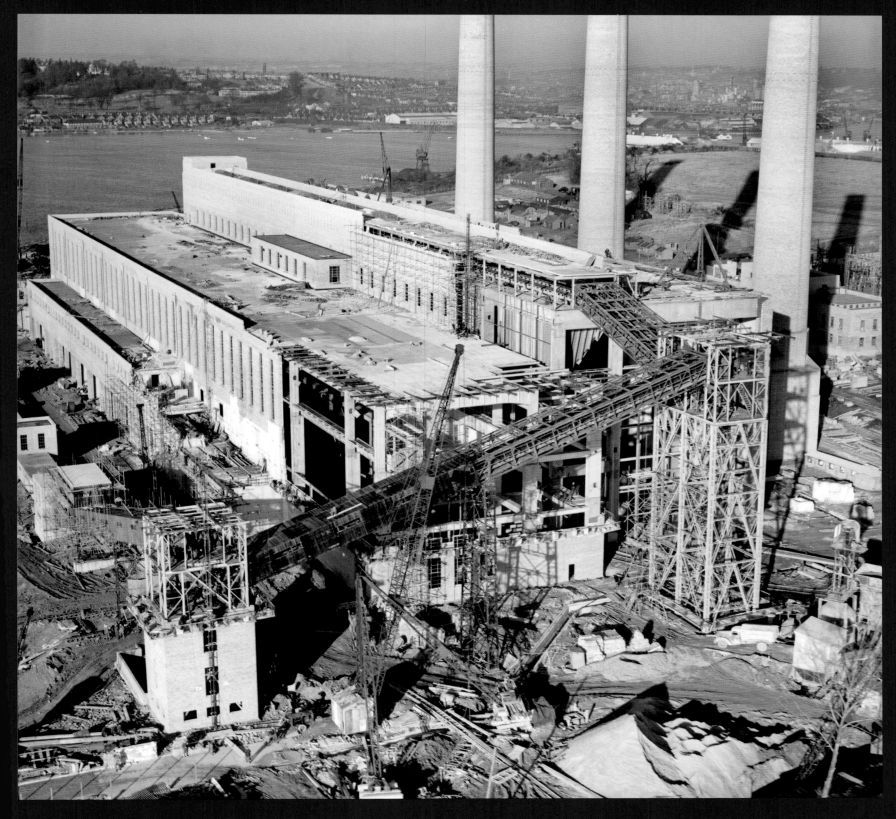

Built over 20 acres of reclaimed land alongside the River Orwell – and capable of producing some 270,000 kilowatts of electricity – Cliff Quay was intended to serve as an emergency supplier to the national grid in the south-east and east of England. By October 1950, there were already nearly half a million more electricity consumers than there had been in 1949, and the government was running public information messages that encouraged people to try to use their supply during off-peak times to avoid exceeding capacity and forcing power cuts. 1948 EAW020688

Two men stand inspecting the skeletal superstructure of the last of Walsall B Power Station's six giant cooling towers. When complete, the towers stood 240ft high, receding in diameter as they rose skywards from 165 feet wide at their bases to 100 feet at their tops. These were the new monoliths of post-war industrial architecture, colossal and imposing concrete cones that came to dominate the skyline of Walsall – and many other regions of Britain. 1950 EAW029340

Power station cooling towers were also monuments, in a sense, to a nation's increasingly voracious desire for, and dependency on, electricity. In 1949, when Walsall B first started generating power, just one of its six, 34,000 kilowatt machines could supply the entire demand of Walsall and Aldridge. A little over a decade later, however, the steep rise in public demand required four out of six of the station's generators to produce energy for the same area. 1950 EAW029343

ABOVE AND RIGHT

Aerofilms were commissioned to record the construction of the major runway extension at Bristol's Filton airport. The result was a series of photographs that showed the site undergoing a transformation from a pastoral landscape of green fields – including the demolition of the hamlet of Charlton in the process – to a transport hub of the future.

This runway was custom-built to serve what *Flight* magazine called 'Britain's Greatest Airliner' – the Bristol 167 Brabazon Mark 1. This aircraft – pictured here in December 1949, as a sleek and streamlined silver dart – was first conceived by a government committee led by Lord Brabazon, Minister of Aircraft Production in Winston Churchill's

wartime government. Concerned that the country was in danger of falling behind in the development of civil aviation, the committee approved the commissioning of a new aircraft that would showcase the best of British design to the world. The Brabazon was a remarkable piece of engineering. With a massive 230-foot wingspan, it pioneered the pressurised

cabin, featured onboard air conditioning, and provided space for 150 passengers. The aim was to produce a high-end, luxury airliner that would serve regular transatlantic London to New York flights. Unfortunately, quality came at a cost – some £12 million in total for the aircraft, runway and hangars. The result was that no airline company, either at home or abroad, was prepared to pay for the Brabazon. Despite a successful maiden flight on 4 September 1949, the Mark 1 – the only Brabazon ever built – was scrapped, and the Mark 2 never made it off the production line.

1947 EAW004183, 1949 EAW027780

This striking image of Windsor Castle was one of five taken by Aerofilms in April 1947 as part of a specially commissioned order. Although the company registers do not mention the client's name, they do record that Aerofilms granted the buyer 'sole rights of reproduction in postcard form for 5 years'. Windsor is the largest and oldest continually inhabited castle in the world – with a history that starts with William the Conqueror and runs through almost every generation of English monarch that has followed. The Castle served as the main residence of George VI, Queen Elizabeth and the Princesses Elizabeth and Margaret during the Second World War. Thought to be a safe haven for the royal household after central London was targeted by the Blitz, it was said that the family sheltered in the Castle's ancient dungeons during air-raids. 1947 EAW004841

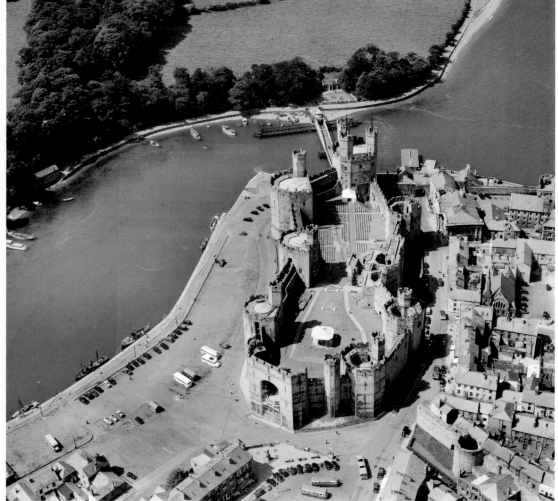

Caernarfon Castle in north-west Wales is shown here in 1953 – the same year as Queen Elizabeth II's coronation. Since the birth of Edward I's son at Caernarfon in 1284, the castle has been the site for the investiture of the Prince of Wales, the male heir to the throne of England, Wales – and subsequently all of Britain. In the aftermath of the Second World War, popular pride and interest in the monarchy had only intensified, and there was huge affection for the young Princess Elizabeth. Always alive to the trends of the day, it is likely that Aerofilms – either on commission or speculatively – were capturing sites of royal interest to sell on to publishers and the media to celebrate the imminent crowning of Britain's new Queen.
1953 WAW050333

Glamis Castle in the Strathmore valley in Angus was the ancestral home of Elizabeth Angela Marguerite Bowes-Lyon – the wife of George VI and the mother of the Princesses Elizabeth and Margaret. By chance, the castle was also the birthplace of Princess Margaret, who was delivered there on the evening of 21 August 1930. The family waited several days to register the birth, however – reputedly to avoid the infant princess being numbered an unlucky 13 in the local parish register.
1947 SAW004859

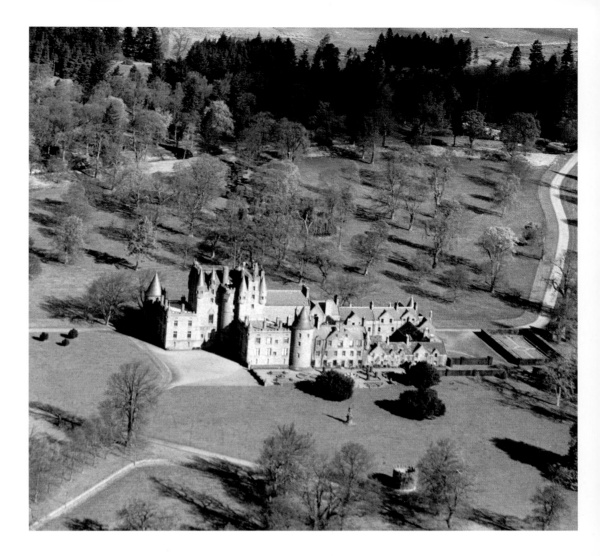

When Britain declared war on Germany on 3 September 1939, the whole royal family was staying at Balmoral Castle, their Highland residence on the banks of the River Dee. While George VI and Queen Elizabeth returned to London, the two princesses stayed in Scotland for several months with their nanny and their governess, who were determined that the girls would enjoy as normal lives as possible – which included joining the local Girl Guides. Around the same time that this photograph was taken – April 1948 – George VI and Queen Elizabeth visited the Aerofilms offices in Borehamwood, and were later presented by the company with a scale model of the Balmoral estate. It is possible that this image was taken either to help prepare the fine details of the model, or perhaps even as a special royal commission.
1948 SAW014749

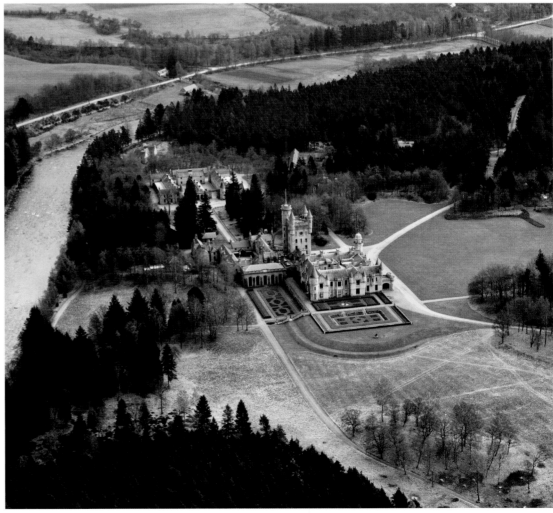

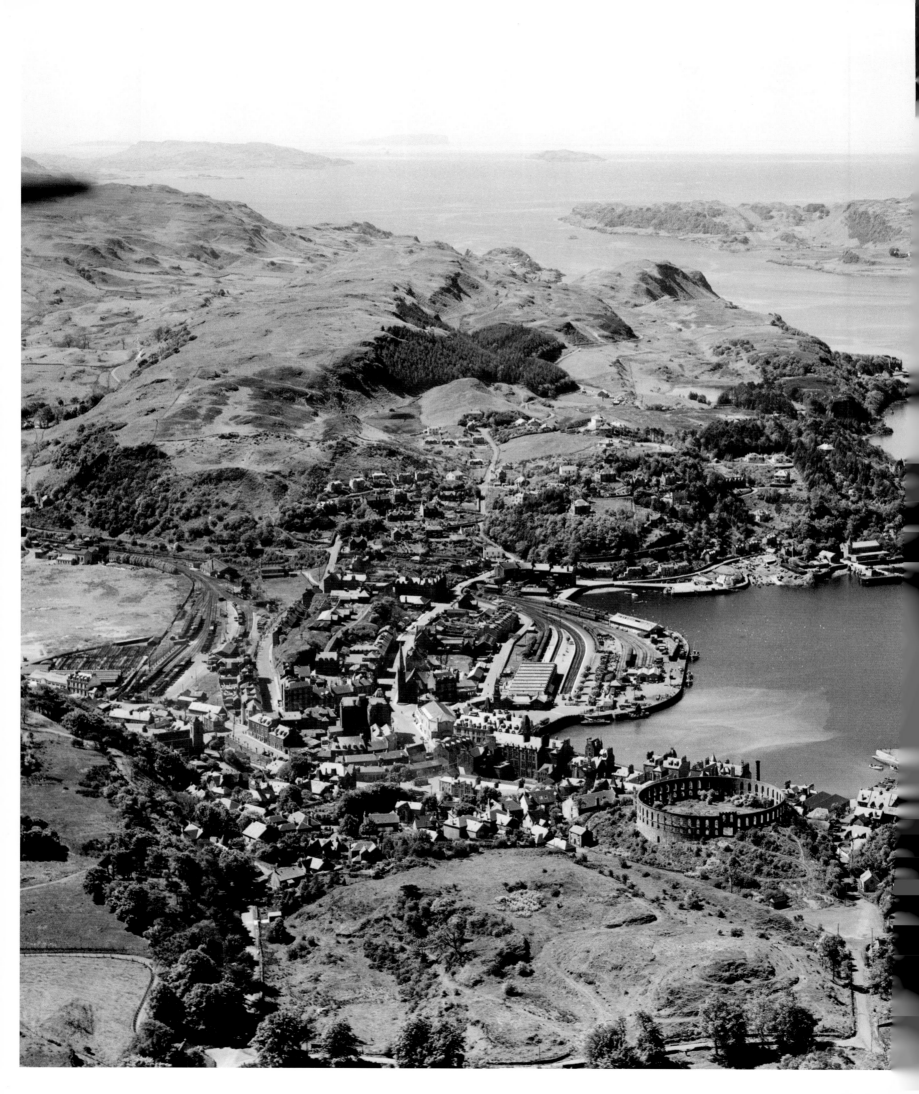

Below the unusual and distinctive structure of McCaig's Tower – a circular and incomplete granite monument based on Rome's Colosseum built by the philanthropic Victorian banker John Stuart McCaig – is the coastal town of Oban, the long-time gateway to the islands of Scotland. With the railway station set right alongside the harbour, visitors and tourists could disembark from their Glasgow trains, and step straight onto ferries sailing to destinations ranging from Islay, Mull and Coll, to Barra and South Uist in the Outer Hebrides. At the same time as recording the construction of a 'new' Britain, typified by the rapid growth of housing and manufacturing, Aerofilms also benefited from the post-war expansion of the civil aviation infrastructure to travel further across the nation than ever before. Photographing picturesque scenes of favourite tourist locations like Oban remained a lucrative sideline for the business. 1950 SAW029875

An Aerofilms photographer frames a bucolic image of the sun-dappled, rolling countryside of Carmarthenshire, one of Britain's major dairy counties, with the River Taf winding gently towards its estuary with the Gower peninsula in the distance. On the right are the Pendine Sands, a 7-mile stretch of almost perfectly flat beach which became famous in the 1920s for a series of attempts to break the world land speed record. Malcolm Campbell raised the record to 174.22mph here in February 1927 in his car *Bluebird*, yet a month later tragedy struck when the Welshman J G Parry-Thomas was killed in a high-speed crash. This landscape is best known, however, as Dylan Thomas country. The poet lived in the town of Laugharne – just outside this shot – from 1949 until his death in 1953, and it was here in 1951 that he wrote his immortal ode to his father, 'Do not go gentle into that good night.' 1951 WAW039194

A mixture of the bright and the brooding, this image looking west down Loch Leven to Loch Linnhe and the sea, captures perfectly the beauty and appeal of the Highland landscape. This, at least in the popular imagination, was Britain's last untamed wilderness: a rugged and imposing terrain that, from the nineteenth century onwards, had become imbued with considerable romantic appeal through its poignant history of rebellion and Clearances – dramatised most famously in the literature of Walter Scott. 1947 SAW003592

This photograph from August 1947 of Buttermere in the Lake District was a speculative shot taken by Aerofilms to sell on to postcard manufacturers and advertisers. The picturesque appeal of the region – which this aerial image was hoping to exploit – had first flourished in the late eighteenth and early nineteenth centuries, as the Romantic Movement encouraged a new, popular appreciation of the natural landscape. Writing in 1810, the poet William Wordsworth described the Lake District as 'a sort of national property, in which every man has a right and an interest who has an eye to perceive and a heart to enjoy'. Over a hundred years later, parliament looked to enshrine in law Wordsworth's idea of the landscape as 'a national property'. In 1931, the creation of a 'National Park Authority' to 'safeguard areas of exceptional natural interest' was first mooted. While there was broad enthusiasm for the concept, the plan ultimately had to be shelved until after the Second World War. 1947 EAW009299

For Clement Attlee's 1945 Labour government, which had come to power on a ticket of major social welfare reforms, National Parks were an important element of Britain's post-war redevelopment. The 1949 National Parks and Access to the Countryside Act was put together under the leadership of Sir Arthur Hobhouse, who explained that 'the essential requirements of a National Park are that it should have great natural beauty, a high value for open-air recreation and substantial continuous extent'.

The first National Park to be designated was the Peak District, on 17 April 1951. The Lake District followed on 9 May 1951, and then Snowdonia on 18 October 1951.

With the 1,085-metre-high Mount Snowdon at its heart – pictured here in the distance – Snowdonia covered some 830 square miles of north-west Wales, with a diverse terrain ranging from mountainous peaks and the forests of Gwydir and Betws-y-Coed, to the marshland coastline of the Lleyn Peninsula. 1946 WAW001745

LEFT

On 10 September 1949, an Aerofilms flight travelled up the spine of western Scotland photographing Greenock and Helensburgh, before heading east to the market town of Perth and then sweeping back out to the coast of Highland Argyll, to capture this stunning view looking inland from Loch Linnhe towards the pass of Glencoe. In one day, the company was able to record everything from the heavy industry of the shipyards at the mouth of the Clyde estuary, to the serene beauty of one of Scotland's – and Britain's – most famous tourist landscapes. 1949 SAW026575

ABOVE

The iconic cantilever superstructure of the Forth Rail Bridge spans the water between North and South Queensferry, with the view inland to the Highland foothills disappearing into the haze. This shot was one of a number of images taken during a single flight – this time over eastern Scotland. From the Forth estuary, the Aerofilms pilot took his photographer round the east 'neuk' – or corner – of Fife, over the Old Course at St Andrews and on to capture Dundee and the Tay Rail Bridge. 1947 SAW005309

FOLLOWING PAGES

Caught in the light of a low sun, the gravestones and crumbling walls of Melrose Abbey in the Scottish Borders cast long shadows in an evocative picture of romantic ruin. Lincoln Cathedral, by contrast, is shot face-on to the light, and stands as a colossal and enduring monument of religious architecture. For Sergeant Don Charlwood, a 61 Squadron Lancaster bomber pilot who flew out of Rutland near Lincoln during the Second World War, it was a also a vision of the unique character of the English landscape. 'As we drew nearer', he wrote of his return from a mission to Germany, 'I saw a cathedral like a crown on the head of a city. In its white walls every window glinted in the sun. Lincoln! Of such places is England made.' 1950 SAW034322, 1949 EAW023932

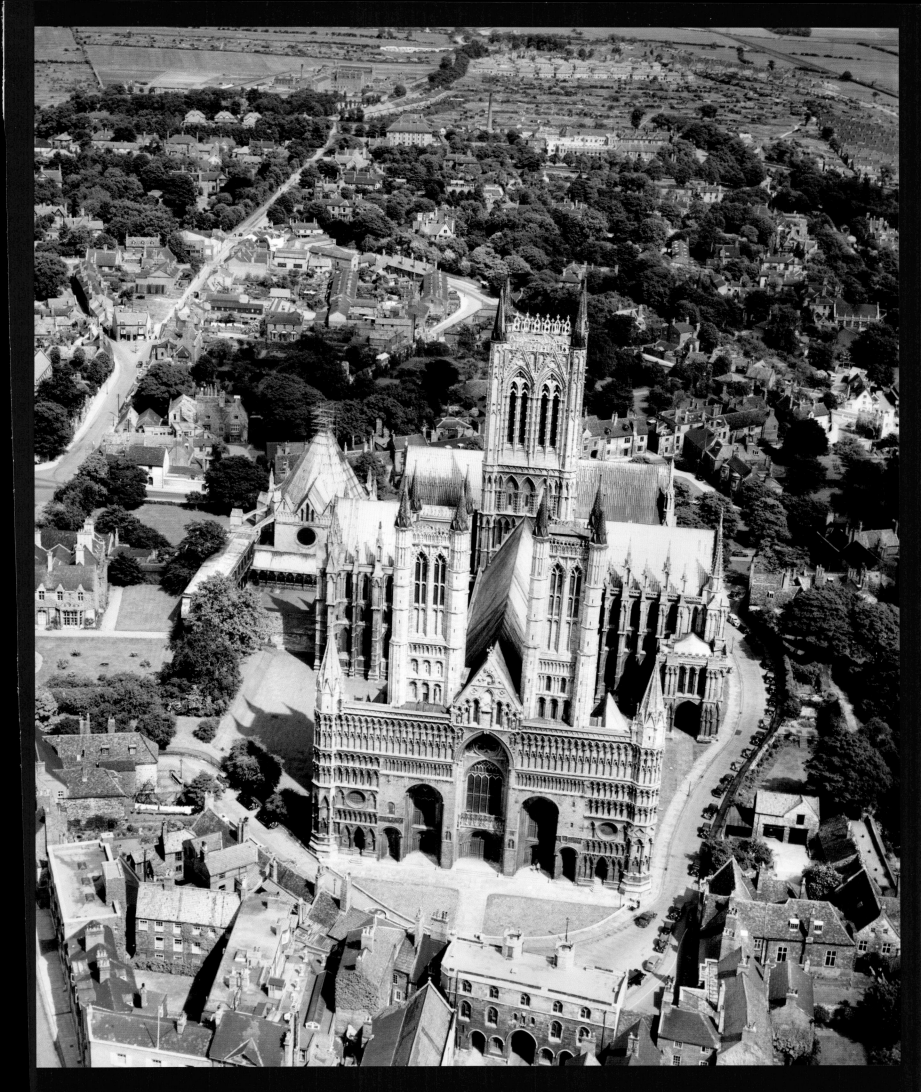

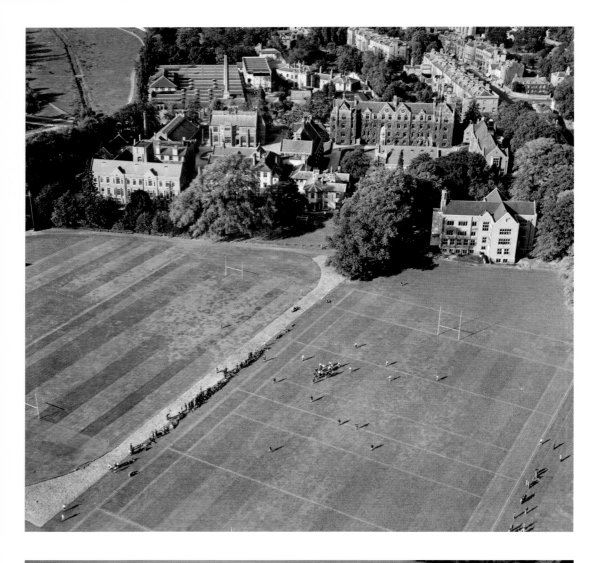

While a great deal of Aerofilms' post-war photography captured the wholesale modernisation of Britain's infrastructure and industry, the company were also producing another type of imagery – scenes of daily life that were symbolic of traditional British values, of a return to normality after years of conflict. Pictured here in October 1946, a rugby match is underway on the playing fields of the Leys School in Cambridge. Throughout the Second World War, the school had been relocated to the Atholl Palace Hotel in Pitlochry in the Highlands of Scotland, with the Leys' building used as annexe to the nearby Addenbrookes Hospital. When this shot was taken, the schoolchildren had only just come back from the Highlands for the start of their new term. 1946 EAW002928

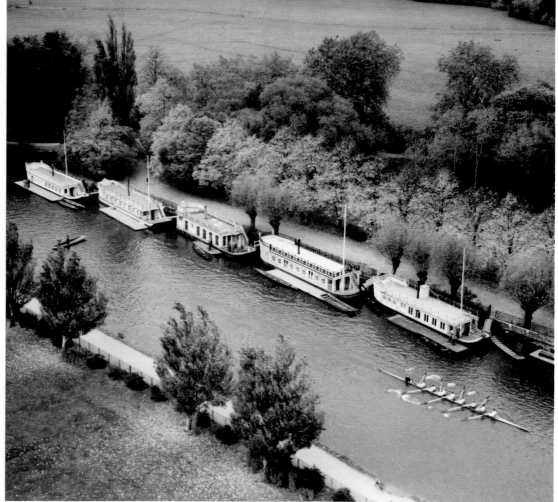

An eights crew rows past a series of 'College barges' moored up on the River Thames alongside Oxford's Christ Church Meadow. The tradition of using barges dated back to 1839, when the Oxford University Boat Club first rented one to store sculls and serve as changing rooms. Over time, individual colleges bought their own barges, and spectators would stand on their roofs to cheer on their teams during races. 1946 EAW003126

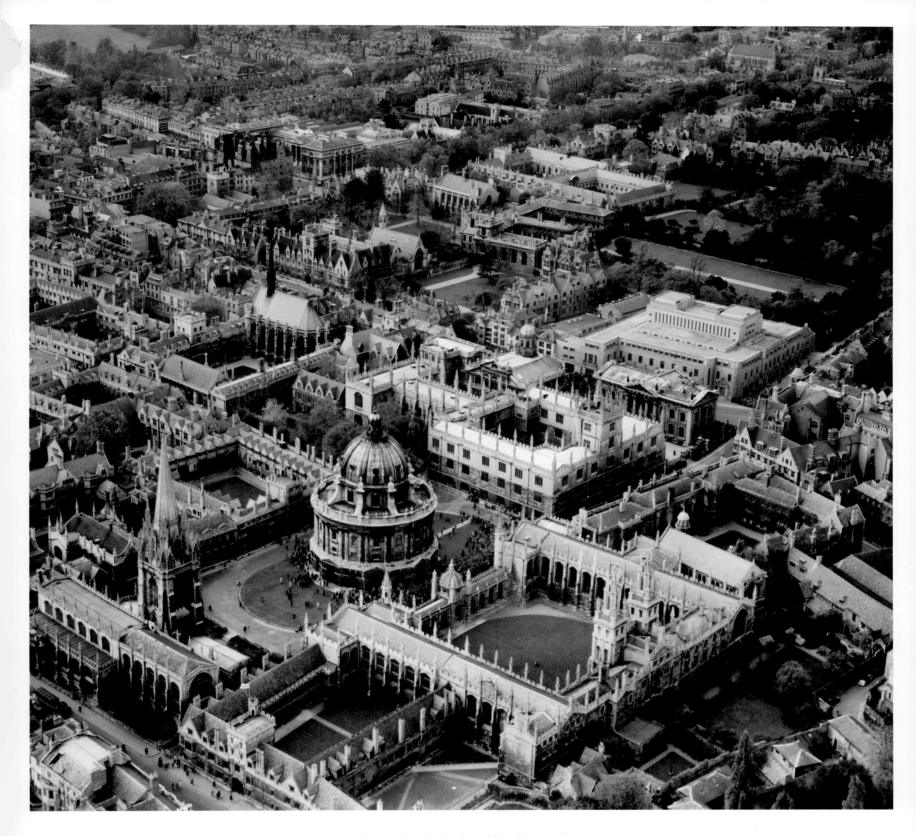

Crowds gather on the lawn around the Radcliffe Camera in Oxford University on 24 October 1946, as part of the celebrations for the opening of the New Bodleian Library by George VI. Although work was completed on George Gilbert Scott's design for the library in 1940 – the new building can be seen here just behind the Radcliffe – the inauguration ceremony was delayed for the duration of the War. This did, however, allow the 1.5 million books held by the Old Bodleian to be transferred to the New. An article in *The Times* from the same day, which described the inner workings of the new building, was impressed in particular by a state-of-the-art electric conveyor, 'which not only shifts books from one deck to another… but takes them when wanted, by a tunnel under Broad Street, to the enlarged reading rooms which are to be fitted out in the old library'. 1946 EAW003112

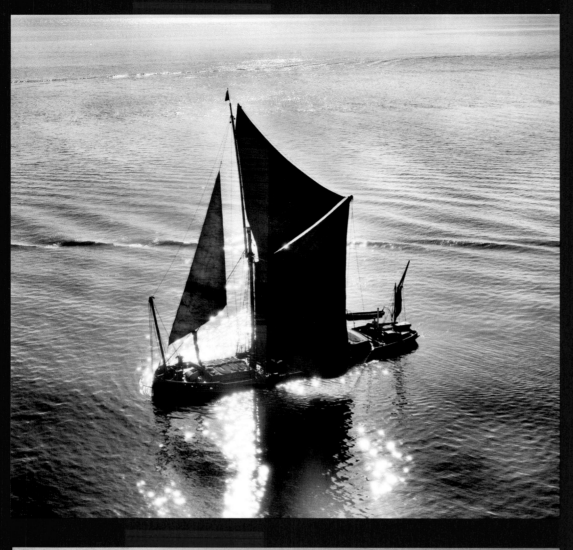

Backlit by the sun, the fully rigged sailing barge the S B *Repertor* makes its way across the calm, shimmering waters of the Thames estuary. These barges were a common sight in the south-east of England in the nineteenth and early twentieth centuries, with their flat-bottomed wooden or steel hulls allowing them to float in as little as a metre of water as they transferred goods back and forth along the river from London to the estuary mouth. They could be piloted by a crew of just two men – as seen here at the fore and aft of the boat – which, for a time, made them an incredibly economical method of moving cargo. Their ultimate decline began in the immediate post-war period, however – the victim of ongoing transport infrastructure developments, and in particular the competition of carrying goods by improved road networks. By the early 1950s, the pace of change in Britain meant that Aerofilms were not just capturing new technological developments. They were also taking some of the last photographs of old industries and ways of life that were about to be lost forever.
1949 EAW026857

Pictured here on 15 August 1946 – exactly a year to the day that Japan's surrender ended the Second World War – a sailing boat loaded with people cruises off the coast of Southend-on-Sea. While this is almost certainly a pleasure trip, there is a good chance that, some six years before, this boat, as with a great many others from the port town, would have been crammed with a rather different type of passenger. During *Operation Dynamo* – the secret codename for the Dunkirk evacuations in the summer of 1940 – a fleet of over 800 vessels, from military destroyers to car ferries, speedboats and private vessels from across the south of England, helped transport nearly 340,000 soldiers of the British Expeditionary Force back across the Channel from France.
1946 EAW002220

Belching thick clouds of smoke, the Paddle Steamer *Prince Edward* cuts through the dark, syrupy waters of Loch Lomond in this image from July 1948. In the same year, ownership of the steamer had passed from the London, Midland and Scottish Railway Company to the British Transport Commission. In the immediate post-war period, Clement Attlee's new Labour government had nationalised the provision of many transport services – including loch steamers – and the Commission's goal was to provide 'an efficient, economical, and properly integrated system of public inland transport and port facilities within Great Britain for passengers and goods'. 1948 SAW017910

In the second half of the twentieth century, the motorboat became an increasingly common sight on Britain's waterways – much easier to handle and control than a sailboat, it was a technology that appeared perfectly evolved for post-war pleasure cruising. In this image from the summer of 1949 – just before the beginning of Cowes week – a motorboat races across the Solent, with its passengers smiling up at the low-flying Aerofilms photographer. 1949 EAW025025

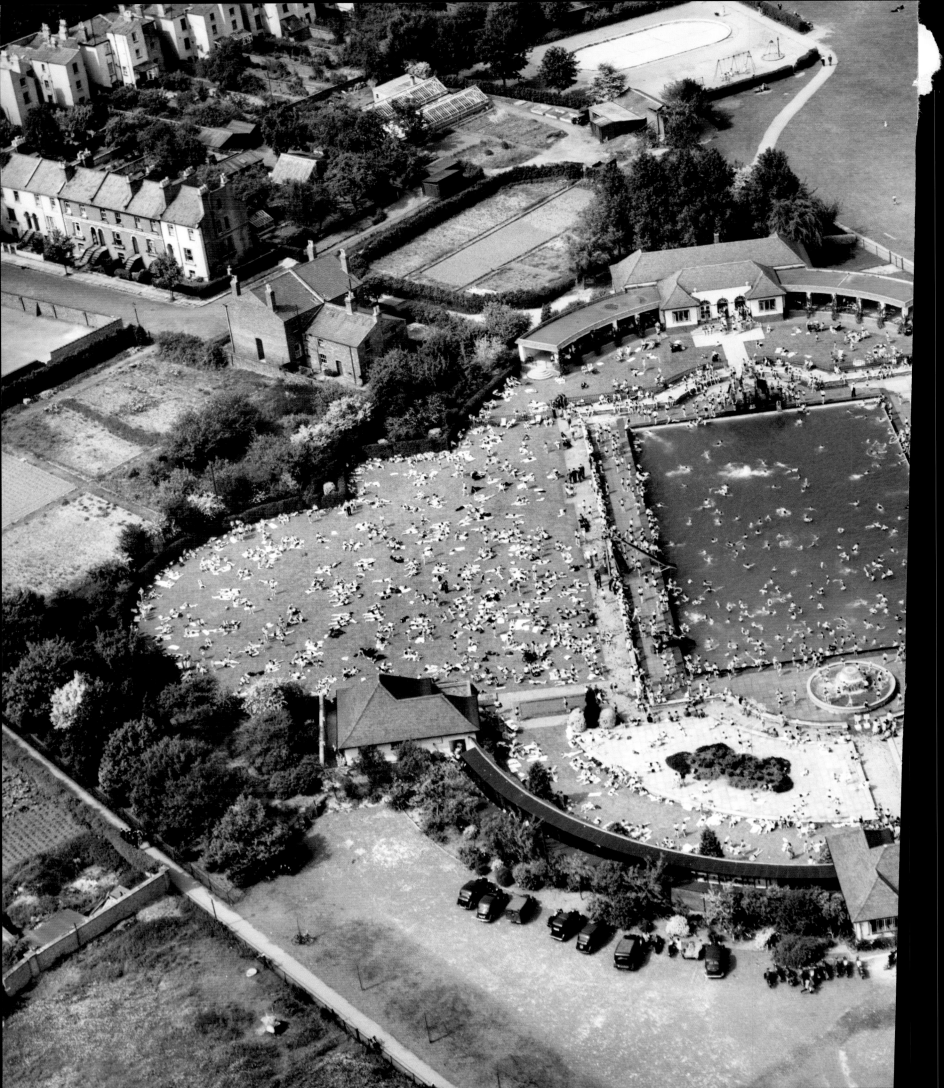

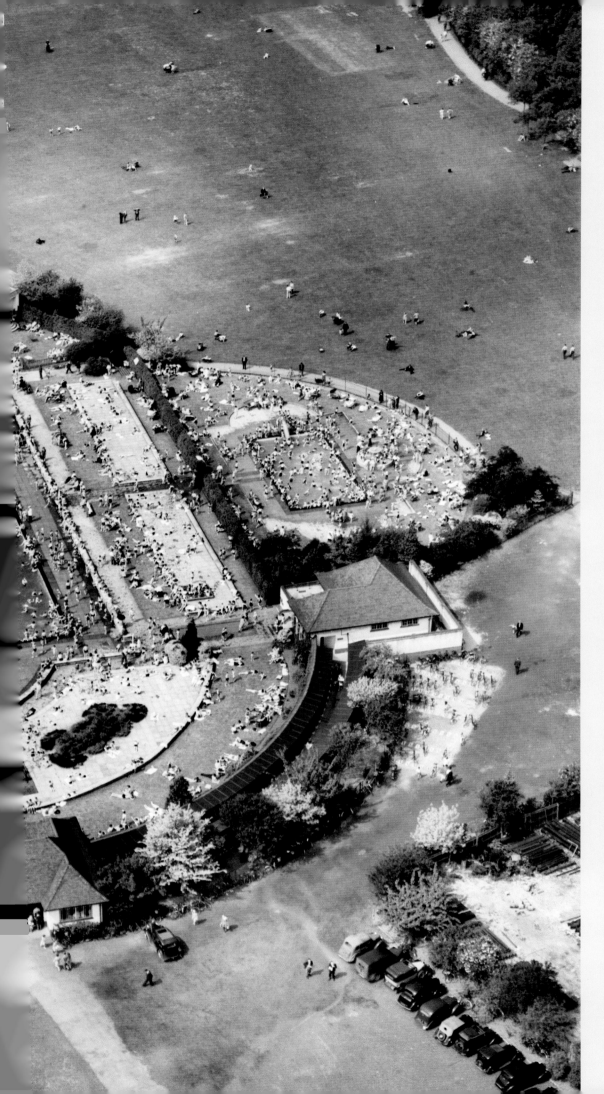

Weekend crowds throng Sandford Park Swimming Pool in Cheltenham in May 1947. First opened in 1935, the Park's massive baths, which measured 165 by 90 feet and held over 498,000 gallons of water, stayed in use throughout the Second World War. Despite a German bomb smashing the paddling pool – seen here on the right of the image – in July 1942, Sandford Park remained extremely popular with the townspeople and visitors, recording some 90,000 admissions each year over the course of the conflict. These attendances may well have been helped by the government's wartime introduction of 'double summer time', which saw the clocks being put forward two hours to allow it to stay light in the south of England until close to midnight.

1947 EAW006518

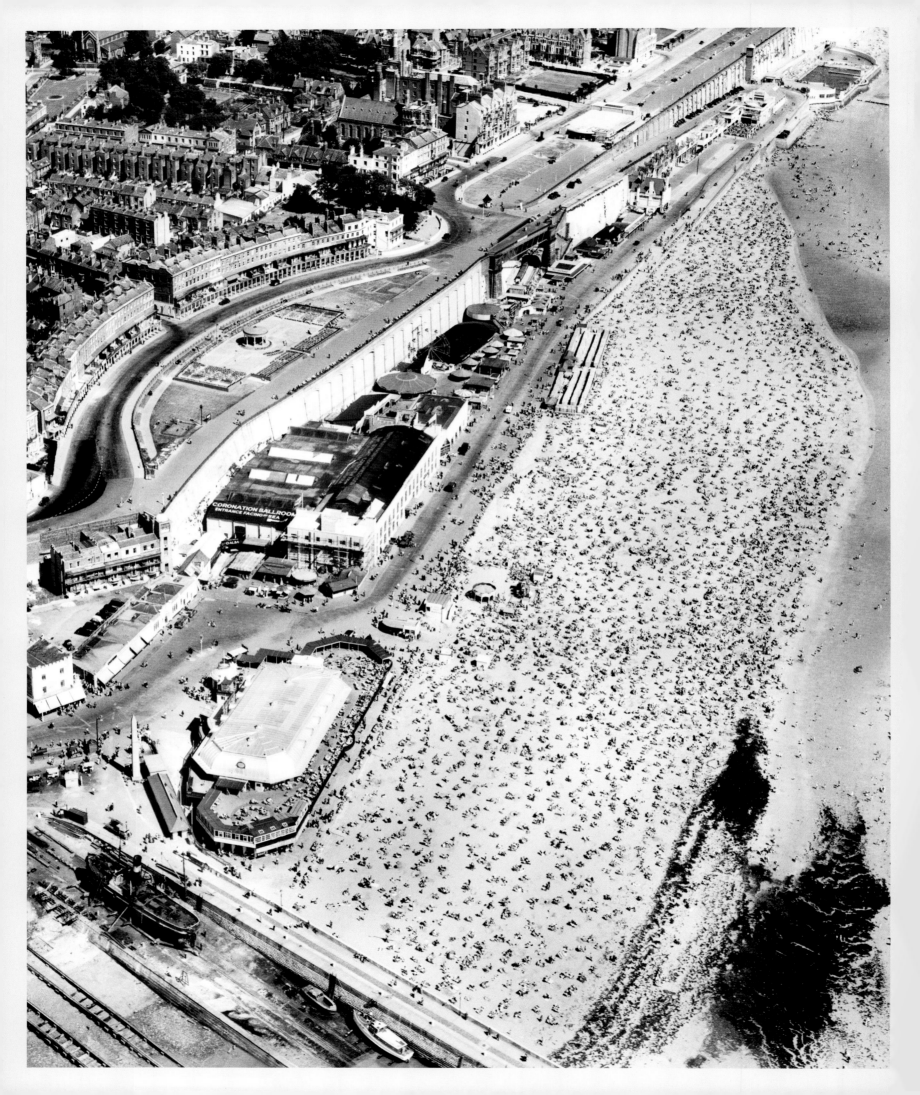

LEFT

The Times weather forecast for 12 August 1947 advised that a ridge of high pressure had moved in over the British Isles, and that 'it will be fair and fine or warm'. Just like the thousands of holidaymakers shown here spread out across nearly every grain of the Ramsgate Sands, Aerofilms were keen followers of the weather. Clear skies and bright sunlight provided optimal conditions for aerial photography and, particularly in the summer months, almost guaranteed that a flight to the coast would offer up iconic, postcard-friendly shots of the British seaside experience. 1947 EAW009014

RIGHT

Perfectly ordered rows of tents run parallel to the cliffside at the Crimdon Park campsite in County Durham. The similarity of this scene to an army encampment is no accident – the aftermath of the Second World War saw a boom in the civilian market for 'army surplus' equipment, which became available through the 'Disposal Service'. Many of the tents in this image – and in particular a number of bell tents – are likely to have been used previously by the army. While Crimdon appealed to the purist 'camper' – and was a favourite of local miners and their families – from the 1930s onwards, there had been a huge increase in the development of custom-built, commercial camps. Pictured here in March 1948, the Beach Holiday Camp at Dymchurch on the south-east coast of Kent offered neat rows of huts and provided improved on-site facilities for those less prepared to 'rough it'. 1948 was a peak year for the seaside tourist industry – indeed, Butlins proved so popular that some 200,000 people were unable to make a booking. Still benefiting from the increased income provided by full wartime employment, and the 1938 Holiday Pay Act, young families, as never before, had time and money to devote to their holidays. 1946 EAW002148, 1948 EAW013668

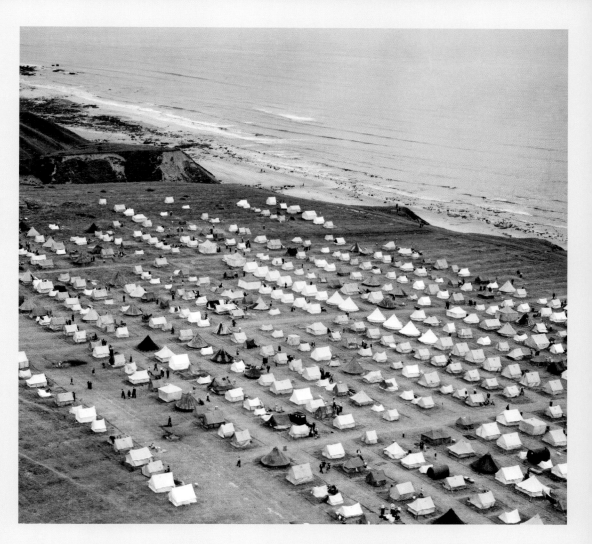

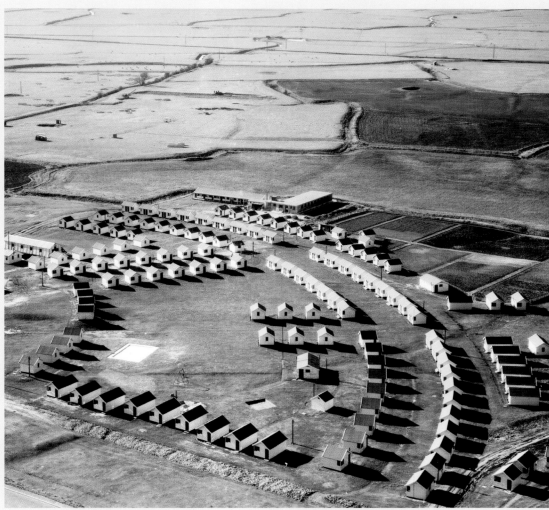

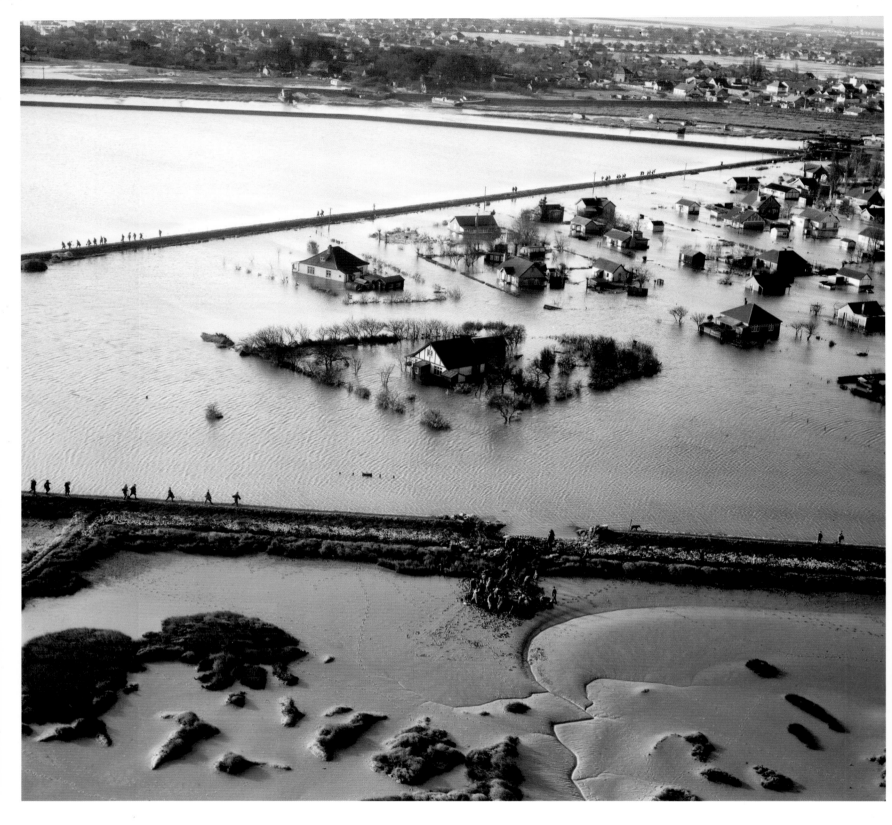

Aerofilms had always been a key source of imagery for the media – most commonly when capturing moments of national pageantry or covering major sporting events. In this shot from 2 February 1953, however, the company was able to use the aerial perspective to show the shocking extent of the Canvey Island Floods – Britain's worst natural disaster of the twentieth century. On the night of 31 January, a severe North

Sea storm devastated the east coast of England. The single greatest loss of life was at Canvey, where the breaching of the sea wall – as pictured here – allowed water to rush into the village's single-storey pre-fab houses at such speed that many residents had no time to escape. Of the 300 people who died in the tragedy, 58 were from Canvey. 1953 EAW048242

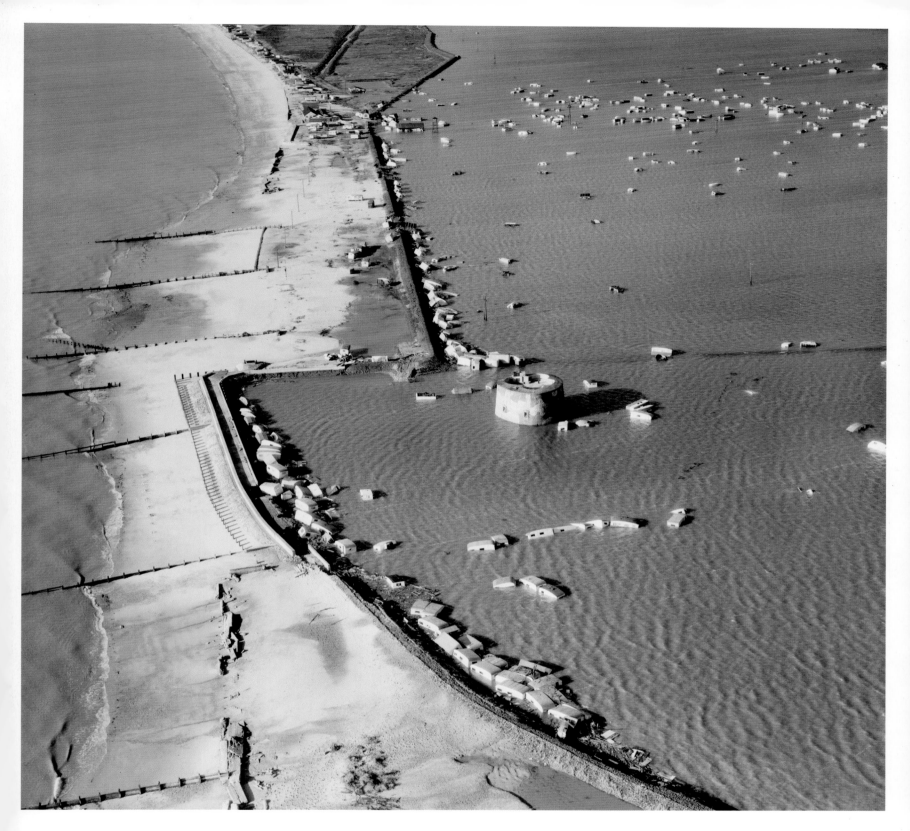

Aerofilms flew across much of the Thames estuary on 2 February 1953, recording the terrifying scale of the damage. Here, the Martello Beach Holiday Park in Seawick – and the famous nineteenth century Martello Tower – are part submerged beneath the flood waters, with caravans and holiday chalets lying in broken piles against the sea wall. In all, over 24,500 homes were destroyed or damaged and 30,000 people were evacuated. Winston Churchill – back as Prime Minister of the new 1951 Conservative government – told parliament that, 'Everything in human power will be done. All the resources of the State will be employed so far as they can usefully and effectively be brought into action to meet this emergency and to make such temporary arrangements for closing the gaps in our sea defences as are necessary for the safety of the population.' *The Times* reported admiringly that there was 'something of the quality of his wartime reports' in Churchill's commanding address to parliament in the wake of the disaster. 1953 EAW048282

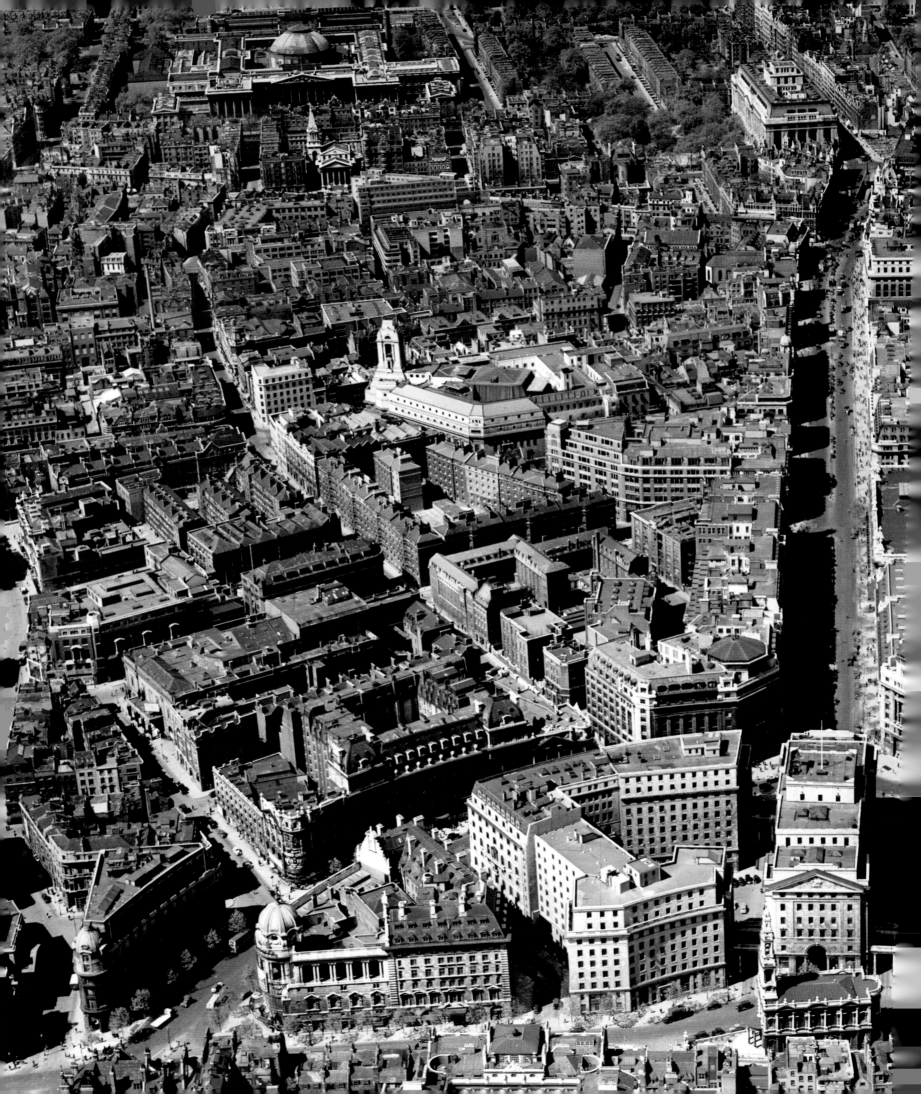

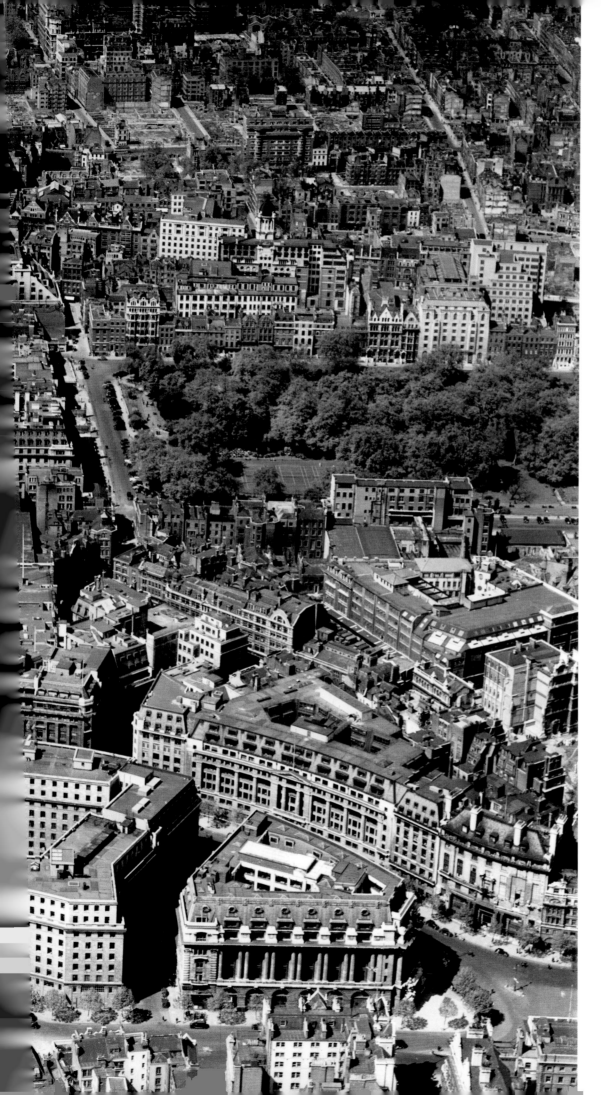

With the grand façade of the British Museum just visible in the top left, the central London transport artery of the Kingsway is picked out here in strong shadow running down to the monolithic Bush House office complex. When first opened in July 1925 – at a construction cost of £2 million – Bush House was declared the most expensive building in the world. Originally built for an Anglo-American trading organisation headed by a man called Irving T Bush, its huge size soon saw other firms leasing office space – including Aerofilms. In 1932, Francis Wills oversaw the rental of 1,000 square feet of the basement of Bush House to accommodate the company drawing offices, darkrooms, and, most important of all, the vast photo library.
1946 EAW000649

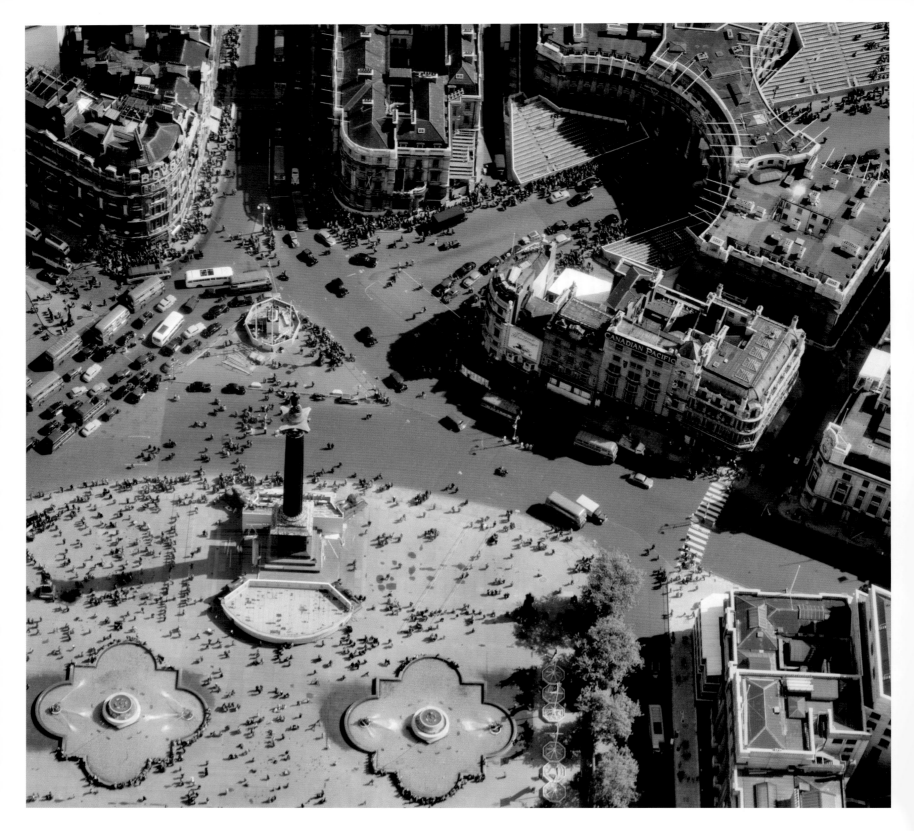

On 30 May 1953 – just three days before the coronation of Queen Elizabeth II – Aerofilms took to the skies over central London. While ant-like figures cover Trafalgar Square, temporary seating and terracing can be seen under construction in the top right, alongside the Admiralty Arch. Stands were being erected throughout the city by the Ministry of Works – the seats visible here were reserved for the Royal Navy – and were fitted with public address systems to allow the public to hear the coronation ceremony once it was underway at Westminster Abbey.
1953 EAW049761

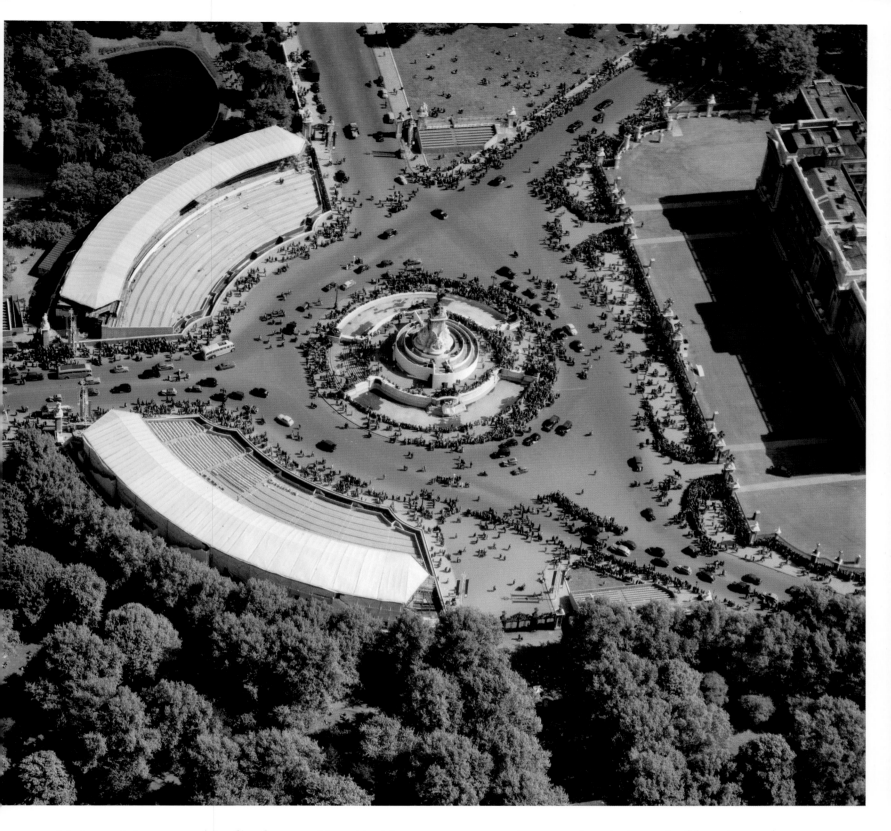

Aviation restrictions prevented Aerofilms from flying on the day of the coronation, so they focused instead on capturing the build up, and in particular what *The Times*, in a report from 25 May, called the 'crowds... out to enjoy a foretaste of a royal occasion'. Here, large numbers of people line the gates of Buckingham Palace and surround the Victoria Memorial, while two temporary terraced stands can be seen built at the end of the Mall – perfectly placed to watch a royal balcony appearance. The coronation was broadcast live by the BBC, with over 20 million people watching on television, and another 3 million lining the streets of London. This was the acme of British pageantry, an event that brought the people of the nation together to celebrate a new Queen who promised that, 'Throughout all my life and with all my heart I shall strive to be worthy of your trust.' It was also a merchandiser's dream, with television, for the first time, beaming a potent British brand into homes around the world.

1953 EAW049762

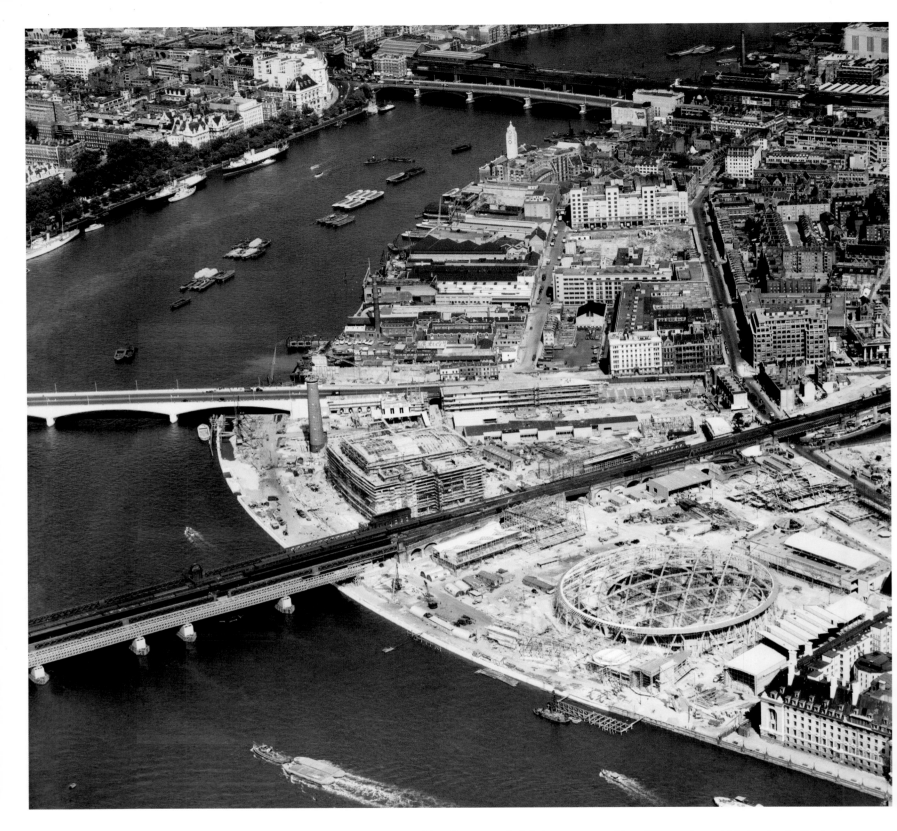

Pictured here in August 1950 and March 1951, London's South Bank is shown as a vast construction site. Where before, massed ranks of Victorian warehouses had clustered along this bend in the Thames by the Waterloo Bridge, here the landscape was being re-imagined as a vision of the future, the epicentre of a nationwide celebration of achievement known as the Festival of Britain. Devised by Clement Attlee's Labour government to 'raise the nation's spirits after the war years' and to 'review British contributions to world civilisations in the arts of peace', the Festival aimed to bring a cultural dimension to social welfare reforms, making the arts and sciences available to every ordinary man, woman or child in Britain. Voicing his approval, King George VI talked of how 'The motives which inspire the Festival are common to us all – pride in our past and all that it has meant, confidence in the future which holds so many opportunities for us to continue our contribution to the well-being of mankind, and thanksgiving that we have begun to surmount our trials.'

1950 EAW031792, 1951 EAW034733

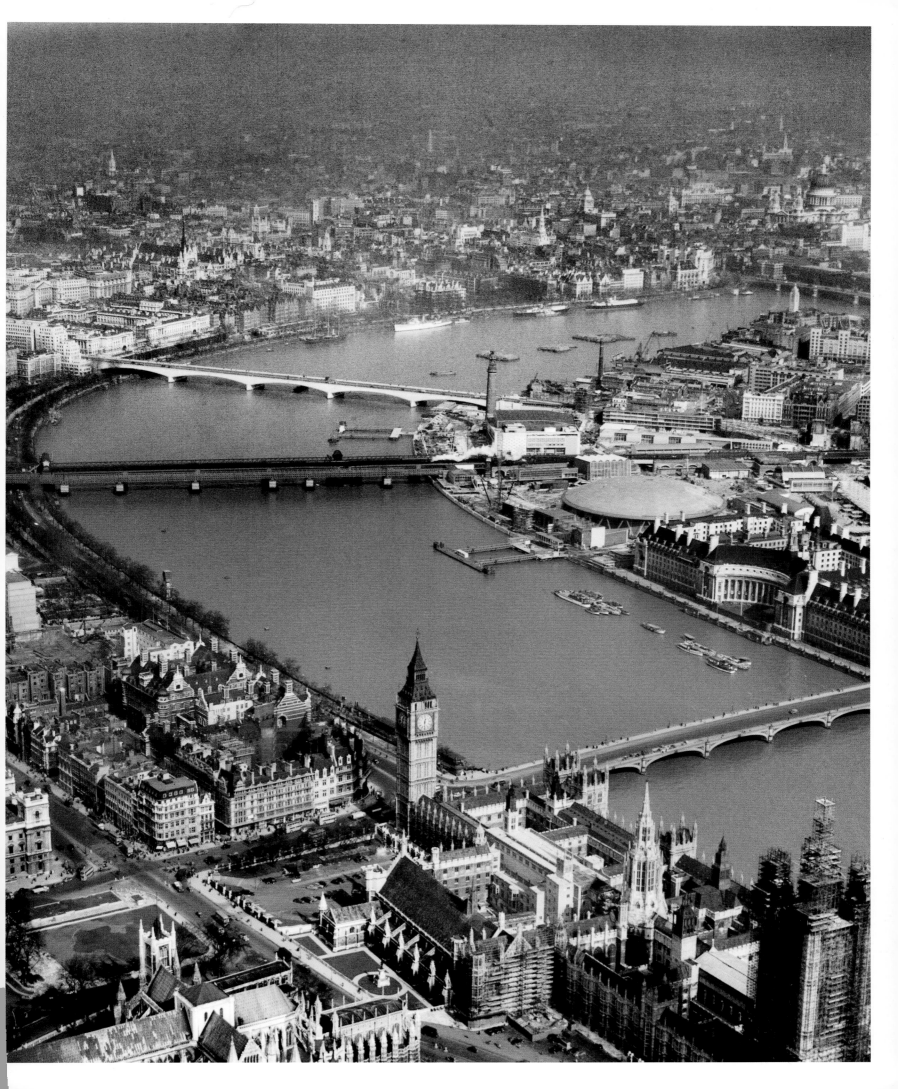

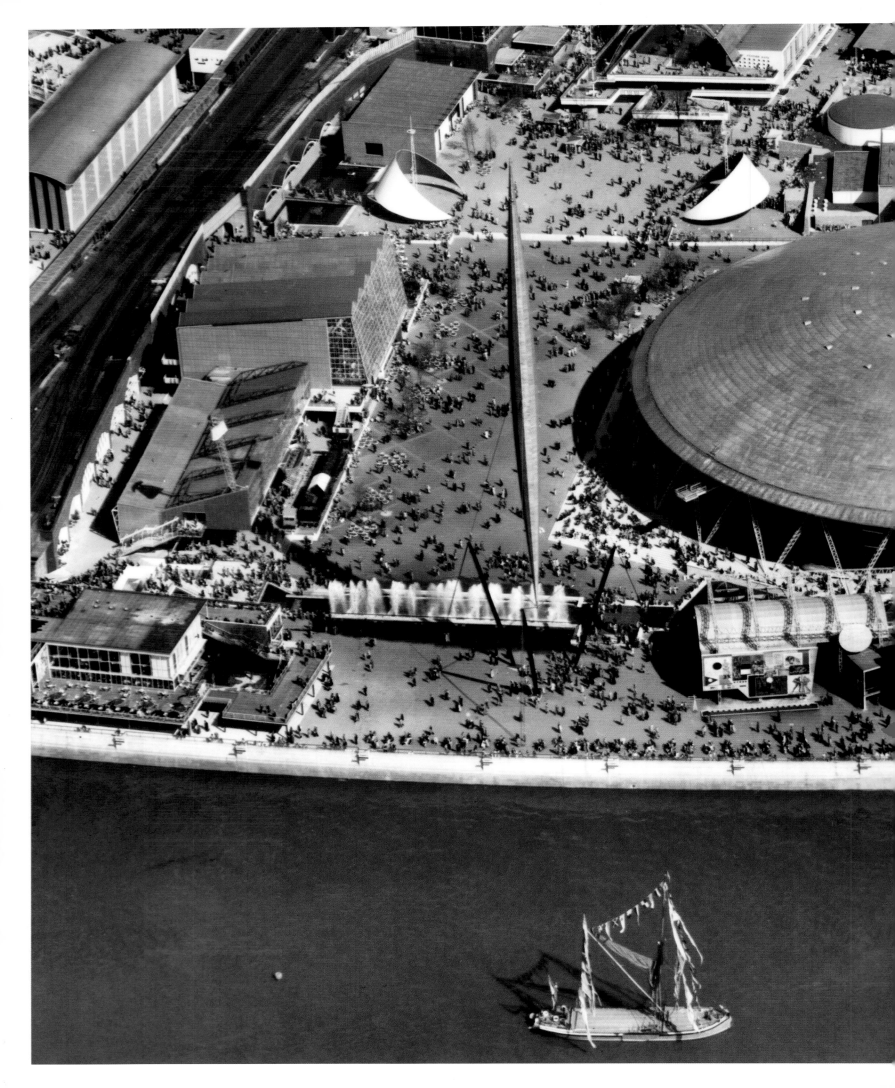

Two futuristic structures dominated the centre of the Festival site – the Dome of Discovery, at the time the largest aluminium structure ever built, and the Skylon, an improbably thin, 290-foot-tall steel, wire and aluminium tower. Britain in 1951 was a bankrupt country still living with rationing – yet here was a glimpse into a world of tomorrow, and the life that might await in a resurgent nation. There was more at stake here than just boosting public morale, however. To paraphrase Labour Deputy Prime Minister Herbert Morrison's description of the Festival, it was not just about Britain *showing* itself to itself – and to the world – it was also about Britain *selling* itself. In the months leading up to the opening, four red London Transport buses toured Europe as a promotional stunt, travelling over 4,000 miles from Norway, Sweden and Denmark to Germany, Holland, Belgium, Luxembourg and France. The buses – which, of course, managed the journey 'without any mechanical problems' – offered free rides to everyone, and were filled with exhibitions of British design excellence. Motorcar and motorcycle manufacturers like Rover, Austin, Morris and Triumph used the Festival to advertise their products as the 'best in the world'. The message was that British industry was once again ready to take a lead. Debate continues over the legacy of the Festival – did it mark a turning point in the post-war years, and herald the beginning of a new, modern Britain? Or was it merely a propaganda stunt and a colossal waste of money at a time of great austerity? Winston Churchill, unsurprisingly, believed the latter. The Conservatives came back to power in October 1951, and by 1952, the Skylon had gone – cut down and pitched into the Thames because Churchill rejected it as a symbol not of Britain, but of socialism. Regardless of the political wrangling, the final visitor numbers were quite remarkable – from May to September 1951, nearly 8.5 million people had come to the South Bank site, many of them from overseas. For the poet John Betjeman, who delighted in witnessing the banks of the Thames 'treated with imagination and happiness', what was most important was that, 'For the first time for a long time', and after years of hardship, the people of Britain 'will see things done for the fun of the thing'.

1951 EAW035702

Epilogue

From the moment of their first flight in 1919, Aerofilms Ltd were starting to build an archive. They captured just 19 aerial photographs in their first six months in business, but this grew rapidly to thousands, then tens of thousands, before ultimately reaching over a million. As the sale and reproduction of imagery was always a major part of the business, the archive moved with Aerofilms from office to office. When ownership of the company passed to the Simmons Geomatics Group in 1997 and to Blom ASA in 2005, the prints and negatives were transferred first to company offices in Borehamwood, and then to Cheddar.

Throughout this later period, it was clear that the commercial value of the archive was decreasing as patterns of demand altered, while overheads were growing. In testing times the staff and management of both Simmons Geomatics and Blom preserved this material as a collection, and so ensured that a unique archive would survive.

Heritage organisations had been aware for some time of the Aerofilms Collection as the largest and most historically significant body of oblique aerial photography held in private hands. Negotiations for the acquisition of the Collection began in 2000 but were protracted, partly because there was no precedent for placing a value on such a major commercial and culturally significant archive. Finally, in May 2007, the Aerofilms oblique aerial photography collection was purchased for £246,750 from Blom ASA by a partnership of English Heritage, the Royal Commission on the Ancient and Historical Monuments of Scotland (RCAHMS) and the Royal Commission on the Ancient and Historical Monuments of Wales (RCAHMW). Financial support was provided by the English Heritage Development Fund, which manages gifts and bequests from members of the public, the National Heritage Memorial Fund, and the Friends of National Libraries.

The three partners took on an archive of some 1.2 million glass and film negatives covering the work of the main Aerofilms Company from 1919 to 2006, and of the Aeropictorial and Airviews companies which Aerofilms had acquired. There were also 2,369 albums containing over 300,000 prints and 162 flight registers and other books. The sheer scale of the Collection made it necessary to seek additional funding from third parties to help preserve the material and make it accessible. In September 2010 the partners secured a major Heritage Lottery Fund grant to conserve, scan and catalogue the first part of the collection – dating from 1919 to 1953 – as part of what was called the Britain from Above project.

As a result of this project, over 95,000 photographs have been made available online on the dedicated, interactive website britainfromabove.org.uk. This conservation of the Aerofilms imagery came at a crucial time: photographic negatives are among the most vulnerable and sensitive of collection materials, and many of the film negatives in particular showed signs of decay. Transfer to the archival facilities of the three partners has ensured that this unique and enthralling picture of Britain in the twentieth century has been preserved, saved and made accessible to the public for the first time. As a growing community engages with the collection – sharing their memories and immersing themselves in this unprecedented visual record of the nation's history – the story of Aerofilms Ltd lives on.

One of the 2,369 albums of prints acquired as part of the Aerofilms Collection.

Select Bibliography

Babington-Smith, C. 1958 *Evidence in Camera* London: Chatto and Windus

Barber, M. 2011 *A History of Aerial Photography and Archaeology: Mata Hari's glass eye and other stories* Swindon: English Heritage

Barker, R. 2002 *A Brief History of the Royal Flying Corps in World War I* London: Robinson

Betjeman, J. 7 May 1951 *The Festival in London* BBC Home Service

Bott, A. undated 'The Airman's View of London' *Wonderful London* vol.1:40–51 London: Amalgamated Press

Bradley, S. and Pevsner, N. 1997 *London, 1: the City of London* London: Penguin

Byron, R. 1932 'Broadcasting House' *Architectural Review* 72:47–49

Cobham, A.J. 1978 *A Time to Fly* London: Shepheard-Walwyn

Conyers-Nesbit, R. 1996 *Eyes of the RAF: a history of photo reconnaissance* Godalming: Bramley Books

Cox, I. 1951 *The South Bank Exhibition: a guide to the story it tells.* London: HMSO

Curle, R. undated 'Some London Vistas' *Wonderful London* vol.1:40–51 London: Amalgamated Press

Dawe, H. 1974 'A relative orientation' *Photogrammetric Record* 8(43):27–36

Derrick, C. (ed) 1978 *A Time to Fly* London, Shepheard-Walwyn

Eden, J.A. 1976 'Some experiences of Air Survey in England Between the two World Wars' *Photogrammetric Record* 8(47):631–645

Finnegan, T.J. 2011 *Shooting the Front: Allied Aerial Reconnaissance in the First World War* Stroud: Spellmount

Friese-Greene, C.H. 1920 *Across England in an Aeroplane* [film] National Film Archive

Grahame-White, C. 1911 *The Story of the Aeroplane* Boston: Small, Maynard and Company

Grahame-White, C. and Harper, H. 1912 *Heroes of the Air* London: Henry Frowde/Hodder and Stoughton

Grahame-White, C. and Harper, H. 1916 *Learning to Fly: a practical manual for beginners* London: T W Lawrie Ltd

Halsall, C. 2012 *Women of Intelligence: winning the Second World war with air photos* Stroud: Spellmount

Hunting, P. 1991 *The Hunting History: Hunting plc since 1874* London: The Huntings Group Ltd

Laws, F.C.V. 1959 'Looking Back' *Photogrammetric Record* 3(13):24–41

Layman, R.D. 1996, 2002 *Naval Aviation in the First World War: its impact and influence* London: Chatham

Macdonald, A.S. 1992 'Air Photography at Ordnance Survey from 1919 to 1991' *Photogrammetric Record* 14(80):249–260

Marshall, J. 1995 *The History of The Great West Road: its social and economic influence on the surrounding area* Hounslow: Heritage Publications

Moller, N.H. 1936 *The Law of Civil Aviation* London: Sweet and Maxwell Ltd

Morrison, K.A. and Minnis, J. 2012 *Carscapes: the motor car, architecture and landscape in England* New Haven, London: Yale University Press

Murphy, E. 1934 *The Lure of the Grid: the plain facts about electricity in the home etc* London: Eileen Murphy

Murrell, C. 1931 'Taking Photographs from Aeroplanes' *Meccano Magazine* May 1931:368–370

Murrell, C.E. 1950 *From the Pilot's Seat: An Airman's View of England and Wales* London: Chapman & Hall Ltd

Olley, G.P. 1934 *A Million Miles in the Air* London: Hodder and Stoughton

Penrose, H. 1967 *British Aviation: the pioneer years 1903–1914* London: Cassell
Penrose, H. 1969 *British Aviation: the Great War and Armistice 1915–1919* London: Putnam
Penrose, H. 1973 *British Aviation: the adventuring years 1920–1929* London: Putnam
Powys-Lybbe, U. 1983 *The Eye of Intelligence* London: William Kimber
Priestley, J.B. (introduced by Margaret Drabble) 1997 *English Journey: being a rambling but truthful account of what one man saw and heard and felt and thought during a journey through England during the autumn of the year 1933* London: The Folio Society
Renwick, A. 2012 *RAF Hendon: the birthplace of aerial power* Manchester: Crécy Publishing Ltd
Shawcross, C.N., Beaumont, K.M., Browne, P.R.E. and Paterson, A.R. 1945 *Air Law* London: Butterworth
Smith, J. 2005 *Liquid Assets: the lidos and open air swimming pools of Britain* London: English Heritage
Smith, R. 2005 *British Built Aircraft: Greater London* Stroud: Tempus
The Air Navigation Act 1920 (10 &11 Geo. 5, c.80) London: HMSO
The Official Secrets Act 1911 (1 & 2 Geo. 5, ch.28) London: HMSO
The Official Secrets Act 1920 (10 &11 Geo. 5, ch.75) London: HMSO
Wallace, G. 1960 *Claude Grahame-White: a biography* London: Putnam
Wells, H. G. 1914 *An Englishman Looks at the World* London: Cassell and Company Ltd
Wilkinson, N. 2009 *Security and the Media: the official history of the United Kingdom's D-Notice system* London: Routledge
Williams, A. 2013 *Operation Crossbow: the untold story of photographic intelligence and the search for Hitler's V Weapons* London: Preface
Williams-Ellis, C. 1951 *Royal Festival Hall* London: Max Parrish
Wills, F.L. and Winchester, C. 1928 *Aerial Photography: a comprehensive survey of its practice and development* London: Chapman and Hall

Key archive collections include

The National Archives AIR 2/4540, AIR 20/5749, AIR 34/83, AIR 40/1169, BT 31/33802/154995; also military service records, census records, BMD records
Blom ASA uncatalogued items relating to Aerofilms Ltd and Huntings Aerosurveys Ltd
RAF Hendon archive collections relating to the Grahame-White Company Ltd
The National Aerospace Library the complete collection of NOTAMS (Notices to Airmen)
English Heritage AFL03 (the Aerofilms Collection holdings)
The National Collection of Aerial Photography (NCAP), Edinburgh
The Medmenham Collection

Key online databases include

The Times Online www.thetimes.co.uk/tto/archive/
Flight Magazine www.flightglobal.com/pdfarchive/index.html
The London Gazette www.london-gazette.co.uk/
Oxford DNB www.oxforddnb.com/
Great Britain aircraft registers to 1939 www.airhistory.org.uk
The National Collection of Aerial Photography (NCAP) ncap.org.uk
British Pathé www.britishpathe.com
BBC www.bbc.co.uk

Acknowledgements

The preparation of this book has benefited from generous assistance from a number of people. Laura Maddison, Alexander Treliving, Angharad Wicks, Lynda Tubbs, Brian Malaws and Helen Rowe contributed additional research; the English Heritage Library provided research support; and members of the Britain from Above Project Team assisted in imagery preparation. Blom ASA kindly provided access to archive material, as did the National Aerospace Library, RAF Museum Hendon and the Trustees of the Medmenham Collection. The Heritage Lottery Fund and Foyle Foundation are the major funders who have helped to make the Aerofilms Collection (1919–1953) available to the public. Additional thanks go to Rebecca Bailey, Oliver Brookes, Alasdair Burns, the RCAHMS photographic team and the National Collection of Aerial Photography (all RCAHMS), Claire Blick, Anna Eavis, Mike Evans, Verity Hancock, John Hudson (all English Heritage), and Angharad Williams (RCAHMW). Indexing and proofreading by Linda Sutherland and Mairi Sutherland.

Index